Photoshop® CS3 Extended Video and 3D Bible

Photoshop® CS3 Extended Video and 3D Bible

Lisa DaNae Dayley

Wiley Publishing, Inc.

Photoshop® CS3 Extended Video and 3D Bible

Published by
Wiley Publishing, Inc.
111 River Street
Hoboken, NJ 07030-5774
www.wiley.com

Copyright © 2008 by Wiley Publishing, Inc., Indianapolis, Indiana

Published by Wiley Publishing, Inc., Indianapolis, Indiana

Published simultaneously in Canada

ISBN: 978-0-470-24181-3

Manufactured in the United States of America

10 9 8 7 6 5 4 3 2 1

For general information on our other products and services or to obtain technical support, please contact our Customer Care Department within the U.S. at (800) 762-2974, outside the U.S. at (317) 572-3993 or fax (317) 572-4002.

Library of Congress Control Number is available from the publisher.

Trademarks: Wiley and the Wiley logo are trademarks or registered trademarks of John Wiley & Sons, Inc. and/or its affiliates, in the United States and other countries, and may not be used without written permission. Adobe and Photoshop are registered trademarks of Adobe Systems Incorporated. All other trademarks are the property of their respective owners. Wiley Publishing, Inc. is not associated with any product or vendor mentioned in this book.

Wiley also publishes its books in a variety of electronic formats. Some content that appears in print may not be available in electronic books.

About the Author

Lisa DaNae Dayley's two great loves are writing and computers. With a degree in Advertising from Brigham Young University, DaNae has owned and operated a media creation business for 13 years, incorporating writing, graphic design, and video editing over the years. She has co-authored *ZENworks for Desktops* and *ZENworks for Servers* with her husband, Brad Dayley, and is the author of *Roxio Easy Media Creator 8 in a Snap*.

DaNae lives in Utah with her husband and four sons. When she's not at her computer, she can be found in the great outdoors, preferably in a Jeep.

To Brad, my hero, my biggest fan, my best friend. Always and Forever

To my fantastic boys, may you always have as much energy as you do now

Credits

Acquisitions Editor
Courtney Allen

Project Editor
Jade L. Williams

Technical Editor
John Lynn

Copy Editor
Marylouise Wiack

Editorial Manager
Robyn Siesky

Business Manager
Amy Knies

Sr. Marketing Manager
Sandy Smith

Vice President and Executive Group Publisher
Richard Swadley

Vice President and Executive Publisher
Bob Ipsen

Vice President and Publisher
Barry Pruett

Project Coordinator
Erin Smith

Graphics and Production Specialist
Jennifer Mayberry

Proofreading
Nancy L. Reinhardt

Indexing
Potomac Indexing, LLC

Acknowledgments

First and foremost, I would like to thank my husband and my biggest fan, Brad. You've been my sounding board, my psychiatrist, and my cheerleader. I could have never done this without you.

Thanks to my boys, who have been patient and loving throughout this process. I am grateful especially to Brendan and Caleb for the extra work this has meant for you. You have taken on the extra without (much) complaint. Thanks to all of you for making such great models as well.

To my other models, Josh, Janece, Becky and Brad's family. Thank you for letting me use your beautiful faces in this book.

A big Thank you to my editors at Wiley. Courtney Alan for your patience in trial and willingness to work with me. Jade Williams for keeping me stylish. Kim Heusel and Marylouise Wiack for making me sound very intelligent and last, but certainly not least, John Lynn for watching my back and making sure that the exercises in this book do what they say they are going to do.

Thanks as well to the graphics team at Wiley, who created the figure composites you see in this book.

Contents
at a Glance

Contents

Contents

Contents

Introduction

Who Should Read This Book

The *Photoshop CS3 Extended Video and 3D Bible* should serve as both a tutorial for beginners and a complete reference for experienced Photoshop CS3 Extended users. In addition, experienced 3D modeling professionals, animators, and video editors will be able to use this book to bring them up speed on what Photoshop CS3 Extended has to offer them. Most of the features covered in this book are new to Photoshop with the release of CS3 Extended, so the book streamlines the learning curve for both new and experienced users of Photoshop.

If you are a new Photoshop CS3 Extended user

If you are new to Photoshop, there is a lot to learn! This book covers the new aspects of Photoshop CS3 Extended, namely the 3D, Animation and Video editing capabilities as well as many of the features found in Photoshop that are most useful for editing these files. If you are using Photoshop Extended specifically for these reasons, this book is a comprehensive guide. If you want to learn all there is to know about Photoshop, this book is meant to be used in conjunction with books that cover all aspects of Photoshop.

If you are upgrading to Photoshop CS3 Extended

If you are an experienced user of Photoshop and are upgrading to CS3 Extended, you'll find that this book covers brand new territory for you. You are very aware of the powerful tools that are found in Photoshop and how they can be used. This book will show you how they can be used to edit 3D models, create animations, and edit video. With the advent of Smart Objects with CS3, there are many different ways that these files can be edited. This book will show you the benefits of each editing method so that you can determine which one will work best in your own projects.

If you are an experienced user of a 3D modeling, animation, or video editing program

Photoshop CS3 Extended is in no way meant to replace any of these programs, but rather it is meant to be used in conjunction with these programs to bring the powerful editing and creation tools of Photoshop to work for you. This book clearly demonstrates the ability Photoshop has to work with these files and the easiest way to make powerful changes that will forever make a difference in the way you edit your files.

How This Book Is Organized

This book covers 3D, animation, and video editing in five different parts. Parts I and II cover 3D files and stand alone as a full reference for these files. Parts III through V cover animation and video editing, both of which utilize the Animation palette. Each chapter can stand alone or point you to any additional information you need.

Part I: Manipulating 3D Models

Part I introduces you to the 3D environment that is new in Photoshop CS3. Understanding the environment and how it works is key to making the most of the tools in Photoshop to edit and create composites with a 3D model or animation.

Part II: Editing and Creating Composites with 3D Models

Part II shows you the best ways to edit the texture of a 3D model or the model itself as well as how to add the model effectively to a composite to create a finished product. This part also introduces Smart Objects and how they work to your advantage when editing a 3D model.

Part III: Creating Animations Using the Animation Palette

Part III introduces the Animation (Timeline) palette as well as thoroughly reviewing the Animation (Frames) palette. This part will take you through the steps of creating animations with the Animation palette in both its aspects.

Part IV: Editing Video Files

Part IV shows you how video files are manipulated using the Animation palette. You will also learn tips and tricks to make video editing a more streamlined process.

Part V: Correcting Video Files and Creating Special Effects

Part V shows you how to use the many editing tools that Photoshop has to offer including styles, filters, and adjustments to correct inherent problems in video files or to add stunning special effects.

How to Approach This Book

You can use this book in two ways: as a tutorial and learning tool, or as a reference.

If you are starting out with *Photoshop CS3 Extended Video and 3D Bible* for the first time, Chapters 1 and 2 will present the essentials you need to know to get started with 3D models in Photoshop. Chapters 8 and 10 introduce the Animation (Timeline) palette and the Animation (Frames) palette respectively. For the basics of video editing, turn to Chapter 13.

To learn how to color correct or create special effects for 3D or video files, turn to Chapters 4 through 7 and 14-17.

To learn more about Smart Objects and how they are useful in these and other types of files, turn to Chapters 4 and 14.

For tips and tricks on making working with video a fun and easy process, turn to Chapter 12.

Icons Used in This Book

To make this book as usable as possible, icons in the margins alert you to special or important information. Look for the following icons:

CAUTION Caution offers important information about a procedure to which you should pay particular attention.

CROSS-REF Cross-Reference refers you to a related topic elsewhere in the book. Because you may not read this book straight through from cover to cover, you can use cross-references to quickly find just the information you need.

NOTE The Note icon alerts you to a special point or supplementary information about a feature or task that may be helpful.

PHOTOSHOP CD The Photoshop CD icon reminds you how to find the 3D models that are supplied with Photoshop so that you can follow along with the exercises that use 3D models.

TIP The Tip icon marks a tip that saves you time and helps you work more efficiently.

To further assist you in reading and learning the material in this book, the following conventions are used throughout:

New words and phrases that may require definition and explanation appear in *italics*. Text that carries emphasis and single characters that may be easy to lose in the text also appear in *italics*.

Menu commands are indicated in chronological order by using command arrows: File➪Open.

Feedback, Please!

I would certainly appreciate your feedback about this book, especially your success stories. Please send your comments by e-mail to `danae_dayley@yahoo.com`.

Part I

Manipulating 3D Models

Manipulating 3D models consists of moving or transforming those models in 3D space. Manipulating a 3D model in 3D space using a two-dimensional interface can be an interesting process. It is easy to lose your perspective. This part serves as an introduction to how the spatial relationships of 3D modeling work.

You will also be introduced to the new 3D Transformation options bar found in Photoshop. Using the Transformation options, you will be able to manipulate and move 3D models, cameras, and lights. Learning the basics of 3D transformation will make you more effective in editing 3D objects and using them to create composites.

Chapter 1

Introducing the Photoshop 3D Workspace

Welcome to the amazing new world of 3D in Photoshop! Whether you are a seasoned Photoshop user who wants to learn a little more about the new 3D environment in Photoshop CS3 Extended or a 3D designer looking to improve your creations by using the tools in Photoshop, this book has something for you.

The 3D environment in Photoshop is limited compared to the 3D environments that can be found in modeling programs. That's because Photoshop isn't meant to create, redesign, or even animate 3D objects or scenes. What it is meant for is what it already does an incredible job of doing: using its powerful filters, styles, and other paint tools to improve the way a 3D image looks dramatically and to create fantastic composites.

I'm going to start at the very beginning, showing you the basics of the new 3D workspace, and how to manipulate objects in the workspace. Then I'll show you how you can change the look of a 3D object by editing its textures or applying filters and styles to it. I'll wrap up by showing you how you can use all these tools in conjunction with masks to create image composites using 3D objects.

Because I want you to be able to follow along, and to some extent create the same effects that I create, I use the 3D models that come with your Photoshop installer DVD. If you didn't buy Photoshop in a bundle, these bonus content files are contained on the same DVD as the Photoshop application. If you did buy Photoshop in a bundle, with Design Premium for example, you received a content DVD as well as an application DVD that includes the 3D models. Every time I use a model provided by Photoshop, I will remind you that you can find it in the bonus content, and I will tell you how to browse to it. You can learn the concepts I teach in this book without

IN THIS CHAPTER

Learning 3D file formats

Getting to know the 3D environment

Understanding the Layers palette

Creating a 3D object

3

following along with the tutorials, but if you do follow along, working with 3D objects in Photoshop will soon become second nature for you.

The 3D models provided by Photoshop are well done but very basic, especially in the textures (or lack of textures) provided. This makes them perfect for learning how the tools in Photoshop can really enhance how they look. As you learn new concepts, please play around with other models provided by Photoshop or some of your own. The techniques I am going to show you will work just as well on sophisticated 3D models as the simple ones you'll be using in this book.

First things first: Before you can have fun with 3D models, you have to start at the beginning. This chapter covers an introduction to 3D basics, including 3D file types, the 3D environment, and an in-depth overview of the Layers palette.

Understanding 3D File Formats

A good place to start is learning about 3D file formats, what they are, and where they come from. I also talk a little bit about image file types, something that isn't exclusive to the 3D world, but plays a big role nonetheless.

Raster and vector images

An image file type is how the file information is contained in computer memory. There are two basic image file types: raster files and vector files. Both of these file types are used when working with 3D models. Understanding the differences between them will enable you to use them more effectively.

Raster images

A raster file is the file most commonly worked with in Photoshop. A photo is a raster file, and even if the closest to Photoshop you ever come is owning a digital camera, you probably understand how a raster file works. A raster file is made up of pixels, or bits of color information that are laid out in square dots. The smaller these squares, the smoother the image looks. That's why the megapixel rating is the number one feature of a digital camera. The more dots you can pack into an image, the smaller they will be.

However, no matter how small the pixels, any raster image begins to look distorted as you zoom into it. If you zoom close enough, you actually see the jagged edges of the squares that make up the colors of the picture.

The files that make up the texture of a 3D object are generally raster files. A raster file is easily editable in Photoshop. You can use any of the tools and filters to make changes to your texture. However, like any other raster file, you need to be careful in stretching it until it loses too much quality. For example, if you replace the texture of a 3D model by placing a JPG file over the existing texture, you would want to make sure that the file wasn't so small that you had to scale it up a great deal to cover the texture. That would cause it to become pixilated, or show the jagged edges of the pixels. You can see how this looks in Figure 1.1

FIGURE 1.1

The image quality of the texture over this 3D model is very poor, because it has been scaled up too far.

Vector images

Whenever you are working with a 3D model, you are working with a vector file. Images that are created in Adobe Illustrator are also vector files. Vector files are made up of geometric shapes that are defined by mathematic equations. When you change the size of a vector file, the image is simply recomputed and the file doesn't lose any quality.

A 3D object rendered in wireframe mode is a basic example of how vector images work. Look at the example in Figure 1.2. The outlines of the chair are stored in the computer numerically; the length, width, and placement are determined by mathematical equations describing each component.

Working with vector files will have a big effect on how you edit your 3D images. Anytime you try to use the paint tools on a vector file, Photoshop lets you know that the tool you are trying to use won't affect your file because you can't change the pixels of a vector file directly. That's because a vector file doesn't contain any pixels, of course. Photoshop can rasterize any vector file, making it possible to use any of the tools or filters on that file, but rasterizing a 3D object will flatten it, turning it into an image rather than a 3D model. There are times when you are creating a composite

that you'll want to do just that, but most of the time, you'll want your 3D objects to maintain their capabilities. Fortunately, Photoshop provides several different ways of changing a 3D object without affecting it directly.

File extensions

By adding the 3D extensions, Photoshop has added a completely new array of readable file formats to its already impressive repertoire. Photoshop supports the following five 3D file formats:

- **3DS:** 3DS is the native file format of 3ds Max, the most widely used 3D application. It has become so much the industry standard that most 3D modeling programs of whatever type will export their files in this format.
- **OBJ:** the OBJ file format is also a widely used industry standard. The 3D models that come with the Photoshop bonus content are OBJ files.
- **COLLADA:** This is the file format used by the video gaming industry. It was originally developed to facilitate transporting digital content from one creation tool to another. COLLADA is also a widely supported file format.

FIGURE 1.2

No matter how large this chair becomes, the lines that make up its wireframe stay crisp.

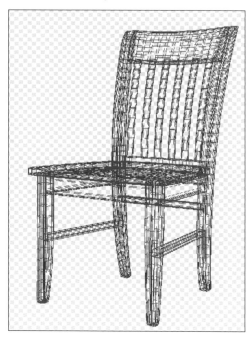

- **U3D:** The Universal 3D file format allows users to share 3D graphics with other users that don't have the 3D modeling program used to design the image. Like JPG or TIF files, these files are working toward being universally available to most image viewers.

- **KMZ:** This is the file format created and used by Google Earth. This file format is specific to the 3D geography that you see when you explore Google Earth.

Getting Acquainted with the 3D Environment

When you open a 3D file in Photoshop, it is brought into the Photoshop environment that we all know and love, with the new advances made in CS3, of course. Transforming, or moving, a 3D object is done just like transforming an image: by opening the transformation environment. Of course, there is much more to a 3D object, and so there is much more to the 3D Transformation palette. In this section, I show you the tools that are in the Transformation palette. I describe some of the tools briefly and cover them in depth in later chapters. Others I explore more thoroughly, showing you what they do and how they work.

After opening a 3D file, you need to know how to open the 3D Transformation palette. The fastest and easiest way to do this is to double-click the thumbnail in the 3D object layer in the Layers palette (see Figure 1.3). You can also open the 3D Transformation palette by choosing Layer ➪ 3D Layers ➪ Transform 3D model.

FIGURE 1.3

Double-clicking the thumbnail of the 3D layer will open the 3D environment.

3-D object layer

The Transformation palette opens by creating a 3D options bar under the File menu. From here, you can select several different options to manipulate or change the settings of your 3D object.

Editing the 3D object

The first two buttons on the toolbar are Edit the 3D Object and Edit the 3D Camera. Clicking one of these two buttons determines not only what the other tools affect, but in some cases, what the other tools are. Look at Figure 1.4, which is a representation of what the 3D options look like when you click Edit the 3D Object. When you have clicked the Edit the 3D Object option, all the changes you make will be to the object itself.

FIGURE 1.4

The 3D Transformation toolbar when you are editing a 3D object.

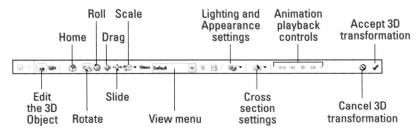

Editing the 3D camera

The Edit the 3D camera button, on the other hand, allows you to change the position of the camera or the view of the object. Look at Figure 1.5. The options for the 3D camera have changed a little. Notice the camera added to the different icons to remind you that you are making changes to the camera and not the object. The icons also have different names. One other difference is the ability to save or delete custom views in the camera View menu, something you can't do in the object View menu.

FIGURE 1.5

The 3D Transformation toolbar when you are editing a 3D camera.

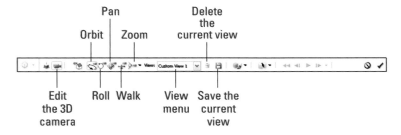

Using the Home tool

The Home tool is the next button on the 3D Transformation toolbar. If you are manipulating your object and you lose it in outer space or just feel like you've contorted its position beyond repair, you can click the Home button to bring your object back to the last saved position. This gives you the freedom to play around with the 3D controls, allowing you to get a feel for the different things you can do with them, and safely return to your home position. After you accept a transformation on your object, however, that save becomes your new home base.

Manipulation tools

The next five tools on the toolbar allow you to rotate, move, or scale (zoom) the 3D object or the 3D camera, respectively. The key to using these tools is to understand that they are a representation of moving a 3D object in a 3D environment (X, Y, and Z planes), but they can only be used on a two-dimensional monitor. That is why there are two tools for each type of movement. For example, rotating and rolling are tools that rotate an object around its axis. The axis is determined by the tool you use.

The best way to understand how these tools work is to jump right in and use them. The next chapter takes you through a few brief exercises that allow you to do just that.

CROSS-REF Manipulation tools are covered in depth in Chapter 2.

Changing the Lighting and Appearance settings

When you click the Lighting and Appearance settings buttons, a dialog box with several different options appears (see Figure 1.6). These options give you the ability to apply different kinds of lights to your object or render your object in a different mode.

FIGURE 1.6

The Light and Appearance settings dialog box.

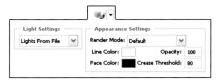

Light settings

Change the light settings by selecting the Light Settings drop-down menu and choosing the type of light you want to use on your object. The default, Lights From File, maintains the light settings created in the original 3D file. Figure 1.7 shows the effects of two different lights on a 3D model of the moon.

CROSS-REF If you want to know more about light settings and how you can manipulate the light's position by changing your camera setting, see Chapter 2.

FIGURE 1.7

The moon lit by hard lights (left) and night lights.

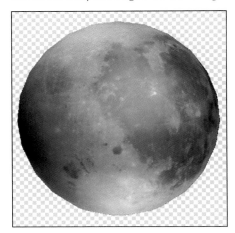 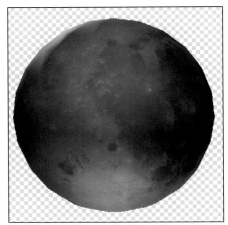

Appearance settings

Rendering a 3D object can be pretty memory intensive. When you manipulate an object or place an object into a composite with other objects or images, rendering that object anew every time you adjust it can be time consuming. Temporarily changing the appearance settings of an object can expedite the render process.

Render mode

The Render mode determines how much of an object will be rendered. You can choose from several different options, most of which can be placed in the following categories:

- **Default:** The Default setting renders the object completely every time the object is moved or placed. If the object is simple, this is usually not a problem, but the more complicated this file is, the longer it takes to make each adjustment.

- **Bounding box:** A bounding box creates the smallest possible box outline of the object. There are three bounding box types. Figure 1.8 shows a transparent bounding box with an outline.

- **Vertices:** Vertices are the points made by the junctions of the polygons that make up the frame of the 3D model. This is the fastest render mode, but it can be difficult to see, as you can see in Figure 1.9.

FIGURE 1.8

The moon rendered as a bounding box.

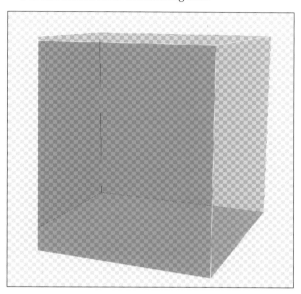

FIGURE 1.9

The moon rendered as vertices.

■ **Wireframe:** Rendering your 3D object as a wireframe is the most complex of the line renders. It has the benefit of being faster to deal with than a fully rendered object, but still maintains the shape of the object — and it's a lot easier to see than the vertices. There are several different wireframe modes. Figure 1.10 shows the moon as it looks rendered in wireframe.

FIGURE 1.10

The moon rendered as a wireframe.

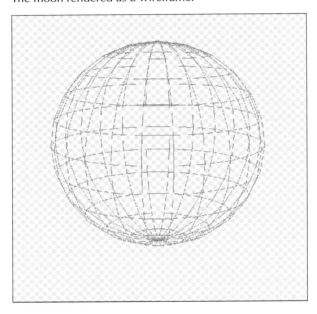

■ **Shaded:** The other render settings are different levels of shading. This can range from the line illustration that just creates a solid color object, to a solid outline, which apart from the outline, can't be distinguished from the default rendering.

Line color

Changing the line color changes the color that the outlines and vertices are rendered in. The default is white, which is almost impossible to see on the transparency grid unless you're rendering a shaded object. Changing this color to something brighter, such as red or blue, makes it much easier to see.

Face color

The face color is the color that any shaded area of the 3D object will render in. The default here is black, which is usually fine, but you can change it to whatever suits you.

Opacity

The opacity setting changes the opacity of the rendering. The lower the number on the opacity setting, the more transparent the rendered object will appear.

Crease threshold

The crease threshold defines the number of lines that appear in a wireframe or line rendering of a 3D object. As you lower the number, more lines appear in the creases and over the curves of your object. Figure 1.11 shows a robot rendered as a line illustration with differing crease thresholds.

FIGURE 1.11

The first robot is rendered with a crease threshold of 90, the second with a crease threshold of 10.

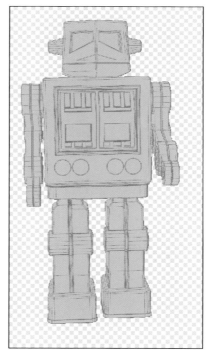

The Cross Section tool

The Cross Section tool is another very versatile tool within Photoshop. Actually using the tool is relatively simple and easy to learn. The applications of creating a cross section, however, are varied.

This is a great tool for use with architectural renderings. It allows you see inside the models of 3D buildings. You can see in Figure 1.12 that the roof is cut off this simple room to show the inside of it. You can see that this could be a very valuable application for looking at or editing more complex buildings or furnished rooms.

FIGURE 1.12

This room had a roof before a cross section was created.

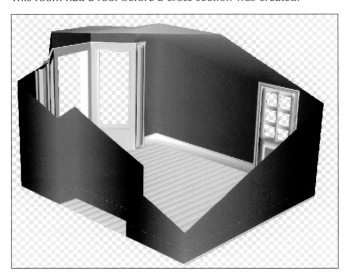

You can also use cross sections to cut down any 3D model for use in a composite. You can intersect a cross-sectioned object with another object or image, or you can just use the cut-down version of an object. By using two instances of the same 3D model, you can open an object, such as a box, by creating matching cross sections.

CROSS-REF Chapter 7 has more information on using cross sections in composites, as well as an exercise that walks you through creating your own.

Click the Cross Section button in the 3D toolbar to open the Cross Section dialog box, as shown in Figure 1.13. Using the settings, you can create a cross section on any plane, position it anywhere on your object, and tilt it from side to side or back to front.

The Cross Section dialog box.

Cross section settings

The Cross section settings allow you to enable the cross section and decide which side of the object to cut away. There are three options in the Cross Section Settings area of the dialog box:

- **Enable Cross Section:** Select this check box to create a cross section. Deselect it to return the object to full view.

- **Flip:** Select this check box to determine which half of the object to show. If this option had been selected when the cross section in Figure 1.12 was created, you would have seen the roof of the house instead of the floor.

- **Show Intersections:** Select this check box to outline the areas of the object that have been affected by the cross section. You can change the color of the outline by clicking the color box and making the change.

Alignment

The Alignment options allow you to set the axis on which the cross section will take place. Select X-Axis and you are left with either the right or left half of your object. Selecting Y-Axis leaves you with the front or back. Select the Z-Axis and you are left with the top or bottom of your object. The house in Figure 1.12 was cut along the Z-axis.

Position and orientation

The three sliders in the Position and Orientation area of the Cross Section dialog box allow you to change where the cross section is placed and the angle at which it runs:

- **Offset:** When you enable a cross section, your 3D object is cut exactly in half. By changing the offset, you can move that dividing line to cut off more or less of your object.

- **Tilt:** The tilt sliders change the angle of the cross section. By default, the angle of the cut is parallel with the base of your object. You can adjust one or both of these sliders to change the front to back angle or the side-to-side angle.

All of the options in the Cross Section dialog box are affected by the orientation of your 3D object. The tilts, for example, work the same way on your object, but differently in your view, as seen in Figure 1.14. The settings are the same for both chairs, and they affected the chair in the same way.

However, in the first picture, the tilt runs from front to back; in the second, the tilt runs from side to side in your view. That's why the tilt settings aren't labeled with a distinguishing direction, and it's easy to see why. You certainly wouldn't want to change the orientation of an object after you apply a cross section and have the cross section change on the object!

FIGURE 1.14

The same Cross Section settings affect the chair in the same way, no matter how it's oriented.

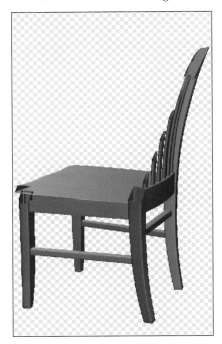

Playing an animation

If your 3D object comes into Photoshop complete with an animation, you can easily watch that animation by using the animation playback controls in the Transformation toolbar.

As you manipulate and edit your 3D object, it will be rendered that way all the way through the animation. To make changes to each frame of an animation, you need to open the Animation timeline and edit your animation there.

CROSS-REF **The Animation timeline and other aspects of creating animations are covered in Part III.**

Accepting or canceling transformations

The last two buttons in the 3D Transformation toolbar are the Cancel or Accept Transformation buttons. Whenever you are in the 3D Transformation environment, nothing else is accessible to you until you either accept or reject the transformations you've made. If you click on the File menu, nothing will be highlighted. If you click on the Layers palette or a tool from the main Toolbox, you'll be asked if you want to accept the transformations. Worst of all, if you click on another open file inside Photoshop (and I've done this so many times it's embarrassing), the trans-formations are automatically canceled and you are ejected from the 3D Transformation environment.

To deactivate the 3D Transformation tools and return to the main Photoshop environment, you need to either cancel or accept the transformation by clicking the corresponding button. You can then make changes using the standard Photoshop tools.

Working in the Layers Palette

The layers of a 3D object are more complicated than most images. When you open a 3D object in Photoshop, unless that object doesn't contain any textures at all, you will have at least one sublayer listed under a textures heading. On top of that, every filter or edit you can make to a 3D object involves the Layers palette in one way or another. It doesn't take very many changes to add several layers to a 3D file or composite. Don't panic yet. Like a well-organized filing cabinet, the Layers palette is a clean and efficient way to organize your effects and filters.

I am going to give you a complete overview of the Layers palette in this section to introduce you to it. You might be surprised at how much editing is done right from the Layers palette. Don't worry if you don't grasp everything right away, especially in the sections that are covered in more depth later in the book. As you go through each new 3D concept in the next few chapters, you'll learn how these concepts work in the Layers palette. By the end of Chapter 7, you'll be an expert in managing 3D object layers and their sublayers.

Start by looking at the Layers palette itself. Figure 1.15 shows the options and menus that can be found on the Layers palette. There are quite a few, so I'll go over them one at a time to give you a better feel for what each one does.

The Layers palette menu

The Layers palette menu consists of actions that can be preformed on a given layer. The options found in this menu can also be found by choosing Layer in the File menu. To access the Layers palette menu, simply click the Layers palette menu button as shown in Figure 1.15. You can also access the Layers palette menu by right-clicking the selected layer. Right-clicking the layer displays a condensed version of the menu that includes only the options that would be highlighted in the larger Layers palette menu, plus a few applicable options from the larger Layer menu.

FIGURE 1.15

The Layers palette.

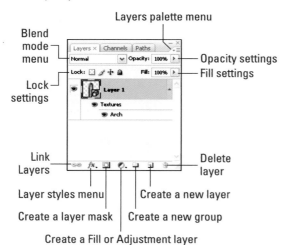

The kind of layer that is selected determines the menu options. A background image layer has relatively few options compared to a 3D object layer (see Figure 1.16). Don't worry too much about understanding the menu options right now. They are either self-explanatory (for example, Duplicate or Delete layer) or they are covered as they become applicable to editing a 3D object or creating a composite.

FIGURE 1.16

The Layers palette menu changes based on the type of layer that is highlighted.

Blend modes

Choosing a blend mode determines how the selected layer will blend into the layers below it. You can use a blend mode whenever you have more than one layer or even a sublayer. You can choose a blend mode from the menu on the Layers palette, or you can right-click the layer and choose Blending Options from the menu.

The blend modes are divided into six general categories indicated by the divisions shown on the menu in Figure 1.17. I will fill you in on the basic properties of each of these categories of blend modes. The layers you are working with really make a difference in how the blend modes look, so the best way to get a feel for them is to jump in and play with them using your own images and models.

FIGURE 1.17

The blend modes.

Normal
Dissolve
Darken
Multiply
Color Burn
Linear Burn
Darker Color
Lighten
Screen
Color Dodge
Linear Dodge (Add)
Lighter Color
Overlay
Soft Light
Hard Light
Vivid Light
Linear Light
Pin Light
Hard Mix
Difference
Exclusion
Hue
Saturation
Color
Luminosity

Normal and Dissolve blend modes

The first group inside the blend modes menu contains Normal and Dissolve. Normal indicates that no special blend mode has been applied. Dissolve looks much the same when you first apply it. The difference comes when you reduce the opacity of the layer that the blend mode is applied to. As you reduce the opacity of a normal layer, it becomes transparent, just as you would expect. As you reduce the opacity of a layer with a Dissolve blend mode applied, it dissolves rather than becoming translucent (see Figure 1.18).

FIGURE 1.18

The Normal and Dissolve blend modes, with the opacity set to 50 percent.

Darkening blend modes

The next group within the blend modes menu contains darkening effects. Each of these five blending filters leaves the darker areas of the affected layer opaque and creates translucency in the lighter areas of the image. Just choosing Darken will do exactly that. Choosing one of the other options adds additional filters to the Darken effect. For example, Color Burn adds a color tint to the translucent portions of the affected layer.

Lightening blend modes

The Lighten group of blend modes works very much like the Darken group. Instead of leaving the darker areas of the affected layer intact, these blend modes leave the lighter areas of the image intact. You can see how this works in Figure 1.19. Look at the Layers palette. What you are seeing is actually two images. The first is the uninspiring texture of a 3D model of a car. The second is a JPG of a nebula. When the image of the nebula is places over the texture of the car, it completely covers it, obscuring any details of the car.

With the Nebula layer highlighted, the Lighten blend mode can be added to it to create opacity. The bright stars are left in the image along with some great color variations for the bland red color of the car. When I save this texture, the changes will be reflected on the original model.

Adding Contrast blend modes

The next group in the Blend Modes menu adds contrast to the affected layer, making the lighter areas more brilliant and deepening the darker areas. You can see in Figure 1.20 that if I had added a Hard Light blend mode to the nebula that you would see a lot more of the nebula over the texture of the car. The lighter areas in the nebula are tinted very heavily with the red of the car and the darker areas are a very dark red.

FIGURE 1.19

Changing the blend mode to Lighten reduces the entire nebula except for the stars and a few light clouds.

FIGURE 1.20

The Hard Light blend mode applied to the nebula makes the lighter areas very bright and the darker areas deeper.

Difference and Exclusion blend modes

The Difference and Exclusion blend modes create an inversion in the colors of the lower layer that is based on the brightness levels of the affected layer. For example, when I set the blend mode to Lighten, bright stars and clouds are left in the texture of the car. If I had set the blend mode to Difference, the bright areas would be the exact opposite color of the car, a bright green.

Influencing blend modes

The last group of blend modes gives the affected layer an influence over the layers it is placed over. You can see in Figure 1.21 that by creating a color overlay layer over the moon and choosing the Color blend mode, I've created a colorcast over the moon. I could reduce the influence of the color by reducing the opacity of the Color Overlay layer.

FIGURE 1.21

When applying the Color blend mode, the color over the moon influences it, rather than completely covering it.

Blending options

After you add a blend mode to a layer, you can right-click the layer and choose Blending Options from the Layers palette menu. This displays the Layer Style dialog box, where you can change the options of the blend mode you have chosen. You can change options such as the opacity and fill of the blend mode, or which color channels will be affected by it.

Opacity and Fill settings

The Opacity and Fill settings in the Layers palette allow you to change the opacity of a selected layer. The Opacity setting will change the entire layer, including all the applied filters and styles. The Fill setting will exclude any effects applied to the layer and change only the opacity of the

pixel content of the layer. You can change these numbers by typing the number in the percentage window, or you can use a hidden slider behind the name of the setting. Click the word Opacity and drag the mouse to the left; the opacity number will decrease in the percentage window.

Lock settings

You can set four different types of lock on any one of your layers (see Figure 1.22). You can also lock groups of layers by selecting more than one layer before setting the lock.

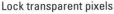

FIGURE 1.22

The Lock settings in the Layers palette.

Lock transparent pixels

Lock position

Lock all

Lock image pixels

- **Lock transparent pixels:** The first Lock setting locks the transparent pixels in the layer so that they can't be edited.
- **Lock image pixels:** Locking the image pixels prevents you from using paint tools on the pixels in the layer.
- **Lock position:** Locking the position of a layer prevents the pixels in that layer from being moved.
- **Lock all:** This setting prevents any changes to the layer.

Linking layers

When you link layers, they are tied to one another; if you move one of them, the other one goes with it. This is very useful when you've created a fill or adjustment layer, a masking layer, or another style layer that needs to affect an image or object layer, even when that layer is being moved around inside the Layers palette. To create a link, select two or more layers by holding down the Ctrl (⌘) key while selecting them and simply click the Link icon at the bottom of the Layers palette.

Layer Style menu

When you click the Layer Style button at the bottom of the Layers palette, the Layer Styles dialog box appears (refer back to Figure 1.15). From here, you can choose special effects to apply to the selected layer, such as a drop shadow or inner glow. You can also change the options of any one of the special effects.

CROSS-REF Layer styles are covered in depth in Chapter 5.

Creating a layer mask

When you click the Mask button, you create a mask on the selected layer. If you don't have a selection in the selected layer, the mask will be white, indicating that the entire layer is selected. After you create a layer mask, you can move it to a different layer by clicking and dragging it. Later, I show you why this can be a very useful feature of masks.

CROSS-REF Masks are an indispensable feature of creating image composites with 3D objects. You can learn more about masks in Chapter 7.

Creating a fill or adjustment layer

When you click the Fill or Adjustment Layer button and choose an option from one of the respective menus, the fill or adjustment that you choose becomes an independent layer in the Layers palette. This layer affects any layer placed underneath it inside the palette. You can mask this layer's effects by creating, or placing, a mask inside it. Because a fill or adjustment layer is a full layer, you can edit it just like any other layer, you can move it, lock it, or add a blend mode or any other special effect to it.

CROSS-REF Because a 3D object is a vector file, the pixels can't be directly affected. Placing a fill or adjustment layer over it in the Layers palette allows you to apply color filters and changes that you wouldn't be able to do in any other way. You can learn how in Chapter 6.

Creating a group of layers

Creating a group of multiple layers gives you one more layer of organization in the Layers palette. Think of the sublayers as folders, the layers as file folders, and the layer groups as filing drawers. Of course, the Layers palette is the filing cabinet. You can create a group by clicking the Group button at the bottom of the Layers palette. After naming the group, you can drag layers into it. (See Figure 1.23).

Create a new layer or delete a layer

When you add paint or text to an image, it is sometimes helpful to do so in a separate layer. You can create a new layer by clicking the New Layer button in the Layers palette. When the new layer is highlighted, any pixels you add are placed inside this new layer. Once inside its own layer, you can use Layer styles, blend modes, and other effects on the drawing or text you've created without affecting other layers.

FIGURE 1.23

A group has been created from the car model and a filter placed on top of it.

NOTE When you drag a selection into an existing file or place a file in it, a new layer containing the new image or object is automatically created.

You can delete any layer by highlighting it and clicking the trash can, or by dragging and dropping it into the trash can.

Flattening an image

As you create composites, and add more files and special effects, your document size will grow very large. You can see the size of your document by looking at the bottom left-hand corner of the document window (see Figure 1.24). The document size is represented by two numbers separated by a slash. The first number indicates the size of the original, or background, document. The other number indicates the size of the document including additional layers.

You can reduce the size of the document in several ways. Although one of the easiest ways is to flatten the layers, I don't recommend this as a permanent solution because you will be rasterizing your entire document into one image containing just one layer. Flattening the layers will reduce the size of your file to the size of the original image. Make sure that you have made all desired changes and transformations to the layers and then choose Layer ➪ Flatten Image. This combines all of your layers into a single image and you will no longer be able to edit them individually. Any 3D objects in the file also become part of the image and lose their 3D capability.

Besides reducing the document size, flattening an image converts it to a raster file. The only way to use the paint tools on 3D or any other vector file is to rasterize the image. Although you can rasterize layers individually, flattening the image allows you to rasterize the entire file in one step.

FIGURE 1.24

You can easily tell the size of your document by looking in the bottom border of the document window.

Original document size Size with added documents and filters

Creating a 3D Layer with Vanishing Point

Before I begin to show you what you can do with a 3D model, I'm going to take you into an area that is a little different from anything else I'm going to show you.

The Vanishing Point filter was introduced in Photoshop CS2. In CS3, Photoshop has introduced some big changes to it, including the ability to export the grids as 3D layers or objects. Vanishing Point is all about perspective, and how it works in a two-dimensional image.

You can create a 3D layer from a two-dimensional image by using the tools in Vanishing Point.

1. Open an image in Photoshop. The image needs to contain a building or other square object that has a prominent corner and at least two different planes. The simpler these aspects are, the easier you'll find this exercise.

TIP If you don't have an image that fits this description readily available, try going on the Internet to search for building images.

2. Choose Filter ➪ Vanishing Point to open the Vanishing Point work area.

3. Create a grid on one of the faces of the building by clicking on each corner.

TIP You are trying to create a blue grid. If your grid is red or yellow, it does not follow the lines of perspective correctly. You can readjust the grid by moving any one of the handles.

4. Click the Create a New Plane button.

5. Hover over the center handle of the first plane on the corner of the building until you see it change to the Selection tool, as shown in Figure 1.25.

FIGURE 1.25

Connect the first plane to the second to create one angled grid.

Click on this icon to create a new plane.

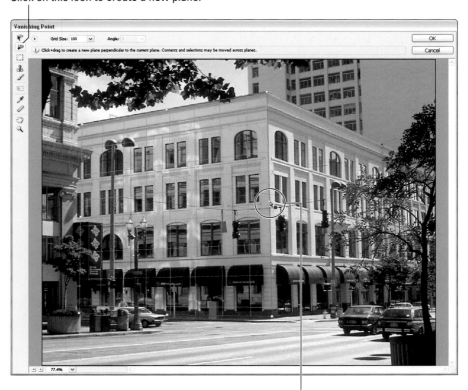

Use this selection icon to connect the second plane to the first.

6. Click the center handle and drag the new plane out a little way. It will be created at a 90-degree angle to the first plane. This will probably not fit the second face of your building.

7. Click the arrow next to the degree indicator in the Angle option at the top of the Vanishing Point window and use the slider to adjust the angle until it follows your building.

8. Finish dragging out the second plane. With two sides of your building selected, you are ready to export a 3D version of this image.

9. Click the little arrow at the top of the Vanishing Point window. This will show you the Settings and commands for Vanishing Point (see Figure 1.26).

FIGURE 1.26

Export the planes into a 3D layer in Photoshop.

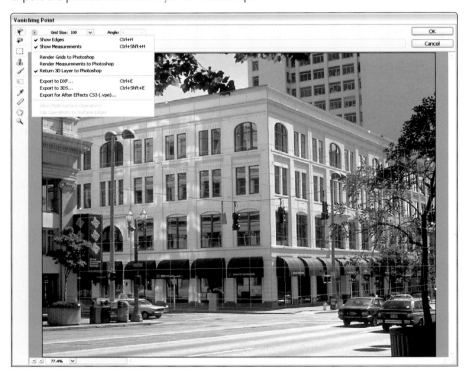

10. Click Return 3D Layer to Photoshop.

11. Click OK to close the Vanishing Point window.

12. Wait as the 3D layer is generated in your image file.

13. Click the eye in the image layer to hide it from view.

14. Double-click the thumbnail in the 3D layer to display the 3D Transformation palette.

15. Play around to view the aspects of this new 3D layer (see Figure 1.27).

FIGURE 1.27

Manipulating a new 3D building.

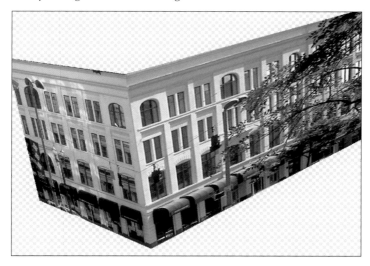

You might have noticed in the Vanishing Point settings that you can also export these planes as DXF or 3DS files. A DXF file will maintain the 3D information and measurements, while a 3DS file will also maintain the textures or the image of this building on the 3D file.

Summary

In this chapter, you learned the basics of the 3D environment and the Layers palette. You learned about:

- 3D file formats
- The 3D environment
- The Layers palette
- Creating a 3D object in Vanishing Point

Now that you've covered the basics, Chapter 2 moves on to an in-depth look into the 3D environment and manipulating 3D objects.

Chapter 2

Manipulating 3D Objects, Cameras, and Lights

Imagine you are standing in a room. As you move in a straight line left to right, you are moving along the X-axis. If you were to jump up and down in place, you would be traveling along the Y-axis. This is a two-dimensional plane, in which coordinates can be given with two numbers: an X location and a Y location. When you work with a two-dimensional file in Photoshop, you are working with an XY plane. If you want to create a third dimension, the Z-axis is added. The Z-axis creates a cube by adding depth to the XY plane. To move along the Z-axis you would walk front to back within the room.

The 3D tools in Photoshop allow you to move 3D models within all three of these planes. If you are already familiar with any 3D modeling software, you will find that the tools used in Photoshop are very familiar. Photoshop designed its manipulation tools to a very standard look and feel. If you have never used 3D tools, then you will find that they are fun and easy to learn to use. Jumping in and working with them as I introduce them to you in this chapter is the best way to familiarize yourself with them very quickly.

As you work with your 3D model, keep in mind that your final product in Photoshop will be a two-dimensional view, not a 3D scene or animation. This will help you keep in perspective what you can accomplish in Photoshop and how to do it.

Changing the View of a 3D Object or Camera

Before moving into your 3D model, I want to show you how changing the view of a 3D object or camera works in Photoshop. This is an area where things work very differently from 3D modeling software, because the final goal in Photoshop is a two-dimensional view.

Understanding static coordinates

The Transformation tools in Photoshop change the 3D object, not the 3D scene. This is true even for the view. When you change the view, you are changing the view of your object, not the view of your scene. The best way to understand this is through a demonstration. Start by opening Executive_Chair.obj in the Office_Chair folder found in the bonus content that comes with Photoshop:

PHOTOSHOP CD For this exercise, use the Executive_Chair.obj file found in the Photoshop CD bonus content. To access this file, insert the CD containing the bonus content and navigate to Goodies ⇨ 3D models ⇨ Office_Chair.

1. Open Executive_Chair.obj.

2. Double-click the thumbnail of the executive chair in the Layers palette to open the Transformation toolbox in Photoshop. Alternatively, you can choose Layer ⇨ 3D Layers ⇨ Transform 3D Model from the menu.

3. From the Transformation toolbar, click the Drag button.

4. Drag the executive chair around. You are moving the chair in the XY plane.

5. Choose View ⇨ Top.

6. Drag the executive chair around again. You are still moving the executive chair in the XY plane (see Figure 2.1).

7. Choose View ⇨ Default.

When you bring the executive chair file in, the view is set to the default view. This is the view set in the program that created the executive chair. As you change that view to the top, you can see this is a 3D object, because the view of it is very different.

You probably noticed two things as you were moving the executive chair around. First, when you changed the view of the executive chair to the top, Photoshop centered the executive chair on the canvas; none of the movements you performed on it earlier affected the new view. The same thing happened when you changed the view back to default; the executive chair returned to the same position as when it you opened it. When you roll, rotate, or scale a 3D object, these changes can be seen across all the views. This can help you make maneuvering changes that might be difficult in the view that you ultimately want to keep.

FIGURE 2.1

Viewing an object from the top doesn't change the view to the XZ plane.

Second, you might be wondering why the planes didn't change with the view. It makes sense that looking at the executive chair from the top would be an XZ view and that moving it would require changing its position in the XZ plane. That would be true if you worked with a 3D space in Photoshop, but Photoshop is only meant to work with 3D objects not 3D spaces. When you change the view of the executive chair, you are actually changing the position of the executive chair. Look at how this affects creating composites with a 3D object:

PHOTOSHOP CD For this exercise, use the Executive_Chair.obj file found in the Photoshop CD bonus content. To access this file, insert the CD containing the bonus content and navigate to Goodies ➪ 3D models ➪ Office_Chair.

1. Open Executive_Chair.obj.

2. Click the Drag icon.

3. Click and drag the executive chair to one side of the view.

4. Click the check mark (labeled Commit 3D Transform) in the Transformation toolbar to accept the Transformation changes.

5. Choose File ➪ Place.

6. Browse to the executive chair file and place another executive chair in your scene.

7. Place it to the side of your first executive chair so that both can clearly be seen and accept the placement by clicking the check mark in the Tools menu. Notice that the new executive chair is given its own layer in the Layers palette.

8. Double-click the thumbnail of Layer 1 in the Layers palette to open the 3D Transformation tools.

9. From the View drop-down menu, choose Top.

As seen in Figure 2.2, only the view of executive chair in Layer 1 changed to the top view and the first executive chair stayed in place. The Transformation tools work on the object, not the scene.

FIGURE 2.2

When the view of an object is changed, the view of the entire scene does not change with it.

In Photoshop, the X, Y, and Z planes don't change in the viewer's perspective. The Y-axis runs up and down, the X-axis runs side to side, and the Z-axis runs back to front, no matter what view you are using. This is true unless you are scaling an object. When changing the size of an object, the X, Y, and Z planes of that object are constant, no matter what the view is set to. For example, if you want to make the executive chair taller, you can do that by constraining the scale to the Y-axis even if you are looking at the object from the top. I'll demonstrate this when I talk about scaling a 3D object later in this chapter.

Saving a view

When you create a view that is different from the view options given in the 3D Transformation toolbar, you can save that view and name it so that you can return to it. You do this by placing a new 3D camera on the 3D object, so it can only be done while editing the camera:

You can save or delete as many views as you want by following these simple steps.

PHOTOSHOP CD **For this exercise, use the Executive_Chair.obj file found in the Photoshop CD bonus content. To access this file, insert the CD containing the bonus content and navigate to Goodies ⇨ 3D models ⇨ Office_Chair.**

1. Open Executive_Chair.obj.

2. Double-click the thumbnail of the executive chair in the Layers palette to open the Transformation toolbar.

3. Click the Edit the 3D Camera button.

4. From the View drop-down menu, choose Top.

5. Choose Orbit the 3D Camera and change your view of the executive chair by clicking and dragging on your view of the executive chair.

6. Click the Save button to save the current view (see Figure 2.3).

7. Name the view.

8. Click the View drop-down menu to open your saved view at any time.

FIGURE 2.3

Saving a custom view.

You can delete your custom views at any time by selecting them in the drop-down menu and clicking the trash can. This is an excellent way to keep views that you like and still have the flexibility to tweak your object's position.

Turning 3D Objects Around a Central Point

Turning a 3D object around a central point is done by using tools to rotate or roll that object. Rotating or rolling an object turns and skews it around the X-, Y-, or Z-axis. While using the Rotate and Roll tools, your object will move around a center point, which never changes position.

Changing an object's orientation is only the most obvious reason to use the Rotate and Roll tools. You can also change the lighting on your object. As you move your object, you'll notice that if you have a light placed in your scene, the lighting changes on your object. You can't actually move the lights in your scene, so if you want to change the position of the lighting, this is the way to do it.

Another use for the Rotate and Roll tools is to look at the texture of your object to make sure it is the way you want it, especially, if you've made any changes to it in Photoshop. You can click the Home button on the Transformation toolbar at any time to return your object to its original position. You can also make any permanent changes to your object and accept them by clicking the check mark in the Transformation palette; then go back to the Transformation palette to make changes that you don't plan to accept permanently.

Rotating a 3D object

The X-axis is a line running side to side through the center of an object. Like a hot dog turning on a roasting stick, if you only rotate your object on the X-axis, the top of the object rotates toward you or away from you. The Y-axis runs up and down through the center of your object. As you rotate your object around the Y-axis, the sides of the object move toward you or away from you. You can rotate an object around either or both the X- or Y-axis:

PHOTOSHOP CD **For this exercise, use the Executive_Chair.obj file found in the Photoshop CD bonus content. To access this file, insert the CD containing the bonus content and navigate to Goodies ➪ 3D models ➪ Office_Chair.**

1. Open Executive_Chair.obj.
2. Double-click the thumbnail in the Layers palette to open the 3D Transformation toolbar.
3. Click the Edit the 3D object button. While you have this option selected, all the changes you make will be to the chair itself, rather than the camera that is shooting the chair.
4. Click the Rotate button in the Transformation toolbar. Your cursor changes to the Rotate tool.
5. Click and drag back and forth across the chair to rotate it along the Y-axis or drag up and down to rotate it along the X-axis. You can constrain the rotation to either the Y-axis or the X-axis by holding the Shift key down as you drag in the appropriate direction (see Figure 2.4).

NOTE **You can roll a 3D object around the Z-axis with the Rotate tool selected by holding down the Ctrl key while dragging across the object.**

6. Click the check box in the Transformation toolbar to accept your transformations.

FIGURE 2.4

Rotating or rolling an object changes its orientation in virtual space.

Rolling a 3D object

Rolling your object around the Z-axis is a similar concept to rotating your object around the X- or Y-axis. Visualize a line running from front to back through the center of your object, which allows it to roll left to right and back again. You can roll your object around the Z-axis by using the Roll tool in Photoshop:

PHOTOSHOP CD For this exercise, use the Executive_Chair.obj file found in the Photoshop CD bonus content. To access this file, insert the CD containing the bonus content and navigate to Goodies ⇨ 3D models ⇨ Office_Chair.

1. Open Executive_Chair.obj.
2. Double-click the thumbnail in the Layers palette to open the 3D Transformation toolbar.
3. Click the Roll button in the Transformation toolbar. Your cursor changes to the Roll tool.
4. Click and drag back and forth across your 3D object to roll it around the Z-axis.

NOTE You can rotate the object around the XY center point with the Roll tool selected by holding down the Ctrl key while dragging across the object.

5. Click the check box in the Transformation toolbar to accept your transformations.

NOTE As you manipulate your object, and even as you save it, remember you are not making changes to the original 3D file by default. By default, your file is saved as a PSD, containing all the layers, but preserving your original file.

Moving a 3D Object through 3D Space

Dragging or sliding a 3D object moves it to a different location in your 3D workspace. Moving your object allows you to place it in the desired position so that you can create composites by adding a photo background or other 3D objects. You may also want to move an object to adjust the lighting or change the perspective.

CROSS-REF You can learn how to create composites in Chapter 7.

Dragging a 3D object

Dragging moves the object around the XY plane and is visually similar to moving a selection in a 2D file. You can drag your object by clicking the Drag tool in the Transformation toolbar:

PHOTOSHOP CD For this exercise, use the Executive_Chair.obj file found in the Photoshop CD bonus content. To access this file, insert the CD containing the bonus content and navigate to Goodies ➪ 3D models ➪ Office_Chair.

1. Open Executive_Chair.obj.
2. Double-click the thumbnail in the Layers palette to open the 3D Transformation toolbar.
3. Click the Drag button in the Transformation toolbar. Your cursor changes to the Drag tool.
4. Click and drag the chair up and down or from side to side within the XY plane of your 3D space. Visually, this looks a lot like placing a selection in a 2D file (see Figure 2.5).

NOTE You can slide a 3D object through the Z-axis with the Drag tool selected by holding down the Ctrl key while dragging across the object.

5. Click the check box in the Transformation toolbar to accept your transformations.

NOTE By selecting the Info window, you can see the effect that moving your object has on its position in your 3D space.

Sliding a 3D object

Sliding moves the object along the XZ plane, which looks very different from what you would expect from a 2-D file. As you move your object toward you or away from you along the Z plane, it looks very similar to scaling, or resizing, your object. You can slide your object by selecting the Slide tool in the Transformation palette:

FIGURE 2.5

Dragging or sliding an object changes its location in virtual space.

PHOTOSHOP CD For this exercise, use the Executive_Chair.obj file found in the Photoshop CD bonus content. To access this file, insert the CD containing the bonus content and navigate to Goodies ⇨ 3D models ⇨ Office_Chair.

1. Open Executive_Chair.obj.

2. Double-click the thumbnail in the Layers palette to open the 3D Transformation toolbar.

3. Click the Slide button in the Transformation toolbar. Your selection icon changes to the Slide tool.

4. Click and drag the chair back and forth to move it along the X plane. This is identical to the effect caused by dragging your object back and forth.

5. Click and drag up and down over the chair. Unlike the Drag command, this slides your object forward and backward along the Z plane, giving the object the illusion of becoming larger or smaller.

6. Click the check box in the Transformation toolbar to accept your transformations.

When working with 3D, sliding an object is a very different effect from actually making the object bigger or smaller, just as walking away from an object in real life doesn't change its actual size, just your perspective of it.

TIP At any time while you are manipulating your object, you lose it in "outer space" or just feel as if you've just contorted its position beyond repair, you can click the Home button on the Transformation toolbar to bring your object back to the last saved position.

Scaling a 3D Object

Scaling a 3D object in Photoshop is very similar to using the Transformation tools to scale an image within Photoshop. By selecting the Scaling tool, you can click and drag across your object to make it bigger or smaller. As you change the size of your 3D object by using the Scale tool, the proportions of the object are automatically maintained. By holding down the Ctrl key while you click and drag, you can adjust the object nonproportionally by making it taller or shorter. If you hold the Shift key down, you can make your object wider or narrower.

Interestingly enough, the Scale tool is an exception to the guidelines established for the 3D object view earlier. If you change the view of your object while you are scaling it, the Ctrl key still makes the object taller or shorter and the Shift key makes the object wider or narrower. Look at how this works:

PHOTOSHOP CD **For this exercise, use the Executive_Chair.obj file found in the Photoshop CD bonus content. To access this file, insert the CD containing the bonus content and navigate to Goodies ⇨ 3D models ⇨ Office_Chair.**

1. Open Executive_Chair.obj.

2. Double-click the thumbnail in the Layers palette to open the 3D Transformation toolbar.

3. From the View drop-down menu, choose Back. This gives you a better view of the changes you make than the default view does.

4. Click the Scale button in the Transformation toolbar. Your selection icon changes to the Scale tool.

5. Click and drag up and down over the chair to make it bigger and smaller. The proportions are automatically maintained.

6. Hold down the Ctrl key as you click and drag over the chair. The chair becomes taller and thinner or shorter and stouter.

7. Hold down the Shift key as you click and drag over the chair. You can now change just the width of the chair.

8. From the View drop-down menu, choose Top.

9. Hold down the Ctrl key as you drag up over your object. You won't see any apparent changes.

10. From the View drop-down menu, choose Back. Notice that you have changed the height of the chair from the top view (see Figure 2.6).

11. Click the Cancel Transformations button in the Transformations toolbar to exit and return your object to its original size.

FIGURE 2.6

Holding down the Ctrl key while using the Scale tool will always change the height of the object, no matter what view is being employed.

Because you can always change the height or the width of a 3D object no matter the view, you can use the views to change the proportions of your object in the way that is visually easiest.

The Scaling tool also has a drop-down menu beside it that allows you to change the position orientation, and scale of your object numerically by typing in values for X, Y, and Z as shown in Figure 2.7. This is usually a better way to scale your object disproportionately. Once you have highlighted the number in any one of the areas, you can type in a new number or you can use your mouse to increase or decrease the number. You can also change these values inside the window by clicking and dragging across the letter that applies to the value you would like to change.

FIGURE 2.7

You can change the position, orientation, or scale of your object numerically.

Positioning the Camera on a 3D Object

You can position and reposition the camera that is viewing the 3D object. These movements are very similar to moving the object, allowing you to view your object from any angle. A few subtle differences let you know you are working with the camera and moving the camera rather than the object.

Probably the first difference you'll notice when changing a camera view and manipulating the object is the lighting. When you manipulate the object, the camera and the lights are stationary, and the object is moving. Therefore, the light changes on the object as it turns and rotates. When you move the camera rather than the light, however, both the object and the light are stationary, so the light stays constant on the 3D object.

Because the movements you make will be to the camera, another difference you'll see right away is that your view shows you a mirror image of your actions as you drag the mouse. For example, as you orbit the camera left by clicking and dragging to the left of your object, your object appears to rotate to the right.

Orbiting and rolling the camera changes the object's orientation in the camera view. Panning and walking the camera moves the camera around the object, as if you were rolling it across the floor. Zooming with the camera changes its focal length, moving the object closer or farther away in the camera's view.

Orbiting with the camera

Unlike moving a 3D object by rotating it, orbiting the camera moves the camera around your object. As you orbit the camera, it is oriented toward the central XY point on the object and continues to stay the same distance from that point. You can Orbit the camera in a perfect circle around a 3D object's center point:

PHOTOSHOP CD For this exercise, use the Flashligh.obj file found in the Photoshop CD bonus content. To access this file, insert the CD containing the bonus content and navigate to Goodies ⇨ 3D models ⇨ Flashlight.

1. Open Flashlight.obj.

2. Double-click the thumbnail in the Layers palette to open the 3D Transformation toolbar.

3. Click Edit the 3D Camera. Any changes you make with this option selected will be made to the position and orientation of the camera rather than the object.

4. Click the Orbit button on the Transformation toolbar. Your selection tool changes to the Orbit tool.

5. Click and drag back and forth over the flashlight to move the camera along the X plane or up and down to move it along the Y plane. You can constrain the rotation to either the Y-axis or the X-axis by holding the Shift key down as you drag in the appropriate direction (see Figure 2.8).

NOTE You can roll the camera around the Z-axis with the Orbit tool selected by holding down the Ctrl key while dragging across the object.

6. Click the check mark in the Transformation toolbar to accept your transformations.

FIGURE 2.8

Orbiting the camera moves the camera in a spherical motion around a 3D object.

Rolling the camera

Rolling the camera is just like rolling an object. The camera itself rotates around its Z-axis, changing the orientation of the object in the camera's view. You can roll the camera from side to side around its Z-axis by using the Roll tool in the camera Transformation toolbar:

PHOTOSHOP CD For this exercise, use the Flashlight.obj file found in the Photoshop CD bonus content. To access this file, insert the CD containing the bonus content and navigate to Goodies ➪ 3D models ➪ Flashlight.

1. Open Flashlight.obj.
2. Double-click the thumbnail in the Layers palette to open the 3D Transformation toolbar.
3. Click Edit the 3D Camera.
4. Click the Roll button on the Transformation toolbar. Your selection tool changes to the Roll tool.
5. Click and drag the mouse back and forth across the flashlight to orbit the camera (see Figure 2.9).

NOTE You can orbit the camera around the XY-axis with the Roll tool selected by holding down the Ctrl key while dragging across the object.

6. Click the check mark in the Transformation toolbar to accept your transformations.

FIGURE 2.9

Rolling the camera rotates the camera around its Z-axis.

Panning the camera

Panning the camera moves the camera up and down or back and forth on its XY plane, moving the object accordingly in the view of the camera. You can pan the camera by clicking the Pan tool in the Camera Transformation toolbar.

PHOTOSHOP CD For this exercise, use the Street_Sign.obj file found in the Photoshop CD bonus content. To access this file, insert the CD containing the bonus content and navigate to Goodies ⇨ 3D models ⇨ Street_Sign.

1. Open Street_Sign.obj.
2. Double-click the thumbnail in the Layers palette to open the 3D Transformation toolbar.
3. Click Edit the 3D Camera.
4. Click the Pan button on the Transformation toolbar. Your selection tool changes to the Pan tool.
5. Click and drag the mouse across the street sign to pan the camera.
6. Click the check mark in the Transformation toolbar to accept your transformations.

Walking the camera

Walking the camera is similar to sliding a 3D object. Instead of moving the object back and forth in space, you are going to walk the camera closer or farther away from your object. You can walk with your camera using the Walk tool in the Camera Transformation toolbar.

PHOTOSHOP CD **For this exercise, use the Street_Sign.obj file found in the Photoshop CD bonus content. To access this file, insert the CD containing the bonus content and navigate to Goodies ⇨ 3D models ⇨ Street_Sign.**

1. Open Street_Sign.obj.

2. Double-click the thumbnail in the Layers palette to open the 3D Transformation toolbar.

3. Click Edit the 3D Camera.

4. Click the Walk button on the Transformation toolbar. Your selection tool changes to the Walk tool.

5. Click and drag the mouse across the street sign to walk with the camera. As you drag back and forth, you see the same effect as panning back and forth with the camera, but as you drag up and down, the camera moves closer or farther away from the street sign (see Figure 2.10).

6. Click the check mark in the Transformation toolbar to accept your transformations.

FIGURE 2.10

Panning or Walking with the Camera changes the view of the object in straight lines.

Zooming the camera

You probably own a camera that can zoom in and out by changing its focal length. Zooming allows you to bring the object closer in the camera's view without actually walking toward the object. You can zoom in on a 3D object by using the Zoom tool in the Camera Transformation toolbar.

PHOTOSHOP CD For this exercise, use the Street_Sign.obj file found in the Photoshop CD bonus content. To access this file, insert the CD containing the bonus content and navigate to Goodies ➪ 3D models ➪ Street_Sign.

1. Open Street_Sign.obj.
2. Double-click the thumbnail in the Layers palette to open the 3D Transformation toolbar.
3. Click Edit the 3D Camera.
4. Click the Zoom button on the Transformation toolbar. Your selection tool changes to the Zoom tool.
5. Click and drag your mouse across the street sign to zoom in and out.
6. Click the check mark in the Transformation toolbar to accept your transformations.

Changing the view

The drop-down menu by the Zoom tool allows you to change the position of the camera numerically, just as you could change the position of your object numerically. You can also adjust the field of view and the Orthographic view from this menu as seen in Figure 2.11.

Field of view

You can change the field of view by degrees horizontal, degrees vertical, or by changing the size of the lens of your camera. This allows you to change the view to match a photographic background that was shot with a specific lens.

Orthographic view

The Orthographic view is just a fancy way of setting the scale of the object in proportion to the surrounding 3D space. The bigger the fraction in this setting, the larger the object will be in your view.

FIGURE 2.11

Camera settings can be changed numerically.

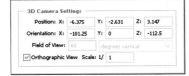

Adjusting the Light Settings

The lighting menu is a very simple menu found on the Transformation toolbar, and you can very easily see the different effects that light has on a 3D object by choosing each light in turn. The lights by default are those that were set originally on the 3D object when it was created. The bonus 3D images that come with Photoshop don't seem to have any particular light setting, which makes it easy to set some fun lights on them and change the way they look.

You can see how the light works as you move either your object or your camera, and how these options can change the look of your 3D object dramatically.

PHOTOSHOP CD **For this exercise, use the Flashlight.obj file found in the Photoshop CD bonus content. To access this file, insert the CD containing the bonus content and navigate to Goodies ⇨ 3D models ⇨ Flashlight.**

1. Open Flashlight.obj.

2. Double-click the thumbnail in the Layers palette to open the 3D Transformation toolbar.

3. Click the Light and Appearance settings button to open the dialog box.

4. Click the Light Settings drop-down menu to view the different lights that can be applied to your 3D model (see Figure 2.12).

FIGURE 2.12

The Light Settings menu.

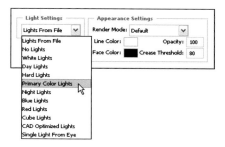

5. Try a few of the light settings out on the flashlight to see what kind of effect they have. End by setting the Primary Color lights; this makes it very easy to see how the different movements of the object and the camera affect the flashlight.

6. Click the Rotate tool from the Transformation toolbar and rotate the flashlight. Because the flashlight is moving and the lights are stationary, you'll notice that the different sides of the flashlight are lit with the three different colors as you rotate it (see Figure 2.13).

7. Press the Home button on the Transformation toolbar to reset the flashlight's position.

8. Click the Edit the 3D Camera button.

FIGURE 2.13

As you rotate the flashlight, the on button is no longer lit in green; it has moved to a darker area.

9. Click the Orbit tool and orbit the camera around the flashlight. It is much easier to see all three colors of light this way, because they stay stationary on the flashlight as you orbit (see Figure 2.14).

FIGURE 2.14

As you orbit the flashlight, you can see that the on button is still lit green.

Part II

Editing and Creating Composites with 3D Models

Editing a 3D model can consist of editing the texture that is placed over the 3D model or applying a style or filter over the 3D model. You will learn how to open the texture of a 3D model, and from there you can use any of the powerful Photoshop editing tools to make changes to it. You can use your improved texture on your object in Photoshop, or you can replace the original texture in your 3D file.

You will also learn how to convert a 3D model into a Smart Object to place a filter or style on it and how to add a fill or adjustment layer to it.

Finally, you will learn how to use all of these tools and more to create image composites combining 3D models, images, and your own Photoshop paint.

Chapter 3

Editing the Texture of a 3D Object

Using the unmatchable image-editing capability to edit the texture of a 3D object might conceivably be the most used feature of the 3D environment in Photoshop. Because the texture of a 3D object is ported into Photoshop as a JPEG, the entire Photoshop environment is open to make changes to that texture. The scope of demonstrating every possible application of Photoshop is much too large for just one chapter, or even one book (although the 1,100-page *Photoshop CS3 Bible* gives it a good go), so I am just going to focus on a few fun examples of what can be accomplished.

I'm going to continue to use the 3D models supplied by Photoshop in the bonus content. These are great examples, because the textures supplied with these models are very basic and could use some spice.

Changing and Correcting the Colors of a Texture

Changing the color of your model might be something you would do in conjunction with creating a composite — using the same or contrasting colors found in a background placed behind your model. Color correction consists of changing the color levels and balances of the texture image.

Changing the colors of a 3D texture

There are several ways to change the colors of the texture placed on your 3D model. The option you choose depends largely on both the complexity of the original texture and what you want to accomplish. The following example

shows you how you can replace a selected color in your texture with any other color. You can also use a color fill to fill the texture file completely with a solid color. You can also select sections of color using the Quick Select tool and fill those using the Paint Bucket.

You can replace a color in your texture by following these steps:

PHOTOSHOP CD For this exercise, use the Car.obj file found in the Photoshop CD bonus content. To access this file, insert the CD containing the bonus content and navigate to Goodies ⇨ 3D models ⇨ Car.

1. Open Car.obj.

2. From the Layers palette, double-click the car sublayer to open the JPG file that consists of the texture of the car.

3. Choose Image ⇨ Adjustments ⇨ Replace Color. From this dialog box, you can use the Eyedropper to select the color you want to replace.

4. Click the eyedropper and select the red color of the car.

5. Double-click the color swatch in the Replacement area of the dialog box to open the color selection tools as shown in Figure 3.1. Choose a new color from the selection palette or use the Eyedropper to select any color showing on the screen. Click OK to close the color selector.

6. Click OK in the Replace Color dialog box to close and apply the changes.

7. Save your JPG file. The changes are reflected immediately on the 3D model (see Figure 3.2).

TIP Use the 3D transformation tools to move your 3D object and look at the texture changes. To return the object to its original setting, click the Home button on the Transformation palette or cancel the transformations.

Color correcting a 3D object

You can color correct the texture of an object many different ways. Changing the levels, the color curves, or the hue and saturation of the texture file are the three most common. You can use each method in succession as shown in the following example. Color changes using these tools can be subtle or dramatic. The examples shown in Figure 3.3 are dramatic so that you can see how powerful these tools are. You can color correct the texture of a 3D object in the following ways:

PHOTOSHOP CD For this exercise, use the Lamp.obj file found in the Photoshop CD bonus content. To access this file, insert the CD containing the bonus content and navigate to Goodies ⇨ 3D models ⇨ Lamp.

1. Open Lamp.obj.

2. From the Layers palette, double-click the lamp sublayer to open the JPG file that consists of the texture of the lamp.

3. Choose Image ⇨ Adjustments ⇨ Levels to open the Levels dialog box.

FIGURE 3.1

The Replace Color dialog box allows you to change the color of the car.

FIGURE 3.2

A red car becomes blue with just a few quick steps.

4. Change the RGB color levels individually or collectively, or use any of the advanced options to tweak the look of your color levels.

5. Click OK to exit the Levels dialog box.

6. Choose Image ➪ Adjustments ➪ Curves and change the color curves collectively or separately. Again, many custom choices here can really change the outcome of your color.

> **NOTE** You can use Levels, Curves, or Hue & Saturation individually or use them in succession as shown here.

7. Click OK to exit the Curves dialog box.

8. Choose Image ➪ Adjustments ➪ Hue & Saturation to change the hue of the colors and their intensity.

9. Click OK to exit the Hue & Saturation dialog box.

FIGURE 3.3

Three quick color corrections on the lamp make it look very different.

Adding Images, Paint, or Text to a 3D Texture

In Photoshop, you don't have to work with what you are given when it comes to the textures of 3D objects. We've already seen how using a color fill covers the details included in a texture. If you recognize how the JPEG is mapped to your 3D object, you can add details such as images, paint, or text to your object to make it more realistic or to personalize it.

Knowing how the texture is mapped to the object is important to successfully changing it. Some textures are tiled on an object, making any changes you make to it repeat on the object as seen on the model of the 3D wall in Figure 3.4.

FIGURE 3.4

This texture is mapped repeatedly to the wall.

The 3D model of the photo album supplied by Photoshop on the other hand not only has a nonrepeating texture, but also gives you a template to work with (see Figure 3.5). I will show you how you can change the look of the photo album by adding your own images, paint, and text.

Adding images to a 3D texture

Adding images to a 3D texture is as simple as placing or pasting those images into the texture JPEG. As you add multiple pictures to your document, they are given their own layer, making it easier to adjust or move them as you work. Be sure and make any edits and changes to the image itself before you add it to a texture JPEG. You can add as many pictures as you desire by repeating the following steps:

PHOTOSHOP CD For this exercise, use the Photo_Album.obj file found in the Photoshop CD bonus content. To access this file, insert the CD containing the bonus content and navigate to Goodies ⇨ 3D models ⇨ Photo_Album.

1. Open the file Photo_Album.obj.

FIGURE 3.5

Adobe's photo album has a texture that shows how it is mapped to the 3D object, providing a template for changing the texture.

TIP **Rotate the photo album so that you can better see the changes you make to it.**

2. From the Layers palette, double-click the photo_album sublayer to open the JPG file that consists of the texture of the photo album. This flat image will make up the background of the changes you make to the photo album.

3. Choose File ➪ Place to open the Place dialog box.

4. Browse to the image you want to place and double-click to open it.

5. Using the Adobe trademark symbols as guides, size and place your image. Don't worry about covering them completely right now.

6. Click the check mark to accept the placement.

7. Repeat Steps 3 through 6 until you have placed enough pictures or images to fill the album.

8. Select the Background layer in the Layers palette.

9. Choose Edit ➪ Fill and change the background to a color, gradient, or pattern, covering any visible Adobe trademark symbols.

10. Save the changes made to the JPG file. The model immediately reflects the changes (see Figure 3.6).

11. Save the file Photo_Album.obj to a new location. It will automatically be saved as a PSD file.

FIGURE 3.6

Personalize the 3D model of the photo album by adding your own images.

Painting on a 3D texture

You can draw or paint on the texture JPEG of a 3D image to add more detail. The images in the last example made the photo album more interesting but left it flat. Of course, you can do many things with the drawing tools in Photoshop, although I am only showing you a simple example.

You can add dimension to the photo album by air brushing around the photos.

For this exercise, use the Photo_Album.obj file found in the Photoshop CD bonus content. To access this file, insert the CD containing the bonus content and navigate to Goodies ⇨ 3D models ⇨ Photo_Album.

1. Open Photo_Album.obj or use the file Photo_Album.psd that you saved in the last exercise.

2. In the Layers palette, click Create New Layer to give your painting its own layer.

NOTE If you don't create a separate layer for the paint you add to your JPEG, you will probably add it unintentionally to the top layer — probably the last picture you added — and that will connect the paint and the picture and make them inseparable.

3. Click the paint brush icon in the Tools Palette.

4. Click the Brush Palette icon to expand the Brush palette (see Figure 3.7).

Click the Brush palette icon to open the Brush palette.

5. Choose your brush and size. I used a 39-pixel dry brush.

6. Close the Brush palette by clicking on the directional arrows in the right-hand corner.

7. Brush around the edges of the pictures you added to the album to give them dimension.

8. Click the Brush Palette icon to expand the Brush palette.

9. Choose the Flowing Stars brush. You can find this brush by hovering your cursor over the different brush thumbnails, the name of the brush will appear.

10. Close the Brush palette.

11. Add stars to your image.

12. Save the changes made to the JPEG. The model immediately reflects the changes made (see Figure 3.8).

13. Save the file Photo_Album.obj as a PSD file.

FIGURE 3.8

A quick paint job gives the photo album a scrapbook feel.

Adding text to a 3D texture

Mapped text on a 3D model is so much more interesting than text on a 2D image. It takes on the dimensions of the 3D object. Adding text to the 3D texture is one more way that you can create the look you want with your 3D model:

1. Open Photo_Album.obj or use the file Photo_Album.psd that you saved in the last exercise.

2. Click the Text icon in the Toolbox. Your cursor changes to the Text tool.

3. Click the spot in your image where you want to place the text and type the desired text.

4. Highlight the text by clicking and dragging over the top of it.

5. Use the Text toolbar at the top of the Photoshop work area to make desired changes to your text, such as font and size.

6. Click the Move tool to reposition your text.

7. Save the changes you've made to the JPEG. The 3D model will immediately reflects those changes (see Figure 3.9).

FIGURE 3.9

Using the Text tool on the texture JPEG will add text to the photo album.

You can do so many more things as you add images, paint, or text to improve the look of the photo album. The images can be cropped, cleaned, or even made into cutouts. Painting and drawing can be taken to a much higher level of detail. Special effects can be applied to all the elements you added to give them a drop shadow or an inner glow to add depth. All of the tools in Photoshop are at your disposal as you work to improve the textures of your 3D models. Photoshop's filters can do even more.

Applying Filters to a 3D Texture

Changing and color correcting the textures of the car and the lamp definitely changed the way they looked, but it didn't add realism or depth to your objects. You can add filters to the texture to enhance or create a realistic texture, to create a glow, and to add depth to an otherwise flat and featureless texture.

The changes that can be made with the filters in Photoshop are endless. As with most of what you do in Photoshop, using the filters is very much an art. Everyone has his or her own individual style. The following are only examples of what is possible.

Creating a Tiffany Lamp

The model of the lamp that you changed the color of earlier has a very dull and flat floral pattern on the shade. There are many different ways to jazz it up. I am going to show you how you can change it to a stained-glass lamp very easily using the filters in Photoshop.

PHOTOSHOP CD For this exercise, use the Lamp.obj file found in the Photoshop CD bonus content. To access this file, insert the CD containing the bonus content and navigate to Goodies ⇨ 3D models ⇨ Lamp.

1. Open lamp.obj.

2. From the Layers palette, double-click the lamp sublayer to open the JPG file that consists of the texture of the lamp.

3. Choose Filter ⇨ Filter Gallery to open the Filter Gallery.

4. Choose the Texture menu within the Filter Gallery and click Stained Glass (see Figure 3.10).

FIGURE 3.10

The stained-glass feature of the Filter Gallery.

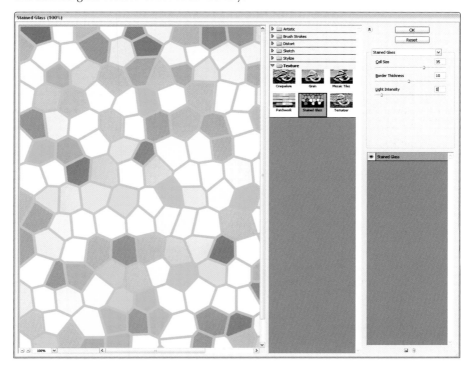

5. Use the sliders to determine the cell size, border thickness, and light intensity. In the example the cell size is set to 35, the border thickness is set to 10, and the light intensity to 1.

6. Accept the changes by clicking OK.

7. Save your JPG file and look at the changes made to the lamp. The stained glass looks flat and unrealistic.

8. Choose Filter ➪ Filter Gallery.

CAUTION If you've used the Filter Gallery recently, there will be two Filter Gallery options in the Filter menu. The first will reapply the Filter that was last applied. The second is the one you want — it will open the Filter Gallery so that you can apply a new Filter.

9. Click Artistic and choose Plastic Wrap from the drop-down menu.

10. Use the sliders to give the stained glass highlight and contour.

11. From the bottom of the Filter Gallery, click New Effect Layer. This allows you to add an additional effect without closing the Filter Gallery.

12. Choose the Brush Strokes menu and choose Ink Outlines to give the edges of the glass a darker outline. Go ahead and move the sliders to change the settings. Click OK to accept the changes.

13. Save the JPG file and look at the lamp again (see Figure 3.11). It looks much better.

FIGURE 3.11

Use the Filter Gallery to change the lamp to stained glass.

Your lamp probably looks quite a bit different from the examples shown here. That goes to show how much variety there is in using the Filter Gallery. It still doesn't look as real as it might.

CROSS-REF In Chapter 4, I'll show you how to add an inner glow to a 3D object, something that improves the look of the lamp even more.

Giving a car a facelift

The car model that came in the Photoshop bonus content reminds me of those plastic toy cars that are just a hollow shell. The color is flat, and the headlights look like flat gray paint. In this section, you learn several different techniques that improve the look of the car.

NOTE There is only so much that can be done to improve the look of the car. In Photoshop, textures can't be added to an object. All of the black imagery of the car is the original look of the 3D model, without any texture added to it. To map texture to the wheels or the windshield, a 3D modeling program must be used. After that, Photoshop can be used to improve the texture.

Turning on the Lights

I'm going to start where you can see the most difference right away by improving the look of the headlights. Sometimes you'll use different filters than you might think; using a glass filter on the headlights doesn't make it look any more like glass. You can improve the look of the headlights by following these steps:

PHOTOSHOP CD For this exercise, use the Car.obj file found in the Photoshop CD bonus content. To access this file, insert the CD containing the bonus content and navigate to Goodies ⇨ 3D models ⇨ Car.

1. Open the file Car.obj.

2. From the Layers palette, double-click the car sublayer named to open the JPG file that consists of the texture of the car.

3. Click the Quick Selection tool in the Toolbox. Your cursor changes to the Quick Selection brush tip.

4. Select the gray areas that resemble headlights on the car texture.

5. Choose Filters ⇨ Filter Gallery to open the Filter Gallery.

6. From the Artistic menu, choose Film Grain.

7. Set the sliders to these levels: Grain 10, Highlight Area 16, and Intensity 4. Doesn't look much like a headlight yet.

8. From the bottom of the Filter Gallery, click New Effect Layer. This allows you to add an additional effect without closing the Filter Gallery.

9. Open the Stylize menu and choose Glowing Edges.

10. Set the sliders to these levels: Edge Width 4, Edge Brightness16, and Smoothness 5.

11. Click OK.

12. Deselect the headlights.

13. Use the Quick Selection tool to select the parking lights.

14. Repeat Steps 5 through 12, but this time set the sliders yourself. The settings will be different from the main lights if you want the lights to remain orange.

15. Save the changes to the JPG file and look at the 3D model as shown in Figure 3.12. Big improvement!

16. Save the improved 3D car. Place it in a folder that will be easy for you to remember and access. The file will be a PSD file.

FIGURE 3.12

FIGURE 3.12

Using the Filter Gallery to make changes to the texture of the car gives the car lights!

TIP Changing the light settings on the car to Day Lights will make it easier to see how the changes to the texture affect the car.

Glossing up the paint

The paint job on the car lacks luster and dimension. You can improve it by using the right filters.

PHOTOSHOP CD For this exercise, use the Car.obj file found in the Photoshop CD bonus content. To access this file, insert the CD containing the bonus content and navigate to Goodies ➪ 3D models ➪ Car.

1. Open Car.obj, or use the file saved in the previous exercise.

2. From the Layers Palette, double-click the car sublayer to open the JPG file that consists of the texture of the car.

3. Click the Quick Selection tool in the Tools palette. You can also use the Magic Wand tool very successfully here.

4. Select all the red areas of the car. Double-check to make sure you have the smaller areas, such as the inside of the zeros.

5. Choose Filters ➪ Filter Gallery to open the Filter Gallery.

6. From the Artistic menu, choose Film Grain.

7. Set the sliders to your preference. The film grain adds a texture that deepens the paint color and gives it variance so that subsequent filters will have more effect.

8. Click OK to accept the filter and close the Filter Gallery.

9. Choose Filter ➪ Blur ➪ Surface Blur to open the Surface Blur dialog box.

10. Set the sliders for Radius and Threshold a little over halfway until the white stripe on the car begins to reflect into the red paint.

11. Click OK to accept the changes and close the Surface Blur dialog box.

12. Choose Select ⇨ Deselect to clear the selections.

13. Choose Filters ⇨ Filter Gallery to open the Filter Gallery.

14. From the Artistic menu, choose Plastic Wrap.

15. Set the sliders to give the numbers and the headlights some depth.

16. Click OK to accept the changes and close the Filter Gallery.

17. Save the JPG file, so the changes are reflected on the 3D model (see Figure 3.13).

FIGURE 3.13

Simple changes to the car by adding Filters have really improved its look.

NOTE If you save a change to the JPG file to see its effects on the 3D model, you can undo that change by choosing Edit ⇨ Step Backward.

CROSS-REF You can also make changes to your texture by adding a layer style or a fill or adjustment layer. These techniques are covered thoroughly as they apply to 3D objects in Chapters 4 and 5.

Creating a Pattern or Texture from Scratch

In Photoshop, you are not limited to making changes to the supplied texture of an object. You can create your own texture by replacing the texture layer with a pattern or texture that you have created yourself.

Generating patterns

Photoshop has a tool that allows you to generate a pattern based on a selection in any image you can bring into Photoshop. You can have a lot of fun with this feature; the patterns you can create are limitless. You can create a pattern by following these very simple steps:

1. Open any image file in Photoshop.
2. Choose Filter ➪ Pattern Maker to open the Pattern Maker dialog box.
3. Use the Selection Tool to choose a section of the image from which to create a pattern, as shown in Figure 3.14.

FIGURE 3.14

This picture has some great pattern possibilities.

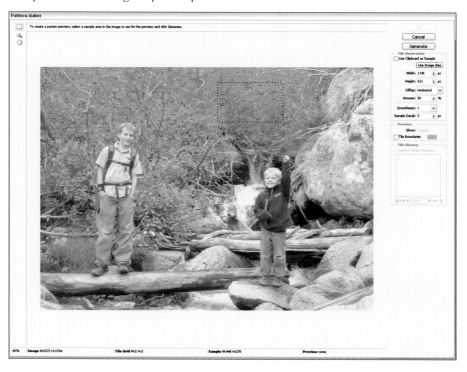

4. Click Generate. A pattern appears in the window (see Figure 3.15).

5. You can play around with the settings and click Generate Again as many times as you want until you find a pattern you like.

6. You can also use the Tile History window shown in Figure 3.16 to go through all the patterns you have generated and choose your favorite.

7. Click OK to close the Pattern Maker. Your image changes to your chosen pattern.

8. Choose File ⇨ Save As and save your file under a new name.

FIGURE 3.15

The trees have turned into an interesting pattern.

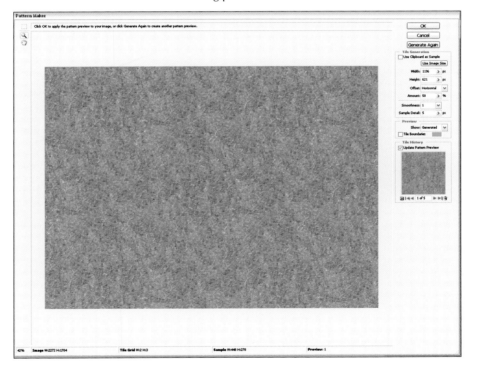

CAUTION Be sure to use the Save As feature when you save your pattern unless you want to overwrite the original image file.

You can now apply the pattern as a texture to a 3D object by replacing the existing texture with the pattern. If you would like steps to follow, refer back to the section "Adding Images to a 3D Texture" earlier in this chapter.

FIGURE 3.16

You can choose from any of the patterns that have been generated.

Creating a texture

You can create a texture from scratch to add to a 3D object. The options are unlimited, so I will show you just one example. You can create a faux wood texture using the following technique:

1. Open a new blank document in Photoshop.

2. Pick a color a little darker than you want your wood to look for the foreground color.

3. Choose Edit ➪ Fill, and choose the Foreground color to fill your document with color.

4. Choose Filter ➪ Render ➪ Fibers to open the Fibers dialog box.

5. Set the Variance to 13 and the Strength to 3. These settings can be higher depending on how small you want the texture of your wood to look. This example uses a large grain.

6. Click OK.

7. Choose Filter ➪ Noise ➪ Add Noise to open the Add Noise dialog box.

8. Add just enough noise to make the fibers look dirty, about 14 percent.

9. Choose Filters ➪ Liquefy to display the Liquefy dialog box.

10. Click the Turbulence tool in the Liquefy toolbox.

11. Using different brush sizes and careful strokes, warp various areas in the wood grain to make it look more realistic.

12. Click the Twirl Clockwise tool in the Liquefy toolbox.

13. Using different brush sizes to create a few random knots in your wood.

TIP If you want to rectify a mistake, you can click the Reconstruct tool. Drag it over any area to change it back to the original texture.

14. Click OK to return the liquefy result to your document (see Figure 3.17).

FIGURE 3.17

Instant wood paneling.

Saving Changed Textures to the Original File

As you change and refine the texture of your object, the saved changes are placed automatically in a PSD, or Photoshop Document, file. Saving the changes to a PSD file protects your original 3D files from corruption. If you are changing the texture of your 3D object so that you can use it in a composite within Photoshop, saving the object as a PSD works just fine. You might want to make the changes to the original file as well, so that you can use the enhanced object in a 3D scene or animation. You can do this, not by saving the texture, but by replacing the original texture.

You can replace the texture by using the 3D Layers palette as shown in the following technique.

1. Copy the folder labeled Plastic_Bottle to a permanent location on your computer.

2. From the newly saved folder open Plastic_Bottle.obj.

3. From the Layers palette, double-click the Plastic_Bottle sublayer to open the JPG file that consists of the texture of the bottle.

4. Choose Filter ➪ Filter Gallery to open the Filter Gallery.

5. From the Sketch menu, choose Bas Relief.

6. Have fun setting the sliders to whatever changes look good to you.

7. Feel free to make any other changes.

8. Click OK to close the Filter Gallery.

9. Save the JPG file to apply the changes to the 3D file.

10. Close the JPG file.

11. From the OBJ file, right-click the Textures layer in the Layers palette and choose Replace Textures. Alternately, you can choose Layer ➪ 3D Layers ➪ Replace Textures (see Figure 3.18). A warning that "This operation will replace the texture files on disk" appears.

12. Click OK. The original JPG file with the Plastic_Bottle.obj file will contain the changes that you made to the textures.

FIGURE 3.18

The Replace Textures option can be found in the Layers palette.

Summary

In this chapter, you learned how to change the appearance of a 3D object by applying a few of the tools found in Photoshop to the texture JPG file. You also learned how to open and apply changes to the texture of a 3D object. I covered the following topics:

- Editing the colors of a 3D object
- Adding images, paint, or text to a 3D texture
- Changing the texture of a 3D object using the Filter Gallery
- Creating textures and fills from scratch
- Making permanent changes to the texture in the original 3D file

In the next chapter, you learn how to use layer styles to apply special effects directly to a 3D object.

Chapter 4

Adding Layers to a 3D Object to Change Its Appearance

When you open a 3D file and select the Filter menu, almost the entire menu is grayed out. In fact, as you browse through Photoshop's regular menus, there doesn't seem to be a lot you can do. This may lead you to believe that you can't do much with a 3D object except for moving it around and changing the texture. Not so. Although you can't affect the pixels of a 3D object directly, you can change the look of the 3D object in countless different ways by adding sublayers that contain Smart Filters, layer styles, or fill and adjustment layers.

Smart Filters are new to Photoshop CS3, and they are one of the more exciting changes. A Smart Filter includes the filters found in the Filter menu and the Filter Gallery. It becomes a Smart Filter when it is added to your object on a separate sublayer. This gives you the capability to edit it, move it, or discard it at will without having to go back in your step history or change any of the other filters or effects you may have added to your object.

NOTE Adding layers to a 3D object to change its look only changes the object in Photoshop. You can't port these changes back to the original 3D file as you could with the changes made to the texture. These changes were meant for 3D files for use in a Photoshop image or composite.

Adding Smart Filters to 3D Object

You won't be using Smart Filters for very long before you're going to wonder how you did it any other way. Adding filters to a file has always been a tricky trial-and-error process that can be time consuming and frustrating. Even if it's something that you do on a frequent basis, every new file changes what

filters you want to add, in what order, and why. Smart Filters take a time-consuming process that almost seems like work, and turn it into play.

As you add Smart Filters, each filter has its own sublayer underneath the object layer. This means that the filter doesn't have any direct effect on the original object. You can view the image with the filter, or turn the view of the filter off, so that you can see the image without the effect. This is especially helpful when you add more than one filter because you can see exactly how the filters affect each other. You can even swap the filters around, changing the order in which they are applied to an object.

Because each filter is contained in its own layer, you can also adjust the filter after the fact. By clicking the button on the right side of the filter layer, you can adjust the blending effect. You can also right-click the filter layer and choose Edit the Filter from the pop-up menu to adjust the original settings of the applied filter.

When you are working with a 3D file, you can't change the pixels directly, and so Smart Filters are the only filters you can add to it. Before you can add Smart Filters to any file, you need to turn that file into a Smart Object, and 3D files are no exception.

Converting a 3D File to a Smart Object

So how do you add Smart Filters to a 3D file? After opening a 3D file, the Filter menu is almost entirely grayed out. You can convert to Smart Filters. This option enables you to use all the other filters.

To add Smart Layers to a 3D object, choose Filter ⇨ Convert for Smart Filters. In order to add Smart Filters to a file, you must turn that object into a Smart Object. You will see the warning, "To enable re-editable smart filters, the selected layer will be converted into a smart object." Once you've clicked OK to accept this, the icon on the layer thumbnail changes from the 3D icon to a Smart Object icon (see Figure 4.1).

FIGURE 4.1

The Smart Object thumbnail looks different from the 3D Object thumbnail.

Adding Smart Filters

Now when you click the Filter menu, you see that most of the options are available for use, as shown in Figure 4.2.

FIGURE 4.2

Many of the filters are available.

NOTE Certain filters, such as Liquify, Pattern Maker, and Vanishing Point, are not available as Smart Filters and can't be applied to a 3D object.

From here, you can choose the Filter Gallery and make visual changes to your 3D object. In the Filter Gallery, you can apply more than one filter before exiting by adding subsequent filter layers. These layers have many of the same properties as the Smart Layers placed on the 3D object. You can click each one to change the properties of that filter, or you can drag them up and down to change the order in which they are applied.

Once you exit the Filter Gallery, you see that the filter you applied has been added as a Smart Filter sublayer in the Layers palette.

The Smart Layer is labeled "Filter Gallery." If you were to choose a filter from the Filter menu without using the Filter Gallery, the layer would be named with the applied filter, as shown in Figure 4.3.

You can apply any of the available filters in this way, with each appearing in its own layer. Once the filters are applied, you can really work with them to change the way they affect the 3D object.

FIGURE 4.3

Smart Layers carry the names of the applied filters.

My robot has three filters applied: a Filter Gallery effect that consists of two filters, a twirl effect, and a noise filter (see Figure 4.4). To see the robot without the Filter Gallery effect, I can simply click the Visibility button on the filter layer. As the eye disappears, so does the view of the effects applied by the Filter Gallery (see Figure 4.5).

FIGURE 4.4

You can change the look of a 3D object using filters.

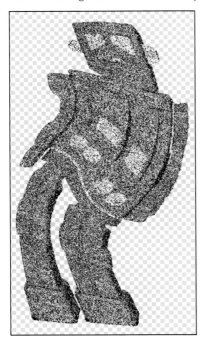

FIGURE 4.5

By clicking the Visibility button in the filter layer, you can hide the filter's effects.

Making Changes to the Smart Layers

By looking at the differences in the robot, you can see the Add Noise filter has diffused most of the changes made by the Filter Gallery. You can adjust the settings of any of the layers by double-clicking that layer. You will encounter a dialog box that lets you know that Smart Filters stacked on top of this filter will not preview while this filter is being edited. This simply means that you will not see any of the other Smart Filters that you may have added after the one you are editing. Click OK and the original filter settings dialog box opens, and allows you to make changes to the original filter settings.

You can also change the look of the filter layer by changing the Blend mode of the layer. Double-click the Edit Blending Options button that appears on the right side of the filter layer. This displays the Blending Options dialog box, where you can choose from a list of several different modes that change the way the filter is applied (see Figure 4.6).

FIGURE 4.6

The Blending Options dialog box.

CROSS-REF **You can learn more about Blend modes and their affect on layers in Chapter 1.**

You can also rearrange the order in which the filters are applied to the 3D object by simply dragging and dropping them into a different order. This can change the look of your object because each filter affects the filters that were added before it, but not the filters that were added after. For example, the Fresco filter adds a smooth, blended appearance to the colors of the robot. (See Figure 4.7.) When it is added first, the other filters that are added on top, such as Add Noise, diffuse the fresco effect, breaking it up and giving the robot added texture. When the Fresco filter is added last, the filters added in the Filter Gallery, which include a dark crosshatch, are a factor in the elements of the Fresco, and it becomes dark as well as smooth.

FIGURE 4.7

A Fresco filter that is added first has a very different effect on the 3D object than when it is added last.

Manipulating a Smart 3D Object

Now that you've turned your 3D object into a Smart Object and made changes to it, does this mean that you've lost the capability to manipulate your object or make changes to the texture? Not at all. Double-click the thumbnail of the original layer. A window opens, reminding you to save any changes you make. These changes will then be reflected in the original 3D file. Wait a minute. Isn't it the original 3D file to which you are trying to get back? Not anymore. You are now opening the layer that contains the 3D information of the original 3D file. Click OK. A new window opens that looks a lot like the original file did before you changed it to a Smart Filter.

In this file, you can double-click the object thumbnail in the Layers palette to open the 3D Transform options bar, or double-click the texture layer to open it and make changes.

Look at the beetle in Figure 4.8. The window is labeled "Layer 1." You'll notice that the thumbnail in the Layers palette has a different look. The icon in the thumbnail is the Smart Object icon rather than the 3D object icon that you are used to seeing. You will also note that there are no textures listed under the Smart Object. The textures are still embedded in this layer and you can still edit them, as well.

FIGURE 4.8

Transforming a 3D object that has been turned into a Smart Object looks a little different than it did originally, but the capability is still there.

NOTE **If you made transformation changes to the 3D file before converting it to a Smart Object, those transformations are still a part of the file.**

Does opening the 3D layer remind you of anything? When you opened the texture JPEG layer embedded in the 3D file, it opened as a separate file that you were required to save before the changes were reflected in the original 3D image. Now you have the 3D file embedded into a Smart Object as well. If you can keep track of all those layers, then it shouldn't be too much more to consider turning a texture file into a Smart Object and adding Smart Filters to it, as well.

NOTE **To turn the texture JPEG into a Smart Object, open the JPEG file by double-clicking the layer containing the texture. Choose Filter ➪ Convert for Smart Filters. Now you can add Smart Filters to the texture, as well.**

Now that I've shown you how to create a Smart Object, I'm going to show you a few examples of what you can do to edit your 3D object using this feature.

Adding a Faux Texture to a 3D Object

The 3D model of the star that is on the installer CD doesn't contain any texture layers, and so the only way to make changes to its appearance is to make them to the OBJ file.

You can give the star color and a glow by adding Smart Filters to it:

PHOTOSHOP CD **For this exercise, use the Star_Style1.obj file found in the Photoshop CD containing the bonus content. To access this file, insert the bonus content CD and navigate to Goodies ➪ 3D models ➪ Star_Style1.**

1. Change the foreground color in the Tools palette to yellow.

2. Open the file Star_Style1.obj. There is no texture added to this star, and so it is very flat and unappealing.

3. Choose Filter ➪ Convert for Smart Filters. Photoshop lets you know that your layer will be turned into a Smart Object. Click OK.

4. Choose Filter ➪ Filter Gallery to open the Filter Gallery.

5. From the Artistic menu, choose Plastic Wrap.

6. Set the sliders to the following: Highlight Strength 15, Detail 9, Smoothness 5.

7. Click the New Effect Layer button at the bottom of the Layers palette to add a new layer.

8. From the Brush Strokes menu, choose Accented Edges.

9. Set the sliders to the following: Edge Width 11, Edge Brightness 14, Smoothness 8.

10. Click the New Effect Layer button at the bottom of the Layers palette to add a new layer.

11. From the Artistic menu, choose Neon Glow.

12. Set the sliders to the following: Glow Size -5, Glow Brightness 38.

13. Change the glow color to a dark yellow.

14. Click OK to accept the filter changes and close the Filter Gallery.

Look at Figure 4.9. What a difference! Even though this star lacked a texture file, its appearance changed completely. Of course, you can always make changes like this to a flat Photoshop file, but the star is still a 3D object that you can manipulate and make other changes to.

FIGURE 4.9

Adding Smart Filters to the Star.obj changes its look, even without a texture file.

Using Smart Filters on a Selected Area

The Flashlight file on the Photoshop bonus content doesn't have a separate texture, either. It does have a texture added, but it is embedded and you can't open a JPEG file to make changes to it. You don't have to add a Smart Filter to the entire object. By selecting a portion of the object, you automatically create a mask that allows the filter to be applied only in the area that is selected. You can select the glass on the front of the flashlight and add Smart Filters to it to make it more realistic.

PHOTOSHOP CD For this exercise, use the Flashlight.obj file found in the Photoshop CD containing the bonus content. To access this file, insert the bonus content CD and navigate to Goodies ⇨ 3D models ⇨ Flashlight.

1. Open the file Flashlight.obj.

2. Choose Filter ⇨ Convert for Smart Filters. Photoshop lets you know that your layer will be turned into a Smart Object. Click OK.

3. Click the Quick Selection tool in the Photoshop toolbox and select the front lens of the flashlight.

4. Choose Filter ⇨ Filter Gallery.

NOTE The Filter Gallery will automatically repopulate itself with the settings that you used last. For example, if you just completed the exercise to add color to the star, you will find that the Filter Gallery will contain three different filters. You can delete the unwanted filters by dropping them in the trash.

5. From the Stylize menu, choose Glowing Edges.

6. Set the sliders to their maximum levels.

7. Click the New Effect Layer button at the bottom of the Layers palette to add a new layer.

8. From the Artistic menu, choose Neon Glow.

9. Apply the following settings: Glow Size -23, Glow Brightness 15.

10. Set the glow color to a light yellow.

11. Click OK to close the Filter Gallery. The Layers palette shows the new Smart Layers.

12. Choose Filter ⇨ Render ⇨ Lens Flare to open the Lens Flare dialog box.

13. Change the flare location to the center of the flashlight glass.

14. Set the brightness to 118. Set the lens type to 50-300mm Zoom. Click OK (see Figure 4.10).

Notice that the Lens Flare effect is added as a sublayer of the Smart Filter layer. You may also notice that although the preview shows the entire flashlight, the Lens Flare effect is only added to the selected area. The Lens Flare effect adds brightness to the center of the light, making it seem as if there was a light bulb inside.

FIGURE 4.10

How smart are these filters? An automatic mask is created so that the filter is only applied to the selection.

I could go on and make other changes to the rest of the flashlight, but this example serves to show that you can make Smart Filter changes to a selection.

NOTE If you right-click the Smart Filter layer and choose Edit Smart Filter, the Filter Gallery reopens. This time, the preview shown in the Filter Gallery is the entire flashlight, but the mask is still in place and any changes you make are still only made to the previously selected area.

Editing Existing Smart Filters

I'll show you one more example to demonstrate how you can apply Smart Filters and edit them later. As you can probably guess, I've already done this several times in creating the previous examples. I guarantee that you will use the editing capability of Smart Filters almost every time you use them. Soon you'll wonder how you ever did it any other way.

From this exercise, you'll learn that the order that filters are applied to an object make a big difference in the way the object looks. You can also change the Blending Options of the Smart Filters. You can't select the Smart Filter layers directly, enabling you to use the Blend Mode menu found in the Layers palette, so it's nice to have that option.

You can edit Smart Filters in several different ways.

PHOTOSHOP CD For this exercise, use the Beetle.obj file found in the Photoshop CD containing the bonus content. To access this file, insert the bonus content CD and navigate to Goodies ⇨ 3D models ⇨ Beetle.

1. Open the file Beetle.obj.

2. Choose Filter ⇨ Convert for Smart Filters. Photoshop lets you know that your layer will be turned into a Smart Object. Click OK.

3. Choose Filter ⇨ Stylize ⇨ Find Edges. This filter is automatically applied without any settings.

4. Choose Filter ⇨ Stylize ⇨ Glowing Edges.

5. Set the sliders to the following: Edge Width 4, Edge Brightness 8, Smoothness 8.

6. Click OK.

7. Choose Filter ⇨ Sketch ⇨ Chrome.

8. Set the detail to 0 and the smoothness to 10.

9. Click OK. The chrome setting is overpowering the other settings (see Figure 4.11). Let's make some changes.

FIGURE 4.11

The Chrome filter is overpowering the other filters placed on the beetle.

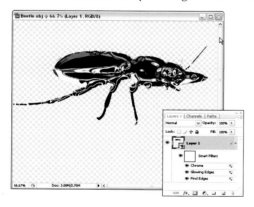

10. Click the Find Edges layer and drag it to the top of the Smart Filters so that it becomes the last layer applied (see Figure 4.12). The beetle changes from a chrome beetle to a line drawing.

FIGURE 4.12

After changing the order of the Smart Filters, the chrome is toned down by the Find Edges filter.

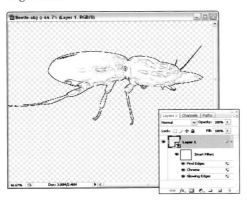

11. Click the Visibility button in the Chrome layer. You can see in Figure 4.13 that the Chrome filter makes a big difference in the look of the beetle.

FIGURE 4.13

Turning off the Chrome filter makes the beetle look more like a line drawing.

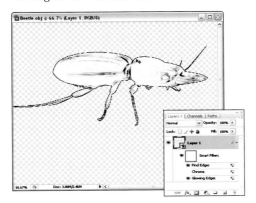

12. Click the Visibility button in the Chrome layer to redisplay it.

13. Click the Blending Options button in the Find Edges layer. The Blending Options button looks like two sliders placed to the right of the layer name. This opens the Blending Options dialog box.

14. From the Mode drop-down menu, choose Hard Light. This Blend mode affects how the Find Edges filter is blended into the main layer containing the beetle. Click OK (see Figure 4.14).

You can also edit the filters by changing the blending options.

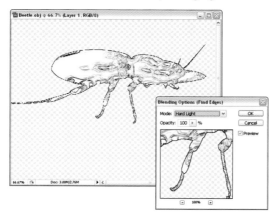

Summary

In this chapter, I've shown you how you can turn a 3D object into a Smart Object so that you can add Smart Filters to it to change its appearance. You learned how to

- Turn a 3D file into a Smart Object
- Add a Smart Filter to your Smart 3D Object
- Edit Smart Filters
- Make transformation changes to a 3D object
- Give a 3D file a faux texture
- Apply a mask to a Smart Filter
- Make changes to an existing Smart Filter

In the next chapter, you learn that Smart Filters are not the only layers you can add to your 3D object to make changes.

Chapter 5

Adding a Layer Style to a 3D Object

Converting a 3D object into a Smart Object is not the only way to make changes to it. A layer style is any one of several effects, including a drop shadow or inner glow. Each layer style is contained in its own sublayer and can be edited, turned off, or discarded. These sublayers can even be turned into their own full layers and can be moved, filtered, color corrected, and edited just like any other layer in Photoshop. You can create several special effects by adding a layer style to an object.

IN THIS CHAPTER

Choosing a layer style

Fine-tuning layer options

Building separate layers

Adding a Layer Style

The Layer Style menu button (*fx*) is found at the bottom of the Layers palette. To add a layer style to your file, click the *fx* button to display the Layer Style menu and choose a layer style. When you have added a new style, it displays as a new sublayer under the object layer.

NOTE You can open the Layer Style dialog box by choosing Layer ⇨ Layer Style.

The Layer Style dialog box is very versatile. Once you open it, you can choose one or more styles to add to your object by clicking the check box next to the style name to select it. Highlight the style name by clicking it, and the dialog box changes to give you the settings for that style. Look at Figure 5.1 and you can see the Layer Style dialog box with the Outer Glow option highlighted.

89

FIGURE 5.1

The Layer Style dialog box.

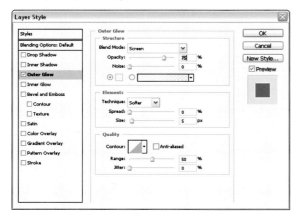

There are several layer styles available and they all have very different effects. Here is a list of what they are and what they do:

- **Drop Shadow:** This style creates a shadow behind your object. You can set options such as the shadow size and distance. The drawback of this layer style is that you can only create a shadow behind the object. Often when working with a 3D object, a shadow below the object would add more dimension.

- **Inner Shadow:** This style casts a shadow over your object. You can set options such as the opacity and choke.

- **Outer Glow:** This style allows you to add a glow around the object. You can set options such as the color and size of the glow.

- **Inner Glow:** This style is like the outer glow, but it creates a glow inside the object. You can change options such as the opacity and technique.

- **Bevel and Emboss:** This style creates edge effects. Although 3D objects don't actually have edges like those on a 2D file, you can create a beveled texture on your object that can really change its look by selecting the Texture option and setting the Bevel options.

- **Satin:** This style creates a gradient wave across your object that mimics the look of satin. You can set options such as distance and size.

- **Color Overlay:** This style adds another color over your object. You can change the color or the opacity to get a solid color or a mixture of colors.

- **Gradient Overlay:** You can add a gradient over your object to change the shadow and color of it. You can choose from several preset gradients or create one of your own.

- **Pattern Overlay:** Like the color and gradient overlays, the pattern overlay sets a pattern over your 3D object. You can set the opacity to cover your object completely or to mix with the object's color. You can also set the scale of the pattern to be larger or smaller.

- **Stroke:** This style creates an outline of your object. You can change its color, width, and position.

Adjusting Layer Style Options

As you highlight each style in the Layer Style dialog box, the settings for that style display. Some of these settings are self-explanatory, while others are not. Here is a list of the settings with which you might not be familiar:

- **Use Global Light:** Selecting this option makes all of the light settings in the layer styles universal. This means that if you add an inner glow and a drop shadow, the angle of the light is the same for both effects.

- **Contour:** This setting controls the shape of the layer style. The shape of the contour represents the color fade from a set opacity to transparent. You can use preset contours or create one of your own.

- **Anti-Aliased:** If this option is selected, the contour has softer edges.

- **Layer Knocks Out Drop Shadow:** This setting simply keeps the drop shadow from being seen through your object. If your object is transparent, the drop shadow can be seen through it, unless you select this option.

- **Jitter:** Jitter is available when you are creating a gradient glow. It randomizes the colors used for the glow.

Whether you create one layer style at a time or use the dialog box to create several at once, each style appears as its own sublayer underneath the 3D Object layer. Figure 5.2 shows the Layers palette with three different layer styles added. Notice how they are grouped under an Effects heading. You can turn off the layer styles collectively by clicking the Visibility button next to the Effects heading, or individually by clicking the Visibility button next to the style you would like to hide.

You can make changes to the layer styles at any time by displaying the Layer Style dialog box. Rather than duplicating a layer style, the changes you make are reflected in the styles already shown in the Layers palette.

TIP You can add styles you've created to the style palette by dragging and dropping them there. You can also use any of the styles on the palette on your 3D object.

FIGURE 5.2

The layer styles are added as sublayers.

Creating a Separate Layer from a Layer Style

The way a layer style is created in the Layers palette is neat and efficient; it locks the layer style to the object for which it was created. Occasionally, though, you will want to create a separate layer from a layer style so that you can edit the layer style separately from the Object layer.

For example, you may want to create an outline of an object, and just use the outline in a composite. You may also want to create a shadow and separate it from the object, giving it greater distance than you can create through the Layer Style settings.

You can separate the layer styles from the original layer by right-clicking them and choosing Create Layers. This creates a separate layer for each of the layer styles, as you can see in Figure 5.3. You'll also notice that the names of the layers are very descriptive; for example, Layer 1's Outer Glow is obviously just what it says it is.

Once you've created a full layer for them, the layer styles are individually editable. You can move them, add special effects to them, create masks from them, or apply any number of Photoshop techniques.

Now that I have discussed how to create layer styles, I'll show you a few techniques using this feature. Going through these exercises will answer any questions you may have and help you feel more comfortable using this feature on your own 3D files.

FIGURE 5.3

The layer styles have become separate layers rather than sublayers.

Creating a drop shadow

When you are creating composites with one or more files in Photoshop, creating a drop shadow behind files that are placed on the background can make them seem like they belong there. The same is true when you are placing a 3D object in a composite. Although I am not going to create a composite now, I'll show you how you can create a drop shadow of a 3D object by creating a layer style:

CROSS-REF You can learn how to create composites in Chapter 7.

PHOTOSHOP CD For this exercise, use the Rug.obj file found in the Photoshop CD containing the bonus content. To access this file, insert the bonus content CD and navigate to Goodies ⇨ 3D models ⇨ Rug.

1. Open the file Rug.obj.

2. Make sure that the layer you want to create a style for is selected. In this case, there is only one layer to select.

3. Click the Layer Styles button (*fx*) at the bottom of the Layers palette.

NOTE You can also add a layer style by choosing Layer ⇨ Layer Style.

4. From the Layer Styles menu, choose Drop Shadow. This opens the Layer Style dialog box.

5. Set the distance to 10 and the size to 6. Leave the other settings the way they are (see Figure 5.4).

FIGURE 5.4

Creating the drop shadow.

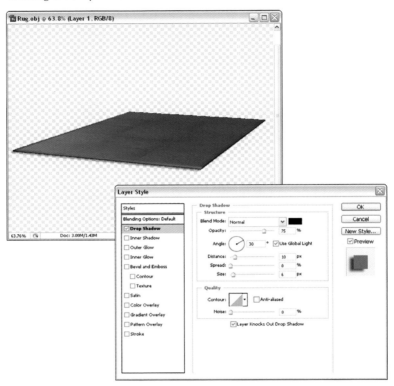

6. Click OK. You've successfully added a drop shadow to the rug. Let's continue with this exercise, though, and make a few changes.

7. In the Layers palette, right-click the Drop Shadow layer and choose Create Layer (see Figure 5.5).

8. When the "Some aspects of the Effects cannot be reproduced with Layers!" warning appears, click OK. The drop shadow becomes its own layer.

9. From the Layers palette, select Layer 1's Drop Shadow.

10. Click the Move tool in the Photoshop toolbox.

11. Click and drag the shadow well below the rug. Amazing! A flying carpet!

12. In the Layers palette, change the opacity to 75 percent. Although it's hard to tell on the transparency layer, this gives the shadow a more realistic appearance (see Figure 5.6).

13. Save this file as a PSD file.

FIGURE 5.5

Create a new layer from the Layer menu.

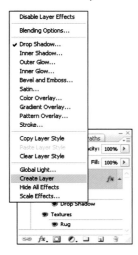

FIGURE 5.6

Separating the shadow from the rug makes it look like it is several feet off the ground.

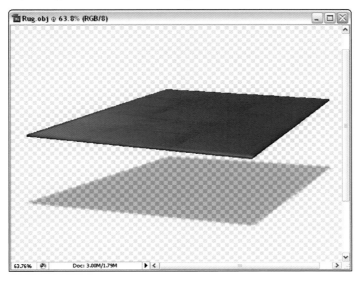

Adding a pattern overlay

Now that you have created a new layer out of the drop shadow, you can select Layer 1 again and add more layer styles as sublayers. You can add texture and realism to the rug by creating a pattern overlay:

PHOTOSHOP CD **For this exercise, use the Rug.obj file found in the Photoshop CD containing the bonus content. To access this file, insert the bonus content CD and navigate to Goodies ⇨ 3D models ⇨ Rug.**

1. If you saved the last exercise, open the file Rug.psd; if not, open Rug.obj.

2. In the Layers palette, select Layer 1.

3. Click the Layer Styles button (*fx*) at the bottom of the Layers palette.

4. From the Layer Styles menu, choose Pattern Overlay. This opens the Layer Style dialog box.

5. Click the down arrow next to the pattern thumbnail to open the pattern selector. Select the metal landscape (see Figure 5.7).

FIGURE 5.7

The pattern selector has a few patterns from which to choose. You can also create your own patterns.

6. Set the opacity to 30 percent. This allows the original color of the rug to show through the pattern.

7. Set the scale to 70 percent to reduce the pattern size (see Figure 5.8).

8. Change the Blend mode to Hard Light.

9. Click OK.

FIGURE 5.8

The Pattern Overlay settings.

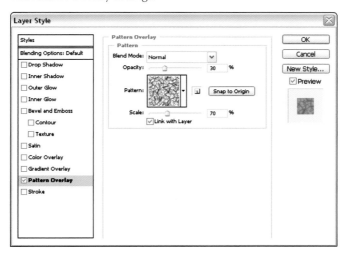

If you used the file that was saved in the last exercise, you'll see that the pattern overlay is placed as a sublayer of Layer 1, while Layer 1's Drop Shadow remains on its own layer (see Figure 5.9). Whenever you plan to separate a layer style from the submenu, you should plan your steps in order that you are only separating the layers needed. The benefit of this is that the sublayers are always embedded inside the layer that they affect, subject to the changes you make to that layer.

FIGURE 5.9

The pattern overlay is embedded as a sublayer, and the drop shadow is a separate layer.

With a pattern overlay, the rug looks a little more realistic (see Figure 5.10). Changing the Blend mode to Hard Light gives the rug more depth. Creating a color or gradient overlay works in much the same way.

A pattern overlay gives the rug more dimension and depth.

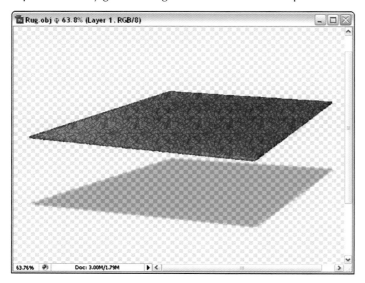

Just in case you were wondering, if you create a separate layer from the pattern overlay, it is placed above Layer 1 rather than beneath it (refer to Figure 5.3). You can still select it and move it separately from Layer 1, but the effect doesn't separate itself from the rug; it only shows up when it is above Layer 1. Feel free to play around with this layer and see how it works.

Creating a mask to give the lamp shade an inner glow

In Chapter 3, I showed you how to create a stained glass lamp using filters on the texture of the lamp file. Now I'm going to show you how you can give the lamp an inner glow to imitate a lighted bulb inside of it.

In this exercise, I show you how to create a mask so that the layer style, in this case a glow, is only applied to the shade of the lamp and not to the lamp stand. You can create a mask and give the lamp an inner glow by following these simple steps.

For this exercise, use the Lamp.obj file found in the Photoshop CD containing the bonus content. To access this file, insert bonus content CD and navigate to Goodies ⇨ 3D models ⇨ Lamp.

1. Open the file Lamp.obj.

2. Right-click Layer 1 and then select Duplicate Layer. When prompted for a name, click OK. A copy of Layer 1 is placed in the Layers palette (see Figure 5.11).

FIGURE 5.11

A copy of Layer 1 is placed above it in the Layers palette.

3. With Layer 1 copy selected, click the Polygonal Lasso tool in the Photoshop toolbox.

NOTE **Click and hold the triangle on the Lasso tool button accesses the menu containing the Polygonal Lasso tool.**

4. Carefully select just the shade of the lamp by clicking each corner; when you click the first corner again to close the selection, the selection is set. To start over with your selection, press the ESC key.

TIP **It may be easier to select the shade if you zoom in to it. Don't worry about being perfectly precise, as the Inner Glow effect will have enough give around the edges to accommodate a slight miscalculation.**

5. Click the Add Layer Mask button in the Layers palette. This turns the selection into a mask.

6. Click the Layer Styles button (*fx*) at the bottom of the Layers palette.

7. From the Layer Styles menu, choose Inner Glow. This opens the Layer Style dialog box.

8. Set the source to Center. This sets the light in the center of the shade so that you can tell where to adjust the other settings.

9. Set the Blend mode to Linear Light.

10. Play around with the other settings. Look at Figure 5.12 to see what I've done.

11. Click OK.

FIGURE 5.12

My inner glow settings for the lamp.

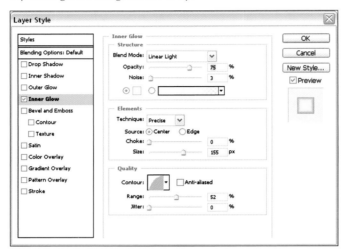

12. Click the Visibility button next to Layer 1 copy. The inner glow disappears.

13. Click the Visibility button again to reveal the Layer 1 copy.

14. Click the Visibility button next to Layer 1. The masked area disappears.

15. Click the Visibility button again to reveal Layer 1. The lamp looks as if it has been turned on (see Figure 5.13).

I had you create a copy of Layer 1 before creating a mask for it. I showed you why by having you hide each of the layers in turn (see Figure 5.14).You also created a mask so that the Inner Glow would only affect the Lamp Shade. I don't personally have very many lamp stands that glow! The mask wasn't as easy to create as it was with the Smart Filters, but it still only took us one extra step. Changing the Blend Mode in the Inner Glow settings gave our light a different dimension.

FIGURE 5.13

Having two copies of Layer 1 allows you to create a mask for the inner glow without hiding the lamp stand.

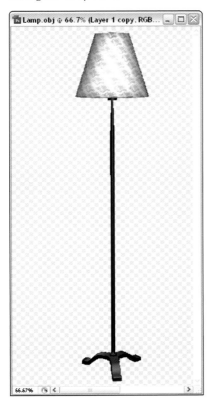

NOTE If this lamp were placed in a composite, I would probably add an outer glow to it as well, to give it the illusion of casting light on the objects around it.

I'm going to leave trying the rest of the layer styles up to you. You've learned enough to play around with the layer styles and add them to your own files. Just remember that it's normal to play around with the settings to get everything just right. Have fun!

FIGURE 5.14

Having two copies of Layer 1 allows you to create a mask for the inner glow without hiding the lamp stand.

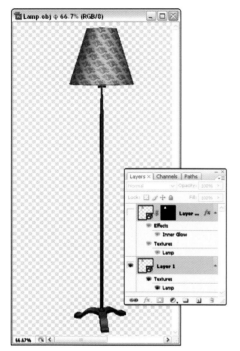 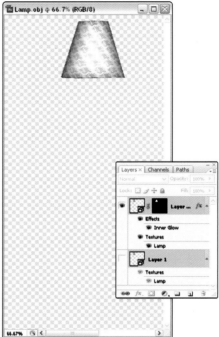

Summary

In this chapter, you've learned what layer styles are and how to add them to a 3D object. I covered

- Choosing a style
- Adjusting style options
- Creating a separate layer from a layer style
- Adding layer styles

In the next chapter, I show you how you can create a fill or adjustment layer for a 3D file.

Chapter 6

Creating a Fill or Adjustment Layer over a 3D Object

After learning about Smart Filters and layer styles, adding a fill or adjustment layer may feel like something you already know how to do. After all, the Layers palette has become a lot less mysterious. It really is almost that simple, and with a few exceptions, you should find that working with these layers is much like working with any other layer.

A fill or adjustment layer can adjust the color, levels, brightness, and contrast of your object. These changes are added as a full layer over the object layer. A fill or adjustment layer can be masked or given a blend mode. Of course, you can move, edit, or delete it just as you would any other layer.

If you are working with other types of files in Photoshop, such as an image file, all of the options that are available as a fill or adjustment layer can be applied directly to the image by choosing Image ⇨ Adjustments. Not so with a 3D file. Because the pixels of a 3D file cannot be changed directly, these changes must occupy their own layer.

The fill or adjustment layer is not created as a sublayer like the Smart Filters or the layer styles; it is a full layer and affects any layer placed below it in the Layers palette. This affects where you should place the fill or adjustment layer in the hierarchy. Remember that with a 3D object, just a few changes can create layers embedded inside of layers. The fill or adjustment layers need to be placed where they can be the most effective.

The fill layers and adjustment layers have all the benefits of placing filters on a separate layer: they are portable and editable; you can create layer masks for each one; and because they are full layers, you can turn them into Smart Objects.

As you can see, a fill or adjustment layer has a lot of potential for a 3D file. This chapter shows you exactly what the different kinds of fill layers and adjustment layers are and how to use them.

Applying a Fill or Adjustment Layer

Because you can't place a fill or adjust a 3D object because it is a vector file, a fill or adjustment layer is the only way to change such things as the Levels, Hue and Saturation, or to add a gradient or a fill. Applying a fill or adjustment layer to your 3D object will create a non-destructive effect over any layer that is placed under it in the Layers palette.

You can place a fill or adjustment layer into your file by clicking the New fill or adjustment layer button at the bottom of the Layers palette. This button looks like a half-black, half-white circle. Clicking this button opens the fill or adjustment Layer menu, which includes 17 options (see Figure 6.1). Clicking the option you want opens a dialog box that allows you to adjust the settings for that option. These options and settings are covered in the next few sections.

> **TIP** To make use of these layers, try changing the blend mode used to place them over other layers. You can create some very interesting special effects. There are several examples of this throughout this book.

Choosing a fill or adjustment layer.

Creating a Solid Color, Gradient, or Pattern Fill Layer

When you add a Solid Color, Gradient, or Pattern fill layer over a 3D object, it fills the entire canvas. This is not the same effect as creating overlays using layer styles; overlays only affect the 3D object. It may seem ridiculous at first to fill the canvas with a color or pattern, completely covering your original file, especially as there do not seem to be many options in the Fill dialog boxes. Remember that you are working with a separate layer, however. Once you have added a fill, you can select the fill layer and reduce the opacity of the layer. When the opacity has been reduced enough, you can begin to see the object behind the fill layer (see Figure 6.2). This is a great way to create a color filter over your file.

You can also move the fill layer underneath your 3D object in the Layers palette, creating a background for it. You can move the fill layer very easily by dragging and dropping it into place. This is a fast and easy way to create a background for a 3D object (see Figure 6.3).

FIGURE 6.2

As you reduce the opacity of the Color fill layer, the bottle becomes visible.

FIGURE 6.3

By using a Gradient fill layer, you can create the perfect background for a 3D bug.

NOTE You can create a mask for any one of the fill or adjustment layers so that they affect only a portion of the layers beneath them.

Adjusting the Brightness and Color of a 3D Object

When you create an adjustment layer, the options you have to choose from are the options that can be found under Image ⇨ Adjustments. These options allow you to correct the color and tone of an image, or in this case, a 3D object. You can also use these adjustments to create special effects. I will give you an overview of each of the adjustment layer options.

CROSS-REF Adjustments have a very different effect on a brightly colored 3D object than on a photo or video file. You can find in-depth coverage of how adjustment layers affect video files in Chapter 15.

Levels

You can adjust the levels of the shadows and highlights in your file by adding a Levels adjustment layer. As you choose the Levels option, a histogram displays, representing the brightest and darkest values found in your file (see Figure 6.4). By adjusting the sliders, you can increase or decrease the darkness of your darkest pixels and the brightness of your brightest pixels. The center slider adjusts the midtones, or gamma setting, of your image.

FIGURE 6.4

Adjusting the levels on this robot gives him richer colors.

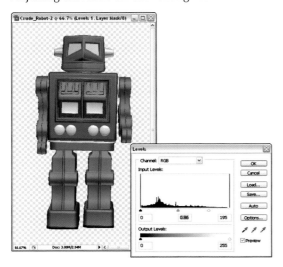

You can also use the gradient at the bottom of the Levels dialog box to choose which level of brightness will be the brightest highlight in the image and which level of darkness will be the darkest shadow in the image. As you move the indicators into the gradient, you will be reducing the contrast of the image because you will be reducing the number of brightness values that are used to define your image.

You can do this in all of the color channels together (the RGB channels are shown in Figure 6.4), or in each one individually.

Curves

The Curves dialog box offers a more precise way to change the tonal range of your image than the Levels dialog box. Rather than adjusting the shadows and highlights generically, you can add a control point for specific colors along the tonal curve. Once the Curves dialog box is open, you can choose any color in the document by using the eyedropper that is automatically displayed when you move the mouse cursor out of the Curves dialog box and hover over your image. Choosing a color will place a control point on the curve that represents the brightness value of that color. You can then change the tonal range of that color by moving the control point, or leave the tonal range the same while adjusting the other brightness values by moving the curve around the control point. You can place up to 14 different points along the color curve.

You can adjust the curve balance in each of the color channels individually or all of them together by choosing a channel from the drop-down menu. You can also choose from several presets to start from. Figure 6.5 shows the Color Negative preset being applied to give the robot a metallic look.

FIGURE 6.5

Adjusting the Color Curve dramatically produces dramatic results.

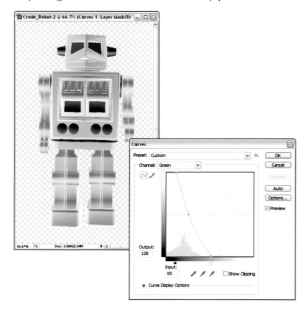

Color Balance

The Color Balance dialog box gets right to the point with sliders that allow you to adjust the balance of the colors in your file. The sliders are clearly labeled in the dialog box. You can increase the red and decrease the cyan in your document by sliding the appropriate slider towards red. You can change the levels of the color channels in your file using the Shadows, Midtones, or Highlights options. This is the easiest way to affect individual colors in your file directly (see Figure 6.6).

This robot's colors aren't very subtle, but you can get a more intense look by deepening the colors and brightening the highlights.

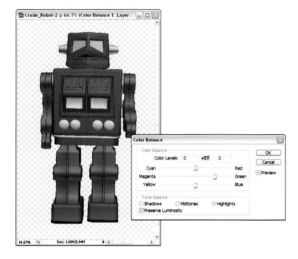

Brightness/Contrast

You can adjust the global brightness or contrast across your 3D file by adding a Brightness/Contrast adjustment layer. The dialog box consists simply of two sliders: one for brightness and one for contrast.

Black & White

This option allows you to control the brightness value of individual colors as they are converted to grayscale. A grayscale image consists of 256 different brightness values. When you convert a color image to a grayscale image, each of the colors are assigned a grayscale value based on their brightness values. You can adjust the grayscale value that is assigned to specific colors (reds, for example) by adjusting the appropriate slider. The Black & White adjustment is also handy in creating Alpha Channels based on color images or channels.

Hue/Saturation

This option allows you to change the hue, saturation, or lightness of your file. You can choose to change the Master, meaning all the color values, or choose an individual color channel from the drop-down menu. Once you have chosen an individual color from the menu, you'll see a slider appear in the color bar at the bottom of the Hue & Saturation dialog box. Using the slider, you can adjust the color that will be affected by the hue and saturation adjustments. This option allows for subtler color modifications than the Color Balance option, and allows you to make saturation changes (see Figure 6.7).

FIGURE 6.7

A hue change makes this red car a stunning green. Desaturating it gives it a more realistic color.

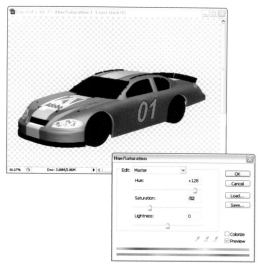

Selective Color

The Selective Color Options dialog box is the Color Balance dialog box on steroids. Instead of adjusting the balance of color in your document, you can adjust the balance of color in a specific color range in your document. In Figure 6.8, you can see the drop-down menu listing the colors from which you can choose. Once Reds have been chosen, changing the sliders of the color balance will only change the color balance in any color in the affected layer(s) that is defined as red by Photoshop. If you were to move the top slider toward red, for example, only the reds in your document would go a deeper red. None of the blues or greens would be affected by the color balance change.

FIGURE 6.8

The Selective Color Options dialog box.

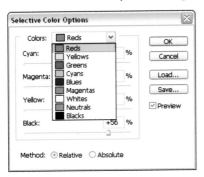

Channel Mixer

The Channel Mixer allows you to add color overcasts to your image. It works a lot like the Photo Filter adjustment, but with more control. There are several presets, all of which change the image to a grayscale image before creating the colorcast to it. This is the fastest way to create a sepia effect or add other colorcasts to a grayscale image. You don't have to convert your image to grayscale. You can use the sliders to create a color overcast to any image.

Gradient Map

Every color that is used by Photoshop is assigned a brightness value that determines the properties of that color. If you were to look at a spectrum containing all the brightness values, it would look familiar to you, like the multihued rainbow that you can see whenever you open the Color Picker dialog box. A Gradient Map replaces that color spectrum with a selected gradient, effectively redefining what the brightness values of the affected layers mean. You can see how this works in Figure 6.9, using a color gradient replaces the blacks on the car with the lowest brightness value defined by the gradient (dark red and pink) and the whites on the car with the highest brightness value defined by the gradient (yellow and orange-red).

Photo Filter

Using a Photo Filter adjustment layer on your object mimics using a photo filter on your camera. You can either use one of 20 preset filters or change the color of the filter using the Select Filter Color dialog box. The filters are subtle color overcasts that change the look of your image. Using a warming filter will add a warm-toned color overcast to your document, for example, orange, brown, or red. The effect is subtle, changing the feel of an image rather than making an obvious difference in the look.

FIGURE 6.9

Adding a Gradient Map adjustment layer creates a very colorful car.

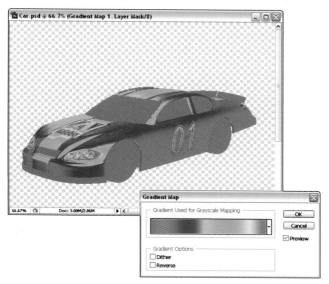

Exposure

The Exposure option is meant to correct exposure problems in a photo image. You can also use it to create great effects in your 3D file. You can change the Exposure, Offset, and Gamma settings to enhance the highlights or dark tones of your file, similar to over- or underexposing a picture.

Invert

The Invert option changes all of the colors in your file to their exact opposite, creating a negative image of your 3D model (see Figure 6.10). The Invert command does not have a dialog box; it simply changes every color to its opposite brightness value.

Threshold

Using the Threshold option changes your file into a true black-and-white image — not grayscale. The dialog box simply contains a slider that allows you to set the Threshold level. Every color above that brightness level is changed to white, and every color below that level becomes black (see Figure 6.11).

FIGURE 6.10

An image of the Earth after applying the Invert option.

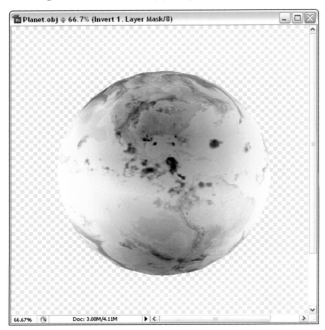

FIGURE 6.11

The colors on the flashlight are very dark, but setting the Threshold level lower creates more white in this image.

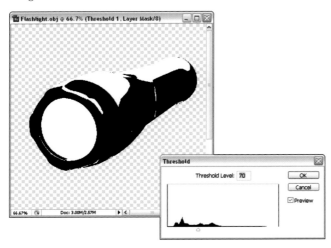

Posterize

Using the Posterize option on your model allows you to change the color brightness to a range between 2 and 255 levels. When you set the levels at a low range, you reduce the number of colors that are used in the image, giving the colors a banded look (see Figure 6.12).

Setting the Posterize levels to 6 on this Earth model creates bands of limited color.

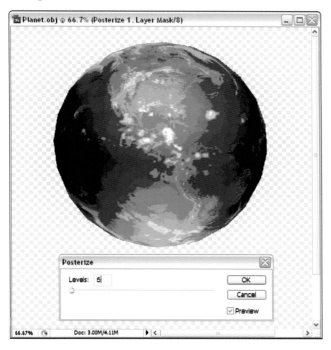

Editing a Fill or Adjustment Layer

Once you create a fill or adjustment layer, it has all the properties of any other full layer on the Layers palette. You can move it in order to change which layers it will affect. You can create a mask for it so that its effects are limited to the unmasked area of your document. You can change its visibility or opacity to nullify or reduce the effect it has on other layers. You can change its blend mode to create special effects. You can even change the original settings of the fill or adjustment at any time.

Moving a fill or adjustment layer

As you now know, you can move a fill or adjustment layer, or any other layer for that matter, by dragging and dropping it where you want it to be in the Layers palette. This example uses the robot in a composite with a lamp. If you apply a Curves adjustment layer over this composite, it affects both the lamp and the robot, but if you drag the Curves adjustment layer under the Lamp layer, it only affects the Robot layer (see Figure 6.13). You can just as easily drag and drop the Curves adjustment layer into the trash, deleting it completely.

FIGURE 6.13

Dragging the Curves adjustment layer below the Lamp layer prevents it from affecting the Lamp layer.

Editing the properties of a fill or adjustment layer

Once you have created a fill or adjustment layer, you can go back at any time to edit the properties of the effect that you have created with the layer. You may need to do this because you have added more objects, layers, or special effects, and you just need to tweak your effect without having to start all over again. Nothing is easier. Just double-click the thumbnail on the effect layer to open the dialog box, and make changes to the original effect. Once you are done, click OK; the changes are applied to your object.

Creating a mask for a fill or adjustment layer

The example in Figure 6.13 works because the robot and the lamp do not touch each other. However, what if a table was added to the composite? It's important to place the Table layer behind the Robot layer, so that the table appears behind the robot in the image. In this case, a mask is created for the Curves adjustment layer, so that it only affects the Robot layer.

Start by selecting the Robot layer, and create a selection around the robot. Once you create this selection, click the Add Layer Mask button in the Layers palette. This creates a mask of the robot in the Robot layer. This does not really help you yet, because the Curves adjustment layer is still applied to the entire canvas. You can fix this easily by dragging the mask from the Robot layer to the Curves adjustment layer. Now the Curves adjustment layer is only applied to the robot, and the table and lamp are masked out (see Figure 6.14).

TIP It is easy to select the whole robot by using the Magic Wand tool to select the transparent background and then invert the selection. Ease of selection is the reason that you are creating the mask inside the Robot layer instead of the Curves adjustment layer.

CROSS-REF You can learn more about masks and composites in Chapter 5.

You can also create a mask by selecting the robot as you create a fill or adjustment layer. This automatically creates a mask of the robot as the layer is created.

FIGURE 6.14

Creating a mask in the Curves adjustment layer prevents it from affecting anything but the robot.

Summary

You've learned that fill or adjustment layer allows you to make changes to 3D object that are not possible by applying a fill or adjustment to the 3D object from the Image menu. You learned how to:

- Apply a fill or adjustment layer
- Create a Solid Color, Gradient, or Pattern fill layer over a 3D object
- Color correct a 3D object
- Edit a fill or adjustment layer

In the next chapter, you learn how to use all of the tools you have learned so far to create composites with 3D objects in Photoshop.

Chapter 7

Creating Image Composites with 3D Objects

IN THIS CHAPTER

Creating seamless composites

Using the Cross Section settings

Placing more than one instance of the same 3D model in a composite

Using masks in a 3D composite

Creating special effects in a composite

Now that you know how to manipulate, edit, and change the textures on a 3D object, you can learn how to put it all together to create composites. This is where all the tools you have learned about so far come together.

You can create a composite several different ways. You can combine two or more 3D files, combine a 3D file with an image file, or use several different kinds of files to create a multilayered, complex image. Throughout this chapter, you will find many examples of not only different composites, but also different effects that you can use on composites to create special effects.

Creating Seamless Composites

A seamless composite is an image that doesn't look like it's been created from more than one element. Even in this case, where you are going to be creating images that have a 3D object that doesn't look realistic in and of itself, you can create images that blend well. Creating a composite is a lot more than just combining two files together and hoping that they will mesh well. Placement, perspective, lighting, and color all play key roles in whether a composite looks great or whether it looks mashed together. This is just as true with 3D files as it is with image files.

Fortunately, there's a reason why a *Photoshopped* image is an image that is considered too good to be real. Photoshop has all the tools you need to create a great composite.

Combining files

Photoshop can open over forty different types of file formats. You can combine almost any one of these types with any one of the others. Photoshop has no problem combining a 3D file with a JPEG or TIFF image, or layering it on top of an Illustrator file. More incredibly, Photoshop maintains the original aspects of each of these files so that they can still be edited and manipulated inside a composite in the same way that they were edited and manipulated in a file by themselves. In fact, in a lot of ways, it is easier to make the changes to a file after it has been placed. That way, you can be sure that the changes are consistent with the end result you are trying to achieve.

There aren't any magic tricks to combining files. It is not only incredibly easy, but you can combine files in more ways than one. The easiest way, especially if you already have the files open, is to drag the object layer from the first file into the window of the second. You can see how this is done in Figure 7.1.

You can also combine files by copying and pasting one file, or a selection from that file, into a different file. As you paste a selection into a file, a new layer is created, containing that selection. This allows you to move the selection and make edits to it.

If you want more immediate control over where your placed file is located on the background file and how large it is, you can use the Place command by choosing File ➪ Place. When you use the Place command to import one file into another file, the imported file is placed inside a bounding box. You can drag and drop the bounding box wherever you want inside the background. You can also use the handles on the bounding box to resize or rotate the placed file.

You can use the numeric values in the options bar to set the position, size, and orientation of the placed file. When you are finished placing the file where you want it, click the Commit button (the check mark icon) in the options bar to accept the changes you made (see Figure 7.2).

FIGURE 7.1

Combining files can be as simple as dragging the object layer from the file you want to move into the window of the file you want to place it in.

FIGURE 7.2

Using the Place command gives you more control over the file's size and position.

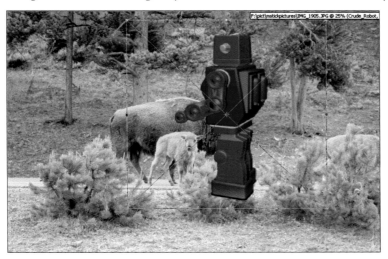

Adjusting a placed file

Even if you have used the Place command to combine files, you may find that you want to make some adjustments. You can move the contents of either file by selecting its layer in the Layers palette and dragging and dropping the file into position.

TIP As you transform and change a 3D model that is part of a composite, you can make those changes faster if you change the render mode of the model to wireframe. You can change the render mode by double-clicking the 3D layer to open the 3D Transform options, and clicking the Lighting and Appearance Settings button in the options.

You can change the size of or rotate a file by choosing Edit ⇨ Transform. The Transform menu has options such as Rotate, Scale, Skew, Warp, and Flip. Choosing Rotate, Scale, and Skew creates a bounding box. You can use the handles on the bounding box to make changes to the file. The Warp option places a mesh over your file, allowing you to pull on strategic points to warp and bend it (see Figure 7.3). You can flip your file horizontally or vertically by choosing the Flip option.

CAUTION Be sure the layer of the file you are attempting to change is highlighted in the Layers palette. If it is not, then you just may find yourself making changes to the wrong layer.

If you need more leeway to move your files around or to enlarge them, change the canvas size by choosing Image ⇨ Canvas Size. From the Canvas Size dialog box, you can expand the canvas without affecting the image it contains.

FIGURE 7.3

By transforming the rug with the Warp tool, you can make it appear to be flying.

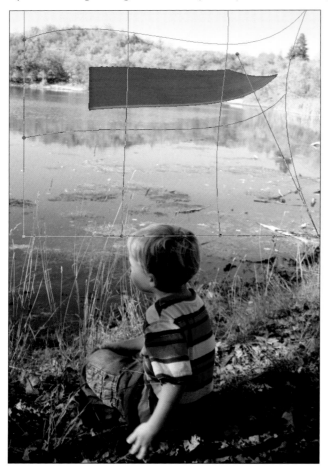

Transforming a placed file

You probably noticed when I placed my robot in Figures 7.1 and 7.2 that it was turned to face left. I didn't make any changes to the OBJ file before placing it. It's very simple to make those changes, and if you've been reading up to this point, you can probably already guess how. You can open the original file by double-clicking the layer containing that file in the Layers palette. Once you open it, you can make transformations and edit it. When you save it, the changes are reflected in the composite document that you've placed it in.

Blending composite files

When you place a 3D object into another file, you may find that they don't really seem to fit together. There are a few quick tricks you can use to make the files blend together better.

Changing colors

Changing the colors of either of the objects or images in the composite can make a 3D object blend in or stand out (see Figure 7.4). You can do this subtly, or completely change the colors involved. To change the color of a placed 3D object, you need to double-click the Smart Object icon in the object's thumbnail in the Layers palette to open the object, and then double-click the texture layer to open the texture. Once you make color changes, you can save the texture file to transport the color changes into the composite.

CROSS-REF You can learn more about making color changes to a 3D object in Chapter 3.

FIGURE 7.4

Changing the color and pattern of the CD case makes these 3D objects look like they belong together.

Refining edges

When you create a selection of a file to place into a new file, you may occasionally get rough, pixilated edges or an edge with a shadow around it. You can soften these edges as you make the selection or after you have placed it, as long as the area is still selected. Click Refine Edge in the selection tool options bar, or choose Select ➪ Refine Edges to display the Refine Edge dialog box (see Figure 7.5).

FIGURE 7.5

The Refine Edge dialog box.

The Refine Edge dialog box has several settings that allow you to fine-tune the edge of your selection. Set the following sliders to achieve the best results:

- **Radius:** Setting the radius determines the pixel width of the edge that is affected by the other settings. If your edge is relatively clean, set the radius lower; if you have a blurred or finely detailed edge, set the radius higher.

- **Contrast:** As you increase the Contrast setting, the edges of the selection become sharper. Noise around the edge is reduced.

- **Smooth:** Increasing the Smooth setting reduces the irregular edges in the selection, which reduces the pixilated edges.

- **Feather:** Feathering blends the edge and creates a soft transition by reducing its opacity. The slider allows you to determine the width of the feathered edge.

- **Contract/Expand:** You can shrink or enlarge the selection boundary by moving this slider. Making other changes to your edge to soften it may change where you want your edge to be. This handy option allows you to adjust the selection boundary without creating an entirely new selection.

As you make changes, you can toggle back and forth from the refinements you have made to the unrefined selection by pressing the P key.

You can also change the way you view the selection as you refine it. Choose from Standard, Quick Mask, On Black, On White, or Mask. Toggle through these settings by pressing the F key. You can also view the selection on the document (without the selection boundaries) by pressing the X key.

The finished product is a selection without the hard or pixilated edges that make it look unrealistic (see Figure 7.6).

Creating a drop shadow

Most objects in a lighted environment create a shadow somewhere in that environment. A drop shadow is limited in the way that it mimics an actual shadow, but in the right setting, a drop shadow works very well to create a shadow effect. You can also add a drop shadow to help blend the edges of an object or file that you have placed.

FIGURE 7.6

Fine-tuning the edge of a selection helps it blend into other files.

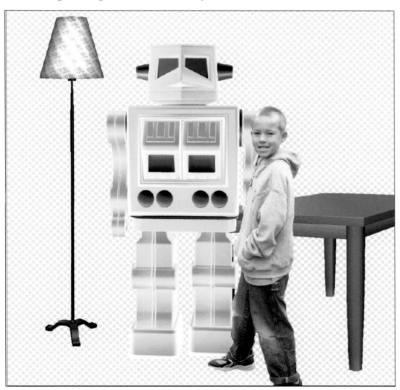

Create a drop shadow by highlighting the desired layer and clicking the Layer Styles button (*fx*) at the bottom of the Layers palette. Select Drop Shadow from the option list and adjust the settings, looking at the file for a preview, until you create the effect you want.

CROSS-REF **Creating a drop shadow of a 3D object is covered in Chapter 5.**

Changing fill or opacity settings

Sometimes a 3D object that is placed in an image file looks hard, lacking the color subtleties and the light and shadow of the image (see Figure 7.7). You can blend the object in very subtly by decreasing the opacity or fill settings of the 3D object. By decreasing these settings until you can make out any details coming through, you can give the object a softer, more blended look. Reducing either of these settings by about five percent is adequate, and although the difference is hardly noticeable, the 3D object blends a little better (see Figure 7.8).

FIGURE 7.7

The robot has hard, bright colors that make it look out of place.

FIGURE 7.8

Reducing the opacity of the robot helps it blend in.

Changing the Blend Mode

Changing the Blend Mode is a more dramatic way to blend a placed file into its background than changing the opacity or fill. These options are usually for creating special effects rather than realism in a composite. You can change the Blend Mode by selecting the layer and using the Blend Mode drop-down menu in the Layers palette to choose a blending option.

CROSS-REF You can learn about the basics of Blend Modes in Chapter 1.

Creating a fill or adjustment layer

When you create a fill or adjustment layer, the layer is placed over all the layers in your document. By making the same changes to all the files in a composite, they have more in common and blend better. Even something as simple as placing a warming filter over both file layers can create depth and bond the files with a common look (see Figure 7.9). Of course, more dramatic fills and adjustments create an even more dramatic bond.

Add a fill or adjustment layer by clicking the New Adjustment Layer button at the bottom of the Layers palette and choosing the fill or adjustment you want to apply.

CROSS-REF The fill and adjustment layers are covered in Chapter 6.

FIGURE 7.9

Adding a warming filter to both the robot and the image creates a common appearance in both files.

Using the Cross Section Settings

When you create a composite of a 3D object, you have the option of using the Cross Section settings in the 3D Transform options bar to create the intersection of the object with other objects or images. A cross-section simulates a cut through a 3D object. If the cut section is turned toward the camera, you can see the inside of the object.

Using a cross-section in an intersection within a composite is not as easy or seamless as using a mask, but because you are able to see the inside of an object, a cross-section is more useful in many ways. It allows you to give your object a truly three-dimensional feel. The composite in Figure 7.10 certainly would not have the same effect if a mask had been used.

The Cross Section settings are found in the 3D Transform options bar. When you use this tool, the result is only a partial section of a 3D model. The example in Figure 7.10 uses two instances of the beetle to create two pieces.

CROSS-REF You can learn more about the Cross Section settings in Chapter 1.

FIGURE 7.10

By using the Cross Section settings, the inside of the beetle is visible.

Placing Duplicate 3D Models in a Composite

By placing a duplicate of a 3D model in a composite, you create two instances of the same object in the same file. There will probably come a time when you want to place more than one instance of a 3D object in the same composite file. In fact, it was necessary to place two beetles in the composite (refer to Figure 7.9). Every duplicate has its own layer, but the way that the duplicate is created will determine the way that each instance of the same object can be edited. This can be a tricky situation, and I'll show you why.

You can place two of the same 3D objects in a composite very simply by following these steps.

1. Open the file Desk.obj.
2. Right-click the Desk layer and select Duplicate Layer.
3. Change the name of the layer to Layer 2 and click OK.
4. Highlight Layer 1 and place the first desk behind Desk 2 in the image, as shown in Figure 7.11.

FIGURE 7.11

You can duplicate the desk by duplicating its layer.

5. Double-click the 3D icon in the Layer 1 thumbnail to display the 3D Transformation bar.

6. Click the Scale button and scale the desk so that it sits proportionately.

7. Click the Commit Current 3D Transform button (the check mark) to accept the transformation.

8. Select the texture of the desk by double-clicking the Desk layer within Layer 1.

9. Choose Edit ⇨ Fill and change the color of the desk. Click OK.

10. Save the texture JPG so that the Desk.obj file will reflect the changes.

11. Select the texture of Desk 2 by double-clicking the desk layer within Layer 2.

12. Choose Edit ⇨ Fill. Choose a different color for this desk. Click OK.

13. Save the texture JPG so that the Desk.obj file reflects the changes.

As you can see from Figure 7.12, you now have two desks that look very different from one another, although they started out as the same file.

FIGURE 7.12

The desks with fills edited.

Let me show you what happens when you try to do the same thing with an image file for a background. You can place two desks on an image file by following these steps.

PHOTOSHOP CD For this exercise, use the Desk.obj file found in the Photoshop CD containing the bonus content. To access this file, insert the bonus content CD and navigate to Goodies ⇨ 3D models ⇨ Desk.

1. Open any image file inside Photoshop.
2. Choose File ⇨ Place.
3. Navigate to Desk.obj and click OK.
4. Use the bounding box to place the desk in your image and click the check mark in the Placement bar to accept the placement of the Desk.obj file.
5. Right-click the Desk layer and select Duplicate Layer.
6. Change the name of the layer to Desk 2 and click OK.
7. Highlight the Desk layer and place the desk behind Desk 2 in the image.
8. Double-click the Smart Object icon in the Desk thumbnail to open the Desk.psb Desk file.

9. Double-click the 3D icon in the Layer 1 thumbnail to open the 3D Transformation bar.

10. Click the Scale button and scale down the size of the desk.

11. Click the Commit Current 3D Transform button (check mark) to accept the transformation.

12. Save the Desk.psb file. You should now see a startling result, both of the desks in the image changed sizes. (see Figure 7.13).

13. Double-click the texture layer to open the texture of the desk.

14. Choose Edit ➪ Fill and change the color of the desk. Click OK.

15. Save the texture JPG so that the desk.obj file will reflect the changes.

16. Save the Desk.psb file.

FIGURE 7.13

Both desks changed size.

You can see in Figure 7.14 that the desks not only change size together, but they also change color together. This has to do with the nature of the Smart Objects the desks become when they are placed in the image file. Because every instance of the 3D file is linked, the changes made to the embedded file of one affect the other.

You can get around this very easily by placing the desk twice in the image file, rather than duplicating the layer. This can be inconvenient in a way, because there are many situations where you might want to duplicate a layer rather than placing a new instance of an object. For example, if you

rotate the first desk before placing the second desk, it would be more convenient to duplicate that layer and preserve the rotation when creating the second desk. Just keep in mind that a duplicated 3D layer also duplicates future edits to the 3D object.

Of course, this can also come in handy in some situations; you can't create original 3D objects this way, but you can create several copies that you can edit in unison. For example, you could create an entire classroom of desks and then turn them to face a different direction or change their textures simultaneously.

FIGURE 7.14

Both desks also changed color.

Using Masks in a 3D Composite

Masks play a vital role in creating realistic composites by allowing you to integrate your objects and images. If masks are new for you, never fear; they are not nearly as complicated as you might think. Simply put, a mask works like a stencil to protect portions of a canvas while allowing other portions to be modified. Of course, masks in Photoshop are a lot more versatile than a stencil, but if you keep the basic premise of a stencil in mind, masks become a much simpler concept.

There are almost as many different types of masks in Photoshop as there are ways to create them. This section could go on for a chapter, or even a book, and so what you will find here is just the very basics of creating a mask, along with a more in-depth approach to how those masks can help you create successful composites that contain 3D objects.

Almost every mask that you create is made up of a white area that indicates the selected area, a black area that indicates the masked area, and gray areas that indicate translucent areas. You can modify any mask by painting on it using white, black, or any of 256 shades of gray.

Making a selection

To create a mask, you start by creating a selection. In fact, a selection is a type of mask. Just like a stencil, once you make a selection, you can paint on or change anything inside that selection without affecting the areas outside of the selection. Because there are several different selection tools, the following section briefly tells you about each one and how it works.

Marquee tools

The Marquee tools consist of three selection tools that are constrained by shape. Pressing the M key activates the Marquee tools. You can choose from four different tools:

- **Rectangular Marquee tool:** Creates a selection around a rectangular area. You can constrain the selection to a square by holding down the Shift key while making the selection.

- **Elliptical Marquee tool:** Creates a selection around an oval area. Hold the Shift key to constrain your selection to a circle.

- **Single Row or Single Column Marquee tool:** These tools create a selection around a row or column that is only 1 pixel wide.

Lasso tools

The Lasso tools create a selection by allowing you to draw around an area. The selection is complete when you close it up, creating a finished shape. You can activate the Lasso tools by pressing the L key. There are three different Lasso tools:

- **Lasso:** This tool allows you create a freehand selection by drawing around the area to be selected without any constraints. This works well for rough selections or selections you intend to modify.

- **Polygonal Lasso:** The Polygonal Lasso allows you create shapes other than a rectangle or ellipse by clicking each corner of the shape you would like to create. This tool works well if you need to select straight-edged shapes that are not rectangular, such as a trapezoid or a polygon.

- **Magnetic Lasso:** The Magnetic Lasso hunts for the edge of what it thinks you are trying to select and sticks to it. If you have a high-contrast image, using the Magnetic Lasso is much simpler than trying to make a freehand selection.

Magic Wand tool

The Magic Wand creates a selection by selecting similarly colored pixels. Choose the color you would like to select by clicking it with the Magic Wand, and any pixels that are the same color in the image are automatically selected. You can activate the Magic Wand or the Quick Selection tool by pressing the W key.

Quick Selection tool

The Quick Selection tool is new to Photoshop CS3. It makes selecting a multihued area from a multihued image (like selecting one person from a group) a quick and easy process instead of a chore. The Quick Selection tool works like the Magic Wand tool, selecting similarly colored pixels in the area where you are using it, but you can drag it to other areas to add to the selection. Like the Magnetic Lasso tool, it shrinks to the edges of the area you are selecting.

Once you choose any of the selection tools, take a look at the Selection Options bar at the top of the Photoshop window. It displays different options — depending on what selection tool you are using — for fine-tuning the way the tool makes its selection. You can change options, such as the tolerance of the color range for the Magic Wand tool, whether to make a new selection with every click, or whether to add to or subtract from the selection.

Once you make a selection, you can create other types of masks to help you refine your selection or to place in layers permanently to create masking effects.

Working with a Quick Mask

After creating a selection, you can create a Quick Mask of the selection to help you refine the edges. You can create a Quick Mask by pressing the Q key, or by clicking the Quick Mask button in the tools palette. This creates a red overlay on the masked, or unselected, area of your image (see Figure 7.15).

FIGURE 7.15

The masked area that can't be changed is indicated by a red overlay.

From here, you can make edits to the unmasked area or refine the edges of the mask. Take a look at your background and foreground colors in the tools palette. No matter what they were originally, in the Quick Mask mode, they are now black and white. Painting white on the mask creates

unmasked, areas, adding to the selection. Painting black creates a mask over that area, subtracting from the selection. You can choose other colors, but they appear as shades of gray. Painting gray in a mask creates a translucent selection area in the image. The translucency level is directly proportional to the shade of gray used; the lighter the shade of gray, the more translucent the mask.

Once you are done editing the selection in Quick Mask mode, click the Quick Mask button again to return to the selection.

CROSS-REF An Alpha Channel mask is more complicated, but more useful, than a Quick Mask in fine-tuning the selection process. Knowing how to create and use an Alpha Channel mask can increase your skill at creating selections and composites in Photoshop. You can learn how to create and use Alpha Channels in Chapter 17.

Creating a Layer Mask

A Layer Mask does a little bit more work than a selection or a Quick Mask. Besides allowing an area to be modified or changed, a Layer Mask hides the area that is not selected, allowing layers underneath to show through. This kind of mask is useful when you are creating a composite.

Creating a Layer Mask requires two or more existing layers in the Layers palette. You can create a Layer Mask in several different ways. The easiest is to click the New Layer Mask button in the Layers palette. If you don't have any part of the highlighted layer selected, an empty mask appears in that layer, indicating that the entire image is a selection. If you do have a portion of the image selected, the mask is created, indicating that selection.

You can also create a Layer Mask through the File menu by choosing Layer ➪ Layer Mask and then choosing one of the following four options.

- **Reveal All:** creates an all-white mask indicating that the entire layer is selected.
- **Hide All:** creates an all-black mask indicating that the entire layer is hidden.
- **Reveal Selection:** creates a mask with the selected area revealed (white) and the deselected area masked (black).
- **Hide Selection:** creates a mask where the selection is inverted, with the selected area masked and the deselected area in white.

A Smart Filter mask is a Layer Mask that is created by adding a Smart Filter to a layer with an active selection. As you create a Smart Filter, an automatic mask is placed on the filter layer.

Once you create a Layer Mask, moving it between layers is a simple matter of dragging and dropping it into another layer. This is a very useful feature that allows you to easily select an area in one image to create a mask in another. To illustrate this, the following steps show you how to create a Layer Mask in a composite. You can make your composites look more integrated by using a mask to combine layers:

PHOTOSHOP CD For this exercise, use the Crude_Robot.obj file found in the Photoshop CD containing the bonus content. To access this file, insert the bonus content CD and navigate to Goodies ⇨ 3D models ⇨ Crude_Robot.

1. Open any image file.

2. Choose File ⇨ Place and navigate to Crude_Robot.obj. Click OK.

3. Place the robot in your image and scale it to the right size.

4. Click the Commit Current 3D Transform button (check mark) in the 3D Transform options bar to accept placement. You can see from Figure 7.16 that the crude robot doesn't look like part of the image at all.

FIGURE 7.16

The crude robot doesn't look like he belongs in this image.

5. Right-click the background layer. You can't create a Layer Mask on a background layer because it is locked, and so you must choose Layer from Background to unlock it. Name the layer and click OK.

6. Pick an area to place the crude robot behind in your image. Click the Visibility button (eye icon) next to the crude robot to hide him from view.

7. Select the area of the photo that you want to hide the robot behind. Make sure the edges that will touch the robot are crisp. The edges away from the robot don't matter as much (see Figure 7.17).

FIGURE 7.17

The Quick Selection tool offers a fast and easy way to select the edges of the astronaut in the foreground. The edges that will not intersect with the crude robot don't have to be as precise.

8. Choose Select ➪ Inverse to reverse the selected area.

9. Click the New Layer Mask button at the bottom of the Layers palette. This creates a Layer Mask from the selection on the image layer. The deselected area disappears from the image (see Figure 7.18).

10. Click the empty Visibility button (eye icon reappears) on the crude robot layer to return him to view.

11. Click and drag the Layer Mask thumbnail to the crude robot layer (see Figure 7.19).

FIGURE 7.18

The deselected area disappears from the image.

FIGURE 7.19

Simply drag and drop the mask from one layer to another layer.

Now that you've moved the mask into the layer containing the crude robot, the mask covers the robot, rather than the image, making him seem as if he is part of the image, as shown in Figure 7.20.

FIGURE 7.20

The crude robot blends into the image.

After you have created a Layer Mask, the Opacity setting on the Layers palette allows you to adjust the opacity of the mask. If you want the masked area to be translucent, reduce the Opacity setting from 100 percent until you reach the desired level.

> **TIP** Whenever you have a palette or dialog box in Photoshop with a numeric setting and no obvious slider, you can click and drag across the name of the setting (for example, the word *opacity* in the Layers palette) to bring the slider up and change the level.

Creating a clipping mask

A clipping mask is another type of mask that may come in handy when creating composites. A clipping mask uses a layer with a transparency background and combines it with at least one other layer to create a cutout. You can see an example of a clipping mask in Figure 7.21.

To create a clipping mask, simply place a layer that contains a transparency background underneath one or more layers. The bottom layer becomes the mask. The area that is transparent is cut out of the top layers entirely, and the top layers conform to the shape of the bottom layer. Right-click the top layer and choose Create Clipping Mask. You can also hold the Alt (Opt) key while clicking the division between the two layers.

FIGURE 7.21

A clipping mask creates a cutout by using the bottom layer as the mask.

Although there are many ways to create masks as well as types of masks, the examples in this chapter give you a sampling of the more useful masks that you can use to create image composites. They also show that masks are indispensable in integrating a 3D object into a two-dimensional image. Although this book does not have the space to cover everything about masks, I strongly encourage you to learn more about masks and their use in Photoshop.

Creating Special Effects in a Composite

Now that you have gone over the basics, you can get started with the fun stuff! Creating special effects is anything from adding light and shadow to an image to changing the look of an image by using a filter or style. This part of the chapter shows you just a couple of ways that you can create special effects in a composite. This will give you a chance to walk through a few examples before you venture out on your own. These examples are pretty step-intensive, but they include several different techniques so that you can see how these techniques work together. When you are done, you will have a better understanding of the fantastic things that you can do with a 3D model in Photoshop.

Flying the carpet over a lake

The following example shows you how to finish the flying carpet that you started in Chapter 5. You will start right from the beginning, following every step necessary to create a successful composite:

For this exercise, use the Rug.obj file found in the Photoshop CD containing the bonus content. To access this file, insert the bonus content CD and navigate to Goodies ⇨ 3D models ⇨ Rug.

1. Open an image file. Your image should contain a good-sized horizontal surface.

2. Choose File ⇨ Place.

3. Browse to Rug.obj and click OK.

4. Place the rug in your image file and scale it to fit the image.

5. Click the Commit button (check mark) in the 3D Transform options bar to accept the placement.

6. Double-click the thumbnail in the Rug layer. This displays the Rug.obj file.

7. Double-click the thumbnail in Layer 1.

8. Rotate the rug until it looks as if it is laying at an angle, similar to Figure 7.22.

9. Click the Commit button (check mark) in the 3D Transform options bar to accept the transformation.

10. Save the Rug.obj file and close it. This brings you back to the composite file containing an image and the rug.

11. With the Rug layer highlighted, choose Edit ⇨ Transform ⇨ Warp.

12. Use the warp mesh to give the rug dimension. Rather than lying flat, make it look as if it were coming in for a landing.

13. Click the Commit button (check mark) in the 3D Transform options bar to accept the changes.

14. With the Rug layer highlighted, click the Layer Styles button in the bottom of the Layers palette and choose Drop Shadow.

FIGURE 7.22

The rug object is stiff as a board, but it looks angled for a landing.

15. Set the spread and size of the drop shadow, depending on the brightness of your background image — the brighter the image, the smaller the spread and size should be. Hard sunlight makes hard shadows.

16. Click OK to exit the Layer Styles dialog box.

17. Right-click the Drop Shadow sublayer and choose Create Layer. Click OK when you see the warning: "Some aspects of the Effects cannot be reproduced with Layers!"

18. Highlight the Drop Shadow layer.

19. Inside the image, drag the shadow below the rug to rest on a horizontal surface.

20. Reduce the opacity of the shadow. How much depends on the image you are using; try to match the opacity of the shadows in the image (see Figure 7.23).

FIGURE 7.23

The shadow of the rug rests on the lake.

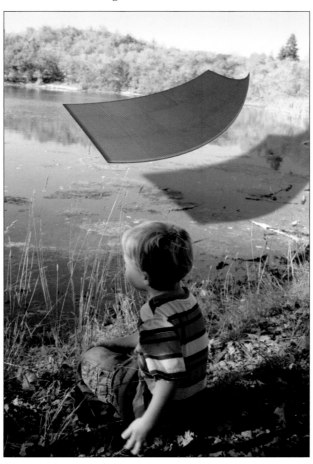

TIP Depending on the angle of sunlight in your image, you may want to rotate, scale, or even warp the shadow to make it look more realistic. With the shadow layer selected, choose Edit ➪ Transform.

21. With the Rug layer highlighted, click the Layer Styles button at the bottom of the Layers palette, and choose Pattern Overlay.

22. From the pop-up palette, choose a black-and-white pattern. This example uses Metal Landscape.

23. Adjust the opacity so that the rug's red color shows through the pattern.

24. Scale the pattern until it suits you.

25. Set the blend mode. Feel free to play around and try different blend modes; they really make a difference in the look of the rug's texture. This example uses Linear Light.

26. Click OK to exit the Layer Styles dialog box.

27. Choose Filter ➪ Brush Strokes ➪ Accented Edges.

28. Set the sliders to the following settings: Edge Width 7, Edge Brightness 2, and Smoothness 2.

29. Click OK to save the changes and return to the image.

30. Select Filter ➪ Blur ➪ Motion Blur.

31. Set the angle to coincide with the angle of the rug. Set the distance to the number of pixels that look good with your image.

32. Click OK to save the changes and return to the image.

33. Save your file.

34. Choose Layer ➪ Flatten Image. This combines all of the elements contained in this file into one layer. With the layers containing Smart Objects rasterized, you can now use the painting tools on your image.

35. Zoom into the edge of the rug.

36. Click the Smudge tool.

37. Using precise strokes and more than one size of brush, brush the edges of the rug out to create a fringe, as shown in Figure 7.24. Do this to both ends or to all four sides of the rug.

38. Choose View ➪ Fit On Screen (See Figure 7.25).

FIGURE 7.24

Drag the edge out to resemble a fringe.

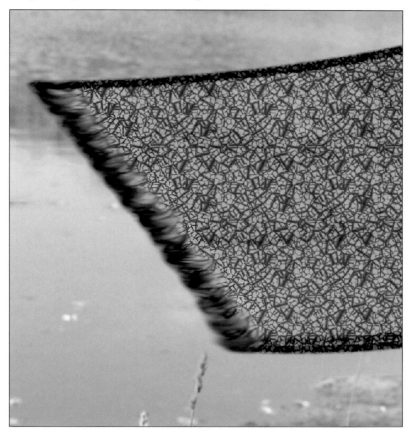

The steps you take to create a flying carpet follow a precise order. It is important to transform the rug by turning and warping it before you create the drop shadow. Once the drop shadow has been separated into its own layer, it no longer mimics the changes made to the rug. In fact, you can make changes to the drop shadow layer separately.

Creating and separating the drop shadow before adding the Pattern Overlay effect, or any other special effect, is just as important. When you choose to create a layer from a sublayer, such as the drop shadow, all other sublayers are also made into their own layers. In this example, you want to leave the additional special effects tied to the main layer, and so you create them after separating the drop shadow.

The shadow gives the illusion that the rug is floating above the surface of the lake by several feet.

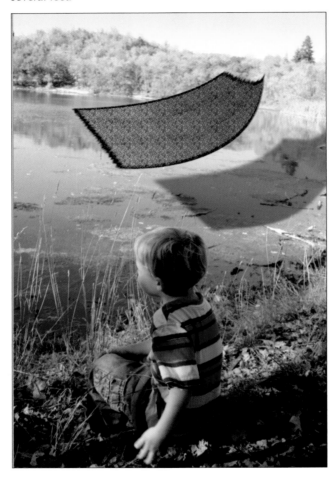

Take a look at the Layers palette shown in Figure 7.26. You have created quite an array of layers. They are well organized and easy to understand, especially because you have created them yourself. Take the opportunity to edit them or reorganize them if you are still not familiar with how they work.

FIGURE 7.26

The Layers palette before the image is flattened.

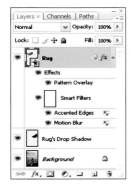

Using several techniques to add realism to a 3D object added to an image file

Here is another example that uses different techniques. In this exercise, you create cross-sections and place more than one instance of an object in a file. You also place a second 3D object in the same file. You are using two different image files, one as a background and one to create a pattern to replace a texture file.

You can use several different techniques to create a sophisticated composite by following these steps:

PHOTOSHOP CD For this exercise, use the Box_with_Lid.obj file found in the Photoshop CD containing the bonus content. To access this file, insert the bonus content CD and navigate to Goodies ⇨ 3D models ⇨ Box_with_Lid.

1. Open the file Box_with_Lid.obj.

2. Double-click the Layer 1 thumbnail in the Layers palette to open the 3D Transform options bar.

3. Open the drop-down menu using the Cross Section Options button.

4. Change the following settings: check Enable Cross Section, check Flip, uncheck Show Intersections, click Z-axis, and set the offset to 11. You should be left with the lid of the box.

5. Click the Rotate and Roll tools and rotate the lid of the box until it is angled to look like it is coming off the bottom of a box.

6. Click the Commit button (check mark) to accept the transformations.

7. Rename the Layer *Lid* by right-clicking the layer and selecting Layer Properties.

8. Choose File ➪ Place. Browse to Box_with_Lid.obj and click OK.

9. Click the Commit button (check mark) to accept the placement.

10. Double-click the thumbnail in the Box_with_Lid layer. When you are reminded to save, click OK.

11. Double-click the Layer 1 thumbnail in the Layers palette to open the 3D Transform options bar.

12. Open the drop-down menu using the Cross-Section options button.

13. Change the following settings: check Enable Cross Section, uncheck Show Intersections, click Z-axis, and set the offset to 10. You should be left with the bottom of the box, minus the lid.

14. Click the Rotate tool and rotate the bottom of the box until you can see into it. You can also use the Roll tool to fine-tune the placement of the box (see Figure 7.27).

15. Click the Commit button (check mark) to accept the transformations.

16. Save the changes and exit the file.

17. Rename the Box_with_Lid Layer as *Box* by right-clicking the layer and selecting Layer Properties.

18. Open an image file with which you can make a pattern.

19. Select an area in your image using the Rectangular Marquee tool in Pattern Maker.

20. Choose Filter ➪ Pattern Maker and create a pattern from your selection. Click OK (see Figure 7.28).

CROSS-REF You can learn how to use the Pattern Maker in Chapter 3.

21. Save the pattern file and return to the Box_with_Lid file.

22. Double-click the layer labeled box2 inside the Lid layer to open the texture file.

23. Choose File ➪ Place and browse to the pattern file you created earlier. Click OK.

24. Stretch the pattern to fill the texture of the box.

25. Click the Commit button (check mark) to accept the placement of the pattern.

26. Save the changes to the texture and close the texture file. The lid of the box should now have a new texture.

27. Double-click the thumbnail in the Box layer. When you are reminded to save, click OK.

28. Repeat Steps 22 through 26 to add the texture to the main portion of the box.

29. Save this file and close it.

You can open the box by creating cross-sections of both halves.

A pattern created from a photo of a nebula.

Now that you've created a box, you can place it in an image so that it looks like it belongs.

1. Open an image that will be fun to place the box in. Choose one that needs a mask to place the box (see Figure 7.29).

2. Choose File ➪ Place and browse to the Box_With_Lid.psd file that you just saved. Click OK.

3. Position and size the box in the file however you like, and click the Commit button (check mark) to accept the placement.

4. Note the areas that need to be masked, and then hide the box by clicking its Visibility button.

5. Right-click the Background layer and choose Layer from Background. Leave the name as Layer 0 and click OK.

6. With Layer 0 highlighted, select the areas that need to be masked.

TIP You can create a jagged selection along the edge of the box as well as a selection around the face to take away the sharp edge that in a real photo would sink slightly into the carpet.

7. Choose Select ➪ Refine Edges.

FIGURE 7.29

The box needs a mask to make it work inside this photo.

8. Adjust the settings to refine the edge of your selection. Click OK.

9. Choose Select ⇨ Inverse.

> **NOTE** You can, of course, select the areas that need to be shown rather than the areas to be masked. Then there is no need to invert the selection.

10. Click the Add Layer Mask button in the Layers palette to create a mask from the selection.

11. Drag the mask to the box layer.

12. Click the empty Visibility button to restore the box layer to view. Your box should be masked into the photo.

13. Choose File ⇨ Place and browse to Moon.obj. Click OK.

14. Size the moon to fit in the box, and click the Commit button (check mark) to accept the placement.

15. Drag the Moon layer to the top of the Layers palette, placing it on top of the box.

16. Set the moon inside the box.

17. With the Moon layer highlighted, click the Polygonal Lasso tool and select the front of the box (see Figure 7.30).

FIGURE 7.30

Create a selection to mask the moon inside the box.

18. Choose Select ⇨ Inverse.

19. Click the Add Layer Mask button in the Layers palette to create a mask from the selection.

20. Double-click the thumbnail in the Moon layer to open the Moon file.

21. Double-click the thumbnail in Layer 1 of the Moon file to open the 3D Transform options bar.

22. Choose Lighting and Appearance settings button from the 3D Transform options bar.

23. From the Light Settings drop-down menu, choose Blue Lights.

24. Click the Commit button (check mark) to accept the transformation.

25. Save the file and close it to return to your composite file.

26. With the Moon layer highlighted, click the Layer Styles button and choose Inner Glow.

27. Adjust the settings to give the moon a nice glow (see Figure 7.31).

FIGURE 7.31

Inner Glow settings for the moon.

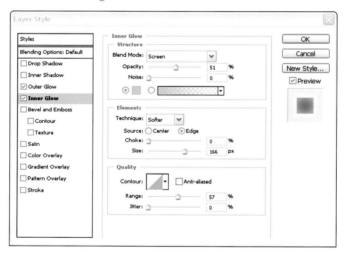

28. In the Layer Styles palette, click Outer Glow.

29. Adjust the settings to give the moon a nice outer glow, as well.

30. Click OK to exit the Layer Styles dialog box.

You should have a good-looking finished product, as shown in Figure 7.32.

You can see that even the most rudimentary 3D objects can become very interesting by using Photoshop tools to enhance them. Just imagine what you can do with more elaborate 3D models.

FIGURE 7.32

The moon is placed in the box, which is placed in an image to make it look as if it always belonged.

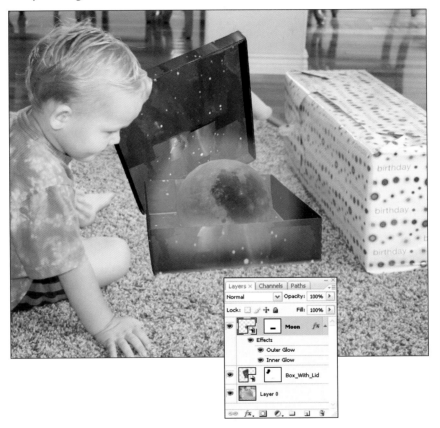

Summary

This chapter showed you how to:

- Create a seamless composite
- Use a cross-section in a composite
- Place more than one instance of a 3D model in the same image
- Create masks for 3D composite
- Put it all together to create special effects in a composite

Now that you know how to edit 3D images, you are ready to move on to the animation timeline, where you can animate 3D objects as well as images.

Part III

Creating Animations Using the Animation Palette

An animation is a file that changes over time. It differs from a video file because it is created movement rather than recorded movement. Photoshop has the ability to animate in several different ways.

This part will introduce you to two different Animation palettes: the Animation (Timeline) palette and the Animation (Frames) palette. You can create animations effectively with either palette, although each has its own particular strengths and drawbacks. You will get to know the tools in both palettes and which palette is best used in which situation.

This part also shows you how to animate in several different ways using both palettes. You can change the properties of an individual layer over time using keyframes to create an animation effect, or you can draw or create frame-by-frame to create animation techniques. You will learn what properties you can animate and the most effective ways to animate them. You will also learn how to create frame-by-frame animation and how to use shortcuts that can save time in this process.

Chapter 8

Getting Started with the Basics of Animation

Welcome to the world of animation in Photoshop. Even if you have used the animation tools found in Photoshop CS2, you are going to be amazed at the new animation capabilities that Photoshop CS3 has to offer. You can accomplish anything from creating a simple animated GIF to building elaborate animations frame-by-frame.

With the new 3D capabilities in Photoshop, you can even animate 3D objects, or incorporate them into an animated scene. Now that you have become very familiar with the 3D environment and creating composites from 3D objects, you are just a few steps away from being able to animate these scenes with ease. In fact, many of the examples throughout the next few chapters make use of 3D objects or image composites.

Photoshop has also added video editing to its ever-growing repertoire. This means that Photoshop has gone from the basics of creating simple, crude animations to being able to paint within video layers and Rotoscope animation. That's a pretty big jump in capability.

This chapter introduces you to the new Animation (Timeline) palette in Photoshop and shows you a few basics in animating: importing image files, animating DICOM files, and rendering animations once they are complete.

IN THIS CHAPTER

Getting acquainted with the Animation (Timeline) palette

Importing image sequences

Animating DICOM files

Rendering and exporting animations

Previewing and exporting files

NOTE To make use of the capabilities in the Animation (Timeline) palette, you must have a copy of QuickTime 7 (or later) installed on your computer. QuickTime is a free download at `www.apple.com/quicktime`.

Getting Acquainted with the Animation (Timeline) Palette

The Animation (Timeline) palette consists of a timeline for creating animations or editing video through time. It has features such as a current time indicator that allow you to move through time in your file and lists the layers that are placed in your file. You can also access layer properties that allow you animate any layer in your file in different ways, depending on the type layer selected. The Animation (Timeline) palette is new to Photoshop and is in addition to the Animation (Frames) palette that was found in Photoshop CS2.

For being brand-new to Photoshop, the Animation (Timeline) palette certainly knows how to assert its authority. It is the default animation palette. In fact, even if you have selected the Animation (Frames) palette, the Animation palette reverts to the Animation (Timeline) palette any time you open a document that does not specify the frame-based palette.

It is easy to see where the Animation (Timeline) palette has its roots. Adobe Premiere and Adobe After Effects have very similar, if more advanced, Timelines than the one found in Photoshop. By making the Animation (Timeline) palette a part of Photoshop, Adobe has increased its capability to animate and edit video exponentially.

So what is so amazing about the Animation (Timeline) palette? I'll start by introducing the basics of the palette itself.

 You can learn about the Animation (Frames) palette in Chapter 10.

Features of the Animation (Timeline) palette

The Animation (Timeline) palette has so many features that it is easier to break them into three categories: time adjustment, work area, and buttons.

Time adjustment

The Animation (Timeline) palette includes many time indicators and time features, as shown in Figure 8.1.

Here is what these features do and how you can use them:

- **Current Time:** The current time is a numerical representation of where the current-time indicator is placed on the Time Ruler. Notice that the current time indicated in Figure 8.1 matches exactly with the position of the current-time indicator.

- **Current Frame Rate:** This number is an indicator of how many frames are in every second of an animation or video. The default setting, and the one indicated in Figure 8.1, is 30 frames per second (fps).

FIGURE 8.1

The time features of the Animation (Timeline) palette.

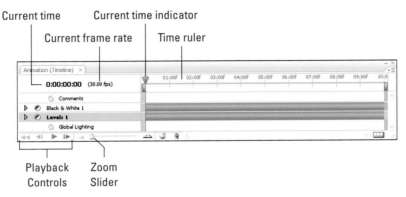

- **Time Ruler:** The Time Ruler indicates the time relative to the video layers.

- **Current-Time Indicator:** The current-time indicator is a slider that allows you to preview your animation or select a particular time or frame in your animation by dragging it back and forth across the video layers.

- **Playback Controls:** The playback controls allow you to rewind, play, pause, and fast-forward your animation or video, as well as move the current-time indicator to the beginning of the animation.

> **TIP**
>
> You can also press the Spacebar to play and pause your animation.

- **Zoom Slider:** The Zoom slider is a very handy feature that allows you to expand or reduce the Time Ruler. Zooming in increases the length of each second in the Timeline. If you zoom all the way up, each frame takes up the same amount of room as each second did at the lowest setting.

- **Current Frame:** The current frame can be viewed in lieu of the current time if you choose Palette Options from the palette menu and then choose Frame Number. You can see in Figure 8.2 how the look of the Animation (Timeline) palette has changed.

- **Frame Ruler:** When the Animation (Timeline) palette is set to the frame number display, the Time Ruler becomes a Frame Ruler, indicating the number of frames relative to the video layers, as opposed to the number of seconds.

You can change the palette options to show the current frame number in the Animation (Timeline) palette.

Current Frame Frame ruler

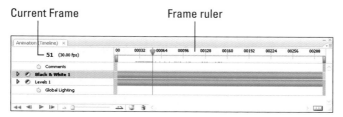

Work area

The work area of the Animation (Timeline) palette includes the following features, which are shown in Figure 8.3:

- **Comments Track:** The Comments track provides a space to enter comments in any area of the Timeline.

- **Global Lighting Track:** The global lighting track allows you to animate global lighting throughout all layers at the same time.

- **Time-Vary Stop Watch:** The Time-Vary Stop Watch can be turned on in any layer property that can be animated. It allows keyframe indicators to be placed inside the property layer.

CROSS-REF A little lost? Comments, global lighting, and the Time-Vary Stop Watch are all covered in depth in Chapter 9.

- **Video Layers:** These represent the layers in your video file. They correspond exactly to the layers in the Layers palette. Notice in Figure 8.3 that the top layer is actually an adjustment layer.

The work area features of the Animation (Timeline) palette

Video Layers Comments track Work area indicators

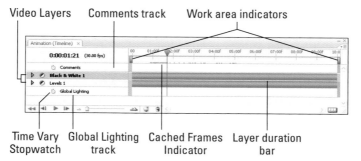

Time Vary Global Lighting Cached Frames Layer duration
Stopwatch track Indicator bar

- **Work Area Indicators:** By dragging these indicators to different spots in your Timeline, you can reduce your work area to the immediate area you are working on. When you start a playback, it is restricted to this area. You can also render and export just the segment of your video or animation contained inside the work area indicators. This tool is more useful as your file becomes longer in duration.

- **Cached Frames Indicator:** The Cached Frames indicator shows the frames that have been cached in the computer's memory and can be easily previewed. When the line is solid, all the frames in that area have been cached. The line can also look jagged, indicating that only a few frames have been cached in that area. If the line is non-existent, none of the frames have been cached yet. As you play back video, you will notice that there are a limited number of frames that can be cached. As a consequence, past frames are discarded as new frames become cached.

- **Layer Duration Bar:** This bar indicates the duration of the layer inside the Timeline. When the bar is light green, the layer is not viewable. Drag either end of the bar to lengthen or shorten it.

Buttons

The buttons around the Animation (Timeline) palette make certain actions quick to perform. Some perform their function with a quick click, while others require more input. The buttons are labeled in Figure 8.4.

FIGURE 8.4

The buttons on the Animation (Timeline) palette.

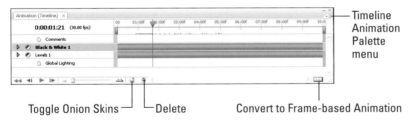

Here is a list of the buttons on the Animation (Timeline) palette and their function:

- **Toggle Onion Skins:** This button allows you to enable or disable your view of onion skins quickly in the frame being previewed.

CROSS-REF Don't worry if you are not sure what onion skins are, as they are covered in depth in Chapter 11.

- **Delete Keyframes:** No explanation is needed here. Click this button whenever you have a keyframe highlighted that you want to discard.

■ **Convert to Frame Animation:** Clicking this button changes the Animation (Timeline) palette to the Animation (Frames) palette. Your file is also converted to a frame-based animation.

CAUTION Changing a Timeline file to a frame-based file causes you to permanently lose some of the properties of the Timeline layers.

■ **Animation Palette Menu:** Clicking this button displays the Animation palette menu. Because this is a big menu, it is described in the following section.

Defining the options found in the Animation (Timeline) palette menu

The Animation palette menu has many features (see Figure 8.5). Some of them are relatively intuitive, and some of them will be covered in much greater depth in this and the following chapters. Here is a quick rundown of the list so that you'll have a comprehensive resource. Where any of these options are covered in more depth in a different chapter, you will find a cross-reference to that chapter after the definition.

FIGURE 8.5

The Animation (Timeline) palette menu.

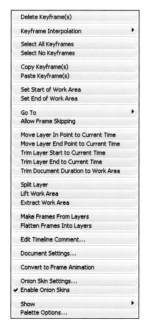

- **Delete, Copy, and Paste Keyframe(s):** Use these options to delete, copy, or paste a keyframe. Duplicating a keyframe duplicates the frame, the keyframe indicator, and if you have selected more than one keyframe, all of the interpolation in between. Keep in mind that you can't use the hotkeys for these functions (Ctrl X, C, and V).

- **Keyframe Interpolation:** This option allows you to set the type of interpolation you want between keyframes: Interpolation, which generates tweening between keyframes, or Hold, which holds the keyframe settings until the next keyframe (Chapter 9).

- **Select All and Select No Keyframes:** Selects or deselects all of the keyframes in the targeted layer.

- **Set Start or End of Work Area:** Click these options to move the start or end of your work area to the position of the current-time indicator (see Figure 8.6).

FIGURE 8.6

Changing the work area highlights a section of the animation or video so that playback is restricted to that area.

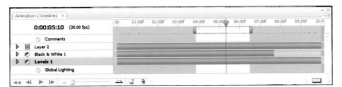

- **Go To:** This option allows you to move your current-time indicator to any one of the following places: a specified time, the next frame, the previous frame, the first frame, the last frame, the beginning of the work area, or the end of the work area.

- **Allow Frame Skipping:** Select this option to skip frames as you preview an animation or video. This allows Photoshop to play the preview in real time, although the quality is not as good as the rendered version.

- **Move Layer In Point to Current Time:** This option repositions the selected layer's start point to the position of the current-time indicator (Chapter 12).

- **Move Layer End Point to Current Time:** This option repositions the selected layer's end point to the position of the current-time indicator (Chapter 12).

- **Trim Layer Start to Current Time:** This option splits the selected layer at the position of the current-time indicator and discards the first portion of the layer (Chapter 12).

- **Trim Layer End to Current Time:** This option splits the selected layer at the position of the current-time indicator and discards the last portion of the layer (see Figure 8.7) (Chapter 12).

FIGURE 8.7

The dark-green segments of the layer indicate the layer duration. The light-green areas indicate that although the video is still playing, that particular layer does not exist in the Timeline.

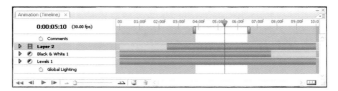

- **Trim Document Duration to Work Area:** This option deletes any video layers or portions of layers that fall outside the work area (Chapter 12).

- **Split Layer:** This option splits the layer into two at the site of the current-time indicator. Once a layer has been split, you can edit each portion individually (Chapter 12).

- **Lift Work Area:** If you lift the work area, all of the layers in the work area are deleted, but a space the size of the work area is left in the Timeline (Chapter 12).

- **Extract Work Area:** Extracting the work area deletes all of the layers contained in the work area, closing the gap in the Timeline left by the deletion (Chapter 12).

- **Make Frames From Layers:** This option allows you to take an image with several layers and create an individual frame from each layer (Chapter 10).

- **Flatten Frames Into Layers:** This option creates a layer for every frame in your video or animation (Chapter 10).

- **Edit Timeline Comment:** This option allows you to create or edit a Timeline Comment in the comments track (Chapter 9).

- **Document Settings:** The Document settings in the Timeline include the duration of the animation and the frame rate.

- **Convert to Frame Animation:** Rather than clicking the Convert to Frame Animation button in the palette, you can go the long way and choose this option from the palette menu.

- **Onion Skin Settings:** Clicking this menu item brings up the Onion Skin Options dialog box. From this dialog box, you can set several options, including what frames become onion skins and their opacity (Chapter 11).

- **Enable Onion Skins:** When this option is selected, you can use the Toggle Onion Skins button at the bottom of the Animation (Timeline) palette to toggle the view of the onion skins on and off (Chapter 11).

- **Show:** From this option, you can choose whether to show all layers or your favorite layers. You can also set up or edit your favorite layers.

- **Palette Options:** This option allows you to change the thumbnail size of the layers. You can also change the ruler on the Timeline from timecode to frame number display.

Accessing the Video Layers menu

There is one other submenu that you should be especially aware of while working in the Animation (Timeline) palette. You can display this submenu by choosing Layer ➪ Video Layers from the File menu. As you start to learn more of the advanced techniques of animation and video, you will use the Video Layers submenu more frequently. You can see this submenu in Figure 8.8.

FIGURE 8.8

The Video Layers menu.

Here is a list of the options in the submenu and their function:

- **New Video Layer From File:** Like the Place command, this option allows you to import a separate file as a layer in your existing file.

- **New Blank Video Layer:** A new blank video layer is handy for making changes to existing video, and imperative if you are animating an image or rasterized layer that does not already contain a video layer. Besides the regular layer properties, a video layer contains an altered video layer that allows you to make changes frame-by-frame. The new video layer is completely transparent until you add changes to it (see Figure 8.9).

FIGURE 8.9

A video layer contains an Altered Video property that allows you to draw in it frame-by-frame.

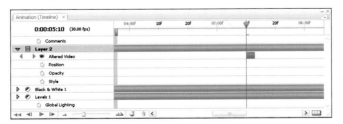

- **Insert Blank Frame:** Creates a blank frame on the altered video layer at the position of the current-time indicator.

- **Duplicate Frame:** Duplicates the current frame on the altered video layer and places it directly after the selected frame.

- **Delete Frame:** Deletes the current frame on the altered video layer.

- **Replace Footage:** Use this option if the file containing the original footage has changed locations and Photoshop cannot locate it. Click Replace Footage and browse to the new location to correct the link between the original file and the Photoshop document you have created with it.

- **Interpret Footage:** If you have video layers that contain an alpha channel, this option allows you to determine how the alpha channel is interpreted. You can also change other options such as whether the video will be interlaced or not. This is also one other place where you can modify the frame rate.

CROSS-REF Do you want to know how to create an alpha channel in video? Alpha channels and all of their settings are covered in detail in Chapter 17.

- **Hide Altered Video:** You can just click the Visibility button on the video layer you want to hide, or you can click Hide Altered Video to do the same thing.

- **Restore Frame and Restore All Frames:** By selecting one of these two options, you can discard the edits you have made to any or all frames. All edits in Photoshop are nondestructive, meaning that they do not affect the original file.

- **Reload Frame:** If the original footage of a video file you are using has been changed, Photoshop will eventually reflect those changes. You can use this option to reload the footage for the current frame you are working on, or you can simply use the playback controls to play the footage, allowing Photoshop to reload the original file.

- **Rasterize:** A video layer is dynamic and can be modified frame-by-frame. When it is rasterized, it becomes a flat image, containing only the data in the frame that was selected when it was rasterized. That data plays continuously through the duration of the original video layer.

Setting up for an animation project

Before you even begin an animation project, you are going to want to adjust the Document Settings to match your project. Changing the settings in the middle of a project can mean making a lot of adjustments that would not be necessary if the settings were correct in the first place.

If you are importing a video file, the Document Settings in Photoshop adjust to the settings found in the original video file.

As your project grows, you will also want to know how you can hide layers that you are not working on. This keeps your work area neater and easier to work in, and you can do this by setting your layer favorites.

Changing the Document Settings

The Document Settings are defaulted to ten seconds in the Timeline at 30 frames per second (fps). You can change the Documents Settings by following these steps:

1. With an animation file open (any file containing a layer that is not a background), click the Animation (Timeline) Palette menu button to open the fly-out menu.

2. Choose Document Settings from the options to open the Document Timeline Settings dialog box (see Figure 8.10).

3. Change the duration of the Timeline to fit your completed animation.

4. Change the frame rate to a reasonable rate for your project. If you are planning to do a lot of frame-by-frame animation, 30 fps could be very tedious! You can choose from the standard frame rates in the drop-down menu, or type any number to create a custom frame rate.

5. Click OK. Your settings are immediately reflected in the Timeline.

FIGURE 8.10

Change the Document Timeline settings to fit the needs of your file.

Setting layer favorites

Setting your layer favorites is even easier than changing your Document Settings. You can do this at any time during your project, and in fact, you may want to change your favorite layers often.

You can set up layer favorites by following these steps:

1. Highlight the layers that you want to place among your favorites. You can select multiple layers by pressing the Ctrl (⌘) key as you click each layer. You can do this in either the Animation palette or the Layers palette.

2. Click the Animation Palette Menu button to open the fly-out menu.

3. Choose Show ⇨ Set Favorite Layers. The unselected layers no longer appear inside the Timeline. These layers are still viewable in the Layers palette, and they are still visible in the animation (see Figure 8.11).

4. You can change your layer favorites by choosing Show ⇨ All Layers and repeating Steps 1 to 3.

FIGURE 8.11

Setting layer favorites cleans up the Animation (Timeline) palette.

Importing Image Sequences

An image sequence is a series of image files that are saved in sequence for an animation or video. Usually they are exported out of a video project. A video file is very intense to render, especially if it contains several layers, high-resolution images, or 3D objects. If you render a video project as an image sequence rather than a video, the rendered — and saved — images are preserved even if your computer crashes, allowing you to start the rendering process where you left off. You can export a video or animation file as an image sequence by choosing File ➪ Export ➪ Render Video and then selecting Image Sequence. This is covered in greater depth later in this chapter. You can also create an image sequence from a series of still shots that are taken in rapid succession. However you do it, Photoshop allows you to import these rendered images together as one animation file.

There are two ways to do this. The first way imports the image sequence as a single layer, creating one video layer from the individual image files, just as if it had been a single video file. The second way imports the image sequence into a stack, giving each frame its own individual layer without any extra steps. The following sections show you how to import using both methods.

NOTE **Before you import an image sequence, make sure that it has been saved correctly. An image sequence should be a series of images saved with sequential filenames and placed in a folder that doesn't contain any other files.**

Importing an image sequence into one layer

Opening an image sequence as one video layer is the fastest — and in most cases, probably the preferred — method to import an image sequence.

You can open an image sequence as just one video layer by following these steps:

1. Choose File ➪ Open.
2. Browse to the folder containing the image sequence, and select the first file in the sequence.
3. Click to select the Image Sequence option at the bottom of the Open dialog box (see Figure 8.12).
4. Click Open.
5. You are prompted to enter a frame rate for your image sequence. If this is an exported video, select the original frame rate. If this is a series of still shots, select the frame rate that will work best, and click OK.

FIGURE 8.12

Be sure to select the Image Sequence option so that all of the files are opened.

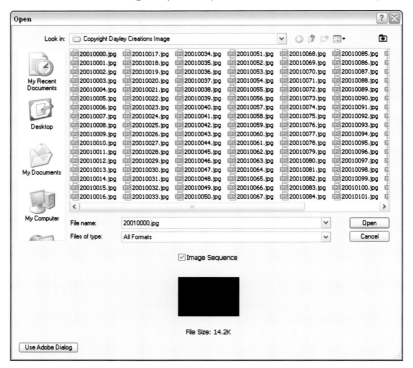

You now have a simple file that looks just like you opened a video file (see Figure 8.13). This file was generated fairly quickly and is very easy to work with.

Importing an image sequence into multiple layers

If you need your image sequence to be placed in separate layers, there is a way to import it that does this as the images are opened. This method renders the images as they are imported, and so there is no waiting time to cache the frames once the file is created.

FIGURE 8.13

You can open an image sequence to create a simple video layer that is easy to work with.

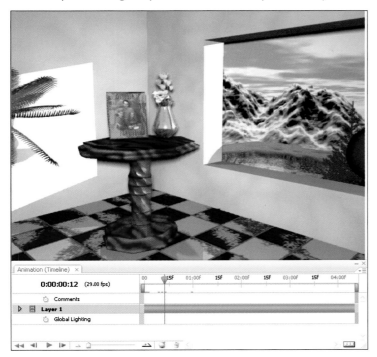

You can create an individual layer for every image in an image sequence:

1. Choose File ➪ Scripts ➪ Load Files into Stack. This opens the Load Layers dialog box (see Figure 8.14).

2. Choose Folder from the Use drop-down menu.

3. Browse to the folder containing the image sequence you want to open.

4. Click OK.

NOTE If your image sequence contains more than 50 files, then you may want to go out to dinner or watch your favorite TV show. Loading these images as separate layers in the Animation (Timeline) palette is a time-consuming process.

5. Now that the images have been loaded into separate layers in a new document, the document settings need to be changed from the default setting. Click the Animation Palette button and choose Document Settings.

FIGURE 8.14

The Load Layers dialog box.

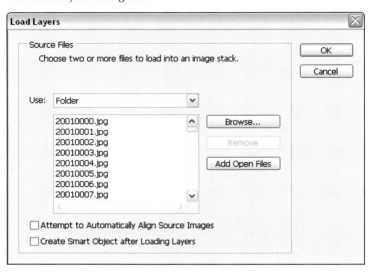

6. Set the duration and frame rate to match the number of frames in your image, and how long you want each frame to last. Click OK.

7. Click the Animation Palette button and choose Make Frames from Layers. This creates one frame for each layer at the frame rate specified in the Document Settings.

CAUTION As you make frames from layers, make sure that your current-time indicator is placed at the beginning of your Timeline. The first frame is placed at the location of the current-time indicator.

Now you have an animation that contains a separate layer for every single image in your image sequence. This is handy if your image sequence is short, containing only a few images, but it is not so great if you have several images. Take a look at Figure 8.15 to see a view of the Animation (Timeline) palette after importing a five-second sequence. The frame rate is set to 29, and so there are 125 images in this file. As a result, there are 125 layers in the Timeline, and 125 layers in the Layers palette.

TIP If you are importing a large number of images, using the first method of importing an image sequence and then choosing Flatten Frames into Layers followed by Make Frames from Layers is a faster process than importing the stack, and it achieves the same result.

FIGURE 8.15

This is about one-third of the layers that are actually contained in this Timeline.

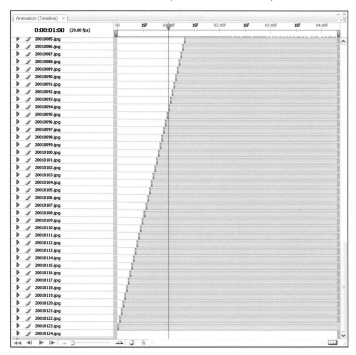

Animating DICOM files

A DICOM file is a medical image or series of images created when you have a sonogram, a CT scan, an MRI, or any number of procedures that take an image of the inside of your body. Photoshop has the capability to view these files as well as animate them. Animating a DICOM file is very similar to importing an image sequence. Of course, to create an animation, you must have a series of DICOM images.

You can open DICOM files and animate them by following these steps:

1. Choose File ➪ Open.
2. Browse to a DICOM file that is a series of images, and click OK. A dialog box opens, allowing you to set the parameters for opening the DICOM file (see Figure 8.16).

FIGURE 8.16

You can open a DICOM file in several ways, or you can simply export it to a JPEG. In this example, you want to animate it, and so you need to create a layer for each image in the DICOM file.

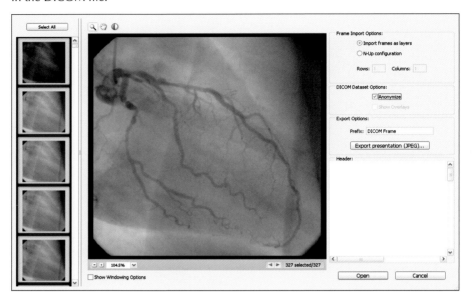

3. Select the frames you want to animate by pressing Ctrl (⌘) as you select them one by one, or click Select All.

4. Click the Import Frames as Layers option.

5. Click the Anonymize option if you would like to scrub out the headers contained in the DICOM images.

6. Click Open.

7. From the Animation palette menu, select Make Frames from Layers.

 You can see in Figure 8.17 that a frame has been created for each image contained in the DICOM file. Now you can view the file as an animation, or export it within a video file format.

FIGURE 8.17

The Animation (Frames) palette shows more clearly how each image has become a frame in this new DICOM animation.

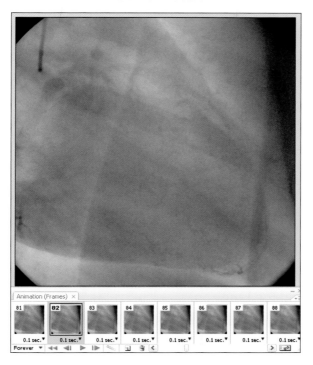

Rendering and Exporting Animations

Rendering or exporting a file completes the process of creating a single file from the layers that you have created. When working with a relatively long video or animation file, it is sometimes easier to render and save pieces of that file separately so that you do not have to work with as much data at once.

Depending on what you want to do with your animation or video file, there are several different ways that you can export it. If you plan to open it and use it in Premiere or After Effects, saving it as a PSD file works just fine. You can also export your file as an image sequence, creating a single still-image document for every frame in your video. Of course, you can also render and export your video as a video file, with a standard file format such as AVI or MPEG. Photoshop also has an interface for saving animation or short video files for the Web and output devices.

Saving your file for use in After Effects or Premiere

Although you can simply open a PSD file in Adobe After Effects or Adobe Premiere and continue to edit it, there are steps you can take to ensure that the file is more streamlined and easier to use in these applications.

You can optimize the effectiveness of using a PSD file in After Effects or Premiere by following these steps:

1. Make any image changes within Photoshop. This can include cropping, scaling, or color correction. Although many of these edits can be performed in the other applications, your video file will be more streamlined if you perform them in Photoshop.

2. Organize and name your layers using original and specific names so that they are easy to recognize and easily manageable in a different program.

CAUTION If you have been working on a PSD document in After Effects or Premiere, do not rename a layer in the video file in Photoshop. After Effects or Premiere may not be able to find that layer.

3. Choose Edit ➪ Preferences ➪ File Handling and choose Always from the drop-down menu next to Maximize PSD and PSB File Compatibility. This ensures that the file will have the maximum possible compatibility with other programs.

Exporting image sequences

Exporting a video file as an image sequence is even easier than importing them. Just as there were two ways of importing an image sequence, there are two ways of exporting it, as well.

There are advantages to exporting a video file as an image sequence rather than in a video file format. First of all, each image is saved right after it is rendered, and so if anything happens to interrupt the render process, you still have a portion of the project that has been rendered and saved. Exporting an image sequence is also a great way to quickly create still shots from a video file.

You can render your animation or video file as an image sequence by following these steps:

1. Choose File ➪ Export ➪ Render Video to open the Render Video dialog box (see Figure 8.18).

2. In the Location section of the dialog box, name your file, select a location to save it, and create a new subfolder for it.

3. In the File Options section of the dialog box, select Image Sequence. Set a file format and indicate how you would like the files to be numbered. You can also change the size of the file to any one of several standard video sizes.

4. In the Range section, select how many frames you want to render: all of them, a specified number, or those contained in the current work area.

5. In the Render Options section, you can choose an Alpha Channel setting and a frame rate.

6. Click Render.

The Render Video dialog box allows you to create a video file or image sequence.

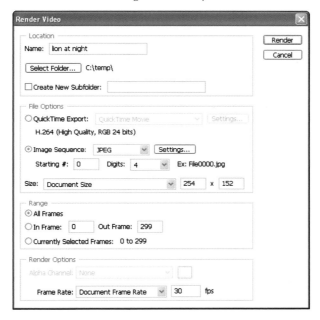

Now you have a tidy folder containing several images that are named in sequential order.

You can export an animation or video file by turning each of its layers into a file. Follow these steps:

1. Choose File ⇨ Scripts ⇨ Export Layers to Files to open the Export Layers To Files dialog box (see Figure 8.19).

2. Specify a location to save your files. You might want to create a new folder for them.

3. Give the files a common prefix.

4. Choose whether or not you want to render layers that are not visible.

5. Choose a File Format and settings for that format.

6. Click Run.

FIGURE 8.19

The Export Layers To Files dialog box allows you to export each layer of your video to different files.

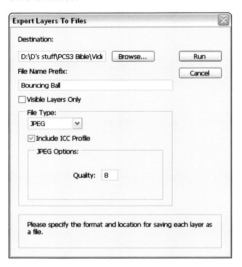

Exporting your layers into files only creates an image sequence if your file contains a layer for every frame of your animation. It also does not let you set as many options as the Render Video dialog box. Of course, this option is not just for video or animation files, and so it has many other uses.

Rendering and saving an animation or video in a video file format

If you are ready to render your file into a video file format, you can do that in Photoshop as well. Save your file as a PSD so that you will have a backup. To export your file in one of several different file formats, follow these steps:

1. Choose File ➪ Export ➪ Render Video. This opens the Render Video dialog box (see Figure 8.20).

2. In the Location area, name your file, choose a location for it, and specify whether to place it in its own folder.

3. In the File Options area, choose the QuickTime Export option and select a file extension. Change the settings for your particular file format by clicking the Settings button.

CROSS-REF For more information on video file formats, see Chapter 12.

4. In the Range area, select whether you want to render all of the frames, a specified number of frames, or the frames contained in the current work area.

FIGURE 8.20

Exporting to a video file format using the Render Video dialog box.

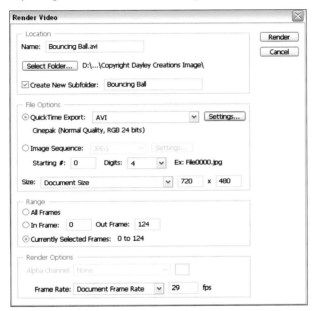

5. In the Render Options area, choose the Alpha Channel settings, if necessary, and change the frame rate if you want.

CROSS-REF Alpha channels and all of their aspects are covered in depth in Chapter 17.

6. **Click Render.**

Depending on the length and settings of your video file, this process may take a few minutes. When it is done, you will have a great movie file that you can share with friends and family, or over the Internet.

Saving Video and Animation Files for the Web and Output Devices

The Save For Web & Devices dialog box is another option that Photoshop gives you for previewing and exporting files. If you have created an animated GIF or video file that you are planning to post to the Web, you may want to use the Save For Web & Devices dialog box to optimize your file for the Internet. The benefits of using this dialog box are its capability to optimize GIF and PNG files as well as optimizing the colors that are used in creating these files. Choose File ➪ Save For Web & Devices to open the dialog box (see Figure 8.21).

FIGURE 8.21

The Save For Web & Devices dialog box

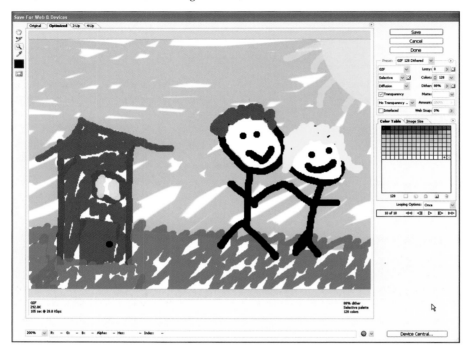

Optimizing GIF and PNG files

The upper-right corner of the Save For Web & Devices dialog box contains a smaller dialog box that allows you to optimize your file format (see Figure 8.22). GIF and PNG are the two animation file formats.

FIGURE 8.22

Optimizing color presets for GIF and PNG files.

The GIF and PNG file formats are used to create Web graphics because they compress color information, reducing file size significantly. They support 8-bit color, and so at the most, they are capable of producing 256 colors. This means that although the file size is great for the Web, documents that contain a great deal of color variance will be compromised in quality. This is where changing the optimizing options is very handy. You can add features to your file that increase its size, but add to the image quality. On the other hand, if your file is very simple, you can reduce the file size by reducing the color information as well as other settings.

Photoshop has provided several easy presets for these file formats, allowing you to choose differing image qualities, ranging from files as small as 32 colors to files that contain 128 colors. Choose any one of these presets from the Preset drop-down menu, and if you are happy with the settings, you do not need to change another thing.

Of course, in excellent Adobe style, you can change any of the individual settings to optimize your individual file just the way you like. Here is what each of these settings can do:

- **File Format menu:** This is pretty self-explanatory. Choose the file format that suits your Web production. GIF and PNG are animation file formats, while JPEG and WBPM are image formats.

- **Color Reduction Algorithm:** To turn a file that was created with millions of colors into one that contains somewhere between 32 and 256 colors means that the colors need to be reduced. This menu allows you to choose which types of color to use. You can choose from options such as Perceptual, which uses colors that are easier to distinguish with the human eye, or (Restrictive) Web, which uses the 8-bit color palette common to Windows and Macintosh, thus ensuring that the colors you see are the ones that appear on the Web.

- **Dithering Algorithm menu:** The Dither setting reduces color bands created in high-color images by dispersing the colors in the image. You can choose a dither method from the Dither Algorithm drop-down menu. These options include diffusion, pattern, and noise. Trial and error will probably let you know which method is best for your particular file. Across from the Dither Algorithm drop-down menu, you can set the dither percentage or use a channel to further optimize your dither settings.

- **Transparency and Matte:** You can adjust the transparency settings in your file, creating a background matte, mixing semitransparent pixels with a matte, or dithering semitransparent pixels with the transparency to create noise.

 In Figure 8.23, I have selected the Transparency option for my animated GIF. I haven't applied any dither, and I've created a matte that you can clearly see through the semitransparent pixels around the edges of the solid colors.

 In Figure 8.24, I have added a Noise Transparency Dither to the settings in Figure 8.23. You can see that the image looks quite different.

- **Interlaced:** Choosing this option displays a low-resolution version of your file as the higher-quality file is downloaded.

FIGURE 8.23

A Transparency setting without a Transparency Dither

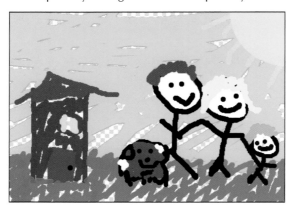

FIGURE 8.24

A Transparency setting with a Noise Transparency Dither added

- **Lossy:** The Lossy setting is for GIF files only and cannot be used in conjunction with the Interlaced option or the texture or Noise Dither settings. Increasing the Lossy setting selectively discards pixel information from a GIF file by using pixel information from previous screens in the file. Depending on the simplicity of your file, you can specify this setting at anywhere from 5 all the way up to 50 without compromising the file quality. This reduces your file size by 5 percent to 40 percent.

■ **Colors:** You can choose the number of colors your file will use from 2 to 256. It goes without saying that the more colors you use, the bigger your file will be.

■ **Web Snap:** This setting determines the tolerance used when adjusting your color settings for the colors available in the browser that runs your file. A higher number adjusts more of your colors.

NOTE **You can view changes that you are making next to the original document by clicking the 2-Up or 4-Up tab at the top of the Save For Web & Devices dialog box.**

Optimizing the color table and image size

Besides optimizing the color settings in the Preset dialog box, you can optimize the colors individually in the Color Table found in the Save For Web & Devices dialog box (refer to Figure 8.21). You can also choose individual colors and make them transparent, shift them to the nearest color on the Web palette, or lock them so that they aren't dropped (see Figure 8.25).

FIGURE 8.25

The Color Table allows you to choose the colors in your file individually and lock or make changes to them.

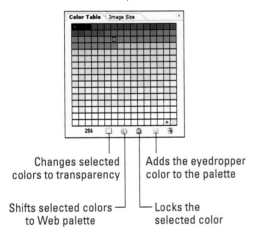

Changes selected
colors to transparency

Adds the eyedropper
color to the palette

Shifts selected colors
to Web palette

Locks the
selected color

You can also adjust the image size of your document by using the Image Size tab. You can change the number of pixels, change the size by percentage, and adjust the quality of the image (see Figure 8.26).

FIGURE 8.26

The Image Size tab.

Previewing Web files

You can use the playback and looping controls from the Save For Web & Devices dialog box to preview your animation more accurately. The preview in the Animation (Timeline) palette is very often slow and imprecise. Previewing your file in the Save For Web & Devices dialog box may be your only reason for opening it.

Summary

This chapter covered the basics of animation and video editing, such as:

- The Animation (Timeline) palette
- Importing image sequences
- Animating DICOM files
- Rendering and exporting animations

The next chapter shows you how to animate using keyframes in the Animation (Timeline) palette.

Chapter 9

Animating Using Keyframes in the Timeline

A s you've known since you were a kid, video and animation is produced by creating a series of images and showing them at such a high speed that it fools our brains into thinking that we are watching true motion. When I was a kid, I always wondered who had to draw and color the millions of pictures it took to make a full-length animated movie. Now I've watched enough special features entitled "The Making of..." to have a pretty good notion that some of those frames did not have to be created in their entirety, but many tips and tricks made the animation more efficient.

When you animate in Photoshop, you can also use many tips and tricks to animate more efficiently, as well as automate some of the most tedious tasks. We've all seen claymation productions — the animations that are created by moving clay figures a miniscule amount and taking a picture, and then repeating the process until all of the pictures are put together to create a movie. I'll tell you now that some of the animation in Photoshop is going to be just like that frame-by-frame animation. Not all of it, though, and that's where keyframes come into play.

A keyframe is one of the essential components of animating in Photoshop. A keyframe allows you skip many of the tedious steps in between "key" points in your animation. In this chapter, I show what a keyframe is, what it does, and how you can create and edit it.

Creating and Editing Keyframes

So what is a keyframe? When you are creating sequential images for an animation, a keyframe is any frame that defines a turning point in that animation. For example, if you were to animate a bouncing ball, the keyframes would be the frame where the ball meets the ground and changes direction, and the frame where the ball feels the inevitable pull of gravity to pull it back down. All the frames in between are just continuations of the up or down movement.

The in-between frames are sometimes referred to as *tweeners*. Creating these frames is called *tweening*, or in Photoshop terms, *interpolating*. When you create keyframes in the Photoshop Animation (Timeline) palette, Photoshop is able to interpolate the frames between keyframes. This provides you, the user, with an animation experience that is fun and easy, rather than tedious. A keyframe is indicated in the Timeline by a little yellow diamond or square, depending on the interpolation setting that is applied to it. You can create a keyframe in different areas of animation such as position, opacity, style, or global lighting.

Creating keyframes

Creating a keyframe is a fairly simple process; creating the right keyframe is something altogether different. For now, I'll just show you how to create a keyframe in the Timeline. I am going to create a bouncing ball by applying a color overlay to the sphere.obj file that is found on the Photoshop bonus content. You are welcome to do that as well, or you can just create a layer containing a circle over a blank canvas background and achieve the same results.

You can create a keyframe by following these simple steps:

1. Create a new file in Photoshop. Use the default Photoshop size or larger.

2. Click the Create a New Layer button in the Layers palette to create a new layer. Name the layer "ball".

3. Use the Ellipse tool found in the Tools palette to draw a circle in the new layer. By using the Move tool, you can move this circle anywhere within the canvas area.

4. Choose Window ⇨ Animation to open the Animation (Timeline) palette.

5. Click the triangle next to the layer name in the Animation (Timeline) palette to show the layer properties.

6. Set the current-time indicator to the beginning of the Timeline.

7. Click the Time-Vary Stop Watch button next to the word Position to activate it.

8. Move your object, or selection, through the canvas to the position you want to use as the start of your animation (see Figure 9.1).

FIGURE 9.1

The ball is ready to drop.

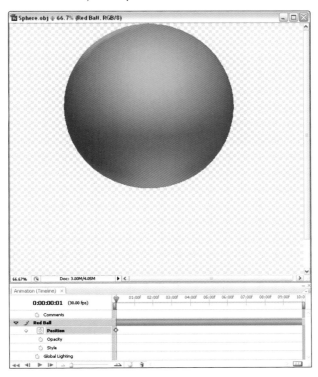

9. Drag the current-time indicator forward to 1 second.

10. Move your object again. A keyframe is automatically created (see Figure 9.2).

11. Slide the current-time indicator between the keyframes, or play back this simple animation to watch how tweening works.

FIGURE 9.2

I've created a keyframe at the bounce.

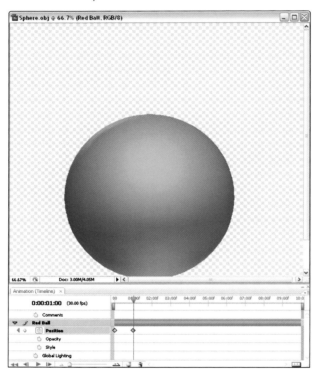

Now throwing you into this exercise was like throwing you into the deep end of the pool. Don't worry, I won't let you sink; I just wanted you to get used to the process. I covered a few areas that you aren't familiar with yet, but I can go over them right now.

Look at Figures 9.3 and 9.4. Note the differences in the layer properties when they are listed in the Layers palette as opposed to the Animation (Timeline) palette. The Layers palette shows the Red Ball layer just as it would look without the Animation (Timeline) palette open. The Animation (Timeline) palette, however, displays all new aspects of this layer.

FIGURE 9.3

The Layers palette is a familiar sight, containing the layers and properties you expect.

FIGURE 9.4

The Animation (Timeline) palette shows a whole new array of layer properties.

Keyframe navigators

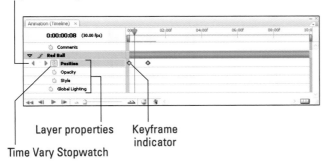

Time Vary Stopwatch Layer properties Keyframe indicator

As you click the triangle next to the layer name, you open up a new world of possibilities. The layer properties that appear are different areas where you can create keyframes. Anywhere you can create a keyframe, you can also create animation. In essence, you can animate in any one of the listed layer properties. The properties listed in Figure 9.4 allow you to animate in any one of the following ways: by changing the position of the layer, by changing the opacity of the layer, by changing the layer style, or by adjusting the global lighting. There are also other possible layer properties. If your layer contains a mask, for example, you could also animate the layer mask position or the layer mask enable.

The Stopwatch button next to each of these sublayers is more correctly called the Time-Vary Stop Watch button. By default, this option is disabled, and keyframes cannot be created. Clicking the Time-Vary Stop Watch button in each of these layers enables keyframing for that layer.

CAUTION Disabling the Time-Vary Stop Watch option after you have created keyframes will delete them. Be very careful that you do not accidentally disable this option and lose all of the work you've put into creating keyframes.

As you enable the Time-Vary Stop Watch option, the keyframe navigators come into view. These navigators enable you to jump from one keyframe to the next. The direction you jump depends on the arrow you click, of course. You can edit the layer properties at existing keyframes as long as the current-time indicator is placed directly over the keyframe. If the current-time indicator is not placed directly over the keyframe, instead of that keyframe being edited, a new keyframe is created. This is an excellent reason for using the keyframe navigator.

For example, in Figure 9.5, I tried to change the drop position of my ball. The current-time indicator wasn't placed correctly over the keyframe indicator, and so I created a new keyframe. When I played this animation back, I ended up with a jump in the ball's position at the end. If I had used the keyframe navigator, the current-time indicator would have been correctly placed to make the edit.

FIGURE 9.5

Every time you move your object, you will create a keyframe.

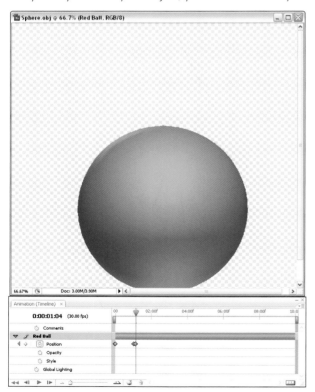

If you click in between the two arrows of the keyframe navigator, you create a new keyframe. This isn't usually the most efficient method, because after you have created the keyframe, you need to change the layer property. If you change the layer property first, then a keyframe is automatically created.

Editing keyframes

You can copy, paste, and delete keyframes inside the Timeline. This is an incredibly useful way to create many keyframes in a relatively short amount of time:

1. Select a keyframe by using the keyframe navigator or by placing the current-time indicator over it. A selected keyframe is highlighted a brighter yellow than unselected keyframes. You can also select more than one keyframe by dragging a selection marquee around the keyframes you want to select or by clicking the Animation (Timeline) palette menu and choosing Select All Keyframes.

2. Once you select one or more keyframes, right-click one of them to open the menu options for the keyframe. You can also find these options in the palette menu.

3. Choose Copy Keyframe and close the menu.

4. Move the current-time indicator to the location in the Timeline you would like to place the first keyframe.

5. Open the Animation (Timeline) palette menu and select Paste Keyframe.

As you can see in Figure 9.6, I've created a second bounce for my ball. I can go on copying and pasting keyframes to continue the bouncing motion.

You can delete a keyframe in the same way, by right-clicking it and choosing Delete. You can also choose Delete from the Animation (Timeline) palette menu, or click the Delete button at the bottom of the Animation (Timeline) palette.

CAUTION Using the hot keys (Ctrl+C, Ctrl+V, or Ctrl+X) for copying, pasting, or deleting keyframes won't work the way you want it to. That's because in addition to selected keyframes, you have the image layer selected in the Layers palette. If you use the hot keys, you are copying and pasting in the Layers palette. As a result, if you are not careful, you could delete the layer you are working on.

You can drag selected keyframes around in the Timeline, placing them wherever you want. For example, one second is a very slow and ponderous bounce. Rather than creating a new keyframe closer to the beginning of the Timeline, you can just drag the second keyframe closer to the first.

FIGURE 9.6

I've copied and pasted the bouncing keyframes to create a second bounce. I've also changed the color of the ball by adding a gradient fill to keep the graphics more interesting.

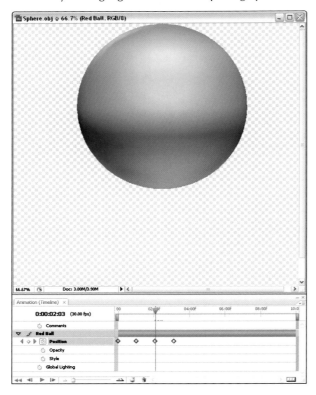

Setting interpolation

I've already talked a little bit about how interpolation works. Once you create keyframes, Photoshop figures out the difference between them and fills in the missing images at the frame rate specified in your file.

The shortest distance between two points is a straight line, and Photoshop isn't going to take any other route. No matter what you do with the file before creating a second keyframe, Photoshop creates a smooth, mathematically exact transition between the two.

I emphasize mathematically exact, because when you first try this method of animation, you'll find out that there are more keyframes in a movement than you might have expected. I don't think I've ever seen a ball that bounced at a mathematically exact rate. They usually go faster right after hitting the ground, hang in the air a little, and then come down, speeding up as they do. That adds at least four keyframes to the bounce.

All of the discussion on interpolation so far has been about the default interpolation setting. This setting is called *linear interpolation* because the interpolation creates a path between keyframes. There is a second interpolation setting that doesn't do that at all. This setting is called *hold interpolation*. When you create a keyframe with a hold setting, Photoshop holds the current status of the layer until the next keyframe, which defines a new status.

To illustrate this, look at Figure 9.7. I've changed the moon into a plain, bouncy ball by animating its layer style. Right now, the keyframes are set to linear, and so the moon morphs to a ball and back again.

FIGURE 9.7

With the style of the moon animated with a linear interpolation, it is halfway between being the moon and a ball when the animation is between keyframes.

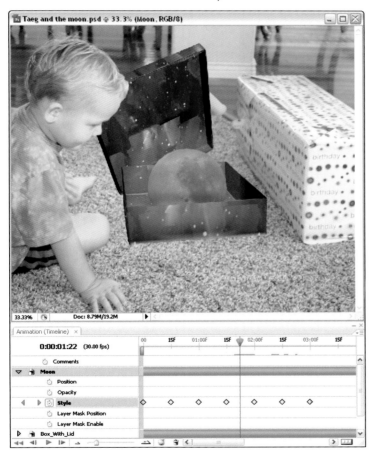

Changing one or more keyframes to a hold interpolation is as easy as right-clicking it and choosing Hold Interpolation from the menu. The selected keyframes change to squares rather than diamonds, indicating that the interpolation is set to hold. In Figure 9.8, I've changed the keyframes in the Style layer property to hold interpolations. Now the moon changes instantly to a ball when the current-time indicator hits a keyframe.

You can also see in Figure 9.8 that not all of the keyframe indicators are diamonds or squares. The second-to-last keyframe indicator looks like it can't decide which one it wants to be. The diamond on the left half of the keyframe indicator shows that the transition coming in is a linear interpolation. The square on the right half indicates that the interpolation going out is set to hold.

FIGURE 9.8

With the style of the moon animated with a hold interpolation, the ball is still solid when the animation is between keyframes.

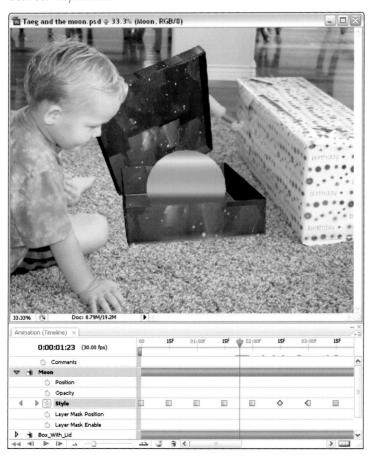

Creating comments

You may have noticed that there is a property at the top of the Animation (Timeline) palette labeled *Comments*. In this property you can place comments on your project. The comments are created just like keyframes. First, you click the Time-Vary Stop Watch button in the Comments property. This creates your first comment box. Type in your comment and click OK (see Figure 9.9). An indicator is placed inside the Comments property (see Figure 9.10). To create subsequent comments, you click between the keyframe navigators to create a new comment indicator at the point of the current time indicator. You can also open the Animation (Timeline) palette menu and select Edit Timeline Comment to create a new comment. DO NOT click the Time-Vary Stop Watch button again, as this will delete all of your comments.

To read your comments, hover the cursor over the comment indicator until a window pops up, displaying the comment. To edit a comment, right-click the indicator and select Edit Comment.

FIGURE 9.9

The Edit Timeline Comment dialog box.

FIGURE 9.10

A comment indicator looks and acts like a keyframe indicator in the Timeline.

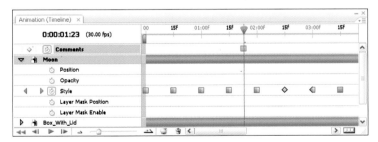

There is so much you can do with keyframes, and you will have a lot of fun doing it. However, you may be stopped short trying to use keyframes to animate something they just won't do, and so before I move on to the specifics of animating each layer property, I'm just going to let you know what you cannot animate using keyframes.

You can't animate transformations using a keyframe. That includes both 2D and 3D transformations. That means no scaling, warping, rotating, or even changing the light settings. If you change any one of these properties on an object or selection, that property remains constant throughout your animation.

You can't animate filters using keyframes. Although you can convert your layers to Smart Objects and add Smart Filters to them, giving them their own sublayer, these sublayers do not have their own property setting in the Timeline and cannot be altered over time using keyframes.

You can't animate any image adjustments. Level adjusting and color correction can be animated by creating a fill or adjustment layer and animating its opacity, but you can't color correct an existing layer over time using keyframes.

You can't animate the painting tools using keyframes. As fun as that would be, painting over time must be done frame-by-frame within Photoshop.

Now that I have the unpleasant limitations out of the way, I'll focus on what you can do with keyframes. The next few sections take you through the particulars of animating the common properties of every layer: position, opacity, style, and global lighting.

CROSS-REF **You can animate the previously listed properties in Photoshop, just not using keyframes. I show you how this is done in Chapter 11.**

Animating the Position of a Layer

As I've already demonstrated in the previous section, you can animate the position of objects or selections within a layer. These positions must be changed with the cursor rather than by transformations.

You've also learned that creating a keyframe is a relatively simple process. Creating the right keyframe, however, can be tricky — even more so while animating position than with animating style or opacity.

The timing of a movement is vital. If you are attempting to create a realistic movement, such as a bouncing ball, it is important to time it so that it looks as if it were truly bouncing. Too slow and you achieve a floating quality. Too fast and you have a spastic ball.

Choosing how many keyframes to place in a movement is also key to creating a successful animation. Most true-to-life movements are not mechanical and precise. Placing several keyframes throughout a movement, even if it is in the same direction, can add variations in movement and speed that make it seem more realistic.

I am also going to show you how you can animate positions across multiple layers — animating objects together so that they move in unison, as well as animating them individually.

These are difficult concepts to demonstrate using still shots in a book, so follow along with the exercises and try things out for yourself so that you can see the results on your own computer screen.

Keyframe placement

For the first exercise, I am going to use my bouncing ball example again. I'm going to reduce the size of it significantly so that it has a lot more room to bounce. You can create a less mechanical bounce to the ball by adding extra keyframes to the timeline:

PHOTOSHOP CD **For this exercise, use the Sphere.obj file found in the Photoshop CD containing the bonus content. To access this file, insert the bonus content CD and navigate to Goodies ⇨ 3D models ⇨ Sphere.**

1. Open the file Sphere.obj.

2. Click the thumbnail in the Layers palette and use the Scale tool to make the ball approximately one-third as big. Add a color overlay from the style menu if you'd like to liven up your scene.

3. Select Window ⇨ Animation to open the Animation (Timeline) palette.

4. Set the current-time indicator to the beginning of the Timeline (if it is not already there), and move the ball to the top of the canvas.

5. Click the triangle next to the layer name in the Animation (Timeline) palette to show the layer properties, and click the Time-Vary Stop Watch button next to the word Position to activate it.

6. Move the Zoom slider to the right to expand the Timeline enough to see half-second increments.

7. Set the current-time indicator to one-half second and move the ball down to the bottom of the canvas.

8. Move the current-time indicator back slightly between the two keyframes, and move the ball up about one third of the way to create a new keyframe. This makes the first part of the ball drop slower than the second.

9. Select all three keyframes and copy them by right-clicking one of them and selecting Copy Keyframe from the menu.

TIP **You can select all of the keyframes in any given layer property by clicking the name of the layer property.**

10. Move the current-time indicator to one second, and paste the keyframes.

11. Move the current-time indicator about one-third of the way between one-half second and one second (when the ball is on its way back up), and create a new keyframe by moving the ball farther up along the path. This makes the ball move faster through the first part of the bounce.

TIP **You can adjust the position of a keyframe by clicking and dragging it in the Timeline.**

12. Copy and paste all of the keyframes several times at each new half-second until the ball bounces several times in succession. Your Timeline should look similar to the one in Figure 9.11.

Adding a couple of extra keyframes can make the ball's bounce more realistic.

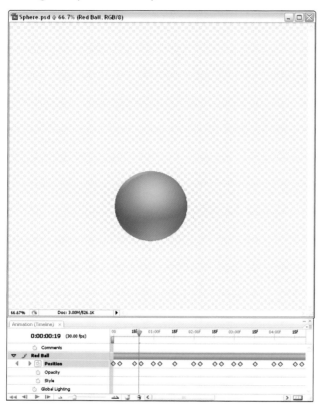

As you play this animation back, you can see that adding a few additional keyframes improves the animation a lot. You can go on to add more keyframes that give the ball a brief pause at the apex of each bounce, or edit the position of the ball with each subsequent bounce so that it doesn't bounce as high each time. You could even have it bouncing all over the walls like a trapped super ball. Trial and error can help you find the spots where a keyframe would be beneficial.

Animating positions in multiple layers

There may come a time that you want to animate objects in different layers simultaneously. The drop shadow of the rug in the flying carpet image shown in Figure 9.12 is on a different layer than the rug. If I want to animate this carpet and show it flying over the lake, I need to animate the drop shadow at the same time.

CROSS-REF The flying carpet image was created in Chapter 7.

FIGURE 9.12

To animate the flying carpet, the shadow needs to come along for the ride.

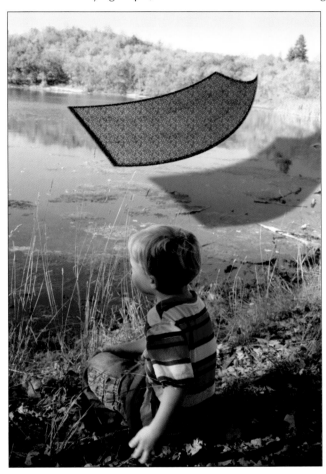

To animate both layers at once, you need to select the Position layer property in both layers by pressing the Ctrl (⌘) key while you click each layer in turn. As you can see in Figure 9.13, both Property layers are highlighted in the Animation (Timeline) palette. Meanwhile, in the Layers palette, both object layers are highlighted as well. Once the keyframes are activated in both Position properties, this allows you to move both objects simultaneously, creating keyframes in both Position properties. You can see how well this works for the flying carpet in Figure 9.14.

FIGURE 9.13

You can animate two layers at the same time by selecting both of them.

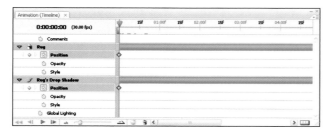

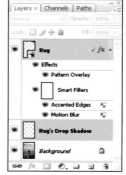

FIGURE 9.14

By moving both objects simultaneously, this really becomes a flying carpet!

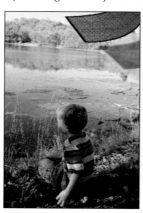
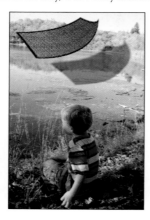
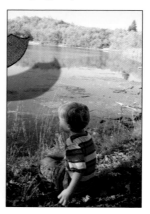

You can animate positions in different layers separately by adding keyframes to each layer property, one at a time. The more layers you have, the more unwieldy the Animation (Timeline) palette can become, especially when you are displaying layer properties. Remember that you can change the settings to show only those layers you are working on.

Of course, the keyframes that you have set operate whether the layer properties are displayed or not, and so you should reduce the view of the layer properties whenever you are not placing keyframes. This is a great way to avoid accidentally clicking the Time-Vary Stop Watch button and deleting all of those hard-placed keyframes.

NOTE As long as the Time-Vary Stop Watch button is active, you don't even have to be display-
ing the layer properties to set a keyframe. Any change in any one of the layer properties
sets a new keyframe, even if you can't see it.

Animating the Opacity Setting

The principles of animating opacity are essentially the same as animating position. You can cre-
ate some pretty cool effects by changing the opacity of layers over time. For example, you can
create ghosts, change the level of special effects, or simply create a fade transition. This feature
can be especially useful in creating special effects for video. Keep in mind that as you learn the
basics of creating keyframes, the applications of using keyframes can be very advanced.

Changing the opacity of a layer is as simple as adjusting the Opacity setting in the Layers palette
(see Figure 9.15). If the Time-Vary Stop Watch button is activated in the Opacity layer property,
simply adjusting the opacity at different locations in the Timeline creates keyframes.

FIGURE 9.15

The Opacity setting in the Layers palette.

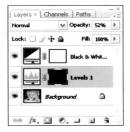

With opacity, setting the keyframes isn't nearly as tricky as it is with changing position. It's as easy
as deciding what opacity you want at different places in your animation, and setting keyframes at
those points. It only required two keyframes to reveal my secrets, as shown in Figure 9.16. You'd
think they'd expect it from me by now, but my very gullible family was very relieved.

The issue is not how hard it is to animate opacity; it's the flexibility that the tools in Photoshop offer
you when animating opacity. You can animate the opacity of any layer in your project, including a
fill and adjustment layer or a layer style that has been converted to its own layer. You can't animate
the actual creation of a paint job or text, but as long as it's on its own layer you can animate its
opacity, fading it in or out over time. Of course, you can set the keyframes to hold interpolations as
well, allowing your images or special effects to pop in and out of sight.

In Figure 9.17, I created a Black & White adjustment layer over the image of a lion, tinted it green,
and applied the Darken blending mode. This simulated the photo being taken with an infrared
camera. By fading the opacity of the Black & White adjustment layer over time, I can show you the
daytime image that I started out with.

FIGURE 9.16

With just two keyframes in the opacity property, the true image is revealed.

FIGURE 9.17

Fading the adjustment layer out is the difference between night and day.

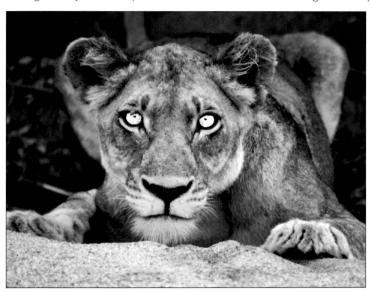

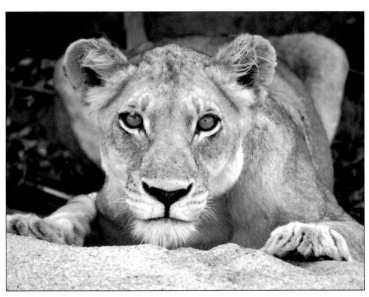

Animating Using Layer Styles

Animating layer styles offers you the most diverse range of animation capabilities in Photoshop. Animating position or opacity changes just one setting of the selected layer, but there are ten different layer styles. Every time you change the setting of any one of these styles, you can create a keyframe. You can use the styles one at a time, or together, or add or subtract the styles in and out of your animation through time. By adjusting layer styles, you can animate a mind-boggling array of special effects.

You can add layer styles to a layer by clicking the Layer Styles button (*fx*) at the bottom of the Layers palette and choosing a style from the list. Once you've selected one of the layer styles, a Layer Style dialog box appears. From the dialog box, you can edit the properties of the layer style that you've selected, and also select additional layer styles (see Figure 9.18).

The Layer Style dialog box.

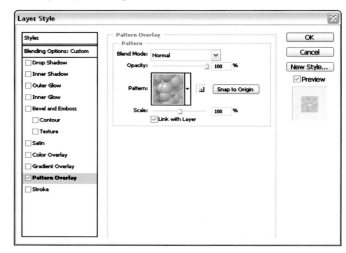

CROSS-REF **The individual layer styles are defined in Chapter 5.**

After you've added a layer style, click the Time-Vary Stop Watch button next to the style property. Adjust the current-time indicator and double-click the layer style in the Layers palette to bring up the Layer Style dialog box again. Making any changes in the Layer Style dialog box, such as adjusting the settings, adding a style, or deleting the style, creates a new keyframe. If you are already over an existing keyframe, the changes you make to the layer styles change the settings for that keyframe.

In Figure 9.17, I created an adjustment layer over the lion and animated it by fading the opacity. You can fade the opacity of a layer style, but not by using the Opacity setting in the Layers palette. Instead, you need to set the opacity of the style in the Layer Style dialog box.

You can, however, change the Fill setting over time by using the Style layer property. The Fill setting changes the opacity of the actual layer pixels and leaves the opacity of any applied effects at the Opacity setting. The Fill setting is located right below the Opacity setting in the Layers palette.

Sometimes, an animated layer style can have surprising effects. In Figure 9.19, I created an animation of the moon changing color. The first and last frames show the styles I created. To get from one to the other, Photoshop's interpolation created a very interesting transition.

FIGURE 9.19

The first and last frames were set as keyframes; the middle two frames were created by interpolation. The opacity of the pink ring was unexpected.

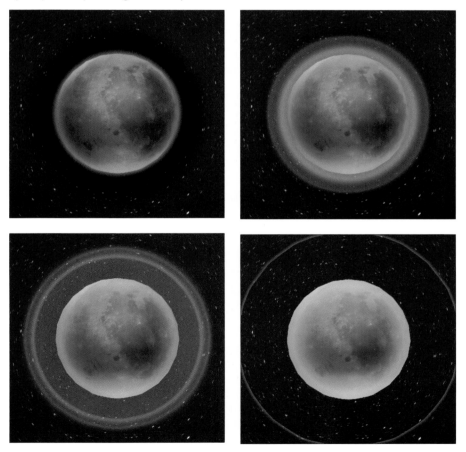

Most of the time, animating layer styles is just plain fun. For example, you can break a lamp with a bouncing ball by following these steps:

PHOTOSHOP CD For this exercise, use the Lamp.obj file and the Sphere.obj found in the Photoshop CD containing the bonus content. To access this file, insert the bonus content CD and navigate to Goodies ⇨ 3D models ⇨ Lamp or Sphere.

1. Open the Lamp.obj file.

2. Using a mask, create an inner glow on the lampshade to give it the illusion of being lighted.

CROSS-REF If you need step-by-step instructions on how to create an inner glow on the lamp, you can find them in Chapter 5.

3. Choose File ⇨ Place and browse to Sphere.obj. Click OK.

4. Size the sphere small enough to fit easily under the lampshade, and click the Commit button (check mark) to accept placement.

5. With the sphere layer selected, click the Layer Styles button at the bottom of the Layers palette and select Color Fill.

6. From the Layer Style dialog box, choose a color for the ball and click OK.

7. You should have three layers at this point: the lamp, the lamp's glow, and the sphere. Rename these layers accordingly so that they are easy to manage in the Animation (Timeline) palette.

8. Choose Window ⇨ Animation to open the Animation (Timeline) palette.

9. Click the triangle next to the sphere layer in the Animation (Timeline) palette to open the layer properties.

10. Click the Time-Vary Stop Watch button next to the Position property.

11. Create several keyframes throughout the Position property to animate the ball bouncing around the canvas. At some point, have the ball go up under the lampshade. From there, the ball drops straight down, bouncing once or twice before coming to rest.

12. Click the triangle next to the sphere layer to close the layer properties.

13. Click the triangle next to the lamp's glow layer to open the layer properties.

14. Click the Time-Vary Stop Watch button in the Style property to activate keyframes.

15. Drag the current-time indicator to the moment that the ball goes up under the lampshade and hits the light.

16. In the Layers palette, click the Visibility button next to Effects on the lamp's glow. This turns off the light and creates a keyframe in the Style property.

17. Select both keyframes in the Style property by clicking the property name, Style, or by dragging a selection marquee around both.

18. Right-click one keyframe and choose Hold Interpolation. This causes the light of the lamp to go out instantly, instead of over time.

19. Rewind and play back your animation, making any necessary adjustments (see Figure 9.20).

TIP As you create animation files with several layers and styles, you'll find that the playback goes slower and slower. To have a better feel for the speed of your project, choose Allow Frame Skipping from the Animation (Timeline) palette menu. This allows Photoshop to skip frames during playback. This helps playback go much faster, if a bit choppy. The final rendered animation contains all the frames specified in the Document Settings.

FIGURE 9.20

Bounce the ball under the lamp shade and turn off the visibility of the lamp's inner glow to create the effect of the ball breaking the lamp.

Animating the Global Lighting

In discussing the layer properties, I've neglected to mention global lighting. That's because global lighting is not a layer property — it is a property that is constant throughout all the layers in the project. You can see in the Animation (Timeline) palette that it is positioned, like the Comments layer, independent of any of the other layers in the palette (see Figure 9.21).

FIGURE 9.21

The Global Lighting layer in the Animation (Timeline) palette.

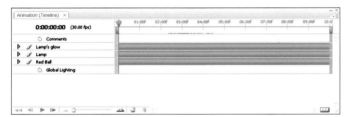

The lighting is set in a layer style that requires an angle of light, such as the drop shadow or bevel and emboss. In any one of the settings for these features, you can select global lighting, indicating that you would like the light settings to stay consistent throughout all the styles applied to that particular layer. Once you do that, whenever you change the setting of the light in any of the layer styles, the light changes in all other applicable styles.

The Global Lighting layer on the Animation (Timeline) palette affects the entire project, changing the light settings for all applicable styles throughout the layers. You animate global lighting just as you would any layer property, by clicking the Time-Vary Stop Watch button and setting keyframes, changing the lighting position at each one.

In Figure 9.22, I've animated the arrow to slide over the image. As it does, the shadow on the arrow moves from the left side of it to the right side, giving the illusion that the light placed on my file is centered on the image. By animating the global lighting, I've ensured that any other special effects I might add to this file are lighted in the same way.

The effect of global lighting in the final animation.

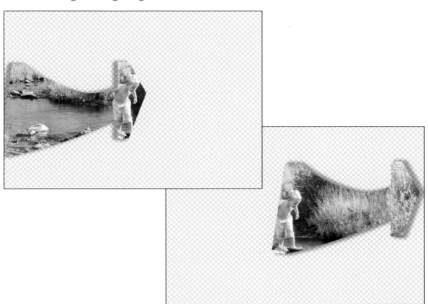

Animating Text

Text is just like any other layer in the Animation (Timeline) palette; you can edit it by changing its position, opacity, or style. This is a fun and easy way to create captions or credits for animations, videos, or slideshows.

Text also has one more property that can be animated: the text warp. Creating keyframes in the Text Warp property lets your text squirm all over the screen.

You animate the text warp by creating a text layer in your animation or video layer. Of course, you want the layer properties that you animate to be activated, and so you need to click the Time-Vary Stop Watch button in the Text Warp layer, as well as any other layer you would like to animate.

Now all you have to do is make the changes. To warp your text, simply click the Create Warped Text button in the Text options bar that appears at the top of the Photoshop work area whenever you have the Text tool highlighted. This opens a Warp Text dialog box where you can set just the kind of text warp you would like (see Figure 9.23). From the Style drop-down list, you can select several types of warp, such as Arc, Wave, and Flag. Then you can adjust the look of the warp you have chosen by moving the sliders in the Bend, Horizontal Distortion, and Vertical Distortion areas. When you are finished, click OK. The warp is created, and so is a keyframe (see Figure 9.24).

FIGURE 9.23

The Warp Text dialog box.

FIGURE 9.24

To begin animating text, add the text and choose a starting position for it.

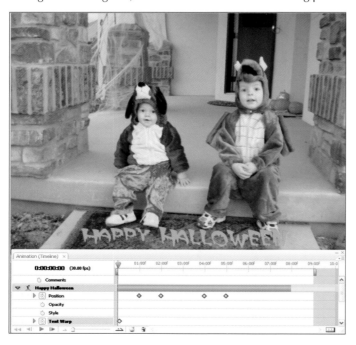

Now you can move on, creating a keyframe whenever you want to change the warp of the text, or any of the other text properties, and really give your video some punch (see Figure 9.25)!

FIGURE 9.25

Animating the warp and position of text can add life to an animation.

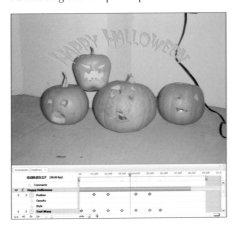 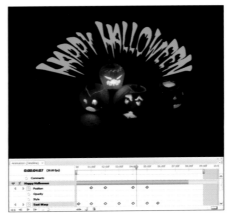

Summary

In this chapter, you gained an understanding of how to create a keyframe to animate different layer properties by learning how to:

- Create and edit a keyframe
- Animate the position of a layer
- Animate the Opacity setting of a layer
- Animate layer styles
- Animate global lighting
- Animate text

This is just the beginning of the animation capabilities of Photoshop. In the next chapter, I show you how to animate by using frame animation.

Chapter 10

Animating Using Frame Animation

ow that you have looked at how the Animation (Timeline) palette works, I'm going to introduce you to the frame-based Animation palette, which is called the Animation (Frames) palette. Of course, as far as animation goes, the frame-based animation palette is not new at all. In fact, if you've ever used Adobe ImageReady, the frame-based animation palette will be very familiar to you.

ImageReady has been completely assimilated by Photoshop CS3, and its features can be found in the frame-based animation palette. Its original purpose was to create animated GIFs for the Internet.

An animated GIF is a small animated image or icon that you see almost anywhere on the Web. They are usually simple, such as the animated smiley faces, and operate at an extremely slow frame rate, giving their motion a jerky appearance.

Although frame animation has most of the capability of Timeline animation, you'll find that its strength lies in creating short, crude animations, such as animated GIFs. Being able to see each frame without having to drag the current-time indicator around is very handy. Frame animation can become very unwieldy in a very few frames, however, as you'll see when you begin to create animations in this chapter.

Some of the other advantages of frame animation are being able to reverse frames and set the frame rate of each frame individually without too much effort. If you change a Timeline animation to a frame animation, however, you permanently lose some of the properties of the keyframes set in your Timeline animation. It is therefore important to determine which animation method you want to use before you begin a project.

IN THIS CHAPTER

Working in the Animation (Frames) palette

Creating tweened frame animations

Creating frame-by-frame animation

You'll find that the palettes and menus of these two types of animation are completely different from one another. In this chapter, I am going to introduce you to the Animation (Frames) palette and show you different methods of animating using this palette.

Working in the Animation (Frames) Palette

Before I show you how to create animations using the Animation (Frames) palette, let's take a look at the features that distinguish the Animation (Frames) palette from the Animation (Timeline) palette.

Palette features

Just as the name implies, the Animation (Frames) palette is composed of thumbnails of each individual frame in your animation. This gives it an entirely different look than the Timeline (see Figure 10.1). The look of the animation is not the only thing that's changed; the palette itself has completely different options. Let's take a look at what the differences are and why they are different.

FIGURE 10.1

The Animation (Frames) palette shows a thumbnail for each frame in an animation.

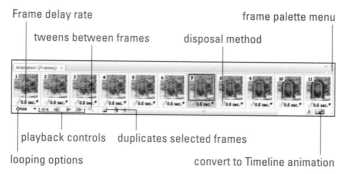

Frame delay rate

The Frame delay rate allows you to quickly set the time you would like each frame to last. Click the arrow next to the time set and select the number of seconds or fractions of seconds you would like your frame to last. Click Other if you would like to set a time that is not specified. You can select one frame at a time and set different rates, or you can select all the frames to change the rates in all of them at the same time. When you add a new frame to the animation, it automatically retains the delay rate of the frame immediately before it.

Disposal method

This option doesn't appear by default on the frame icons, but if you right-click one or more selected thumbnails, you are asked to choose a disposal method.

A disposal method simply determines whether the current frame is disposed of as the next frame is displayed. There are three different disposal options:

- **Automatic:** This is the default option. It allows Photoshop to determine the disposal method for each frame automatically. The current frame is disposed of if the next frame contains layer transparency. When you select this option, there is no icon in the frame thumbnail.

- **Do Not Dispose:** This setting preserves the current frame as the next frame is brought into view. If there is any part of the frame that is transparent, the preceding frames show through.

- **Dispose:** This option disposes of the frame as the next frame is displayed, preserving the transparency of the current frame.

Looping options

Setting the looping options simply decides how many times your animation plays without stopping. Click the Looping options button to open a drop-down menu and choose Once, Forever, or Other. If you choose Other, a dialog box opens, allowing you to specify the number of times you would like the animation to loop.

Tweening icon

There are no keyframes in the Animation (Frames) palette, but you can still take advantage of tweening. Tweening is the process of creating frames between two frames with different properties, making the change gradual over several frames. Enough frames can give the change the illusion of true motion. Although there are no layer properties in the Animation (Frames) palette, the properties that can be animated in the Timeline are the same properties that can be tweened in the Animation (Frames) palette. These properties are position, opacity, and effects, which is the same thing as animating style in the Animation (Timeline) palette.

To create tweening frames, select one or two frames in the palette and click the Tweens Animation Frames button (see Figure 10.2). The Tween dialog box opens, allowing you to set options for the tweening (see Figure 10.3).

Select one or two frames to tween.

FIGURE 10.3

The Tween dialog box.

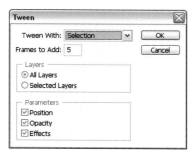

Tween With

The first option available in the Tween dialog box is a Tween With drop-down menu that allows you to set which frames you are going to tween.

- **Selection:** If you've selected the two frames that you want to tween, this is the option that defaults in the menu. If you don't have two frames selected, this option is not even highlighted.

- **First Frame:** You can only choose this option if you have selected the last frame in the animation. If you select First Frame, Photoshop tweens between the last frame and the first frame of the animation, creating a seamless loop.

- **Last Frame:** This option is only available if you have selected the first frame of the animation. Just like the First Frame option, this creates tweening from the last frame to the first.

- **Previous Frame:** This option creates tweening between the selected frame and the frame before it.

- **Next Frame:** This option creates tweening between the selected frame and the frame next to it.

Frames to Add

This option allows you to specify how many frames you want to be created between the frames you are tweening. This is determined by how long your frame rate is and the complexity of the difference in the frames you want to tween.

Layers

You can set the layers that will be affected by the tween. Choose the All Layers option if you would like to animate all of the layers within the file, or choose the Selected Layers option to confine the tweening to layers you have selected.

Parameters

The Parameters setting is reminiscent of the animation properties in the Animation (Timeline) palette. Here you can decide whether to tween all changes in position, opacity, and effects, or if you would like to tween only one or two of these parameters. Choosing a parameter is the equivalent of using linear keyframes in an interpolation, whereas deselecting a parameter is like creating a Hold keyframe. Once you've set the tweening options, click OK. The frames you have specified are created (see Figure 10.4).

FIGURE 10.4

Just like setting keyframes, tweening creates a smooth transition from one frame to another.

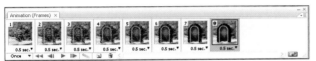

Duplicating selected frames

Click the Duplicates Selected Frames button on the bottom of the Animation (Frames) palette; all the frames you have selected at the time are copied and pasted directly behind the last frame selected. This is a quick and easy way to duplicate the last frame and then make changes to it.

Converts to Timeline mode

With this handy button, you can toggle back and forth between the Animation (Frames) palette and the Animation (Timeline) palette. I wouldn't encourage you to do so, though. Moving from the Animation (Timeline) palette will cause some of the properties — keyframes in particular — to be lost. Toggling back to the Animation (Frames) palette will not restore the lost properties. It's best to decide which animation palette you would like to work in before opening or creating a new document, and stick to that decision.

The Animation (Frames) palette menu

Click the menu button to activate the fly-out menu for the Animation (Frames) palette. As you will see in the following section, if you are used to the Animation (Timeline) palette menu, then you are in for a shock.

Animation (Frames) palette menu

Just in case you hadn't noticed yet, taking a look at the Animation (Frames) palette menu lets you know that you are not working with the same tools as the Animation (Timeline) palette. Take a look at Figure 10.5. The menus not only look different, but they have completely different options.

FIGURE 10.5

Comparing the Animation (Timeline) palette menu with the Animation (Frames) palette menu.

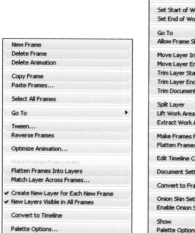

CROSS-REF To learn more about the options found in the Animation (Timeline) palette, refer to Chapter 8.

These differences highlight the features of each palette and the reasons why you would use both. I'll briefly define the features on the Animation (Frames) palette here. If you find that a short definition is not enough, don't worry, you'll see more on these features later on in this chapter.

- **New Frame:** Creates a frame at the end of the animation. This frame is a duplicate of the last frame in the animation.

- **Delete Frame:** Deletes any selected frames.

- **Delete Animation:** Deletes all frames except the first, leaving an image rather than an animation.

- **Copy Frame:** Copies selected frames.

- **Paste Frames:** Pastes copied frames. You can choose four options for pasting a frame:

 - **Replace Frames:** Replaces all selected frames and their accompanying layers with the copied frames.

 - **Paste Over Selection:** Pastes the copied frames over the selected frames, creating two levels of layers: the layers in view belonging to the copied frames, and the layers that are hidden, belonging to the selected frames.

▪ **Paste Before Selection:** Pastes the copied frames before the first selected frame.

▪ **Paste After Selection:** Pastes the copied frames after the last selected frame.

■ **Select All Frames:** Selects all frames within the animation.

■ **Go To:** Selects the frame specified: next, previous, first, or last.

■ **Tween:** Performs the same function as the Tweens Animation Frames button in the palette. This option creates a specified number of frames in between two selected frames to bridge the gap in their differences.

■ **Reverse Frames:** Reverses the order of any selected frames. If only one frame is selected, the order of the entire animation is reversed.

■ **Optimize Animation:** You can reduce the file size of an animation by optimizing the frames to include only areas or pixels that change from frame to frame. There are two options for optimization: selecting Bounding Box crops each frame to an area around the changing pixel, and selecting Redundant Pixel Removal makes any unchanged pixels transparent.

■ **Make Frames From Layers:** This option is only available when there is only one frame or image in the animation. When you select Make Frames From Layers, all of the layers contained in the image become an individual frame.

■ **Flatten Frames Into Layers:** You can create an individual layer for each selected frame in the Layers palette by selecting this option.

■ **Match Layer Across Frames:** This option allows you to align layers according the parameter of position, visibility, and style.

■ **Create New Layer for Each New Frame:** Creates a new layer in the Layers palette for every frame created in the Animation (Frames) palette.

■ **New Layers Visible in All Frames:** When you select this option, the new layers that you create on any frame are visible in all of the frames. Deselect this option if you want to add a layer to a selected number of frames.

■ **Convert to Timeline:** Just like the Converts to Timeline Mode button on the Animation (Frames) palette, choosing this option converts your frame-based animation to a Timeline animation.

■ **Palette Options:** This option allows you to set a thumbnail size for the frames in your animation.

Layers palette features

When you are in frame-based animation, you see differences in the Animation (Frames) palette and the palette menu, as well as in the Layers palette. Added to the Layers palette is an array of tools that allow you to unify changes made to the layers that display in the Layers palette. The properties that can be unified are the same properties that can be animated. By default, making changes to these properties only takes place on the selected frame. By unifying these properties, you can make changes to all of the frames at once. Figure 10.6 shows the buttons that are used for this purpose.

FIGURE 10.6

The Unify buttons and the Propagate Frame 1 option in the Layers palette.

Unify layer visibily

Unify layer position | Unify layer style

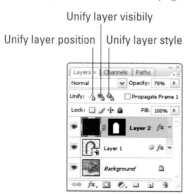

Here is a list of the Unify and Propagate buttons and what they do:

- **Unify Layer Position:** Click this button to make changes in the position of a layer throughout the animation. Deselecting this option allows you to make changes in the position of the selected image only, leaving the rest as they were.

- **Unify Layer Visibility:** When you click this button, the visibility of all of the frames can be changed at once.

- **Unify Layer Style:** When you click this button, you create a layer style across all of the frames in the animation.

- **Propagate Frame 1:** When you select this option, all of the changes made in the first frame of the animation are also made to subsequent frames in the animation. This is an easy way to make the changes that can be animated in other frames and still be able to change the position, visibility, and style of all the frames simultaneously.

Creating Tweened Frame Animations

Now that I've shown you all of the basics of frame-based animation, I'll show you the steps needed to create one. In this section, I'll show you how to create an animation using the tweening process, which essentially produces the same results as using keyframes in the Animation (Timeline) palette.

Opening an image to animate

The first step is to open or create a file in which you would like to animate at least one of three properties: position, opacity, or effects. An image that is composed of several layers and styles can

be a lot more interesting and fun to animate than a simpler image. Figure 10.7 shows an image created by using a composite of a photo, a 3D object, and several layer styles to show a gateway to another world. I am going to use this image to animate the gateway opening.

A gateway is created using an image, a 3D object, and several layer styles.

After opening a file, choose Window ⇨ Animation if you don't already have the Animation palette open. The Animation palette opens by default to the Animation (Timeline) palette. Use the Converts to Frame Animation button at the bottom-right corner of the palette to convert the palette to frame-based animation. You can also choose Convert to Frame Animation from the palette menu.

Your image has become the first frame in your new frame animation. Take a moment to change the frame rate by clicking the arrow at the bottom of the frame thumbnail. Remember that you can also change the size of the thumbnails by opening the palette menu and choosing Palette Options.

Creating keyframes

Now that you've opened a document and the Animation palette, you need to create keyframes. I know, you're thinking that you left keyframes behind in the Animation (Timeline) palette. It's true

that the Animation (Timeline) palette allowed you to create keyframe icons that let you visualize where the changes were being made. It's also true that a keyframe is defined as a frame that determines a change in the animation process. In Frame mode, you can actually visualize your keyframes themselves, because they each have a frame thumbnail in the palette. The downside is that once you tween those keyframes, there is nothing to delineate them from any other frame in the palette.

To create a keyframe, you need to determine what it is you are going to animate and how you want that animation to proceed. Is the image you opened the first, middle, or last of your animation? Before you create a new frame, change anything you need to in the first image to make it look like you want your first frame to look.

I would like to make two new keyframes for my gateway project. First, I would like to have the gateway appear, and then I would like the gateway to activate. Because I am going to start with a view of just the photo, I change the opacity of the arch and the layer style to zero (see Figure 10.8).

Now you are ready to create a new frame. Click the Duplicates Selected Frames button at the bottom of the Animation (Frames) palette. A new frame is created that has the exact same features as the first frame, including the same frame rate and same image. You need to make changes to this second frame to make it your second keyframe.

FIGURE 10.8

The first keyframe.

In my example, I am going to turn the opacity of the gate up to 100 percent to create my second keyframe. The gate is in Dissolve blend mode. After tweening these two frames, my gate dissolves into view over several frames (see Figure 10.9). I want my gate to dissolve in more slowly than I want it to activate, and so I change the frame rate of my second keyframe to one-half second, which is half the rate of the first keyframe.

You can continue to create keyframes just like this. Create a new frame and make changes to it to create one more step in your animation. I have one more keyframe to create in my animation, and so I create another frame and turn the opacity of the layer style up to 100 percent in that layer. Now I end up with the same image that I brought in, creating three distinct keyframes (see Figure 10.10).

FIGURE 10.9

The second keyframe.

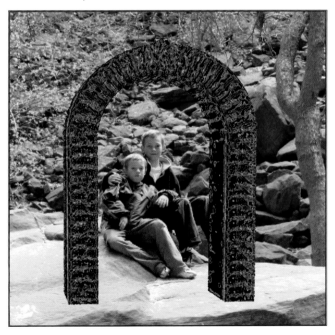

FIGURE 10.10

I've created three distinct keyframes.

Tweening keyframes

Now that you've created the keyframes, it's time to create an animation by tweening them. Select the first keyframe and click the Tweens Animation Frames button at the bottom of the Animation (Frames) palette. The Tween dialog box appears, allowing you to determine the tween settings. Tween to the next frame and enter the number of frames to add to the animation. If you made changes to more than one layer, tween all of the layers; if not, then choose the selected layer. Deselect any properties that are not being tweened.

With my first frame selected, I add five frames to tween it to the next frame. The only parameter I changed between the first frame and the second is the opacity of the gateway, and so I choose the Selected Layers and Opacity options (see Figure 10.11). After I have added the frames between the first and second frame, I select the second keyframe and repeat the process. The result is thirteen frames, creating the animation of the gateway appearing (see Figure 10.12).

FIGURE 10.11

I've customized the Tween dialog box to set my animation properties.

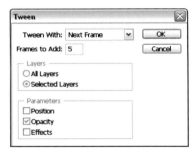

FIGURE 10.12

By tweening three keyframes, I've created a complete animation.

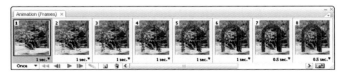

As you create more frames, you can start to see the limitations of frame animation. If you were to create an animation with the frame standard of the Animation (Timeline) palette, you'd create thirty frames per second of animation. My gateway animation is nine-and-one-half seconds long, very jerky, and — with the relatively miniscule amount of thirteen frames — already starting to

become unwieldy and hard to manage. You can imagine what it would be like if I had tweened it out to three hundred frames to create a smooth animation!

So even though the Animation (Frames) palette is able to animate almost anything that the Animation (Timeline) palette can, it is realistically limited to animated GIFs, which is what ImageReady was created for in the first place.

Creating a Frame-by-Frame Animation

When you want to create an animation using the paint tools in Photoshop, you need to animate it frame-by-frame, using a new layer for every frame so that you can add paint or effects to each frame without affecting any of the other frames.

In this section, I'm going to show you how to use the Photoshop paint tools to build an animation frame-by-frame. There are two different ways to do this: first, you can create a layered image, containing all of the elements needed for an animation and then turn it into an animation, or second, you can simply start building the animation right in the Animation (Frames) palette. I'll show you how to create an animation using both ways.

Creating an animation from a layered image

When you create an animation from a layered image, you need to first create an image with several layers that will eventually become frames in your animation. You can create an image in Photoshop that contains all of the layers needed to turn it into an animation in just a few simple steps:

1. Open a new document in Photoshop.

2. Fill the background layer however you want, or leave it blank.

3. Click the New Layer button in the Layers palette to create a new layer.

4. In the new layer, create any part of the animation that will be present in every frame (see Figure 10.13).

5. Create another layer. In this layer, you are going to create what will be the first real frame of your animation. This layer, combined with the first two layers, should make a complete image.

6. Continue creating new layers, changing each layer to create movement from the last. Toggle your views of previous layers on and off when necessary.

7. When you are done, you should have a file that contains several layers (see Figure 10.14). Save your file.

8. Choose Window ➪ Animation to open the Animation palette.

9. Click the Convert to Frame Animation button at the bottom-right corner of the Animation (Timeline) palette to convert it to the Animation (Frames) palette.

FIGURE 10.13

To animate a flower opening, I want to create a stem that will be consistent throughout the animation.

FIGURE 10.14

My animated flower contains six individual layers. When all of the layers are visible, it looks very jumbled.

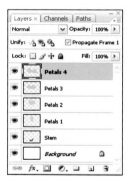

10. From the Animation (Frames) palette menu, choose Make Frames from Layers. Each layer of your project becomes a separate frame inside the animation (see Figure 10.15).

11. With the first frame selected (the background layer) and the Propagate Frame 1 option selected in the Layers palette, turn the visibility of the second frame on. This should make the second layer visible in all other layers (see Figure 10.16).

FIGURE 10.15

Before and after making frames from layers.

FIGURE 10.16

The stem is now visible throughout all of the layers.

12. With the first frame selected, choose Match Layer Across Frames from the Animation palette menu. This opens a dialog box that asks you which properties you would like to match. Choose one or all of the properties, and click OK. Now you should have a solid background in each frame.

13. Now that each frame is exactly how you want it to look, you can discard frames one and two. Click the Deletes Selected Frames button twice in succession to accomplish this. You should be left with the completed frames (see Figure 10.17).

14. From the Animation (Frames) palette menu, choose Select All Frames.

15. Click the arrow in the bottom-right corner of the first frame, and change the frame delay time. Your animation is now ready to preview.

FIGURE 10.17

With the background and stem frames discarded, I now have my animation.

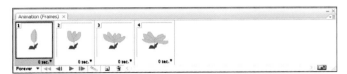

There are advantages to creating a small, animated GIF by using a layered image. Although the Layers palette can eventually become unwieldy, it really is a easier interface than trying to work with frames and layers at the same time — as you do in building the animation in the frame-based palette from the beginning. The downside to this method is that any frame that includes changes in position, opacity, or style will have to re-create in a new layer.

Building an animation in the Animation (Frames) palette

When you build a completely new image, you use the Animation (Frames) palette to create new frames as you create new layers (or vice versa). Each new frame contains a change from the last frame, and over several frames, it turns into an animation.

You can build an animation by creating a new frame each time you make a change to your image. Follow these steps.

1. Open a new document in Photoshop.
2. Open the Animation palette by choosing Windows ➪ Animation.
3. Click the Converts to Frame Animation button in the bottom-right corner of the Animation (Timeline) palette to convert it to the Animation (Frames) palette.
4. In the Animation palette menu, choose Create a New Layer for Each Frame.
5. In the Animation palette menu, deselect New Layers Visible in All Frames.
6. Create a background for your animation on the existing frame, or leave it blank and create a new frame to create a background on.

> **TIP** To change the background layer into a regular layer that you can paint on, right-click it in the Layers palette and choose Layer From Background.

> **NOTE** As you create new frames, leave the visibility of the Background layer on. This saves the extra step of matching the layer across frames.

7. Click the Duplicates Selected Frames button at the base of the Animation (Frames) palette. A new frame is created, as well as a new layer in the Layers palette. This frame initially has the same properties as your last frame.

> **NOTE** Because you are working in a new layer, you can change anything you want about your image and it is not reflected in any other frames. If you do want your changes to be consistent across frames, select New Layers Visible in All Frames from the Animation palette menu.

8. Use any of the tools in Photoshop to create the next frame for your animation.

9. Repeat Steps 7 and 8 until you complete your animation (see Figure 10.18).

10. Discard any background frames that aren't part of the animation.

FIGURE 10.18

You can build an animation in the Animation (Frames) palette.

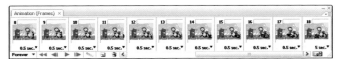

When you build an animation using frames as well as layers, you can animate position, opacity, and style instead of creating a new layer. For example, in my animation of my crayon family, each member of the family only has three poses: two walking poses and a face-front pose. In frame 2, I show the figure entering the picture; in frame 3, he walks farther into the frame with a different stride; in frame 4, I discard the new layer and turn on the visibility of frame 2, moving the figure forward once again. Figure 10.19 shows Frame 2, 3, and 4 of my animation. I followed the same steps with each figure in my animation.

FIGURE 10.19

As I build frames, I can reuse layers to animate the position of the figure.

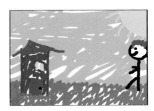 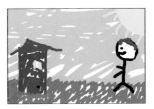 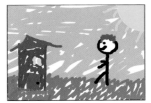

Looking at my Layers palette in Figure 10.20, you'll see that the frames are not in order. That's because the last few frames of my animation show a dog running in and joining the family. I wanted the dog to run behind the family, and so after creating the layers that animate the dog, I dragged them underneath the layers that contain the family.

FIGURE 10.20

My frames don't have to be in order on my Layers palette.

 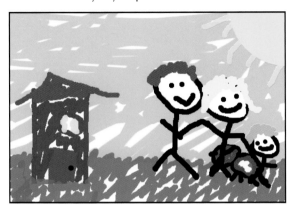

I also created a Hue and Saturation adjustment layer and changed the hue of the entire image in every other frame by simply clicking the visibility of this layer on and off. You may be able to see the difference in Figure 10.19. I added this element so that the whole picture would seem to change slightly between frames, I You can add any filters or adjustment layers as you change each one of your frames. Unlike the tweening process, you can animate anything as long as you are creating new layers.

CROSS-REF When it comes to frame-by-frame animation, there is still a lot to learn. I'll show you how to create frame-by-frame animations in the Animation (Timeline) palette in Chapter 11.

Summary

In this chapter, I've showed you everything you need to know about the Animation (Frames) palette and how to use it by covering these topics:

- The Animation (Frames) palette
- Using tweening in the Animation (Frames) palette
- Using the Animation (Frames) palette to create a frame-by-frame animation

In the next chapter, I show you advanced animation, including frame-by-frame animation and Rotoscope animation in the Animation (Timeline) palette.

Chapter 11

Using Advanced Animation Techniques

In the preceding chapters, you learned how to employ the basics of animation in the Animation (Timeline) palette and in the Animation (Frames) palette. Using keyframes and the frame palette are very limiting, however. You can't animate filters or even paint over time. These animations can be created.

In this chapter, you learn how you can animate just about anything by employing the technique of Rotoscoping. I focus on the basics first, creating a blank video layer and adding frames to it, and then move on to advanced techniques that use some of the more powerful tools of Photoshop to have some fun with animating. You can create animations from scratch, but I also show you how you can animate using live video.

There is a trick to animating filters or transformations on a still image or 3D object as well. It can't be done as easily as creating a blank video layer, but it can still be done, and I'll show you how.

There are, of course, thousands of ways to use Photoshop tools to create fantastic animations. Out of necessity, you'll only see a few examples to familiarize you with the concepts behind animation.

Rotoscoping Basics

Rotoscoping has been around almost as long as movies themselves. It entails tracing animated characters or scenes over live-action film. It is a very useful tool in aiding animators to create more realistically, because they are copying that movement from life. It is also used to create special effects, such as the light sabers in the *Star Wars* films.

Today, with the use of computers, Rotoscoping takes on a broader definition. Now when you hear the term, it can mean any painting or editing of a video frame, whether that frame is over a live-action scene or not.

In this section, you learn the details of frame-by-frame animation in the Animation (Timeline) palette. Although viewing your frames is not as easily done in the Animation (Timeline) palette as it is in the Animation (Frames) palette, the Animation (Timeline) palette has more capability. On top of that, you can create a frame-by-frame animation without creating a new layer for every single frame. If you plan an animation that will include more than just a few frames, the Animation (Timeline) palette is definitely the way to go.

Creating a new video layer

The first thing you are going to want to do in order to start animating frame by frame in the Animation (Timeline) palette is to create a new video layer. If you start by opening a new document, you need to do this in order to have a video layer at all. Even if you have other video layers in your document, you'll want to create a new video layer in which to store changes. In fact, it's a good idea to create a new layer for each major element in your animation.

Creating a new video layer is as simple as choosing Layer ➭ Video Layers ➭ New Blank Video Layer. After you do that, a new video layer is added to your project.

> **TIP** The first thing you'll want to do with a blank video layer is give it a unique name that is descriptive of the element on that layer.

Any video layer has at least one additional property to those in a still shot or 3D object layer. That property, as you can see in Figure 11.1, is an Altered Video sublayer. Within that sublayer, frames can be altered one at a time to create an animation.

Creating modified frames

Now that you have a new blank video layer, you are ready to animate. You can animate frame by frame in the Animation (Timeline) palette by creating modified frames inside the blank video layer.

You can create individual frames inside any video layer by following these steps:

1. With the blank video layer highlighted, move the current-time indicator in the Animation (Timeline) palette to the position where you want to make the first change.

2. Paint or otherwise make changes to the layer.

3. Click the triangle next to the name of your blank video layer. This displays the properties of that layer, including the Altered Video sublayer. Within the Altered Video sublayer, a small segment appears that indicates an altered frame (see Figure 11.2).

FIGURE 11.1

Animation can be created on a new blank video layer.

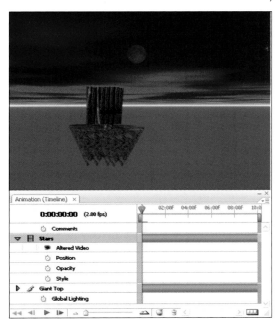

4. Choose Layer ➪ Video Layers ➪ Duplicate Frame to move to the next frame and dupli-
 cate the frame you just created. This allows you to build onto your animation.

5. Make further changes to your animation.

6. Continue duplicating frames and making changes to your animation until you have com-
 pleted it (see Figure 11.3).

You may not want to build on the animation created in a previous frame. That's okay; just navigate
to an unaltered frame and make new changes. You can move to the next frame by clicking the
Next Frame button in the animation playback controls or by choosing Go to Next Frame in the
Animation (Animation (Timeline) palette) palette menu. You can also choose Layer ➪ Video
Layers ➪ Insert Blank Frame.

TIP **You may notice that there are no shortcuts for the menu-intensive task that you just
completed. When you are duplicating frames as often as building animation requires,
you get tired of constantly navigating through the menu to do it. You'd probably like to create a short-
cut. Choose Edit ➪ Keyboard Shortcuts (Alt+Shift+Ctrl+K), and you can create your own shortcuts
for the actions that you perform most frequently. Now your only worry is actually finding an unused
shortcut!**

FIGURE 11.2

The purple segment in the Altered Video property indicates one altered frame.

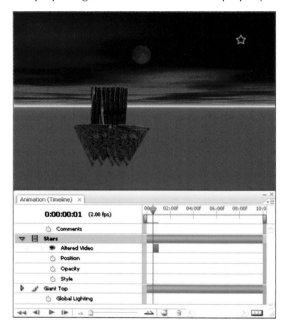

Utilizing onion skins

Onion skins are something you've probably been wondering about for a few chapters now. You've seen the button and the menu options, but I have yet to explain what an onion skin actually does.

A real onion skin right off of an onion is semitransparent. This quality makes it ideal for making semitransparent paper, which you can still find at most craft stores. Semitransparent paper is used in animation to make the transitions from one frame to the next smoother. The idea is that the previous frame can be traced onto the next frame, making the small changes necessary to create movement.

Computer animation has made onion skinning an incredibly simple process. By temporarily making your animation frames semitransparent, you can create the next step in your animation by referring to the last one.

FIGURE 11.3

The stars appear a little at a time in the night sky.

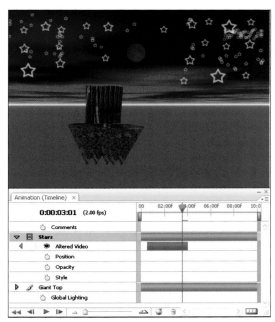

That's the basic idea. Photoshop allows you to set parameters for onion skins that go way beyond just being able to see the last frame from the present frame. Besides having multiple onion skin settings, there are other benefits of using Photoshop. You can create onion skins in any layer and make modifications in a different layer. For example, you might want to animate a motion trail for something that is moving in a video layer, for example, a spaceship. You could add onion skins to the live-action video layer and paint over the motion in a blank video layer.

Onion skin settings

To access the onion skin settings, choose Onion Skin Settings from the Animation palette menu. The Onion Skin Options dialog box appears, and you can set any number of ways for your onion skins to work. As you make changes in the dialog box, you'll be able to see how they affect the view of the current frame in the Animation (Timeline) palette in real time (see Figure 11.4).

FIGURE 11.4

The Onion Skin Options dialog box gives you a much greater range of options than a piece of tracing paper.

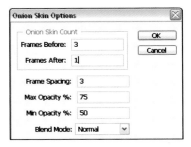

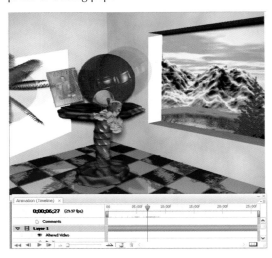

- **Onion Skin Count:** You can set the number of frames that you want to show through to the current frame, both before and after the current frame. You can show up to eight frames before and eight after.

- **Frame Spacing:** This determines whether the frames being shown are consecutive or appear with gaps in between. A setting of 1 means the frames will be shown in consecutive order. A setting of 2 means that only every other frame is shown.

- **Max and Min Opacity:** If you have more than one onion skin count, you probably want to see the closer frames at a higher opacity than those that are farther out from the current frame. These two settings allow you to set the maximum opacity for the closer frames and the minimum opacity for the farthest frames. The frames in the middle will be a setting somewhere in between the two opacities.

- **Blend Mode:** This changes the way that the opacity setting is applied to the onion skins. Different files are easier to work with in different blend modes. You can choose from four different blend modes in the Onion Skin Options dialog box: Normal, Multiply, Screen, and Difference. You can see an example of how each of these blend modes affects the animation in Figure 11.5.

When you have made the changes in the Onion Skin Options dialog box, click OK to close the dialog box. The onion skins are automatically enabled with the setting that you specified. You can toggle the onion skins on and off by clicking the Toggle Onion Skins button at the bottom of the Animation palette.

FIGURE 11.5

These four blend modes can make onion skins look very different.

As you move along in your animation, the onion skins move with you, helping you to create any frame along the Animation (Timeline) palette. Of course, you can change the settings any time your animation needs changing.

Restoring frames

As you make changes to various frames, you might come to a point where you want to discard the edits to one frame or all of them. This is as easy as selecting the frame you want to restore to its original look and choosing Layer ➪ Video Layers ➪ Restore Frame. If you want to discard all of the altered frames, choose Layer ➪ Video Layers ➪ Restore All Frames. Unfortunately, this process is not as easy as using the hotkey for deletion or dropping the altered layers into the trash, but you won't need to use it too often.

Animating 3D Objects and Still Images Frame by Frame

Whenever you place a 3D object or a still image in a file, they are automatically given their own layer. You can animate the layer properties of these layers, and you can paint on these layers by placing a blank video layer over the top of them. However, there are other properties that you might want to animate, such as transformations or filters. This can't be done in a blank video layer; these changes can only take place in the object or image layer. Because a still image or 3D object is not a video layer, they cannot be modified frame by frame in the manner just discussed. They can still be animated, however, by creating a new layer for every frame that needs to be altered.

There are similarities between this process and the process of creating animated GIFs in the Animation (Frames) palette. There are also similarities to the process of importing image sequences. In fact, it's entirely possible that you'll see the benefit of creating an image sequence instead of creating these animations in the Animation (Animation (Timeline) palette) palette, especially in the case of 3D models. Although you won't specifically learn how this is done, reading this section along with the section on importing image sequences will give you enough information to accomplish this.

CROSS-REF For more on importing image sequences, see Chapter 8.

Despite the similarities, there are enough differences to make animating transformation properties on non-video layers a more advanced process. When you create new frames in the Animation (Frames) palette, you can build on previous frames by retaining the visibility of previous layers. When you animate a transformation or filter, you probably aren't going to be building on any previous layers, so every layer in the animation needs to be built from scratch. You can do this in the Animation (Frames) palette for smaller, less complicated animations, but the Animation (Animation (Timeline) palette) palette has more capability and is the better option in the long run.

CROSS-REF You can absolutely try these techniques out in the Animation (Frames) palette if you are more comfortable with it. Read more on how to use the Animation (Frames) palette in Chapter 10.

TIP Because a frame-by-frame animation involving a separate layer for every frame can be a complicated and memory-intensive process, you might find it easiest to create this animation in a separate document, rather than in a composite with other video layers. You can render it and bring it into a new composite document as a video layer.

Animating 3D object transformations and filters

Several limitations can make animating 3D objects frame by frame a very difficult process. It can be done, though, if you are persistent and patient enough.

The biggest obstacle in animating a 3D object is that a 3D layer in the Layers palette can't be duplicated and then individually transformed. When the layer is duplicated, the two instances of the object are linked, making any transformation made to either of them universal. This means that you can't copy the changes made in one layer of a 3D object to the next layer up.

CROSS-REF If you want more information on what works and what doesn't when you place two instances of the same 3D object in the same file, turn to Chapter 7.

You can place a new instance of a 3D object into a file without it being linked to previous objects. After placing several instances of the same file in one document, you can change the position of each to create an animation. This brings up the next obstacle: whenever a 3D object is placed into a file, it becomes a Smart Object. That's great news! This means that you can still open it and make any changes to it that you want. The downside is that you have to open it to make any changes that you want. Every frame of a 3D transformation animation must be opened, changed, and saved — a tedious and complicated process at best.

I'll start at the beginning and walk through the process. It's not hard at all, just tedious.

You can animate the transformation of a 3D object by creating a new instance of the object in each frame of your animation:

PHOTOSHOP CD For this exercise, use the Car.obj file found on the Photoshop CD containing the bonus content. To access this file, insert the bonus content CD and navigate to Goodies ⇨ 3D models ⇨ Car.

1. Open the Car.obj file.
2. Double-click the thumbnail in the Layers palette to display the 3D Transform options toolbar.
3. Click the drop-down menu next to the Scale tool to display the Object Position dialog box.
4. Change the Orientation settings to X = -4.5, Y = 6.3, and Z = -78.
5. Accept the transformation and save the file as Turning Car.psd.
6. Choose File ⇨ Place and browse to Turning Car.psd. Click OK.
7. Accept the placement.
8. Repeat Steps 6 and 7 eight more times until you have ten layers containing the car.
9. Add the numbers 1 to 10 to the name of each layer to distinguish them from one another: Turning Car 1 should be on the bottom, and Turning Car 10 should be on the top of the Layers palette (see Figure 11.6).
10. Double-click the Smart Object icon of Turning Car 2 in the Layers palette. Click OK when reminded to save.
11. Double-click the 3D Object icon of Layer 1 in the Layers palette to display the 3D Transform options bar.

FIGURE 11.6

Ten identical instances of the same model car.

12. Click the drop-down menu next to the Scale tool to display the Object Position dialog box.

13. Subtract two from the Orientation setting of Z so that the orientation is -2 degrees different from the last layer. (Turning Car 1, Z = -78; Turning Car 2, Z = -80; Turning Car 3, Z = -82; and so on).

14. Click the Commit 3D Transform button (check mark) to accept the transformations.

15. Save Turning Car 2 and close the document.

16. Repeat Steps 10 to 15 for each of the remaining Turning Car layers. When you are done, you will have a very interesting 3D scene (see Figure 11.7).

17. Choose Window ⇨ Animation to open the Animation (Timeline) palette. It should already contain ten layers of the ten cars (see Figure 11.8).

18. Click the Animation palette menu and choose Document Settings.

19. Set the frame rate in the Document Settings dialog box to 1 fps.

20. Click the Animation palette menu and choose Make Frames from Layers. Each layer becomes a single frame in the animation (see Figure 11.9).

FIGURE 11.7

Ten slightly different instances of the same model car.

FIGURE 11.8

The Animation (Timeline) palette contains ten layers.

FIGURE 11.9

The completed animation of the turning car.

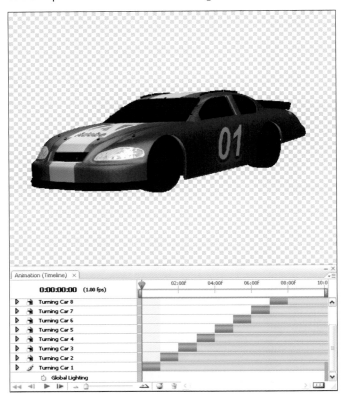

You've now successfully animated the transformation of a 3D object. By making each frame one second long, you've created an animation that is crude and jerky. You can imagine the work it would take to create a smooth, transitional animation in this manner. You would probably be better served to animate these kinds of transformations in the original 3D modeling software and then import them into Photoshop.

If you do use this capability in Photoshop, I highly suggest that you render and save your document as a video file before creating any kind of composite with it. This makes it much easier to manage.

NOTE You can animate filters on a 3D object in the same way that you can animate its transformation. You have to take a further step of converting the 3D file for Smart Filters after you open the individual 3D models. Remember that the filters won't morph. Drastic changes from frame to frame are discouraged, unless it is the look you want.

Animating transformations and filters on still images

Animating transformations or filters on a still image is easy compared to doing the same with a 3D object. Not only can you duplicate the layer of the still image, you also don't have to open every instance in a separate document. You can animate a transformation or filter on a still image by following these steps:

1. Open a still image in Photoshop. It is placed as the background in the Layers palette (see Figure 11.10).

An image opens as a background in the Layers palette.

2. Right-click the still image layer in the Layers palette and choose Layer from Background.

3. Right-click the still image layer again and choose Duplicate Layer. A duplicate layer is added to the Layers palette, and the new layer is automatically selected.

4. Choose Filter ⇨ Distort ⇨ Twirl. The Twirl dialog box appears (see Figure 11.11).

The Twirl dialog box.

5. Adjust the Angle setting in the Twirl dialog box to 25 degrees. Click OK.

6. Right-click the still image again and choose Duplicate Layer. A duplicate of the newly twirled layer is added to the Layers palette, and the new layer is automatically selected.

7. Choose Filter ⇨ Distort ⇨ Twirl again and click OK, or press Ctrl+F, which applies the last filter.

8. Repeat Steps 6 and 7 until there are 20 layers in the Layers palette. Each layer should be slightly more twirled (see Figure 11.12).

9. Choose Window ⇨ Animation if the Animation (Animation (Timeline) palette) palette is not already open.

10. From the Animation palette menu, choose Document Settings.

11. Leave the duration setting at 10 seconds and change the frames per second to 2 fps. Click OK.

12. From the Animation palette menu, choose Make Frames From Layers. Each layer in the Animation (Animation (Timeline) palette) palette is converted to one half-second frame (see Figure 11.13).

FIGURE 11.12

A new layer must be created for every frame when animating a filter.

FIGURE 11.13

Changing the twirl effect incrementally in each layer results in a completed animation.

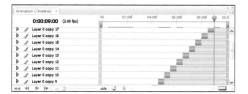

Although creating a frame-by-frame animation of a still shot can be a tedious process, the filters and transformations that can be applied in Photoshop are unmatched, and so the process will often be worth it.

NOTE After you convert your still image layers to frames, you can no longer transform them or add filters to them unless you convert them to Smart Objects. You can do this, of course, but then you are subject to the same tedious process of opening each file in order to make changes to it. Making the right changes before creating frames from the layers is a much more efficient method.

CROSS-REF Want to find out how Photoshop can take many of the tedious, repetitive steps out of creating a frame-by-frame animation? Learn how to record your own action, a feature in Photoshop that performs several commands in a specified order with the click of a button. You can learn how to create one, or to use several presets, in Chapter 12.

Reviewing Animation Techniques

Several animation techniques for several different types of animation have been covered in the last few chapters. This section quickly reviews each of these techniques and the best way to animate them so that you can see at a glance what technique you need to use to create the animation you want.

Keyframe animation in the Animation (Timeline) palette

Keyframe animation is by far the simplest and easiest technique in Photoshop. You create the keyframes and Photoshop automatically creates the rest of the frames by tweening or interpolating each keyframe. The properties of a layer that can be animated using keyframes are listed under that layer in the Animation (Timeline) palette. The type of layer being animated determines what kind of properties that layer has to animate. A text layer with a mask includes all of the following properties: Position, Opacity, Style, Layer Mask Position, Layer Mask Enable, Text Warp, and Global Lighting (see Figure 11.14).

FIGURE 11.14

This text layer contains six properties that can be animated. The Global Lighting property affects all of the layers in the Animation (Timeline) palette.

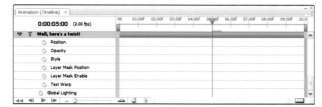

CROSS-REF Learn how to create keyframe animations in Chapter 9.

Animating in the Animation (Frames) palette

You can animate in the Animation (Frames) palette in two ways. First, you can create keyframes and have Photoshop tween them. Although the end result is much the same as using the Animation (Timeline) palette to create keyframes, the Animation (Frames) palette is more limited because you can easily edit or move a keyframe in the Animation (Timeline) palette. After you tween two frames in the Animation (Frames) palette, the keyframes are no longer specific. Changing them won't change the frames in between as it would in the Animation (Timeline) palette.

The second way that you can animate is in the Animation (Frames) palette, by creating a new layer each time you want to build a new frame in your animation. The advantages of using the Animation (Frames) palette are mostly visual: the individual frames of your animation are very easy to identify by their thumbnails (see Figure 11.15). Using the Animation (Frames) palette is great for creating short, uncomplicated animations, such as an animated GIF. Animations that are more complicated can become very interesting as the Layers palette begins to fill with more and more layers, however. Rotoscoping in the Animation (Timeline) palette is a better way to go if your animation is more than just a few frames.

FIGURE 11.15

The Animation (Frames) palette has visual appeal.

CROSS-REF Animating in the Animation (Frames) is covered in detail in Chapter 10.

Rotoscoping in the Animation (Timeline) palette

Rotoscoping, or painting in a video layer in the Animation (Timeline) palette, is done by creating altered frames in the video layer. The capability to create individual altered frames within Photoshop allows you to build frame-by-frame animation without creating a new layer for each individual frame. This makes it possible to create very complex animations without creating a very complex file.

Anything that can be added on top of a layer as a separate layer can be animated in this way. Using the paint tools of Photoshop is the most obvious use of this feature.

Animating transformations or filters on a 3D object or still image

You can add a filter or transform a file easily in the Animation (Timeline) palette by adding a Smart Filter or creating the transformation. When you want the filter or the transformation to be animated, however, you must create the effect frame by frame. Arguably, this can be done in the Animation (Frames) palette as easily as in the Animation (Timeline) palette, because to animate a 3D object or still image, a new layer must be created for every new frame. Although animating these types of transformations can be time consuming and tedious, the amazing effects that can be created using Photoshop filters can make the process worth the effort.

Including Other Files in an Animation

You've learned how to create an animation from scratch and how to create an animation using different file types. Now you are going to learn how to import more than one file into an animation to create a composite.

Dragging a file into an animation

The most basic way to add a file to an animation is to click the layer in the Layers palette, and then drag and drop it into the window of the animation file. If the first file contains more than one layer, you can select all of the layers to move them, or just move the layers that you want to include (see Figure 11.16). This is a quick and easy way to combine your files. The downside to this method is that both files must be open, and you will most likely need to move and resize the first file anyway, which are actions that you can perform while placing a file.

Using the Place command

Using the Place command takes a bit more effort initially than just dragging the first file into the second, but in the long run, it can save time and effort. Choose File ➪ Place and browse to the file you want to place inside your animation. After you select the file, click OK, and the file is placed on top of your animation inside a bounding box. You can resize it, rotate it, or move it using the bounding box so that it is placed correctly inside your animation file. Then you simply click the Commit button in the 3D Transform options bar at the top of the screen to accept the placement of the new file.

Importing new layers

You can import an image sequence or 3D model by importing it as a new layer. Simply choose Layer ➪ Video Layers ➪ New Video Layer from File, or Layer ➪ 3D Layers ➪ New Layer from 3D File.

FIGURE 11.16

You can drag one or more layers from one file into the window of another.

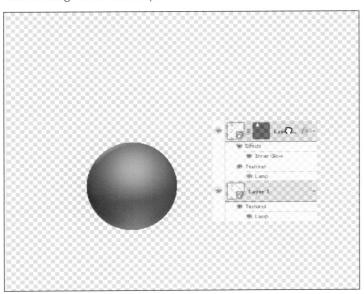

FIGURE 11.17

You can even place a video file over another file and make it a different size for a picture-in-picture effect.

The New Video Layer from File option can be used instead of dragging or placing a video file. Because you will likely want your video files to fill the document, you usually won't need the transforming power of the placement tool. This allows you to place a new video file or image sequence quickly.

Importing a 3D object places the object into the document in much the same way as dragging and dropping it. You won't be able to resize or move the 3D object before it is placed. The benefits of this are that the file is placed as a 3D object rather than a Smart Object, allowing you to make adjustments without having to open the 3D file. The downside is that you can't import PSD files this way, only the original 3D file. You could have made the animation of the turning car one step simpler by importing each instance of the car in this way, but you wouldn't have been able to use the improved car that was saved as a PSD file.

Creating Special Effects in an Animation

In this section, you will see a few examples of how special effects can be created in an animation. You know that you can animate style as a layer property, that a filter can be added to a layer or animated frame by frame, and, of course, that you can animate a fill or adjustment layer because they are layers. By now, you probably have a good handle on all of this. In this section, you will see a few of the many special effects that can be created using the tools found in Photoshop.

Animating a layer mask position in an adjustment layer to create a flying comet

When you create a composite that includes more than one object and you want to apply a filter to an animated object, the only way to get that filter to follow the animated object is to create a mask on that filter and animate its position. You can animate a layer mask to create a moving filter by following these steps.

PHOTOSHOP CD For this exercise, use the Sphere.obj file found in the Photoshop CD containing the bonus content. To access this file, insert the bonus content CD and navigate to Goodies ⇨ 3D models ⇨ Sphere.

1. Open an image file of the night sky. You can use one of your own images or search for one on the Internet.

2. Choose File ⇨ Place and browse to Sphere.obj. Click OK.

3. Shrink the sphere until it is very small compared to the image, and then click the Commit button to accept the placement (see Figure 11.18).

4. Click the Add a Layer Style button at the base of the Layers palette and create an Inner Glow and a Color Overlay effect on the sphere to give it a bright, celestial appearance (see Figure 11.19).

FIGURE 11.18

The sphere is just the right size for a large comet.

FIGURE 11.19

A glow makes the sphere look more like a comet.

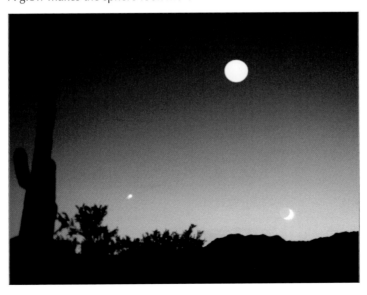

5. With the image layer highlighted, create a selection around the sphere that resembles the glow and tail of a comet (see Figure 11.20).

TIP To create a soft edge for the tail of the comet, click Refine Edge in the Selection tool options bar and adjust the Feather and Radius settings.

FIGURE 11.20

Create the tail of the comet by creating a selection that is just the right shape.

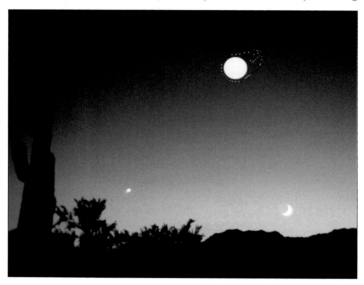

6. Click the New Adjustment Layer button at the base of the Layers palette and select Curves.

7. In the Curves dialog box, adjust the levels of the selected area until you have a glowing tail for your comet. Click OK. The selection becomes a mask for your comet, applying the Curves adjustment around your sphere.

TIP Experiment with the blend modes of your Curves layer to get different effects. My image looks good with a Normal blend mode, but yours might look better with a different one. Change the blend mode using the drop-down menu in the Layers palette.

8. Click the triangle next to the Sphere layer in the Animation (Timeline) palette to show the layer properties.

9. Click the Time-Vary Stop Watch button next to the Position property.

10. Click the triangle on the Curves layer to show its layer properties. Because there is a mask applied, one of the layer properties is Layer Mask Position.

11. Click the Time-Vary Stop Watch button in the Layer Mask Position property to enable animation.

12. Hold the Ctrl (⌘) key down to select both the Sphere and the Curves layers.

13. Create keyframes by moving the sphere and the tail simultaneously across the night sky over time (see Figure 11.21).

Because the position of the mask on the Curves layer can be animated, the Curves adjustment can be applied around the comet, not affecting any more of the image than the tail of the comet requires.

FIGURE 11.21

The comet crosses the sky, bringing its tail along for the ride.

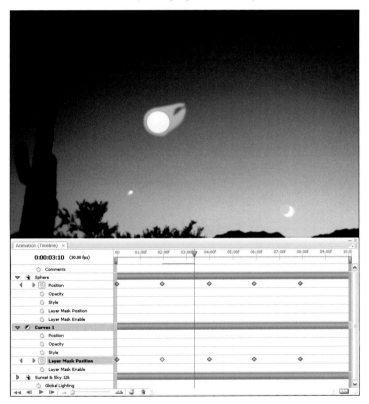

Animating live video with Rotoscoping

If Rotoscoping is painting over live video to create an animation, Photoshop is the champion Rotoscoping tool. Let's have some fun creating an animation from a live video file.

You can do some true Rotoscoping by using filters to create animation from live video. Follow these steps.

1. Open a live-action video file.
2. Duplicate the video footage by right-clicking the layer in the Layers palette and selecting Duplicate Layer.
3. With the upper layer highlighted, select an area in the first frame of the video file (preferably an area that stays constant throughout the video) (see Figure 11.22).

Select an area that stays constant throughout the video that you are animating.

4. Click the Add Layer Mask button in the Layers palette to add the mask to the second layer of the video.
5. Choose Filters ➪ Filter Gallery to open the Filter Gallery.
6. Choose a filter that creates an animation from your selection. Most of the filters under the Artistic menu create an effect similar to paint or colored pictures. Your image will determine which filter and which settings look best. The Dry Brush filter is used in Figure 11.23.

FIGURE 11.23

The preview window in the Filter Gallery doesn't distinguish the masked area of the video.

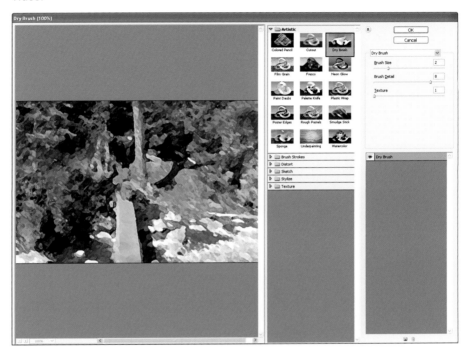

7. When you finish in the Filter Gallery, click OK.

8. Click the Next Frame button in the playback controls found in the Animation (Timeline) palette.

9. Press Ctrl+F (⌘+F) to reapply the Filter Gallery features to the new frame.

10. Repeat Steps 8 and 9 until you have animated your video clip (see Figure 11.24).

This is a simple way to jazz up a video clip. The filter is applied frame by frame, but using the Next Frame button and pressing Ctrl+F (⌘+F) to apply the filter continuously makes it a quick process.

Of course, you could have animated the entire video without creating a mask, and you could have changed the mask in different frames for additional effects. There are so many options here for fun animation using the special effects found in Photoshop.

FIGURE 11.24

After changing each frame of an animation, there is a solid line in the altered video property.

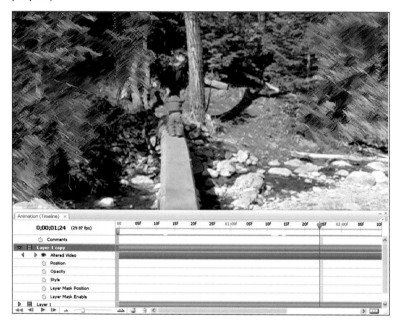

As you learn how to work with video in upcoming chapters, you may even find a way to create this animation in a much easier way.

Summary

In this chapter, you learned several advanced animating techniques and solidified your knowledge of what can be animated and how by employing the following techniques:

- Using Rotoscoping to paint animations
- Creating frame-by-frame animation of 3D objects and still images
- Reviewing animation techniques
- Adding other files to an animation
- Creating special effects in an animation

In the next chapter, I introduce you to tools that you'll need in order to be successful at using the video-editing capabilities of Photoshop.

Part IV

Editing Video Files

Editing video files as defined in this part is the ability to make several layers from a video file in order to arrange and rearrange the video that you are seeing.

You will learn about video file formats and aspect ratios to build a solid base for working with video files. Working with video is time and space intensive, so you will learn how creating actions and arranging the work area in Photoshop are vital to working effectively with video files.

You will also be shown how to use the Animation (Timeline) palette to split, remove, and trim video files, both to create a finished product and to edit select portions of video.

Chapter 12

Introducing Video Editing Capability in Photoshop

You probably noticed right away that adding the Timeline to Photoshop added not only animation capability, but also the ability to edit video. Although working with video in Photoshop is all about frame-by-frame editing, cleaning it up, or adding Rotoscoping, there are concepts related to video file formats that do not apply to image files.

Additionally, there are advanced tools in Photoshop that are available for any kind of file editing — image, 3D, and video — but while they are helpful with other files, they are vital in video editing.

This chapter introduces you to video file formats and helps you understand pixel ratios. After that, you learn how to use and create your own actions, something you may have never done before, but should never be without. I finish by showing you all the new features available to you in setting up your palette views in Photoshop CS3.

IN THIS CHAPTER

Understanding video file basics

Using automated actions

Creating optimized Toolbox views for video editing

Understanding Video File Basics

To work with video successfully, you need to know the basics of video file formats, why they are different, and how they work. Some file formats are higher quality and, consequently, larger than those that are of lower quality. It is also vital to understand aspect ratios. There are more possibilities for changing the aspect ratio in Photoshop than you might think. Using the right aspect ratio and understanding the settings is an important part of creating successful video files within Photoshop.

Video file formats

With the addition of the Animation (Timeline) palette, Photoshop adds several video file formats to the huge list of supported file formats. Not only can you import movies with the following extensions, but you can also import image sequences with the usual image extensions that Photoshop already supports.

Following are the different types of file extensions you can open in Photoshop:

- **MOV:** This is the native file format of QuickTime. A MOV file can contain several types of tracks, such as video, audio, effects, and text. This makes them easily editable and portable because a MOV file can be used in both the Mac and Windows platforms.

- **AVI (Audio Video Interleave):** This multimedia container format can compress files with many different codecs (or coding formats) into one file format. That means that the quality of the file is dependent on the original format of the file that is saved as an AVI. It is the most widely used video file format, and it is therefore accepted almost universally by applications that allow you to view or edit video.

- **MPG/MPEG:** The MPG file format is the native format for DVDs and most movies that you see on the Internet. The quality can range from very good (MPEG-2) to fast and easy to post (MPEG-4).

> **NOTE** To play video in Photoshop, you must have QuickTime 7 installed on your computer. You can download QuickTime free from www.apple.com/quicktime.

Setting aspect ratios

Aspect ratio is the relative width to height of a video or an image. The frame aspect ratio indicates the ratio of the video or image frame. You are probably very familiar with the 4:3 and 16:9 aspect ratios that are industry-standard TV sizes. The next step in getting to know all about pixels and the pixel aspect ratio is.

Correcting the pixel aspect ratio

Individual pixels also have aspect ratios. Depending on the video standard, pixels have either a square aspect ratio or a rectangular aspect ratio. A computer monitor, for example, is usually set up for square pixels. A 4:3 monitor typically has a setting of 640 pixels wide and 480 pixels tall, which results in square pixels.

Television sets do not have square pixels. Their pixels are most likely to match the aspect ratio of the National Television System Committee (NTSC), which is rectangular. NTSC is the analog television system in use in the U.S. and Canada, as well as Japan, Mexico, the Philippines, South Korea,

and Taiwan. Television pixels may also match the Phase Altering Line (PAL) standard that is common in Western Europe. This means that when you play a movie on your computer that is a standard video format, the video will be distorted unless the pixel aspect ratio is taken into account and adjusted.

When you import a video file into Photoshop, it automatically performs a pixel aspect ratio correction on the document, so that it appears just as it would appear on a TV screen. This reduces the preview quality of the document, but it is only for preview purposes and doesn't change the document materially in any way (see Figure 12.1).

You can turn off the Pixel Aspect Ratio Correction viewing mode and preview the video with all of the pixels intact. The image looks distorted, but it actually contains the correct number of pixels. Simply choose View ➪ Pixel Aspect Ratio Correction to toggle the correction on or off (see Figure 12.2).

NOTE You can view both pixel settings at once by choosing Window ➪ Arrange ➪ New Window for (document name). This opens a second window containing your document. You can correct the pixel aspect ratio in one and leave the correction off in the other.

FIGURE 12.1

When the Pixel Aspect Ratio Correction viewing mode is turned on, the image looks normal.

FIGURE 12.2

This is like watching regular 4:3 television on a 16:9 television.

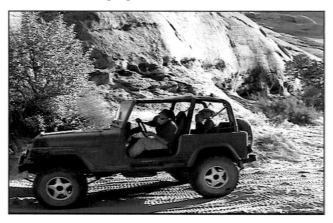

Changing video aspect ratios

You are probably familiar with common video aspect ratios such as 4:3 and 16:9. You are probably less familiar with pixel aspect ratios, which is what Photoshop uses. Here's a list of the Photoshop preset aspect ratios to help you translate pixel aspect ratios into more familiar terms. The number listed in parentheses is the relative height of the pixel to a width of 1. For example, D1/DV NTSC (0.9) has an aspect of 1 pixel wide and .9 pixels high, making it slightly wider than it is high.

The following aspect ratios are available in Photoshop:

- **Square:** Most computer monitors have square pixels. Some video made for a 4:3 screen ratio is also captured at 640 x 480, making the pixels square.

- **D1/DV NTSC (0.9):** This is also a very standard capture ratio for pixels with a pixel ratio of 720 x 480. Your television and video camera both probably have this setting, although widescreen is becoming more popular (see Figure 12.3).

- **D4/D16 Standard (0.95):** This is a less-used ratio, although it is closer to square than the .9 pixel ratio.

- **D1/DV PAL (1.07):** The PAL pixel ratios create a pixel that is taller rather than wide. This is the standard pixel aspect ratio used for 4:3 screens. PAL is the video format used in most countries outside North America.

- **D1/DV NTSC Widescreen (1.2):** This is the common pixel aspect ratio for an NTSC 16:9 screen. Most video cameras also shoot in this aspect ratio.

FIGURE 12.3

A pixel ratio of 1:0.9 creates nearly square pixels and is just right for a 4:3 frame.

- **HDV 1080/DVCPRO HD 720 (1.33):** This is the standard pixel aspect ratio for big-screen movies and is becoming more popular with higher-quality video cameras. The frame size is 1440 x 1080 pixels for the highest quality setting. The screen size used for this pixel aspect ratio is 16:9.

- **D1/DV PAL Widescreen (1.42):** This is the common pixel aspect ratio for a PAL 16:9 screen.

- **D4/D16 Anamorphic (1.9) and Anamorphic 2:1 (2):** This pixel ratio should only be used if your footage is shot with an anamorphic lens. An anamorphic lens creates wide pixels that condense to be shown at 4:3 or 16:9 aspect ratios.

- **DVCPRO HD 1080 (1.5):** This pixel ratio is also used in a video ratio of 16:9. It has a high-quality pixel level with a 1280 x 1080 frame size (see Figure 12.4).

You can also create a custom pixel aspect ratio by choosing Image ➪ Pixel Aspect Ratio ➪ Custom Pixel Aspect Ratio. This displays a dialog box that allows you to name your custom ratio and set the height of the pixel (with the width equal to 1). This can be an interesting way to create a special effect with your video (see Figure 12.5).

FIGURE 12.4

A pixel ratio of 1:1.5 creates rectangular pixels.

FIGURE 12.5

It looks cool now, but it will play back normally on a 4:3 television, just as it would play back stretched on a 16:9 display.

The pixel aspect ratio is important to know a bit about, but if you are wondering if you are in over your head, don't worry too much. When you open a video file, the pixel aspect ratio is automatically set to the aspect ratio at which the video footage was shot. As long as you are editing just one aspect ratio, you should be okay. When it comes to adding an image to your video footage, however, you may want to correct its aspect ratio to match that of the video.

Correcting the aspect ratio of an image

You can add as many images to a video file as you want. The video file can even be set to the correct aspect ratio. When you place images that don't fit the aspect ratio, any portion of the image that doesn't fill the frame of the video will be transparent (see Figure 12.6).

FIGURE 12.6

A tall image set in a 4:3 aspect ratio shows transparency in the areas that the image doesn't cover.

You can solve this problem in one of two ways: You can create a background for all the images that are placed in the video, or you can create a background for each image. Either way, you need to create an image document that is the right pixel aspect ratio.

You can create a document in Photoshop with the correct pixel aspect ratio for your video file. Follow these steps:

1. Choose File ➪ New to display the New dialog box.
2. From the Preset drop-down menu, choose Film & Video. This creates several presets for your document and gives you several more menu options (see Figure 12.7).

FIGURE 12.7

The Film & Video preset in the New dialog box.

3. Choose the correct size from the appropriate drop-down menu. Don't be intimidated by the options. NTSC DV or NTSC DV Widescreen will probably work for you unless you're creating special video footage. (If you are not in North America, use the PAL settings.)

4. From the Pixel Aspect Ratio drop-down menu, choose the pixel aspect ratio you want for your footage.

5. Click OK.

The default settings created by the Film & Video preset are standard for most video files. If you want to create an HD video, you can change the number of pixels and the resolution to a higher quality, of course. You can also change the color settings and background contents among other things. The important thing is to create a document that is the same size and pixel resolution of the video you are trying to create.

As you click OK to create the new document, you are reminded that Photoshop has just turned on Pixel Aspect Ratio Correction viewing mode for this document because it should eventually be part of a rendered video file.

The document created by the Film & Video presets looks different from the usual Photoshop document. You can see in Figure 12.8 that there are guidelines added to the blank canvas. These guides don't print or appear in your video; they are there to indicate the safe zones in the video file. As long as your action is contained within the outside bounding box and your text is contained within the inside bounding box, you won't lose any of the important pieces of your video to a television that cuts out the edges of the video and enlarges the center.

FIGURE 12.8

The Film & Video presets allow you to see guides for placing and editing your video.

Title Safe Area

Action Safe Area

> **NOTE** If you are creating a video for the Web, you probably chose the square pixel settings, which means that the Pixel Aspect Ratio Correction viewing mode doesn't have to be turned on. You can disregard the guides, as well, because computer monitors play the entire video without cropping the edges.

You can now place an image in this document or create a neutral background that can be placed in the video file as a separate layer behind any photos that are placed in the video file.

> **CROSS-REF** To learn more about placing files into a video file, see Chapter 13.

Video filters

Video filters can be used on image files that will be placed into video or video files. These filters work to reduce the random pixels, commonly known as noise, in a video file.

De-Interlace

Interlaced video is created by generating every other line of video in one pass and then filling in the missing lines in the second pass. De-interlacing can reduce the lines in a moving video by removing either the odd or even lines and filling those lines in by either duplicating or interpolating the existing lines. The difference can be dramatic, especially on a computer monitor with an output quality that is high enough to catch the variable scans. Figure 12.9 shows the same frame before and after de-interlacing.

 NOTE Using the De-Interlace Filter only works on one frame at a time. To de-interlace the entire video file, choose Layer ⇨ Video Layers ⇨ Interpret Footage and click the De-Interlace option.

FIGURE 12.9

The top image is fuzzy, and you can see the image echo. The bottom image has been de-interlaced and is much clearer.

Choose Filter ⇨ Video ⇨ De-Interlace to open the De-Interlace dialog box, as shown in Figure 12.10. You can select whether to use the odd or even lines of the video file and whether to use duplication or interpolation for filling in the gaps.

FIGURE 12.10

The De-Interlace dialog box

NTSC colors

When you apply the NTSC Colors filter to an image or video file, you are restricting the colors used in that file to the colors that are used in television production. This keeps your video cleaner by preventing oversaturation and bleeding of colors. You can change the colors to NTSC colors by choosing Filter ⇨ Video ⇨ NTSC Colors.

Using and Creating Automated Actions

Photoshop CS3 does an excellent job of providing simple-to-use keyboard shortcuts (hotkeys) for most common tasks. The more you use Photoshop, the more you will rely on these shortcuts. They save a lot of time, allowing you to create at a much faster rate. However, even performing shortcuts repeatedly can become very tedious. That is where actions come in to play.

Actions are a list of operations that are performed from the Actions palette with the click of a button. Actions can include most of the tasks that you can perform using the shortcuts, menus, and palettes in Photoshop. Actions can range from something as simple as adding a special effect to the active document, to a long series of operations that include creating several new documents and layers with numerous effects, filters, and masks. There really isn't a limit to what you can do with custom actions.

The reason actions save so much time is that you can perform an action, whether it involves two steps or 50 steps, just by clicking a button or pressing a hotkey. Photoshop CS3 comes with several predefined action sets for various common tasks, including a video action set.

The video action set comes with several predefined tasks that do everything from creating alpha channels to restructuring the pixel aspect ratio of images so that they can be played in a slide show. As you work more with the Animation (Timeline) palette, you'll soon find that there are actions that you really want to be automated (duplicating frame after frame and adding the same filter to each one comes to mind). Then you'll want to create your own custom action, which is as simple as recording your steps as you take them.

> **NOTE** After you play an action, you can click the History tab to view the History palette and see each step that was taken by the action.

Introducing the Actions palette

The Actions palette enables you to implement actions to speed up your work. You can access the Actions palette by choosing Window ⇨ Actions from the main menu. By default, the Actions palette is grouped with the History palette.

The Actions palette is made up of four main components, as shown in Figure 12.11: the action list, the Actions palette menu, the toggle boxes, and the Actions Palette buttons.

FIGURE 12.11

The Actions palette.

Palette Menu
Action List
Toggle item on/off

Toggle dialog on/off

Action set
Actions

Recorded Commands

Actions

Quick Buttons

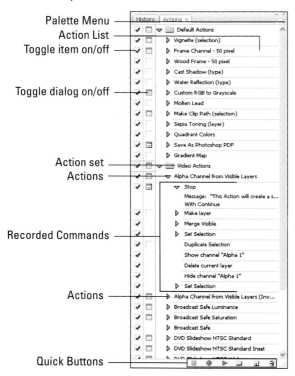

Action list

Located in the main portion of the palette is the action list. The action list is made up of the following three components:

- **Action set:** This is a method for grouping a list of actions into a category. An action set is indicated by a folder icon next to the name of the set. You can see two different sets in Figure 12.11, Default Actions and Video Actions. You can load any one of seven predefined action sets from the Actions palette menu or you can create your own. Click the triangle next to the action set name to see a list of actions contained in the set.

- **Actions:** An action is a preset list of operations that can be performed quickly and automatically by selecting an action and clicking the Play button at the bottom of the Actions palette. Click the triangle next to the action name to see a list of recorded commands that are contained in the action.

■ **Recorded commands:** This is a list of commands that have been recorded in a set order to perform the same series of operations every time the action is played. These commands may also contain submenus. For example, clicking the triangle next to the Stop command in Figure 12.11 shows the message displayed by the command.

Actions palette menu

Located in the upper-right corner of the Actions palette, the palette menu contains menu items that allow you to set the palette mode, add new actions, load action sets, save action sets, and set other options for the Actions palette.

Toggle boxes

Located along the left side of the palette, there are two toggle boxes available for each action set, action, and operation in the action list. The left toggle box, the Included Command toggle, enables or disables the set, action, or operation. If this toggle box is not selected, the operation is not applied when the action is run. The right toggle box, the Modal Control toggle, enables or disables any dialog boxes contained in the set, action, or operation. If a dialog box icon is displayed in the toggle box, Photoshop displays the dialog box associated with the operation when running the action. For example, if an operation adjusts the levels of an image, you can toggle on the dialog box icon to display the Levels dialog box, which waits for you to adjust the Levels manually every time the action runs.

Actions Palette buttons

The Actions Palette buttons are located at the bottom of the Actions palette. These buttons provide quick access to the Stop, Record, Play, Create New Set, Create New Action, and Delete commands for actions. Each of these commands is also available in the palette menu.

Changing the view of the Actions palette

Just when you thought you had a handle on the Actions palette, you can dramatically change the way it looks by choosing Button Mode from the Actions palette menu. You can see in Figure 12.12 that the action list has converted to buttons. This allows you to click the action you want to perform without the dual steps of highlighting it and clicking the Play button. You can see that each of the action sets is delineated by color.

FIGURE 12.12

The Actions palette in Button mode.

Loading existing action sets

When you initially open the Actions palette, it is blank. At this point, you can either load an existing action set or create your own custom action set. Loading an existing action set can be accomplished in one of two ways. First, the predefined action sets that are loaded in Photoshop are listed at the bottom of the palette menu, and you can load them by clicking them. Second, you can load sets that you created previously or downloaded by choosing Load Actions in the palette menu and navigating to the location of the action set.

 Action sets have an ATN file extension.

When you load an action set, it is added to the action list. Photoshop automatically expands the action set to show all actions contained inside.

Creating custom actions

Custom actions are created by recording operations you want to add to the action as you apply them. Once you begin recording the action, all steps that affect the current document are recorded, including the creation of new documents. You should be prepared to perform the steps in order without any extra steps.

To create a custom action, follow these steps:

1. If you want to add the action to an existing set, skip to Step 3. Otherwise, choose New Set from the Actions palette menu.

2. Type the name of the new action set, and click OK.

3. Select the new action set, or the action set to which you want to add a new action.

4. Create a new action by choosing New Action from the Actions palette menu to display the New Action dialog box, as shown in Figure 12.13.

The New Action dialog box.

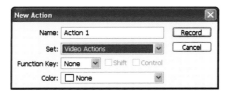

5. Type the name of the new action in the Name field. You can also select a function key that will automatically run the application after it is recorded, and you can select a color to be used when displaying the action in Button mode.

TIP You will want to group similar actions with similar colors to make the Button mode easier to use.

6. Click the Record button in the New Action dialog box to start recording the action. As soon as you click the Record button, Photoshop begins recording.

7. Perform the desired operations in order. Perform these operations as you normally would, including modifying settings in dialog boxes and so on.

NOTE Don't worry if you mess up a little bit when performing the operations. You will be able to go back and insert forgotten operations, delete unwanted operations, and even modify operations that weren't performed quite right.

8. Click the Stop button in the Actions palette to stop recording and save the action. The new action appears in the action list.

Editing actions

You can edit an existing action in several different ways. You can add stops and operations, move the operations around, duplicate operations, and insert items that can't be recorded when you are creating the action. This allows you to not only correct an existing action, but you can also create a new action that is similar to an existing action without starting over.

Adding a stop

A stop is an operation that pauses the running action and displays a message. Users can read the message and decide whether they want to continue running the action. You may want to insert a stop into actions prior to performing complex or data-changing actions. For example, if your action makes changes and then saves the document, you may want to display a message to that effect so that the user can decide whether to change the file.

To insert a stop into an action, select the operation that you want the stop and then choose Insert Stop from the palette menu. This displays the Record Stop dialog box (see Figure 12.14). Select the Allow Continue option if you want the user to be able to continue after the stop. After you click OK, the stop is inserted before the highlighted command.

FIGURE 12.14

The Record Stop dialog box.

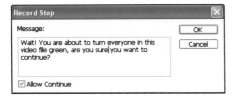

Adding operations

You may decide that you want to add additional operations to an existing action. This can be useful for a couple of different purposes: You may have forgotten a step when you recorded the action or you may want to create a variation of an existing action.

To insert additional operations into an action, highlight the operation that you want to add additional operations below and click the Record button. Perform the operations that you want to add. When you finish recording the operations, click the Stop button and they will be added to the action.

Moving operations

Operations can be moved from one location in the action list to another by simply dragging them to the new location. Operations can even be moved from one action set to an action in an entirely different action set. You can select multiple operations in the same action by holding down the Ctrl (⌘) key and clicking each operation. Then you can move the selected group together.

Duplicating actions and operations

You can duplicate actions or operations by holding down the Alt (Opt) key while dragging them to their new location. Holding the Alt (Opt) key leaves the original operation or action in place and creates a copy of it in the new location. If you duplicate an action inside the same action set, "copy of" is added to the name.

Modifying operations

Some operations can also be modified after the action is recorded. This can be extremely useful if you make a mistake or decide later that you want the operation to use different settings. Instead of having to delete the operation and rerecord it, you can just double-click the operation to display the dialog box used to create it. Change the settings that you want to modify and click OK in the dialog box to update the action.

Manually insert operation

At times, you may need to insert an operation manually into an action. Photoshop does not record operations that do not appear to change the current document, such as enabling additional palettes or zooming in on the document.

Insert a menu item

To insert an operation manually into an existing action, highlight the operation right before the operation you want to insert. Then select Insert Menu Item from the Actions palette menu to display the Insert Menu Item dialog box. You can now add an operation by clicking through the menu path of the operation. For example, if you want to zoom into your image, choose View ⇨ Zoom In (see Figure 12.15). When the operation you want to insert appears in the dialog box, click OK to insert the operation into the action.

Insert a path

You can create a complex path as part of an action, but if you try to record several complex paths, each new path replaces the last one. You can insert new paths into an action by choosing Insert a Path from the Actions palette menu after the action has been recorded. Select the operation in the action that will come directly before the path and choose Insert a Path from the Actions palette menu. You can create a path with a Pen tool, use a path found in the Paths palette, or import a path from Illustrator.

FIGURE 12.15

The Insert Menu Item dialog box.

Deleting an operation

You may also want to remove operations from an existing action. Select the operation and drag it to the Delete button at the bottom of the Actions palette to delete it. You can select multiple actions and delete them at the same time using the Ctrl (⌘) key.

Modifying the action name and function key

You can modify the action options of an existing action, including the name, function key, and color. To open the Action Options dialog box, hold down the Alt (Opt) key and double-click the action. You can also choose Action Options from the Actions palette menu. You can then use the Action Options dialog box to modify the name, function key, and color of the action.

Saving actions

After you create a new action or modify an existing one, you will want to save the action. You do this by saving the action set, which is a document. Select the name of the action set and choose Save Actions from the Actions palette menu. You can use the default location or browse to another location.

Temporarily adjusting action settings by using the Included Command toggle

You can temporarily adjust the actions by selectively toggling the operations in them off or on. If you click the left toggle box, the Included Command toggle, for an operation and deselect it, running the action will skip the deselected operation. You can save a lot of time in creating new actions if you use this feature judiciously. Create an action with all the possible steps that you might want to take and then deselect the steps that aren't necessary, depending on the circumstance.

Playing actions

Now that you've learned everything about creating and modifying actions, you can get to the fun part, which is using them. Playing an action is an incredibly simple process. If you are in Button mode in the Actions palette, simply click the button and the action is performed. If you are in List mode, select the action and click the Play button at the bottom of the Actions palette. If you've set up a hotkey for a particular action, you can also use it. You can also play an action starting at a particular operation in the action list by selecting that operation and then clicking the Play button.

Managing the action list

With seven predefined action sets and an unlimited number of actions that you can create or download, you can imagine how cluttered the Actions palette can become if it's not managed well. Here are a few Actions palette menu commands that can help you keep your actions organized:

- **Clear All Actions:** The Clear All Actions command wipes the Actions palette clean of any action sets. You can't get much cleaner than that!

- **Reset Actions:** Choose this command to replace all of the action sets in the Actions palette with the default set. You can also select Append to add the default set to the actions on the palette, rather than replacing them.

- **Replace Actions:** You can replace the actions in the Actions palette with an action of your choice by choosing Replace Actions from the Actions palette menu. You can browse for the action you want to add to the palette.

Optimizing the Photoshop Toolbox Views for Video Editing

Between the Animation palette, a Layers palette that will most likely contain numerous layers, and a busy Actions palette, the work area for video and animation files can quickly become very cumbersome. If you're familiar with Photoshop, you are probably already aware that you can change the palette views easily to optimize your work area. Photoshop CS3 has made the palette menus easier to work with than ever. Following is a brief description of the options you have for changing and cleaning up your work area.

Using the Window menu

The Window menu is found in the File menu. It contains a list of all the palettes that are available in Photoshop. The palette names with a check mark beside them are in view in the Photoshop work area. Most of the other palettes are also in the work area, but if they are tabbed behind another menu or collapsed, they are not selected (see Figure 12.16).

The Window menu.

Clicking the name of a palette displays that palette in the work area. If that palette is tabbed with another palette, the second palette becomes deselected. For example, if you choose to view the Actions palette by clicking it in the Window menu, the History palette, which appears in the same palette view will be deselected and no longer be visible.

Deselecting a palette name in the Window menu removes that palette from the work area entirely. If you find that you don't use the Navigator/Histogram/Info palette while editing video, you can remove it from the work area to leave more room for other palettes that you use more often. If a palette is collapsed, selecting it in the Window menu is one way to expand it if you haven't figured out all of the palette buttons.

Collapsing, expanding, and resizing palettes

There are several different ways that you can change the size and the view of a palette. Figure 12.17 labels the buttons that allow you to customize the look of each palette.

FIGURE 12.17

There are several different ways to collapse and expand palettes.

Collapse to buttons

You can collapse your palettes into neat little buttons that can be placed in a corner of the Photoshop work area (see Figure 12.18). To expand individual palettes, all you need to do is click the button for that palette. None of these collapsed palettes will be selected in the Window menu. You can collapse some palettes and leave others expanded by moving only the palettes you want to be expanded to other locations.

Expand to dock

Expanding the palettes to dock is the opposite of collapsing them. Figure 12.19 shows the Brush and Tool Presets palettes, which are usually buttons next to the default palette menus, expanded out to their full dock size. There wouldn't be much room to work if both sets of palette menus were expanded!

FIGURE 12.18

Collapsing all the palettes creates a neat little package of buttons.

FIGURE 12.19

Expanding the palettes opens them to full view.

Collapse content

Clicking anywhere on the palette header expands or collapses the contents of the palette. When the contents of the palette are collapsed, all you see is the header (see Figure 12.20). To expand the palette, simply click the tab of the palette you want to expand. This is a great way to have all of your palettes available and still be able to see the contents of palettes such as the Layers palette and the Actions palette when they are very full.

FIGURE 12.20

The palettes reduced to headers.

Close palettes

If you aren't using a set of palettes, you can close that set completely by clicking the X in the palette header. You can move tabs from one palette to another, organizing them so that you can close the palettes that you aren't using.

Changing the size of the palettes

You can change the size of individual palettes by clicking and dragging the division between two palettes up or down (see Figure 12.21). If you click and drag the side of the palette window, the entire palette section expands.

FIGURE 12.21

The multidirectional arrow shows that you can drag the palette borders up or down.

Moving palettes

Many of the options in changing the size of the palettes are dependent on being able to move them. Maybe you use the Navigator and History palettes frequently, but really don't need the Information or Actions palettes. Perhaps the Layers palette is indispensable to you but the rest aren't used enough to keep them expanded all the time. There are several different ways to move the palettes around to adjust to your needs.

Moving palette groups and buttons

You can grab any palette group by its header and drag it anywhere in the palette menus. If you prefer to have your Layers palette on the top of your palette menus, go ahead and put it there. You can also drag your palettes sideways. Put your lesser-used palettes in the button menu and keep the well-used palettes expanded. You can even drag all of your palettes into the button menu for the tightest palette package of all (see Figure 12.22).

FIGURE 12.22

Dragging all of the palettes into the button palette bar creates a lot of room in your work area or gives you plenty of room for that one important palette.

Moving tabs

Moving tabs is just as easy as moving the palette groups. Rather than grabbing the palette header, you can grab the tab and move it into another palette group. This is a great way to see all of your important palettes at once by placing them in different palette groups, or creating one palette group with your important tabs and closing or collapsing the others.

Separating a palette from the palette menus

You can separate any one of the palettes from the palette menu and drag it anywhere in your work area. If you are working in a palette frequently, even the long mouse drag to the palette menus adds up to a lot of time. Simply click the palette tab or header and drag it to the workspace. To replace it in the palette menus, drag it back. When you see a bright blue line, you know that dropping it connects it to the palette menu (see Figure 12.23).

FIGURE 12.23

The bright blue line indicates the location where the palette will connect.

Summary

This chapter covered the topics that prepare you to edit video successfully in Photoshop. You learned:

- Video file basics
- Automated actions
- Optimized Toolbox views for video editing

In the next chapter, you learn how to use the Animation (Timeline) palette to edit video files.

Chapter 13

Video-Editing Basics

Adobe Photoshop isn't meant to create an extensive video project; that's what Adobe Premiere is for. Photoshop does enable you to import pieces of video that need that special Photoshop touch, and clean them up a bit. You can also create fantastic composites with video files that you may not be able to accomplish in fine Photoshop style anywhere else. The Animation (Timeline) palette gives you just enough capability to make working with video files an efficient and relatively uncomplicated process.

The first step in being able to edit your video files in Photoshop is to understand the video workspace. If you've been reading this book through, you know quite a bit about the Timeline already. I'm not going to cover the basics of the Timeline again; instead, I jump right into video-editing basics, the features that will allow you to maneuver in the Timeline and make changes in your video files.

Opening and Placing Video Files

Getting started with video editing in Photoshop is as easy as opening a video file After you have one video file, you can place one or more video files in the same document to create a composite.

NOTE Photoshop has no sound capability when it comes to editing video clips. Although your sound is embedded in your video file (and will still be there after your Photoshop edits), you can't hear it or edit it in Photoshop.

Opening a video file

Opening a video file in Photoshop isn't any more difficult than opening any other kind of file. It is important to import the smallest possible file for editing, however. Photoshop is not meant to create and manage extensive video projects. A large video file has the capability of creating a very unwieldy work area at best, and bringing your work in Photoshop to a grinding halt at worst.

You shouldn't be discouraged from bringing in the entire file that needs to be edited, but don't bring in any more than necessary. You can trim larger video files down to an editable size in the video editing program of your choice by creating a work area or trimming around the area you want to edit, and rendering just that portion to a separate video file that you can then import into Photoshop. Taking the time to trim your video files down to manageable sizes will save you a lot of time and frustration later.

To open a video file in Photoshop, choose File ➪ Open and browse to a video file with a supported extension. Your video file will open in Photoshop. If you don't have the Animation palette open, you can still play your video file by using the Spacebar to stop and start the playback. To open the Animation palette, choose Window ➪ Animation. Your newly imported video file appears as one uncomplicated layer in the Timeline. Don't worry; you'll change that right away (see Figure 13.1).

TIP For your own sanity, rename your layers as soon as you import them. As you can see in Figure 13.1, the layer associated with the opened video file is named Layer 1. If you've never bothered about your layers in the past, keeping track of them through their icons or knowing which ones they were just because there were only two or three, it's time to change your ways. Give each layer a descriptive and unique name.

Adding video files

You can add video files to an open video document in several ways. You can drag a video layer from another file into the window of the file in which it's being placed, or you can choose Layer ➪ Video Layers ➪ New Video Layer from File menu. Either one of these options will place a new video layer on top of the video or other layers already present in your file. Most of the time, this is exactly what you want to do, and so either of these methods works really well. Figure 13.2 shows two video layers placed together in the Timeline. The first layer contains a video taken at a child's first birthday party, and the second layer contains a video taken on the actual day of birth of the same child. You can combine clips from both layers to create one final video project.

FIGURE 13.1

A newly imported video file.

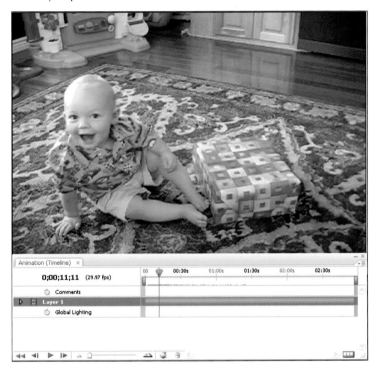

There are circumstances where you may want to place a new video file differently than just by inserting it over another one. For example, you can change the size of the video file to create a picture-in-picture effect. In this case, you will want to place the new video file. Choose File ⇨ Place and browse to the new video file. The new file is placed over the existing layers with a bounding box around it, allowing you to scale, rotate, and place it where you want. Figure 13.3 shows the birth video layer over the first birthday video layer.

FIGURE 13.2

Two video layers in the Timeline.

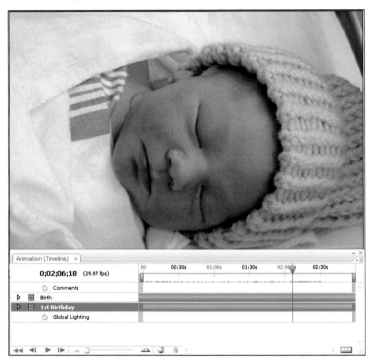

You can create the same effect after the fact by selecting the video layer and choosing Edit ➪ Free Transform, but placing the video file in the first place saves the extra step.

NOTE **Whether you use the Place command or the Free Transform command, a transformed video layer becomes a Smart Object.**

FIGURE 13.3

Create a picture-in-picture effect by placing the second file.

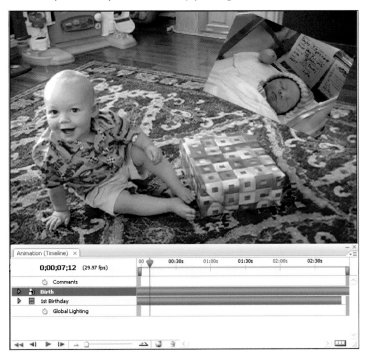

Trimming Video Layers

After importing a new video layer, you may find the layer needs trimming ore editing. Trimming a video layer consists of cutting the unwanted ends off the layer and leaving the rest of the video intact. There are several different ways to trim a layer, you can do it manually, by dragging the layer duration bar, or you can use the Animation (Timeline) menu options.

CROSS-REF If you missed the introduction to the Timeline in the animation chapters, you can get acquainted with the Timeline in Chapter 8.

Dragging the layer duration bar

The easiest and most rudimentary way to trim a layer is to drag the ends of the layer to the point in time where you want the video to start or end. First, place the current-time indicator in the place where you want to begin or end the clip. You will probably get to that spot just by your initial preview of your video clip. Then simply grab the end of the layer duration bar by clicking and holding it as you drag it to the current-time indicator. This isn't a precise method, but it works well for a preliminary trim (see Figure 13.4).

FIGURE 13.4

Dragging the end of the layer duration bar to trim it.

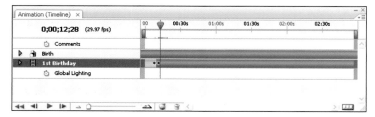

When you drag the beginning of the layer in to trim it, the layer doesn't reposition itself at the beginning of the document automatically. If you want your layer to start at the beginning of the document, you can do one of two things: drag and drop the already trimmed layer to reposition it, or simply drag the untrimmed layer forward, moving it out of the beginning of the document. Place the current-time indicator at the beginning of the document. This way, the preview window will show what is at the beginning of the document and you can preview the video as it is pushed out of the document, in order to find the right starting place.

Trimming layers using the menu option

If you want to trim your video more precisely, move the current-time indicator to the proper area and in the Animation palette menu, choose Trim Layer Start to Current Time or Trim Layer End to Current Time to trim the layer to the current time. Again, this leaves the beginning of your layer at the current-time indicator rather than at the beginning of your document (see Figure 13.5). This might do exactly what you wanted it to, but if you want the layer to start at the beginning of the document, you have one other choice.

TIP You can move the current-time indicator to the exact frame you want to trim to by clicking the Select Next/Previous Frame buttons that are found in the playback controls at the bottom of the Animation palette.

FIGURE 13.5

Using the Animation palette menu to choose Trim Layer Start to Current Time or Trim Layer End to Current Time will leave you with a gap at the front of your video document.

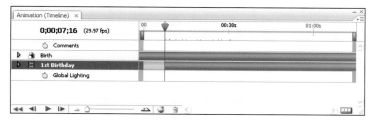

Trimming the document duration to the work area

To change the document duration to the trimmed areas of your video, you can set the work area to surround the video you want to keep and choose Trim Document Duration to Work Area from the Animation palette menu (see Figure 13.6). This quickly and concisely crops your video to the size of your set work area. If you have only one video layer in your document, this is probably your best option for trimming your video file (see Figure 13.7).

CAUTION If you have more than one layer in your Animation (Timeline) palette, be aware that trimming the document duration to the work area trims all of your layers to the work area. To prevent inadvertently trimming a layer too short, be sure that all the video that you want in your final product is contained inside the work area.

FIGURE 13.6

Move the work area indicators to the beginning and end of the area to which you want to trim.

Work Area Indicators

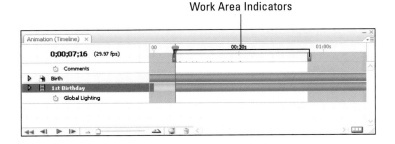

FIGURE 13.7

Choose Trim Document Duration to Work Area from the Animation palette menu, and the work area becomes your entire document.

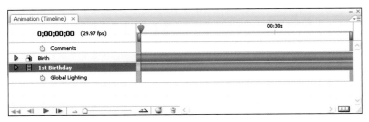

Looking at trimmed layers in the Animation (Timeline) palette

When you start trimming, splitting, and moving layers in the Timeline, the look of the layers changes to help you visualize the edits you are making. This can be confusing until you understand what all the different colors represent. In Figure 13.8, you can see that the Layer Duration bar looks different, depending on whether there is content available or if that content is visible.

FIGURE 13.8

The color of the layer duration bar indicates where content is available and visible.

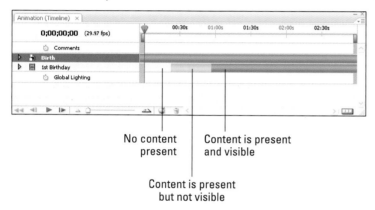

No content present

Content is present and visible

Content is present but not visible

When you place a video file in the Timeline, the entire file is always available to you, no matter how many times you trim or split it. Trimming a file changes the visibility of that file, but just like a hidden layer, the visibility can always be restored. You can do this by simply dragging the ends of the dark-green areas of the layer duration bar into the light-green areas to restore visibility. You can also place the current-time indicator anywhere in the light-green area and choose Trim Layer Start to Current Time or Trim Layer End to Current Time, which moves the dark-green area back to the current-time indicator. Of course, you'll be working blind if you use this method because the light-green area isn't visible. If your layer duration bar is light gray, this indicates there is no content in that area. As you add more files to your video project, you'll see this more often, as some of your files will have a longer duration.

Moving Video Layers

Moving video layers is a straightforward process. It consists of changing the position of your video layers so that they appear in different areas of your Timeline. You'll probably find yourself frequently dragging layers around without even thinking about it as you work on your video project.

You can move your layers around several different ways. You can change the layer hierarchy to give the top layer precedence over other layers; you can drag layers into different positions in the layer duration bar; or you can change them precisely by using the Animation (Timeline) menu to set their in and out points.

Changing the layer hierarchy

Changing the layer hierarchy in a video project is done exactly the same as any other project. As you work in the Timeline, don't forget that the Layers palette is very much part of your work area, as well. You can select, delete, and move layers in the Layers palette. To move a layer up or down in the hierarchy, click it inside the Layers palette and drag it into position.

Dragging layers inside the layer duration bar

To change the relative position of a video in your Timeline, you can simply click and drag its layer duration bar back and forth inside the Timeline. There isn't a distinguishing button for this action, but if your layer is visible, you can preview the movement in the document window. It looks a lot like changing the position of the current-time indicator manually, but, of course, the layer is moving rather than the indicator. As mentioned earlier, you can drag a layer right past the beginning or end of the document, effectively trimming the ends of the layer. This content is available even then, because you can always drag it back into the document.

Changing the position of the layer in and out points

The most precise way to move a layer is to use the palette menu to change the layer in or out point to the position of the current-time indicator. Simply move the current-time indicator to the position that you want the layer to begin or end, and select Move Layer In Point to Current Time or Move Layer Out Point to Current Time. This slides the indicated end of the layer to the current-time indicator. If the layer has been previously trimmed, the layer in/out point is defined as the visible end of the layer (see Figure 13.9).

FIGURE 13.9

After moving the layer in point to the current-time indicator, the trimmed section (light green) is still before the current-time indicator, and the "in point" is defined as the beginning of the visible section of the video layer.

Splitting Video Layers

Splitting a video layer consists of cutting the layer into two sections. In Photoshop, splitting a layer creates two layers: the layer with the video content before the split and the layer with the video content after the split.

To split a video layer, move the current-time indicator to the location where you want to split the video and choose Split Video Layer from the Animation palette menu. When a video layer is split, it is divided into two layers, with the beginning of the split video segment on one layer and the end on another (see Figure 13.10). If you watch a video right after you split it, you won't see any difference in the video playback.

You can see from looking at the layer duration bars that the full content of the video file is on both layers. This means that you can drag either layer to duplicate the content of the other one. In fact, this is a viable reason to split the layer in the first place. By dragging out the end of one of these layers and repositioning it, you can create a stutter effect in the video (great for kissing shots).

FIGURE 13.10

Splitting a layer creates two layers from one.

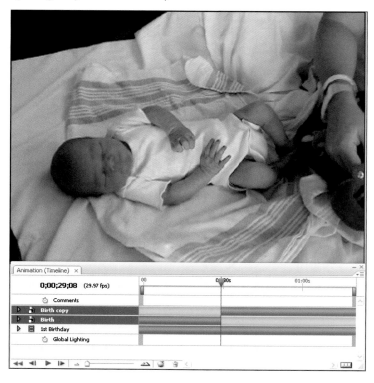

Another reason to split video layers is to insert something in between the two clips — another video, a still shot, or a title. Figure 13.11 shows a title placed after the first segment of the split video, the first birthday video placed after that, and the second half of the birth video coming back in after a few seconds of watching the first birthday party.

As you saw in Figure 13.11, it doesn't take very many split layers with other layers added to make the Animation palette look busy. When you look at the Layers palette, you only have to understand how the layer hierarchy works to know which layers are visible. When you look at the Animation (Timeline) palette, you need to understand the hierarchy and the layer duration bar.

In Figure 13.12, the layers are clearly marked so that you can see which layers are visible and when. Follow the layer hierarchy down to the first visible layer. That layer is visible until another layer higher up in the hierarchy takes its place. Once the top layer ends, the bottom layer in the hierarchy is the only one visible, and so it is played until it is superseded by the second layer, higher up in the hierarchy. The concept is simple, but as you add more layers, it can look very intimidating. Even if you understand exactly how it works, it will take practice and experience to understand what is happening with the layers at a glance.

FIGURE 13.11

Splitting a layer allows you to insert other layers between the two segments.

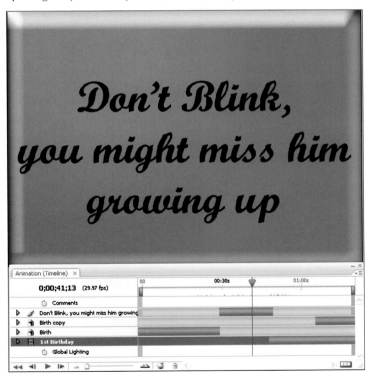

TIP You can set layer favorites to show only the layers that you are working with at any given time. Choose Set Layer Favorites from the Animation (Timeline) palette menu.

FIGURE 13.12

First, look at the layer hierarchy, and then look for the first active layer.

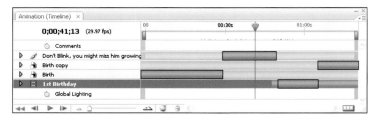

Lifting and Extracting Unwanted Sections of Video

Lifting and extracting unwanted sections of video clips your video layer and takes unwanted sections out of your video in just one step. You can lift or extract any portion of a video layer: beginning, middle, or end. Lifting a video creates a gap in the area that the video once occupied, and extracting the video takes the video out and closes the gap, so that the video layer plays continuously.

Lifting a section of a video layer

Lifting a section of a video layer takes the work area out of the video, leaving a gap in the video the size of the video that has been removed.

To lift a section of your video, set the work area around the section that you want to lift. Choose Lift Work Area from the Animation palette menu. The video layer becomes two video layers, and a gap is created inside the work area. You can see in Figure 13.13 that the work area is empty. Now you can place another file to fill the gap.

NOTE You can change the work area by sliding the blue beginning and end markers to surround the area that you want to work on. This allows you to limit the rendering process so that your system resources aren't taken up in rendering video that, at the moment, you are not interested in previewing. The work area is also used to perform edits, such as lifting and extracting portions of your video layer.

FIGURE 13.13

Lifting the work area deletes the video layer inside the work area, but leaves a gap where the video used to be.

Extracting a section of a video layer

Extracting a section of video is a little different. Rather than deleting the video and leaving a gap, extracting it deletes the video and closes the gap. This is the easiest way to simply delete unwanted video from the middle of your video file.

You can extract a section of a video layer by setting the work area around the section that you want to delete. Choose Extract Work Area from the Animation palette menu. The video layer becomes two video layers, and the second portion of the video is moved into the work area to close the gap created by the extraction. Figure 13.14 shows that the extracted video has been replaced by the remaining video. This allows uninterrupted playback of your video file without having to fill the gap that is created by lifting a video file.

FIGURE 13.14

Extracting the work area deletes the video layer inside the work area and closes the gap.

Performing Slip Edits

Performing a slip edit is simply a matter of dragging video footage through a trim, gap, or extraction in that video footage. For example, I created a gap in my footage by lifting the work area. Now I want to add another video file to fill the gap. I add the file and trim the ends to fill the gap perfectly (see Figure 13.15).

Extracting the work area deletes the video layer inside the work area and closes the gap.

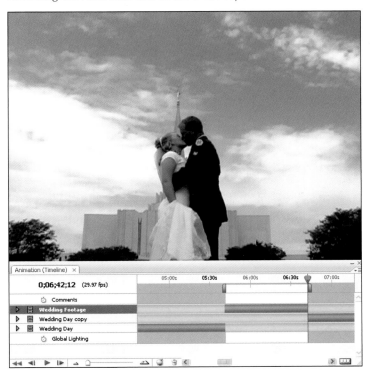

After I trimmed the new video clip, I realized that I wanted a slightly different section of video. Without the capability of a slip edit, changing this clip would be a multistep process. I would have to drag the ends of my video to the portion of the clip I wanted and then drag that section back into place to fill the gap. A slip edit can do all this in just one easy step.

To perform a slip edit, simply grab the light-green area at either side of the video clip and push it into the visible content. The content stays in the same place, but the video contained inside the content changes. It's fun to watch, and difficult to show you with the still images in a book, but you can see in Figure 13.16 that the content has changed in relation to the current-time indicator.

FIGURE 13.16

Use the light-green area in the layer duration bar to push the content through the active video segment.

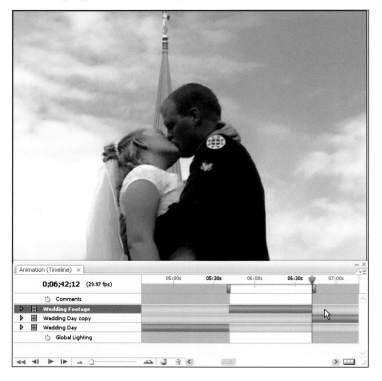

When you are trying to slip edit, be sure that you click the light-green area to drag your video content. If you click the dark-green area, you'll drag the active video segment through the Timeline rather than moving the video content through the active segment (see Figure 13.17).

FIGURE 13.17

Clicking the dark-green, or active, segment of the layer moves the segment through the Timeline.

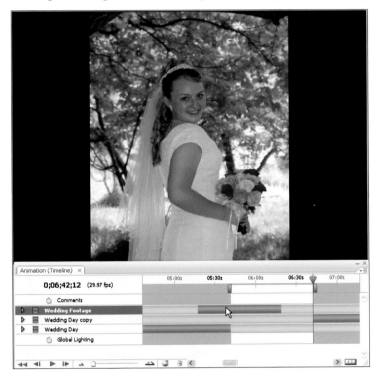

Adding 3D or Image Files to a Video Project

Adding still images or 3D models to a video file is very similar to adding video files. There are lots of reasons to add them: You may be creating a title screen for your video, adding a background, or creating a special effect. These kinds of files look different from a video file in the Timeline as well as the Layers palette, and so I'll show you some of the things that distinguish these files.

Adding a still image to a video project

Adding a still image to a video project will add a new layer consisting of that image to the Layers palette and consequently the Animation (Timeline) palette. There are several different ways to add a still image to your video project. In this case, the term "still image" represents all of the different kinds of images that can be manipulated in Photoshop, such as photos, painted images, vector images, and text. It therefore makes sense that there are so many ways to add them, from creating a new layer to placing a separate file.

Creating a new layer

If you are building an image rather than importing it, you'll want to create a new layer for the image, especially if your other layers consist of video files. You can add a layer by creating a blank layer or by creating text.

Adding a blank layer

To add a blank layer, simply click the New Layer button at the bottom of the Layers palette. You can also choose Layer ➪ New ➪ Layer (Shift+Ctrl+N or Shift+⌘+N). A new layer is created in both the Layers palette and the Timeline (see Figure 13.18). Change the name of your layer immediately. You can move your layer up and down in the layer hierarchy by dragging and dropping it in the right spot in the Layers palette. An empty layer is a blank canvas waiting for you to create whatever you want.

FIGURE 13.18

Adding a new layer is as easy as clicking the New Layer button in the Layers palette.

Adding a text layer

Adding a text layer is as simple as selecting the Text tool from the Toolbox, clicking in your document, and typing the text. A separate text layer is automatically created, which allows you to move and edit the text separately from the rest of the file.

Creating a title

Creating a title for a video project is the perfect example of optimizing the Photoshop tools to create the best results for your video project. You can create a title for a video file in Photoshop, or you can create a title separately to import into a video project being created in a different application. Either way, the tools in Photoshop make it easy to create a custom title.

You can create a title for a video file by using a text layer in conjunction with a background layer. Follow these steps:

1. Click the New Layer button in the Layers palette to create a blank layer.
2. Change the name of your new layer to Title Background.

3. Choose Edit ➪ Fill, or use the Paint Bucket tool to fill the layer with a solid color.

4. From the Styles palette, click the Blue Glass button. This creates a blue beveled background (see Figure 13.19).

FIGURE 13.19

The Styles palette contains preset styles that can save time by adding several styles to the selected layer when you click a single button.

5. Double-click Color Overlay in the list of effects for the Title Background layer (see Figure 13.20). This displays the Layer Style dialog box.

FIGURE 13.20

You can use a preset style and then customize it by clicking on any of the styles to open the Layer Style dialog box.

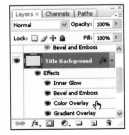

6. Change the color of the overlay to the color you want in your title and click OK.

7. Select the Text tool from the Toolbox and click the background image.

8. Type the text for your title. Change the font, size, and color of your text using the Text toolbar. Give the text a warp, if you want.

9. With the new text layer selected, click the Layer Style button (*fx*) at the bottom of the Layers palette to open the Layer Style dialog box.

10. Here's your chance to have some fun applying the styles to text. You can get ideas from the style added to the background, or just play around until you have a style that you like (see Figure 13.21).

FIGURE 13.21

Make your text pop by using the Layer Style dialog box to change or add styles to it.

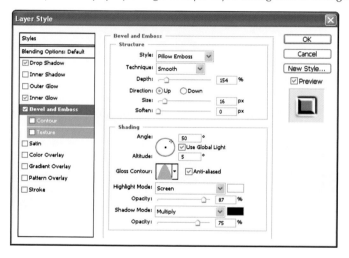

11. If you want to be able to duplicate this style for all the titles in your video, choose Styles ⇨ New Style in the Layer Style dialog box. Name your style and click OK. Now you can apply this style at any time by clicking it inside the Styles palette.

12. Close the Layer Style dialog box by clicking OK.

13. Select both the text layer and the title background by holding the Ctrl (⌘) key as you click both layers.

14. Right-click a layer and then select Merge Layers from the menu. Your title is now one layer that is easy to maneuver (see Figure 13.22).

FIGURE 13.22

The finished title can be merged into one layer, making it easy to work with in the Timeline.

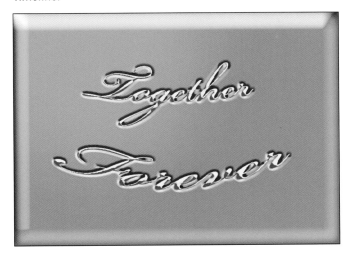

CAUTION Before performing the last step, be certain that the title is just the way you want it to look. Although merging the layers makes them easier to work with in the Animation (Timeline) palette, after you merge the layers you won't be able to change the styles or edit the text.

This is one example of how you can create a title for a video project. Of course, in Photoshop you don't have to limit your creativity to simple elements like text and solid colors. Feel free to create anything you want. Any layer you add to the Layers palette will be in the Timeline for you to work with in your video file.

Adding or placing an image file

If you have a photo or an image that is a separate file, you need to add it to your video file for it to be part of your project. This is easily done by choosing File ➪ Place and browsing to the file you want to add. The file is added to the video file in a bounding box that you can scale and rotate to place the file just how you want it inside your video project.

You can also drag a new file in by clicking the layer containing the still image and dragging it into the window of your video file. You can also copy and paste all or part of an image file.

Placing or dragging an image into your video file creates a new layer in your video containing the new image file. If you copy and paste an image, be sure to create a blank layer to paste it into. However you import an image, make sure the layer is labeled well and placed in the hierarchy where it needs to be.

Adding or placing a 3D model

You can add or place a 3D model in the same way you can add a still image: simply choose File ⇨ Place, or click and drag the object into your file.

You can also choose Layer ⇨ 3D Layers ⇨ New Layer From 3D File. This command adds the object as if it has been dragged in, and you are not given a bounding box to change your placement options.

If you drag a 3D object from its own file or create a new layer from a 3D file, the 3D object is imported as a 3D layer. You can transform the 3D object directly from the file in which it has been placed.

When you use the Place command to place a 3D object in any other type of file, the 3D object becomes a Smart Object. You can still edit it and transform it, but you must open the originating file to do so. This creates an extra few steps in the editing process.

A 3D object is distinguished in the Layers palette by the 3D icon in the corner of the layer thumbnail. A Smart Object has a different icon, as you can see in Figure 13.23.

FIGURE 13.23

Placing a 3D object creates a Smart Object; dragging it in leaves it as a 3D object.

Column brought in by choosing
Layer⇨3D Layer⇨New Layer
from 3D file

The columns were placed
using File⇨Place

Looking at still image and 3D layers in the Timeline

In this chapter, you've seen a lot of examples of how new layers look when added to the Layers palette. However, you're also concerned with the Animation (Timeline) palette. What does an image or 3D layer look like in the Timeline? Take a look.

Figure 13.24 shows the title from the previous section, and some new 3D objects in the Timeline. You can see by their duration that they are determined to dominate the screen at any given time. Any file that is not a video file is added for the entire length of the document in the Timeline. This simply indicates that the layer is available anywhere in the Timeline. You can use your new trimming and extracting skills to place these files not only where you want, but also when you want.

Figure 13.25 shows one other basic difference between a video layer and other layers. A video layer always contains the altered video property, indicating that you can modify it frame by frame. Other layers don't contain this property. This makes sense, because the other layers would only be one frame if they had this property. They can be changed and transformed at any time, and the changes will be effective throughout the video.

FIGURE 13.24

Still images and 3D objects are placed in the Timeline to fill the entire document.

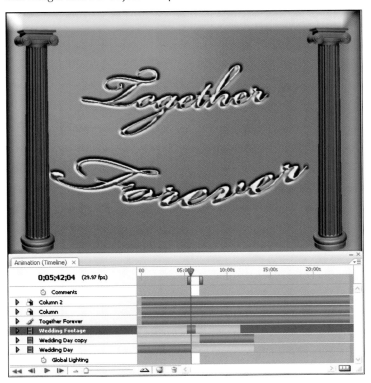

FIGURE 13.25

Video layers contain an Altered Video property; other layers do not.

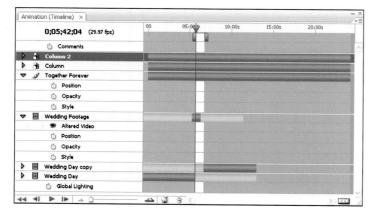

Creating Transitions

As you add new files and layers into a video, you may find that you want to create transitions from one image to another. Creating transitions is limited in Photoshop, because most video editing applications contain at least a few standard transitions that can be placed with a click of the mouse into a video file. You can create any number of cool transitions from scratch in Photoshop, however, and although this may not make up for the lost ease of one-click transitioning, it can be a lot of fun.

Many of the cooler transitions are created using advanced Photoshop techniques, of course. Because I have yet to cover most of these techniques when it comes to video editing, I'll you show a quick and fairly simple example of creating a transition. Keep in mind as you read the next few chapters that all the Photoshop techniques that create great special effects in video are also available to create great transitions.

The easiest transition to do is a fade. This is accomplished very easily by animating the opacity of the ends of the layers going out and coming in. Dragging one or both layers to overlap each other makes the fade incorporate both layers at the same time. In Figure 13.26, you can see how this works.

This transition could just as easily be done by animating style or position, or creating a cool filter over the transition.

FIGURE 13.26

Create a transition by animating the opacity between two layers.

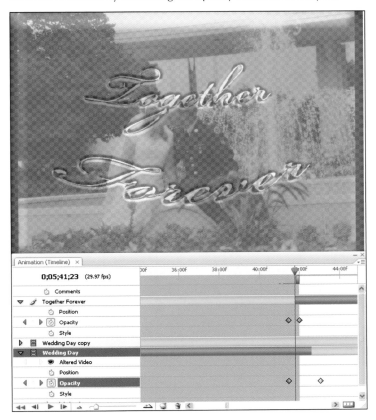

Summary

In this chapter, you learned a lot of the basics of how video layers look and move in the Timeline and how to edit them by:

- Opening and placing video files
- Trimming video footage
- Moving video layers
- Splitting video clips

- Lifting and extracting unwanted video clips
- Slip editing video footage
- Adding images and 3D files to a video project
- Creating transitions

In the next chapter, I show you how to change the video footage and make some edits that will make a difference.

Part V
Correcting Video Files and Creating Special Effects

Correcting a video file consists of changing the color or tone or removing defects in the file to make it look more realistic or to keep imperfections or unwanted elements from detracting from the subject of the video. There are numerous filters and adjustments to make these changes. You will be shown how to use filters, adjustments, and the cloning and healing tools to improve the look of your video. Learning how to apply these elements effectively to a video file and the basics of the elements themselves will help you to make the corrections necessary for your individual projects.

Video special effects can be anything from creating a picture-in-picture effect to creating a liquid metal video to anything you can imagine. Using the same elements used to correct video, you can create countless effects. You will be shown several examples of different ways to create these effects that will give you a good base to move ahead confidently in creating your own special effects.

Chapter 14

Using Filters to Correct Video Files or Create Special Effects

When you import a video into Photoshop, it isn't to create a video project. Chances are you just want to make a few needed edits and send it back to Adobe Premiere or another video-editing application. Adding a filter to your video is one of the ways in which this can be accomplished. You can use a filter to sharpen the video to give it a crisp look, to soften and blur your video for a soft look, or to reduce the noise, dust, and scratches on old or badly captured video.

Filters can do so much more than just improve the quality of your video file, however. The special effects that can be created are limitless. Are you interested in creating a liquid metal video? How about adding spotlights? Maybe you'd like to add an underwater undulation. All this and much, much more are possible using the filters in Photoshop.

IN THIS CHAPTER

Using Smart Filters on a video layer

Correcting a video layer using filters

Adding filters to a video layer to create special effects

Turning a Video Layer into a Smart Object

Smart Objects are new to Photoshop CS3 and are among the major advancements in CS3. They allow you to apply filters to a layer by adding those filters as sublayers. These filters are called Smart Filters.

There are several benefits of turning a layer into a Smart Object. Changes that are made to a Smart Object are never destructive to the original file, even if that file is already in PSD format. When you change a layer into a Smart Object, the original file can only be accessed by double-clicking the Layer button and opening the original file in its own window. Changes made and saved to the original file are automatically updated on any instance of that file as a Smart Object.

Another huge benefit of a Smart Object is the separate sublayers that contain each filter as seen in Figure 14.1. Having separate layers for each filter allows you to rearrange them, edit them, toggle the view on or off, or delete them entirely, no matter when they were added to the Smart Object.

Figure 14.1 shows an example of a Smart Object with three filters applied. You can click and drag these filters to rearrange them, just as you would any layer. You can also see that each one has an eye icon, enabling you to view the effects of the filter or to remove the effects filter temporarily. Double-clicking any one of these Smart Filter layers displays the dialog box shown in Figure 14.2, which allows you to change the settings of that particular filter. You can also click and drag any one of these layers to the Delete button to delete it permanently.

CROSS-REF Although a good overview of Smart Objects is presented here, they are covered more fully in Chapter 4.

FIGURE 14.1

Smart Filters are placed on a sublayer under the Smart Object so that they can easily be edited.

Changing a video layer into a Smart Object not only has the same benefits as changing an image to a Smart Object, but it completely changes how that video layer can be edited. I'll show you what that means.

You can add a filter to just one frame of video by following these steps:

1. Open a video file.
2. Choose Window ➪ Animation to display the Animation (Timeline) palette if you don't already have it displayed.
3. Click the triangle next to the video layer to display the Layer properties, including the Altered Video layer property.
4. Use the Zoom Slider to stretch the Timeline so that each individual frame is easy to discern.
5. Choose Filter ➪ Filter Gallery.
6. From the Distort menu, add the Glass filter. Use whatever settings you want.
7. Click OK.

FIGURE 14.2

Double-clicking the Glass filter opens the Filter Gallery so that you can make changes to the filter.

Observe the changes you have made as demonstrated in Figure 14.3. You have a normal video layer in the Animation (Timeline) palette. The Timeline is stretched so that each frame is easy to see. This layer, labeled Jeepin', has the usual layer properties, as well as the Altered Video property that allows you to change it frame by frame.

Adding a Glass filter to this video layer changes one frame in the video layer. The purple bar inside the Altered Video layer property shows that one frame has been altered. When you move to the next frame, the filter is no longer applied.

Does this mean that to add a filter to the video, it must be added frame by frame throughout the entire video? Not at all. This is where turning the video file into a Smart Object comes into play. Before you add a filter to the video, you are going to change the video layer into a Smart Object first.

FIGURE 14.3

A Glass filter is added very easily to give the jeep an interesting look.

To change a layer into a Smart Object, choose Filter ⇨ Convert for Smart Filters. Before Photoshop converts your layer into a Smart Object, it displays a warning to let you know that it is doing this. There are downsides to turning your layers into Smart Objects. When you want to make changes to the original file, such as transforming 3D objects, having a Smart Object means extra steps in the process. You can't even paint directly onto a Smart Object. There are also filters that can't be added to a Smart Object: Liquify, Pattern Maker, and Vanishing Point. You can always access the original file to make these changes, but as you will see as you work with a video file, it requires a few extra steps.

You can see the effect that changing a video layer into a Smart Object has by following these steps:

1. Open a video file.

2. Choose Window ⇨ Animation to display the Animation (Timeline) palette if you don't already have it displayed.

3. Click the triangle next to the video layer to display the layer properties, including the Altered Video layer property.

4. Choose Filter ➪ Convert For Smart Filters. A warning that you are converting your file to a Smart Object appears. Click OK.

5. Choose Filter ➪ Filter Gallery.

6. From the Distort menu, add the Glass filter. Use whatever settings you want.

7. Click OK.

When you change a layer into a Smart Object, the thumbnail in the Layers palette changes to show that the layer is treated differently. Figure 14.4 shows the Layers palette with a video layer and with a Smart Object layer. The Smart Object thumbnail is universal for all types of files, and so a video layer that has been converted to a Smart Object doesn't look any different in the Layers palette from a photo that has been converted.

FIGURE 14.4

Converting a layer to a Smart Object changes the way the thumbnail looks in the Layers palette.

Video Layer icon Smart Layer thumbnail

After you convert a video layer to a Smart Object, you can see a difference in the Animation (Timeline) palette as well. Figure 14.5 shows the Animation (Timeline) palette after the video layer has been changed to a Smart Object. There is no Altered Video property for a Smart Object. Now this layer is just like an image or 3D layer; any changes made to it affect the entire layer.

Now when the same filter is added to the video file, it affects the entire layer, and the filter is applied as a sublayer in the Layers palette. As you play back your video, you'll see the filter's effects all the way through.

FIGURE 14.5

There is no Altered Video property in a Smart Object, even if it was once a video layer, so the Smart Filter is applied to the entire layer.

After you convert a video layer to a Smart Object, you can still make all the same changes and in the same way that you made to the video layer. You can do this by double-clicking the Smart Object layer thumbnail. Photoshop opens the original document containing a video layer to which you can make frame-by-frame changes by using the Altered Video property (see Figure 14.6). When you finished making changes to the original file, save it, and the changes are reflected in the new file containing the Smart Object. As mentioned earlier, this adds a few steps to the editing process, but it is still fully available, so don't hesitate to turn your layer into a Smart Object if you want to apply a filter across the entire video layer.

In essence, having the option to turn a video layer into a Smart Object gives you full editing capability; you can apply a filter frame by frame, or you can apply the filter to the entire video clip. The method you use depends on the effect you are trying to create, of course. Using a filter to correct a video layer usually incorporates the entire file. If you are creating special effects, however, you may want to change your filter frame by frame or add it to a small segment of your video.

CROSS-REF If you want to apply the filter to a segment of a video clip, simply create one or more layers from your video using the editing tools that are covered in Chapter 13.

Now that you understand the different ways that you can add a filter to your video file, the next section discusses the actual filters so that you can see the advantages of using them.

FIGURE 14.6

Double-clicking the thumbnail of a Smart Object gives you two files to work with: a video layer that can be changed frame by frame, and a Smart Object file.

Using Corrective Filters

Some of the filters in Photoshop are used to correct a file rather than to add a special effect. The Sharpen filters can be used to sharpen a video image, The Blur filters will soften the image, or use the Noise filter to reduce noise and remove dust and scratches. You can use these filters to enhance high-quality video subtly, or to correct old video that has several major problems.

Sharpening a video file

There are five Sharpen filters in the Filter menu. The Sharpen, Sharpen Edges, and Sharpen More filters are applied instantly, without input from the user. They can be applied automatically and do just what they say. Applying the Smart Sharpen or Unsharp Mask filter opens a dialog box where you can adjust the levels of sharpness on your video.

Using the Unsharp Mask filter

The Unsharp Mask filter increases the sharpness of a file by increasing the contrast between the edges in an image. It determines these edges by comparing the brightness values of the pixels to adjacent pixels in the image. Wherever the brightness values differ, the brighter pixels become brighter and the darker pixels become darker. To use the Unsharp Mask filter, choose Filter ➪ Sharpen ➪ Unsharp Mask, and the Unsharp Mask dialog box appears. The Unsharp Mask dialog box has three adjustable settings: Amount, Radius, and Threshold (see Figure 14.7). As you adjust the settings, you can preview their effects in the Preview window in the dialog box, as well as in the file window, so that you can achieve the exact effect you want with no guesswork. To help you understand what each of these settings represents, the following sections cover them in more detail.

FIGURE 14.7

The Unsharp Mask dialog box.

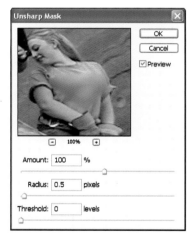

Amount

The amount is simply a numerical representation of how much you want the filter to sharpen your video file. The default setting is 100, which is a good intermediate setting. The percentage ranges from 1 to 500, but you'll notice that 100 is a little more than halfway up the slider setting, a sure sign that the numbers surrounding it are the more common settings for this feature.

As you adjust this setting, be aware that it is affected quite a bit by the other two settings, especially the radius. Turn the amount up to 200 percent and you could have an image that looks great at a radius of .5. Turn the radius up to just 2, and you've a grainy, high-contrast image that doesn't look nearly as good. Leaving the radius at 2 and reducing the amount back to 100 percent produces a better result (see Figure 14.8).

FIGURE 14.8

Changing the radius setting affects the amount of sharpening that looks good in an image.

Amount 200%, Radius .5

Amount 200%, Radius 2

Amount 100%, Radius 2

Radius

The Radius is defined by the thickness of the edges in your image. The Radius setting simply determines what thickness those edges will be. Although the radius can be adjusted anywhere from .1 to 250, any number higher than 2 or 3 will result in an image that is very high in contrast. This is also affected by the Amount settings, of course.

The ideal Radius setting for any given document can be determined based on the resolution of the document; the higher the resolution, the higher the Radius setting should be. The resolution of most video files is 72 ppi, a very small resolution. For a 72 ppi video file, the ideal Radius setting is .5. As an image becomes higher in quality, you can set the Radius slightly higher by dividing the resolution of the image by 150. That gives you a Radius setting of 1 for a 150 ppi image, 2 for a 300 ppi image, and so on.

Threshold

The Threshold is simply a determination of how different two pixels have to be before they can be considered an edge. A Threshold setting of 0 sharpens the entire image. As you turn the threshold up, the difference in the brightness values between two neighboring pixels must be higher than the threshold number for those pixels to be affected by the Unsharp Mask. If you have an image with high contrast, the threshold can be set relatively high, and the Unsharp Mask will still affect the image.

As you change the settings on the Unsharp Mask filter, or any filter for that matter, be conservative. Remember that you are working with a video file that is full of images of all different colors and contrasts. Using one image to determine your settings can have disastrous results for the rest of the video as you can see in Figure 14.9. This is a great time to start splitting the video clip and applying different effects to different areas of the video.

Using the Smart Sharpen filter

The Smart Sharpen filter is all of that and then some. Not only can you define the amount and radius of the Sharpen effect, but you can remove blur caused by camera motion or motion inside the shot. If you select the Advanced settings, you can define the sharpness of the shadows and highlights, as well. To open the Smart Sharpen dialog box, choose Filter ➪ Sharpen ➪ Smart Sharpen (see Figure 14.10).

FIGURE 14.9

Sharpening the image to create crisp, crystal water droplets makes the rest of the video clip look horrible; the edges in the second image are so sharp and full of contrast that it is hard to distinguish the features of the bride and groom.

FIGURE 14.10

The Smart Sharpen dialog box.

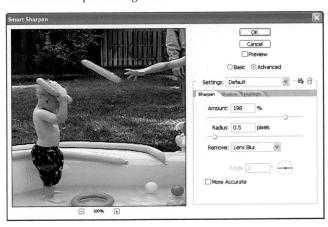

Choosing the Remove setting

The Remove setting allows you to set the parameters for the Smart Sharpen filter by indicating what kind of blur you prefer to remove from the image.

- **Gaussian Blur:** If you set the Remove setting to Gaussian Blur, you are sharpening the picture overall. The Unsharp Mask removes the Gaussian Blur by default.

- **Lens Blur:** Setting the Remove setting to Lens Blur counteracts the blur that can be created by a shorter focal length. This setting sharpens edges and detail, and reduces the halos that can be caused by other sharpening methods.

- **Motion Blur:** This setting removes or reduces the blur caused by camera motion or the motion of the subject. If you choose Motion Blur, you can also set the angle to set the specific direction the blur should be reduced. This is probably not an option that you'll use much with video, unless you have film that is capturing motion in just one direction, such as a race.

Shadow and Highlight settings

By selecting the Advanced option in the Smart Sharpen dialog box, you can target the shadows or highlights of your video for sharpening. The settings are the same for both, and they are very similar to those found in the Unsharp Mask dialog box, but with slightly different names.

- **Fade Amount:** This is simply the amount to sharpen the shadows or highlights. You can choose a value from 0 to 100 percent.

- **Tonal Width:** This is similar to the Threshold setting; it determines how dark (or light) a pixel needs to be before it is considered a shadow or highlight. The lower the Tonal Width value, the fewer pixels that are affected.

- **Radius:** This determines how large the area around a pixel is used to determine whether it is a shadow or highlight.

In short, Smart Sharpen is a very powerful tool for precisely sharpening an image. It is a harder tool to use on video, however. Just like Unsharp Mask, it needs to be used conservatively. Using such a precise method of sharpening is more useful to video that is very similar throughout. However, by working conservatively, sharpening a video can produce very good results (see Figure 14.11).

Blurring a video file

The Blur features in Photoshop are so varied and powerful that they could arguably be placed in the special effects category. There are 11 blur filters in Photoshop. Some of them soften your video files, and some of them take the files for a spin. You can use the Blur filters by choosing Filter ➪ Blur.

FIGURE 14.11

Before and after using the Smart Sharpen filter.

The Blur filters are the exact opposite of the Sharpen filters: Instead of increasing the contrast between pixels, they reduce contrast to produce a softer, less focused image. The Blur feature you choose determines how the contrast is reduced. If you select the Gaussian Blur, for example, each pixel is compared to pixels around it in an even radius; pixels that are closer receive higher weight than pixels that are farther away. Choosing the Blur filter softens the edges in your image by blurring only those pixels that are in high-contrast areas. If you select a Box Blur, each pixel is compared to pixels around it in a box shape, giving the end result an edgier appearance. If you really want an interesting result, select a Shape Blur, from which you can choose dozens of shapes to use for the pixel comparison.

Automatic Blur filters

The first three blur filters on the list are automatic Blur filters, meaning that they don't require any input from the user. These filters are Average, Blur, and Blur More.

The Average filter takes the average color of the frame (or selected area) and fills the entire frame with that color. Not a great photo enhancer, but it could be useful for creating matching backgrounds when placing odd-sized photos in a video file.

The Blur and Blur More filters automatically smooth the color transitions in an image to soften the edges. The Blur More filter is three or four times stronger than the Blur filter, but both are very subtle.

The Gaussian, Box, and Shape Blur filters

The Gaussian Blur, Box Blur, and Shape Blur filters blur all of the pixels throughout an image or selection rather than selected pixels in high-contrast areas as the Blur and Blur More filters do. The pixels are blurred by reducing the contrast between each pixel and surrounding pixels. The surrounding pixels are determined by which filter you use and the radius setting.

The Gaussian Blur compares the pixels in an even radius around each pixel and applies a weighted average to each pixel to reduce its contrast to the surrounding pixels. Its effect is a general softening of the image. You can apply a Gaussian Blur filter by choosing Filter ➪ Blur ➪ Gaussian Blur to open a dialog box that allows you to set the radius of the blur. The radius is the number of pixels around each pixel to which it will be compared. The Gaussian Blur is a very smooth blur, as you can see in Figure 14.12.

FIGURE 14.12

A Gaussian Blur has been liberally applied to the background to demonstrate clearly the effect.

A Box Blur compares the pixels in a box shape rather than the feathering-out comparison of the Gaussian Blur. The result is a blur with edges. The Box Blur can be applied by choosing Filter ➪ Blur ➪ Box Blur. This filter has the same dialog box as the Gaussian Blur, consisting of a preview window and a Radius setting. With the Radius set to 30, you can clearly see the difference in the Blur filters in Figure 14.13.

FIGURE 14.13

The Box Blur gives the background an edgy look.

As if having a soft blur or an edgy blur weren't enough, Photoshop gives you the choice of literally dozens of shapes to use when comparing pixels. This works in just the same way as the Gaussian and Box Blur, except the pixels are compared to one another in the shape chosen. It's quite possible that someone at Adobe had too much time on his or her hands, but the result can create some very interesting blur effects.

Open the Shape Blur dialog box by choosing Filter ➪ Blur ➪ Shape Blur. You can see in Figure 14.14 that the dialog box is full of all sorts of fun shapes that you can use in the Shape Blur filter. Click the triangle next to the list of shapes to choose from a menu of all the available shapes. Of course, the Preview window and the Radius setting are part of the dialog box, as well. The higher you set the Radius, the more likely you are to see a real difference in the effects created by each shape. Figure 14.14 is an example of what the arrow shape will do for this blur effect.

The Motion and Radial Blur filters

The Motion and Radial Blurs create the illusion of motion in your video file. The Motion Blur simulates movement in a straight path, determined by setting the angle in the dialog box. You can see the dialog box and the effects in Figure 14.15.

The Radial Blur can be set to Spin or Zoom. The Spin setting creates an illusion that the image is spinning in a circular motion. The Zoom setting blurs the edges of the image to a greater degree than the center, creating the illusion that the image is moving rapidly toward or away from the viewer. Figure 14.16 shows the result of using the Radial Blur.

FIGURE 14.14

The Shape Blur, with a radius of 30 (as in the previous examples) has a completely different look than either the Gaussian Blur or the Box Blur.

FIGURE 14.15

The Motion Blur creates a directional blur.

FIGURE 14.16

The Radial Blur offers both Spin and Zoom options.

Surface Blur filter

The Surface Blur filter is the opposite of the Blur and Blur More filters. Rather than softening the edges, the Surface Blur works by softening the midtones, leaving the edges sharp and crisp. This is perfect for smoothing out slight imperfections or noise in a video file without losing the crispness of the file.

Smart Blur filter

The Smart Blur filter allows you to blur with more precision. The Radius and Threshold settings allow you to specify the number of pixels involved and what the difference in the pixels should be before the filter is applied to them. You can also choose the quality of the Blur filter: High, Medium, or Low.

The Smart Blur can also create some great special effects. You can choose a Normal blur, which gives you the expected results, or you can choose Edge Only or Overlay Edge. The Edge Only setting turns the image entirely black and creates white edges. The Overlay Edge setting overlays the edges in the image with white. You can see an example in Figure 14.17.

FIGURE 14.17

Using the Overlay Edge setting in the Smart Blur has unexpected results.

Lens Blur filter

The Lens Blur filter is by far the most advanced Blur filter available. It includes a very involved dialog box that allows you to change the field of depth, as well as the highlights of your image.

The whole point of the Lens Blur is to allow you to blur parts of your image while leaving other areas in sharp focus. It is very difficult to use the Lens Blur filter with any kind of precision on a video file without going frame by frame, and so this filter is not covered in detail. Figure 14.18 shows the options found in the Lens Blur dialog box.

The Lens Blur dialog box shows a full preview of your image by default. Because the Lens Blur will probably affect different areas of your image differently, you can see the effects the changes you make have on your full image. Because the precise changes made by the Lens Blur can take time, you have the option of choosing between a faster or more accurate preview.

Depth Map

An image or video file in Photoshop is just a pixel map. Photoshop can't determine which areas of an image should be in focus and which shouldn't unless you specify them. Setting the Depth Map options tells Photoshop which pixels to keep sharp and which ones to blur. You can create a depth map in several ways. Clicking None from the Source drop-down list blurs the pixels in your image indiscriminately. Clicking Transparency blurs the pixels based on their Transparency values. If you click Layer Mask, the blurring is based on the grayscale values in the layer mask. If you create a gradient layer mask, for example, the lighter areas of the gradient will be less blurry than the darker areas.

FIGURE 14.18

The Lens Blur dialog box is loaded with options for creating a custom blur.

Probably the best way to create a depth map is to load an alpha channel. You can create an alpha channel by selecting a part of your image and choosing Select ➪ Save Selection. You can also create an alpha channel by duplicating one of the color channels and renaming it as an alpha channel. You can see in Figure 14.19 that I have one of each. When you create an alpha channel, it appears in the Source drop-down menu, and you can use it to determine which pixels will be blurred. Click anywhere in your image to choose the pixel brightness that will determine which areas of your picture will stay in focus.

FIGURE 14.19

The Channels palette contains an alpha channel created with a selection, and one created by duplicating a color channel.

After you select a source, you can choose the focal distance of the blur by adjusting the Blur Focal Distance slider.

Iris

The iris determines the size and shape of the aperture of a camera. The Iris settings in this dialog box allow you to simulate the different types of irises found in different cameras. You can change the Shape, Blade Curvature, and Rotation settings. The Radius setting, as always, determines the number of pixels sampled to create the blur effect.

Specular Highlights

When you blur a photograph using a mathematical formula, your whitest whites tend to get darker as they are mixed with the surrounding pixels. This never happens in a real photo, no matter how blurry it becomes. You can readjust the whites in your image by adding specular highlights. The Brightness slider will increase the brightness of the pixels in your image and the Threshold determines the brightness cutoff, letting you determine which colors will be affected by the Brightness slider.

Noise

Noise is also something that is found in a true photograph, even a blurry one. To create a more realistic blur, you can add noise to your image. Move the Amount slider up as you preview your image to determine the amount of noise that will be added. You can add noise uniformly throughout your image or by using the Gaussian curve. When you add noise, it will consist of many different colors by default. To reduce this effect, select the Monochromatic check box, and the noise added to your image takes on one tone.

Adding or reducing noise in a video file

The last corrective filter covered in this chapter is the Noise filter. Adding noise to a video file can add texture and dimension, or in the case of an animation, prevent banding that can occur as it is rendered as an animated GIF. Reducing noise and removing dust and scratches can improve the look of older or badly captured video.

Add noise

Adding noise to a video adds texture that can simulate film grain. It can be helpful for adding texture to an animation or camouflaging areas that have been corrected. Choose Filter ➪ Noise ➪ Add Noise to open the Add Noise dialog box, as shown in Figure 14.20.

You can add noise using the Uniform setting, which randomizes the values used to create the noise pattern, or the Gaussian setting, which uses the bell curve to create the values. When you add noise to an image, it can appear in varied colors, which can change the color integrity of your file. Click the Monochromatic option to create noise of just one color.

FIGURE 14.20

The Add Noise dialog box.

Despeckle

The Despeckle filter is a lot like the Surface Blur. It detects the edges in your image by finding high-contrast areas and blurs the areas between the edges, reducing the overall noise in the image.

Dust & Scratches

You can reduce the imperfections in your video file by choosing Filter ➪ Noise ➪ Dust & Scratches. The key to success with this filter is to find a good balance between the Radius and Threshold settings. Turning up the Radius setting while leaving the Threshold setting at zero quickly reduces the dust in your image, but just as quickly adds a blur to it. Increasing the Threshold setting maintains sharpness in the image and still reduces the imperfections (see Figure 14.21).

Median

The Median filter works like the Dust & Scratches filter without the Threshold setting. The Median filter searches the radius of a pixel to find pixels that are a similar brightness. If it finds pixels that are different from their surrounding pixels, it replaces them with a pixel that is determined by the median brightness value of the pixels around it.

FIGURE 14.21

Getting a good result from the Dust & Scratches filter is a balancing act between the Radius and Threshold settings.

Original Video

Radius 5, Threshold 0

Radius 8, Threshold 8

Reduce Noise

The Reduce Noise filter has the most interactive dialog box of all the Noise filters. The effect it has on your video file is not as dramatic as the effect you get when you use the Dust & Scratches filter, however.

Noise is defined as the random pixels that can appear in a file for any number of reasons, such as age, motion, high zoom levels, or saving a file as a low-quality JPEG. The different settings in the Reduce Noise dialog box help you to create the kind of noise reduction that benefits your individual file the most.

To use the Reduce Noise filter, choose Filter ⇨ Noise ⇨ Reduce Noise to open the Reduce Noise dialog box, as shown in Figure 14.22. From this dialog box, you can adjust the strength of the filter, balancing it with the setting that allows you to preserve the details of the image. Reducing the color noise removes the random color pixels in the image: the higher the setting, the more color is removed from your file.

FIGURE 14.22

The Reduce Noise dialog box.

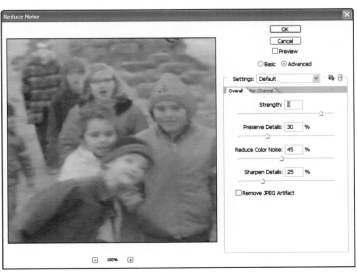

Removing the noise blurs your picture. The Sharpen Details setting is built into this feature to counteract that problem. You can use this setting, or you can use a more powerful sharpening filter after you reduce the noise.

The last feature, the Remove JPEG Artifact option, is designed to reduce the blocky image artifacts and halos that can be created when a file is saved as a low-quality JPEG image.

Using Filters to Create Special Effects

Most of the filters in Photoshop are used to create special effects. There are literally dozens of filters in several different menus. If you think that a photo looks cool rendered in the Chrome filter, wait until you see the liquid metal effect you can achieve by applying the filter to video. There are many cool filters and combinations that it's hard to know where to begin. The following section provides an overview of the Filter Gallery, as well as some of the filters that you won't find in the gallery. You can have fun creating whatever effects you want with your own video file.

Using the Filter Gallery

The Filter Gallery, shown in Figure 14.23, is like the filter fun house for images — many of the filters are available inside. To open the Filter Gallery, choose Filter ➪ Filter Gallery. The Filter Gallery contains a full preview of your video file in the left pane.

FIGURE 14.23

The Filter Gallery contains a good portion of the special effects filters that are available in Photoshop.

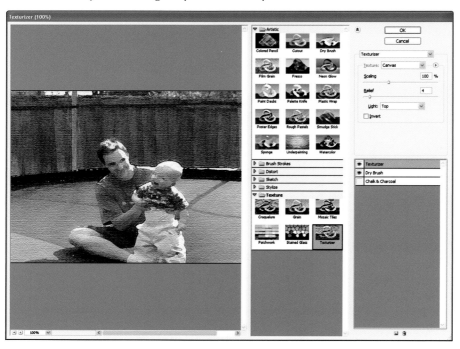

The central pane of the Filter Gallery contains the folders in which each filter is found. Click the triangle next to each folder to display the effects contained in the Filter Gallery. These folders correspond with the Filter menu, but they leave out Blur, Noise, Pixelate, Render, Sharpen, Video, and Other. The folders in the Filter Gallery also do not contain all of the filters available in the Filter submenu. The Stylize folder, for example, only contains Glowing Edges, leaving out Diffuse, Emboss, Extrude, Find Edges, Solarize, Tiles, Trace Contour, and Wind. So why use the Filter Gallery? Well, it's a great place to start if you are unfamiliar with the filters, and if the filters you are using are contained in the Filter Gallery, it certainly makes applying them much easier.

The right pane in the Filter Gallery contains the settings for the selected filter. It also contains the area that makes the Filter Gallery worthwhile. Each one is listed in the order in which they were applied with the most recent filter on top. You can create a new Filter Effect layer by clicking the New Effect Layer button at the bottom of the right pane. After you have more than one, you can change the order in which they are applied by dragging and dropping them in a different order (see Figure 14.24). To see what the preview looks like without one of the filters, just toggle the Visibility button (eye icon) off, and the visibility of that filter is turned off.

FIGURE 14.24

Moving the Texturizer effect below the Dry Brush effect dramatically changes the end result on the image.

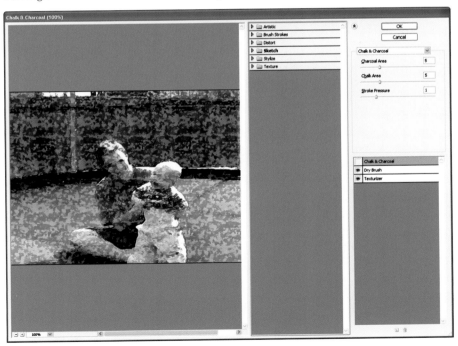

After you finish playing around with the possibilities in the Filter Gallery, click OK to accept the filter. If you are applying the Filter Gallery to a Smart Object, it appears as a sublayer to the layer to which it is applied in the Layers palette (see Figure 14.25). You can see that a possible downside of using the Filter Gallery is that filters are not listed individually in the Layers palette. It is very easy to go back and make changes to any of them at any time, however, simply by double-clicking the name of the filter (in this case, Filter Gallery) to open the Filter Gallery or dialog box.

FIGURE 14.25

If you add a Smart Filter to a Smart Object, it appears in the Layers palette.

Using other special effects filters

Quite a few filters are not found in the Filter Gallery. Some of these do not have interactive dialog boxes, and others, such as Liquify or Pattern Maker, require a dialog box that is even more advanced than the Filter Gallery.

Using filters that aren't so smart

I've already mentioned that Liquify, Pattern Maker, and Vanishing Point are unavailable as Smart Filters. These filters must be applied frame by frame to a video file. It's really too bad, because Liquify is arguably the coolest filter in Photoshop. It's also a lot smarter than most filters, despite the label that has been liberally applied to the Smart Filters.

Figure 14.26 shows the Liquify dialog box. Just a few strokes changes this poor buffalo into something fit for an alien invasion (so *that's* what they do to the cattle they steal). With an array of tools that include Twirl, Bloat, and Mirror, as well as the ability to make changes to the brush settings and full masking capability, the Liquify dialog box is almost an application by itself.

FIGURE 14.26

The Liquify dialog box.

Using the Pixelate filters

The Pixelate filters are simple filters that create different types of pixelation in your file. Figure 14.27 shows an example of each of these filters. The dialog boxes are simple, focusing on the size of the pixelation. Some of the filters, such as the Fragment filter, don't have a dialog box at all.

Using the Render filters

The Render filters range from the simple Clouds filter that creates clouds from the foreground and background colors without any input from the user, to creating a lighting effect that can require detailed input. Rendering a lighting effect is a fun and easy way to change the lighting dramatically of your video file.

To add a lighting effect, choose Filter ➪ Render ➪ Lighting Effects to open the Lighting Effects dialog box (see Figure 14.28). The preview window shows a very small preview of your entire image with one light placed in the file. The handles placed around the preview of the lighting effect give you control of the direction and intensity of the light. From the Light type drop-down menu, you can choose Spotlight, Omni, or Directional. You might be tempted to just pick one of these three, set your light, and exit the dialog box. If you do, you are missing some of the more incredible aspects of this filter.

FIGURE 14.27

There are seven filters in the Pixelate menu that can give your video an interesting look.

Crystallize Facet Fragment

Pointillize Color Halftone Mosaic Mezzotint

FIGURE 14.28

The Lighting Effects dialog box.

You can add more than one light to your file by clicking the Light icon at the bottom of the preview pane. You can also take advantage of some of the presets by choosing one from the Style drop-down menu. You can see three examples of these presets in Figure 14.29. You can also save your own light settings as a style.

FIGURE 14.29

Using a preset style for your lighting effect can have very different and dramatic results.

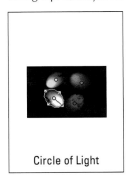

Circle of Light

Five Lights Down

Triple Spotlight

You can also change the properties of your light. For example, you can change the Gloss, Material, Exposure, and Ambience settings to suit your taste. Be sure and play with the Texture Channel setting. I won't spoil your fun by previewing it here, but it's well worth your time to see what this effect can do for your image. You can see how a good lighting effect can make a big difference in your video file in Figure 14.30.

FIGURE 14.30

Before and after applying a lighting effect.

Using blend modes to enhance the effect of a filter

To use some of the filters effectively, you need to understand how to adjust the Blend modes for a filter. When rendering the Clouds or Fibers filter, for example, Photoshop uses the foreground and background colors to create an opaque fill over your image, as you can see in Figure 14.31. This isn't very useful unless you want to create a background. If you use a Blend mode to modify the blending options on the filter, however, you can get an entirely different look.

You can change the effect a filter has on your image by changing the blend mode. To do so, follow these steps:

1. Open a video file.

2. Choose Filter ➪ Convert for Smart Filters to change your video file into a Smart Object.

3. Set the foreground and background colors in the Tools palette to colors from which you want to create fibers. In this example, the colors are blue and white.

4. Choose Filter ➪ Render ➪ Fibers to open the Fibers dialog box.

5. Change the settings as you like and click OK. Now you have the opaque filter over your image, as shown in Figure 14.31

6. In the Layers palette, double-click the Blending Options icon. The Blending Options dialog box appears (see Figure 14.32).

FIGURE 14.31

Rendering a Fiber effect over the video doesn't leave much of the original image in view.

FIGURE 14.32

The Edit Blending Options icon in the Layers palette.

7. Set the Blend Mode setting to Screen and the Opacity setting to 53 percent, as shown in Figure 14.33.

FIGURE 14.33

The Blending Options dialog box.

8. Click OK.

You can see in Figure 14.34 that changing to the Blend mode on the Fiber filter reduces the fibers to a filmy, transparent filter, as if you were looking through a sheer drapery. Using the Blend modes in conjunction with filters gives you many more choices for creating unique filters for your video files.

FIGURE 14.34

This filter has created a sheer drape or an invisibility cloak.

Summary

This chapter briefly described the numerous filters that you can use to correct your video and add special effects to it. You should now be familiar with many of the filters found in Photoshop and have a good understanding of the following:

- Creating your own effects using filters
- Converting a video layer into a Smart Object
- Using filters to correct a video layer
- Adding filters to a video layer to create special effects

The next chapter focuses on tonal and color correction in video layers.

Chapter 15

Correcting the Color and Tone of Video Layers

C olor correction can enhance almost any photo. Videos are usually more susceptible to environmental lighting problems that need correction. You can color correct a video using the options in the Image menu, or you can add a fill or adjustment layer over your video layer. There are so many color-correction techniques in Photoshop that it's sometimes hard to choose which one will work best for your specific document. After reading this chapter, you'll understand the color-correction techniques a little better and you'll understand the advantages and disadvantages of the different methods you can use when you add fill or adjustment layers to your video.

IN THIS CHAPTER

Deciding on a method for color correction

Changing the color and tone of a video

Using a fill or adjustment layer to create special effects

Choosing a Method for Color Correction

When it comes to color correcting a video layer, you can use the Image menu to change the video frame by frame, or you can create an adjustment layer using the Create a New Fill or Adjustment Layer button in the Layers palette that affects the entire video layer. Unless you are creating a special effect or animating a color correction, you'll want to skip the tedious process of frame-by-frame color correction. On the other hand, color corrections are very individual to the image that you are working with. They are different than filters in this respect. You can sharpen a video file arbitrarily over the entire file and probably not be disappointed with the results, but if you adjust the levels of a

video file that contains a combination of lighter and darker images, you will find that the overall results are horrible. As you color correct, you will want to carefully split the video layer into sections that consist of very similar areas in color and tone.

Splitting video layers into several individual layers to color correct them with fill or adjustment layers that are also full layers is a tricky process. You need to think about layer organization, of course, but there are also the effects of the fill or adjustment layers to consider. Because these layers are not automatically linked to a particular video layer, by default, they affect any layer that is below them in the hierarchy. I will show you how you can add fills and adjustments to just the video layer you want to affect.

Color correcting frame by frame

If, for whatever reason, you decide to color correct a video file frame by frame, you can choose Image ⇨ Adjustments and use the menu options found there. There are one or two more options available in this menu over the fill or adjustment layer menu found in the Layers palette, such as the Auto adjustments and the Shadows and Highlights option. In the case of the Auto adjustments, you will find an auto option in the corresponding dialog box. If you were to choose a Levels adjustment layer, for example, the dialog box contains a button that creates an auto adjustment. The other options that can't be found in the fill or adjustment layer menu must be added frame by frame to a video to apply them.

In Figure 15.1, you can see that adding a Levels adjustment to this video, by choosing Image ⇨ Adjustments ⇨ Levels, has changed just one frame of this video, as shown in the Altered Video property. This section of the video only lasts about five seconds, but splitting this video down so that this segment can be adjusted with one fill or adjustment layer saves 150 frame changes if the rate is 30 fps.

There are several reasons to make these changes frame by frame, of course. Animating a color effect by changing the color adjustment a little in each frame is an example. In Figure 15.2, you can see two frames of just such an animation. The image in the figure is a still shot placed into a video, and so I gave it life by simulating the lights changing colors.

FIGURE 15.1

The purple segment in the Altered Video layer property shows that one frame of the video has been changed.

FIGURE 15.2

To animate a color change, apply the Color Balance adjustment frame by frame.

If you find yourself in a situation where you are performing the same tasks over and over again to achieve similar results (and you usually will when you start animating frame by frame) then it's time to create an action. An action fully automates the process. For example, you can animate a color change by creating an action that works any time on any video file just by clicking the Play Action button (see Figure 15.3). You can also create a color change sequence that prompts the user for input when the Color Balance dialog box is used, so that the animation has custom settings every time the action is used (see Figure 15.4).

CROSS-REF If you missed the section on creating action sequences in Chapter 12, you will definitely want to read it. Frame-by-frame changes become tedious very quickly, and creating an action to take some of the repetitive steps out of the process is very helpful.

FIGURE 15.3

You can fully automate a process by recording a sequence of steps to create an action.

FIGURE 15.4

Toggle the dialog box icon on if you want to be able to set the input of the Color Balance adjustment while the action is playing.

Adding a fill or adjustment layer

The fastest way to color correct a video file is to add a fill or adjustment layer. A fill or adjustment layer is added to the Layers palette, and can be placed directly over the video layer or linked with it so that it affects the entire layer. You can see an adjustment layer being used in Figure 15.5. With

only one video layer in the Layers palette, the adjustment layer affects it and nothing else. You can change the settings of the layer at any time by double-clicking the fill or adjustment layer thumbnail. This displays the original dialog box that you used when creating the layer, and you can make any necessary adjustments (see Figure 15.6).

In addition, every fill or adjustment layer is created with a layer mask. If you have an area of your video file selected, the mask automatically reflects that selection. If you don't have anything selected in the file, the mask is white, indicating that the entire file is selected. You can delete or change the layer mask at any time, but you need to keep in mind that it will also affect the entire video file.

FIGURE 15.5

A fill or adjustment layer is a full layer in the Layers palette that affects any layer below it in the hierarchy.

FIGURE 15.6

You can adjust the settings of a fill or adjustment layer at any time by clicking the thumbnail of the layer in the Layers palette.

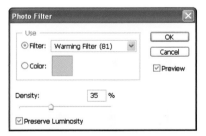

If you want the fill or adjustment layer to affect some of the video, but not all, split the video layer and place the layer that you don't want to be affected on top of the fill or adjustment layer, as shown in Figure 15.7. Of course, you may want to create a fill or adjustment layer that affects the second segment of video, and this creates a problem. You can create a fill or adjustment layer, as shown in Figure 15.8; however, that layer will not only affect the layer that it is placed directly over, but it will also affect the layers underneath. In Figure 15.8, the Rappelling layer has a Hue

and Saturation adjustment applied to it, but the Hue/Saturation adjustment layer also affects the Photos layer. How do you keep the Hue/Saturation adjustment layer from affecting the Photos layer without moving it in the layer hierarchy? There are three ways, actually, each with its own benefits and drawbacks. The first and most obvious is to change the duration of the fill or adjustment layer in the Timeline so that it occupies the same time as the video you want it to affect. The second way is to merge the layers, making the fill or adjustment part of the video layer. The third way is to turn the Rappelling layer into a Smart Object.

FIGURE 15.7

An easy way to keep a fill or adjustment layer from affecting a video segment is to place that segment above the fill or adjustment layer in the Layers palette.

FIGURE 15.8

The Hue/Saturation adjustment layer has the ability to affect both video layers.

Adjusting the duration of a fill or adjustment layer

Figure 15.9 shows the Timeline associated with the Layers palette. You can see that the duration of the adjustment layers is automatically set to the entire length of the Timeline. You already know that this is fairly easy to adjust: you just drag the beginning and end of the layer duration bar to match the duration of the Rappelling layer. The benefits of this method are obvious: it's easy, it's visible, and the layers are still viewable and editable in the Layers palette. There is one more step you can take to make this option even more attractive: you can group the layers.

FIGURE 15.9

Adjusting the duration of a fill or adjustment layer is an easy way to restrict its effects to just one video layer.

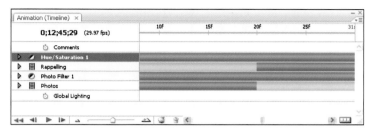

If you only have two or three video layers that you are color correcting individually, you will probably be able to manage the fill or adjustment layers in the Timeline without too much trouble, but you can see that it won't be too long before things could really get out of hand, especially if you need to create several adjustments on a single layer. The best way to work with the layers is to group them. Create a new group by clicking the New Group button in the Layers palette. Give the group a unique name, and click and drag the layers that you want to be grouped together into it (see Figure 15.10). Now, in the Timeline, you can change the duration of the group layer, and all the layers inside that group are subject to the change. You can see in Figure 15.11 that, even though the Hue/Saturation layer is active across the entire Timeline, it is subject to the duration of the Rappelling group.

TIP When adjusting layers to precise lengths, zoom in so that you can see each frame. To trim a layer to an exact location, choose Trim Layer Start to Current Time or Trim Layer End to Current Time from the Timeline menu.

FIGURE 15.10

The Rappelling layer and the Hue/Saturation layer are neatly packaged into the Rappelling group.

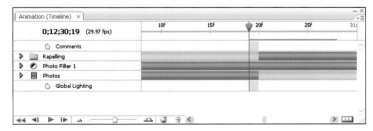

FIGURE 15.11

The Hue/Saturation layer is subject to the duration of the Rappelling group layer. Compare the difference in this video, just one frame before the group is active in the Timeline, with the very next frame.

Merging layers

Merging a fill or adjustment layer with the layer or layers you want it to affect has the benefit of isolating its effects to the selected layer, as well as cleaning up the Layers palette and the Timeline. The downside of this method is that merging a fill or adjustment layer with another layer makes the fill or adjustment a permanent change. You won't be able to remove it or adjust its effects.

To merge two or more layers, hold the Shift key while selecting each one. Right-click any of the layers to display the Layers menu, and choose Merge Layers. The layers take on the name and duration of the top layer in the hierarchy — in this case, your topmost fill or adjustment layer. You'll most likely want to rename the layer and adjust the duration.

Adding a fill or adjustment layer to a Smart Object

The last way to restrict the effects of a fill or adjustment layer to an individual layer is to turn that layer into a Smart Object. Right-click the video layer and choose Convert to Smart Object. As you are well aware by now, this converts the video layer into an embedded file that you can open and change, independent of other layers in the file. After you convert the layer into a Smart Object, simply open it before adding the fill or adjustment layer. This method has the benefit of keeping the Layers palette and Timeline less cluttered, while still retaining the full capability to adjust or remove the effects. The only downside of using Smart Objects is the extra steps required to make changes to a Smart Object file.

Figure 15.12 shows two Smart Object layers placed neatly in the Timeline. One has a Black & White adjustment layer embedded in it, while the other has a Hue/Saturation adjustment layer embedded in it.

CAUTION Remember that when you create a Smart Object from a video layer, the Smart Object doesn't have an Altered Video property. To change the video frame by frame, open the Smart Object and change the video layer.

FIGURE 15.12

Converting a video layer into a Smart Object has the advantage of cleaning up the Timeline while still having the ability to change the settings of a fill or adjustment layer.

Correcting the Tone and Color of a Video

You can use a fill or adjustment layer to correct the color or tone of your video. Color correction is necessary when the colors in a video are not captured correctly. Correcting the tone is necessary when the lighting in a video is not captured correctly. A few of the adjustment layers are meant only to correct color, a few are meant only to correct tone, and a few correct both. Some of the adjustment layers are very similar to one another, and it's often difficult to determine which one is the best to use. You'll probably find as you work that you'll gravitate to a favorite few, but even so, it's important to be aware of what each adjustment can do and why you should, or shouldn't, use it.

CROSS-REF This chapter gives specific examples of a few of the adjustment layers. For a comprehensive list of all of the fill or adjustment layers, see Chapter 6.

First, I'll show you several different methods that you can use to correct the tone of your video. The tone of an image is the brightness and contrast in that image. It doesn't have to be limited to the brightness of the white and darkness of the black in the image; it can also be the level of individual colors. There are several different adjustments that correct tone — Levels, Brightness and Contrast, Exposure, and Black & White, to name a few. Some of the adjustment layers correct the tone of individual colors, such as Hue/Saturation and Curves.

After you learn how to correct the tone of your video file, I'll show you how to correct the color. Unless you are working with video taken in a studio (and sometimes even then), you'll find that your environment has a very big impact on the colors of your video. For example, fluorescent lighting adds a yellow cast to your video file, and using a video light causes colors to fade away. You can correct these problems to some extent by using the adjustment layers that correct color — Hue/Saturation, Color Balance, Selective Color, and Channel Mixer.

Correcting tones in a video file

Correcting the tones of a video file can be done with very simple adjustments such as the Brightness/Contrast adjustment, or with more complex adjustments such as Hue/Saturation. It's tempting to use the quick fixes, but understanding how to use the more complex adjustments can give you a richer, more realistic result. Following are some examples of how tonal correction can make a big difference in the look of a video file.

Changing the levels of a video layer

My personal favorite tonal correction tool is the Levels adjustment. The Levels adjustment allows you to set the highlights, midtones, and shadows in your image to a specific level, evening out the tones of the image. Adjusting the levels improves the look of almost any image. You must be very careful to adjust levels judiciously in a video layer, however, because what looks good in one frame may not work for the next.

Click the New Fill or Adjustment Layer button in the Layers palette and choose Levels to open the Levels dialog box. The Levels dialog box contains a histogram that represents the levels of brightness found in your image. When you work with a video file, the histogram only represents the current frame in that file. You can see in Figure 15.13 that the histogram is weighted very heavily to the left because the video is extremely dark. To lighten it, you can drag the arrows under the histogram toward the bulk of the histogram, changing the color indicated by the arrow on the right to white and adjusting all other levels accordingly. Of course, the middle arrow sets the midtones and the left arrow sets the level of black. You can change the levels of individual colors as well, by using the drop-down menu at the top of the Levels dialog box to choose an individual color channel.

FIGURE 15.13

The Levels histogram is a representation of the brightness values that are found in the selected image, or frame of video.

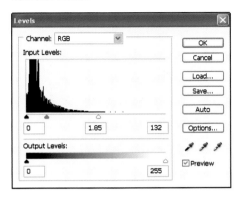

The eyedroppers allow you to manually select the tones that will be used for the highlights, midtones, or shadows, and the Output Levels allow you to adjust what level of black or white your shadows and highlights can achieve. The Preview option is selected by default, and so, as you make changes to the levels, you'll be able to see the effect on your image. When you are satisfied that the levels of your image are as good as they can get, click OK to close the Levels dialog box and create the Levels adjustment layer in the Layers palette (see Figure 15.14).

NOTE You'll notice that the corrected image is extremely grainy. This is a common result of correcting images that are so light or so dark that some of the pixels do not contain any color information at all.

FIGURE 15.14

A simple levels change can restore visibility to even a very dark file.

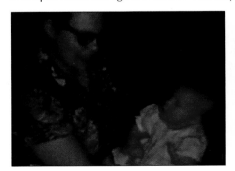
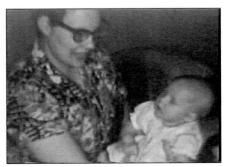

Changing the exposure of a video layer

Changing the exposure of a video layer is a simpler adjustment than the Levels adjustment. It is occasionally all you need to do to correct the tone of an image. The Exposure adjustment allows you to change the Exposure, Offset, and Gamma levels of an image, counteracting a faulty exposure setting in the original photo. Although the effect is optimized in Photoshop for high dynamic range (HDR) images, it works well on most images and video files.

You can correct the exposure of a video file by following these steps:

1. Open a video file.
2. Click the New Fill or Adjustment Layer button at the bottom of the Layers palette to open the Fill or Adjustment menu.
3. Choose Exposure from the menu to open the Exposure dialog box, as shown in Figure 15.15.
4. Adjust the exposure setting. This will adjust the highlights of your video with minimal effect on the midtones and shadows. Moving the slider up brightens your image; moving it down darkens it. You can preview the changes you make by looking at your video file.
5. Adjust the Offset setting. This adjusts the shadows and midtones of your video with minimal effect on the highlights.
6. Adjust the Gamma setting. The Gamma setting adjusts how the lighting of an image is displayed on a computer monitor.
7. Alternately, you can use the eyedroppers to adjust the exposure. The eyedroppers in the Exposure dialog box change the luminance values of the video, rather than the color brightness values. The eyedropper containing the least amount of ink represents the highlights, the eyedropper in the middle represents midtones, and the eyedropper with the most amount of ink represents the shadows. Simply choose an eyedropper and click an area in your image to change the luminance value of the highlights, midtones, or shadows to match the chosen area.
8. When you are done making changes to your image, click OK to close the Exposure dialog box.

The Exposure adjustment has benefits over the Levels adjustment. Using the Exposure setting on the example used for the Levels setting produces an image that is less grainy. Without the ability to correct individual color channels, however, the image is distinctly oversaturated (see Figure 15.16).

FIGURE 15.15

The second image has been corrected subtly using an Exposure adjustment to give it a deeper and richer look.

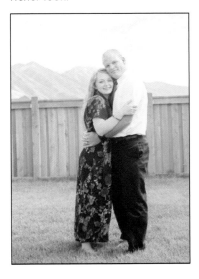

FIGURE 15.16

The Exposure adjustment creates an image that is less grainy, but oversaturated compared to the Levels adjustment on the same image.

Correcting the color of a video layer

Choosing which adjustment to use to color correct an image in Photoshop is the hardest part of the entire process. Like tonal correction, there are adjustments that are easier to understand because they have less capability than more complicated color adjustments. Lucky for you, when you work with video files, the more generic color adjustments are the better choice, because they can be applied more generally to a video that consists of several different images. I'll show you how to use the more common adjustment layers to color correct your video.

Adjusting the curves of a video file

Adding a Curve adjustment layer to a video file can correct the color and the tone of the video in one dialog box. Understanding how to use the Curves adjustment isn't easy, though. Figure 15.17 shows the expanded Curves dialog box, and you can see how many different options can be adjusted to tweak the curves.

FIGURE 15.17

The Curves dialog box has so many options that it's hard to know where to start.

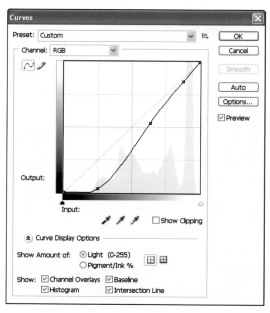

The idea behind curves is a fairly easy one to understand. The bottom left of the diagonal line represents the darker colors in the image, while the upper right represents the lighter colors. The histogram behind the line is a representation of the brightness values found in the image. The key to using the curve is to create control points at strategic locations on the curve. You can do this by selecting colors in your image. The colors you select are those that you definitely want to change and those that you definitely want to remain the same. Press and hold the Ctrl (⌘) key as you click these colors in your image. Corresponding control points, or handles, appear on the curve (see Figure 15.18). The Color Sampler is automatically displayed as the cursor hovers over the image; don't confuse it with the eyedroppers inside the Curves dialog box, which perform an entirely different function.

FIGURE 15.18

You can create control points for different colors in your image by Ctrl (⌘) + clicking them.

After you create the controls, it should be easy to adjust the levels of the chosen colors by dragging the curve line either higher, to make the image lighter, or lower, to make the image darker. If you want your specific colors to change, move the control points. If you don't want them to change, move the curve in between the control points. Figure 15.19 shows the incredible difference that changing the curves just a little makes on an image.

NOTE You don't have to place control points to move the curve; you're welcome to experiment by dragging the curve around. You can also place control points just by clicking the curve; you just won't know what color range they will be in. Using the colors in your image helps you to create the right curve without as much guesswork.

FIGURE 15.19

With your colors placed as control points on the curve, it's easy to see where to change the curve for the best effect.

Adjusting the hue and saturation of a video file

When you find that your video file has a color cast to it, such as a yellow tint from filming under fluorescent lighting, adjusting the hue and saturation immediately comes to mind. You can very quickly change the hue, saturation, and brightness of several individual colors by using the Hue/Saturation dialog box.

Figure 15.20 shows a portion of video that has a strong yellow cast. To open the Hue/Saturation dialog box, click the New Fill or Adjustment Layer button in the Layers palette and choose Hue/Saturation. To choose a specific color to adjust, use the drop-down menu at the top of the dialog box. You can further target a specific color range by moving the slider at the bottom of the dialog box up and down the spectrum. In this example, I wanted to change the yellows in my image, toning down the lightness and saturation. I also moved the color bar slider down just a little to target the more orange yellows. The result is an image with crisp colors but no yellow color cast.

Adjusting the Selective Color

The Selective Color adjustment is very subtle compared to the Curves and Hue/Saturation adjustments. With the Selective Color adjustment, you can change nine different color tones by adjusting the levels for each of the CMYK colors. For example, if you choose the red color tones and you change the cyan levels, only the cyan levels in the red colors in your image will change; none of the cyan tones in green areas of the image will change.

In Figure 15.21, you can see that by focusing on just the blue tones of the image, the color of the sky is deepened without compromising the other colors in the image.

FIGURE 15.20

Changing the saturation and lightness of the yellows removes the yellow cast from the image.

FIGURE 15.21

Selective color corrections are very subtle, but precise.

Creating Special Effects with a Fill or Adjustment Layer

Creating a special effect with a fill or adjustment layer usually creates changes in a video that are based on color or tone. Going to extremes with any of the color correction tools will create a special effect, rather than a color correction. The Curves adjustment has a preset that converts your video into a negative, and the Hue/Saturation adjustment can be used to give the colors of a video a bright, surreal look or change them entirely. Other fill or adjustment layers are best used as special effects. The Gradient Map, for example, creates some very neat effects, but could hardly be termed a color correction.

As you place fill or adjustment layers, the blend mode you use can have a big effect on the end result. I'll show you some of the special effects you can create with fill or adjustment layers, and then I'll show you how to use blend modes to multiply the special effect possibilities.

Applying a gradient fill to a video

A gradient fill consists of placing a gradient pattern over the image, regardless of the individual attributes of the image. Some gradient fills contain transparency, and you will be able to see the image through the transparent areas of the gradient. Others do not, and unless you reduce the opacity of these gradient fills, they completely cover the image.

You can place a gradient fill over your video by following these steps:

1. Open a video file.
2. Click the New Fill or Adjustment Layer button at the bottom of the Layers palette to open the Fill or Adjustment menu.
3. Choose Gradient from the menu to open the Gradient Fill dialog box, as shown in Figure 15.22. The gradient that appears with the dialog box is automatically displayed over your image and changes as you make adjustments to the gradient.

FIGURE 15.22

The Gradient Fill dialog box has several options that will customize your gradient.

4. Click the arrow next to the gradient to display a drop-down menu of gradients to choose from.

5. Click the arrow in the drop-down menu to display a menu that contains several more options for choosing and adjusting your gradient, as shown in Figure 15.23.

FIGURE 15.23

The Gradient Fill dialog box expands to give you many options for choosing a gradient.

6. After you choose a Gradient menu option, close the Gradient Fill menu.

7. Once you select a gradient, close the Gradient Picker.

8. You can also create a custom gradient very easily. Double-click the gradient color to open the Gradient Editor, as shown in Figure 15.24. You can make adjustments to the color and banding of your gradient by changing the settings in this box.

9. Click OK to close the Gradient Editor.

10. From the Gradient dialog box, choose a gradient style. You can reverse the style by selecting the appropriate check box at the base of the Gradient dialog box.

11. Adjust the angle of the gradient by clicking and dragging the angle indicator around the circle.

FIGURE 15.24

The Gradient Editor gives you the ability to create custom gradients.

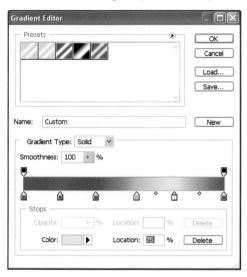

12. Adjust the scale or size of the gradient by either typing a new number or by clicking on the down arrow next to the numerical representation of the scale and using the slider to adjust it. The default size is 100 percent, but it can be adjusted up or down from there.

13. Choose to align the gradient with the layer or dither it by clicking the appropriate box.

14. When you finish applying your gradient, click OK.

15. With the gradient fill layer selected, use the Opacity slider in the Layers palette to reduce the opacity of the gradient on the layers it is placed over.

You can see in Figure 15.25 that a gradient fill has been applied to a video. The gradient fill chosen does not have any transparency, so the opacity of the gradient is reduced to 70 percent to make the image visible underneath.

FIGURE 15.25

The Steel Blue gradient placed as a gradient fill with an opacity of 70 percent.

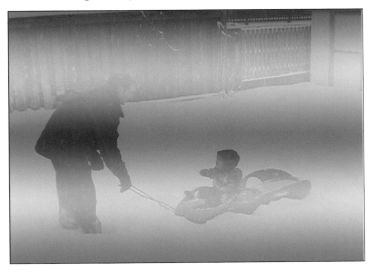

Applying a gradient map to a video

A gradient map is very different from a gradient fill. A gradient map uses the brightness values of the image to map the colors found in the gradient to the image. This results in an image where the primary features are still very discernible, even when the gradient map is placed at full opacity.

You can see how applying a gradient map has a different effect on your video than a gradient fill:

1. Open a video file.

2. Click the New Fill or Adjustment Layer button at the bottom of the Layers palette to open the Fill or Adjustment menu.

3. Choose Gradient Map from the menu to open the Gradient Map dialog box, as shown in Figure 15.26.

4. Click the arrow next to the gradient to display a drop-down menu of gradients to choose from.

5. Click the arrow in the drop-down menu to display a menu that contains the same menu as the Gradient Fill dialog box with several more options for choosing and adjusting your gradient.

6. Double-click the gradient to open the Gradient Editor that allows you to customize your gradient.

FIGURE 15.26

The Gradient Map dialog box has fewer options than the Gradient Fill dialog box because changing the gradient is enough to change the way a gradient map is applied to your file.

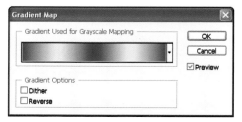

7. Check Reverse or Dither as desired.

8. After you choose a gradient and apply the desired options, click OK.

You can see in Figure 15.27 that the gradient map looks very different from the gradient fill. That's because using a gradient map combines the information of the brightness values in the image with the color and gradient information to create an image that incorporates aspects of both. A gradient fill, on the other hand, does not take the image into account, but simply covers any image indiscriminately.

FIGURE 15.27

The same Steel Blue gradient placed as a gradient map has a completely different effect from the gradient fill shown in Figure 15.25.

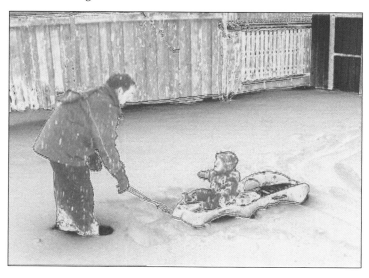

Creating tinted video

There are actually several adjustment layers that can add a colored tint to your video for several different kinds of effects. The Hue/Saturation and Photo Filter adjustments are obvious candidates. The Black and White filter allows you to add a tint to your video after changing the color to grayscale. You can create a sepia effect or tint your video any other color you want. Click the New Adjustment Layer button in the Layers palette and choose Black and White. The Black and White dialog box allows you to set the brightness value that each color becomes in your grayscale image. To tint your image, select the Tint option. After you do that, you can use the Hue and Saturation sliders to choose the exact color of the tint. Your final product will be a grayscale version of your video file with a colored tint over it (see Figure 15.28).

Using the Black and White dialog box to change the video file to a sepia tone.

Using blend modes

Using a blend mode increases the effectiveness of the special effects you can create on your video layers. Some of the fill or adjustment layers can overpower the image on your video. Using a blend mode, as well as adjusting the opacity of the fill or adjustment layer, can really improve the effect.

A blend mode is added to a layer by clicking the Blend Mode drop-down menu in the Layers palette and choosing from the blend modes that are displayed there. To give you a feel for how blend modes can make a difference, I will take you through several exercises that use blend modes to change the look of the fill or adjustment layer.

Using a blend mode to create falling snow

The Linear Dodge blend mode falls in the Lightening blend modes. It can be used with a pattern to create the illusion of falling snow.

You can create falling snow by following these steps:

1. Open a video file.

2. Click the New Fill or Adjustment Layer button at the bottom of the Layers palette to open the Fill or Adjustment menu.

3. Choose Pattern from the menu to open the Pattern Fill dialog box.

4. From the Pattern Selection drop-down menu, choose the pattern called Streaks. (The name of the pattern is displayed as you hover over the pattern for a few seconds.)

5. Set the scale of the pattern to create the effect of falling snow or sleet.

6. Click OK to close the Pattern Fill dialog box.

7. Change the Opacity in the Layers palette to 25 percent.

8. Click the Blending Options drop-down menu and choose Linear Dodge. Your results should be similar to those in Figure 15.29.

FIGURE 15.29

The first image is the original video file, the second is the file with the pattern fill added, and the third uses the Linear Dodge blend mode to soften the results of the pattern fill.

Using a blend mode to create a surreal color effect

When you created a gradient map earlier in the chapter, it had a dramatic effect on your video. It doesn't have to have such a strong effect if a blend mode is used.

To create a surreal color tint for your file, follow these steps:

1. Open a video file.
2. Click the New Fill or Adjustment Layer button at the bottom of the Layers palette to open the Fill or Adjustment menu.
3. Choose Gradient Map from the menu to open the Gradient Map dialog box.
4. Click the arrow next to the gradient to open the Gradient picker drop-down menu.
5. Click the triangle in the gradient picker and select Noise Samples from the pop-up menu. A dialog box asks if you want to replace the Gradient menu. Click OK to replace or Append to add this menu to the one already selected.
6. From the gradient picker, choose the gradient called Ultra Violet.
7. Click OK to close the Gradient Map dialog box.
8. Using the Opacity setting in the Layers palette, change the opacity of the gradient map to 75 percent.
9. From the Blending Options menu in the Layers palette, choose Saturation.

You should have a result similar to the example shown in Figure 15.30. The blend mode made quite a difference, didn't it?

Using a blend mode to combine color and grayscale in the same video file

At first perusal, the Black and White adjustment seems like something that you wouldn't use very often unless you wanted to turn your file to grayscale or give it a tint as demonstrated earlier. Using it in conjunction with a blend mode, however, can create very cool special effects.

To make colors pop in a grayscale image, follow these steps:

1. Open a video file.
2. Click the New Fill or Adjustment Layer button at the bottom of the Layers palette to open the Fill or Adjustment menu.
3. Choose Black & White from the menu to open the Black and White dialog box.
4. The setting you use in this dialog box depends entirely on your image. Use the sliders to change the levels of brightness for the colors in your image.
5. Click OK. You are left with a grayscale video file.
6. Using the Blending Options drop-down menu in the Layers palette, choose Multiply.

This exercise is more dependent on what video file you use than the previous exercises, but you can see an example of the result in Figure 15.31.

FIGURE 15.30

The Ultra Violet gradient map used with a Saturation blend mode at an opacity of 75 percent gives this video a soft, surreal effect.

FIGURE 15.31

Using the Black and White filter along with the Multiply blend mode gives the flowers in this picture more pop.

Using a blend mode to change the colors in an inverted video

Using an adjustment layer with a blend mode can be a very simple process. Here is the easiest exercise yet.

You can create a dreamlike quality for your video file in four easy steps:

1. Open a video file.

2. Click the New Fill or Adjustment Layer button at the bottom of the Layers palette to open the Fill or Adjustment menu.

3. Choose Invert. This option does not have a dialog box; it simply inverts the colors of your video file.

4. Using the Blending Options drop-down menu in the Layers palette, choose Hue.

Adding a blend mode completely changes the effect the Invert adjustment had on the video, as you can see in Figure 15.32. The possibilities are limitless and with a good base to start from, you can now begin to imagine and create your own special effects.

FIGURE 15.32

Using the Invert adjustment with a Hue blend mode can add a dreamlike quality to your video.

Summary

You've learned many ways to use the fill or adjustment layers to color correct or add special effects to video layers. You've also learned several different ways to apply a fill or adjustment to a video layer, and how to color correct video frame by frame. In addition, you have learned the following techniques:

- Adding a fill or adjustment layer to a video layer
- Changing the color and tone of a video
- Using a fill or adjustment layer to create special effects

In the next chapter, you learn how to change your video frame by frame, focusing on using the Clone and Healing tools.

Chapter 16

Cloning and Healing Images on a Video Layer

Adding filters, styles, and fill or adjustment layers can correct many of the inherent problems in video layers and create fantastic special effects, but sometimes you want to change the content of the actual video layer.

Video is probably even more prone to the problems that are common with photos: dust and scratches, unsightly backgrounds, or extra people in the shot. You can use the same Photoshop tools that you would use to fix these problems in your photos, the Clone Stamp and the Healing Brush tools, to do the same to your video layers.

Although these changes need to be made frame by frame, the addition in Photoshop CS3 of the Clone Source palette makes the job much easier. After you learn how these tools work in depth, cleaning your video will be second nature.

Using the Clone Stamp Tool to Correct a Video Layer

The Clone Stamp tool in Photoshop CS3 has made an incredible transformation from CS2 to become a much more powerful and useful tool. It is invaluable in correcting video layers, with its new features helping to take the guesswork out of taking spots, scratches, or eyesores out of your favorite video clips. I'll show you how the Clone Stamp tool works and how you can use it to change your video files frame by frame.

Cloning basics

Cloning is a method of removing unwanted areas of an image by copying, or cloning, another area in the image and using it to paint over the unwanted area. In past versions of Photoshop, it was best used on areas of an image that were easy to blend, without hard lines or colors.

You can use the Clone Stamp tool to erase an object from an image by following these steps:

1. Open an image or video file with an area you want to change.

2. Click the Clone Stamp tool in the Toolbox.

3. Place the cursor over an area that you want to clone.

4. Hold the Alt (Option) key as you click the image. This sets the clone source of the image (see Figure 16.1).

FIGURE 16.1

Alt+clicking (Option+clicking) the pavement sets this area as the clone source for the image.

5. Drag over the area that you want to take out of your image. The clone source is copied to that area. The crosshair shows the area that is currently being cloned (see Figure 16.2).

6. Reset the clone source as needed by holding the Alt (Option) key and clicking your image.

7. Repeat Steps 4 to 6 until the object is gone from your image. With a little help from the Smudge and Healing Brush tools, you'd never know that the vehicle was there (see Figure 16.3).

FIGURE 16.2

Clicking and dragging the cursor over the vehicle will continue the pavement and erase the vehicle. The crosshair shows the area being copied to the new area.

FIGURE 16.3

The cloned area still needs a little cleanup, but it's hard to believe there was a vehicle in this area just a few moments ago.

That's it. That's the Cloning tool that was available in Photoshop CS2, and if you didn't know the basics of cloning, you know now how it works and what a useful tool it is. The new features found in Photoshop CS3 make cloning so much easier that the slightly smudged-looking image in Figure 16.3 can be improved greatly in less time.

Using the Overlay features in the Clone Source palette

You're going to repeat the cloning process from the last exercise, but this time you learn how to use the Clone Source palette, which is new to Photoshop CS3. The Clone Source palette button is, by default, one of the smaller palette buttons found to the left of the full-sized palettes. Click the palette button to open the Clone Source palette (see Figure 16.4). You can also choose Window ➪ Clone Source. After you open the palette, it remains open until you close it.

FIGURE 16.4

Click the Clone Source palette button to open the palette.

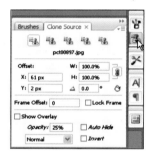

> **TIP** If you plan to use the Clone Source palette frequently or at least for an extended period, you might want to dock it with the main palettes to keep it out of your work area. Drag it into place and drop it when you see a blue highlight indicating that it is linked to the other palettes in the main area.

You can greatly increase your cloning ability and efficiency by using the Overlay option found in the Clone Source palette.

1. Open an image or video file with an area you want to change.
2. Click the Clone Stamp tool in the Toolbox.
3. Click the Show Overlay option in the Clone Source palette (see Figure 16.5).

FIGURE 16.5

The Show Overlay option is selected.

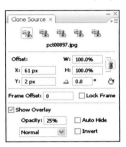

4. Place the cursor over an area that you want to clone.

5. Hold the Alt (Option) key as you click the image; this sets the clone source of the image. Now as you move across the image, the overlay follows the cursor (see Figure 16.6).

FIGURE 16.6

The overlay can be a big help in lining up the clone source with the area to be cloned over.

6. Set the overlay in position and click to clone over the area you want to remove. After you click your image, the overlay locks into place so that the clone is consistent.

7. Click and drag over the area that you want to clone out. The overlay permanently affects only the areas in which you use the clone cursor.

Once again, you can reset the clone source by holding the Alt (Option) key while clicking the image. You can see what an advantage having the Overlay feature is in cloning. Without the overlay, lining up areas is a matter of guesswork.

Changing the blend mode of the overlay

Depending on your file, you can choose different blend modes to show your overlay so that it is more visible. You can choose from Normal, Darken, Lighten, or Difference. What you choose is entirely dependent on the file you are using and what blend mode is easiest for you to see and distinguish. Figure 16.7 shows examples of all the different blend modes you can use.

FIGURE 16.7

Using different blend modes for your overlay can help you see the overlay better.

You can also click the Invert option to change the look of all four blend modes for four more choices on how your overlay is displayed. You can see an example of the Invert option used in the Normal blend mode in Figure 16.8.

Using the Auto Hide option for the overlay

You can click the Auto Hide option to hide the overlay as you paint. This is not the default. When you use the overlay, it is usually visible throughout the entire cloning process. Using the Auto Hide option allows you to focus on the image, so that only the areas that you want to be changed in the original image are changed, rather than focusing on the overlay. Figure 16.9 shows that the overlay has disappeared as I begin to paint the "twins" into the image.

FIGURE 16.8

Selecting the Invert option gives you more options when it comes to the look of the overlay.

FIGURE 16.9

When the Auto Hide option is selected, the overlay disappears as the Clone tool is used to paint into the image.

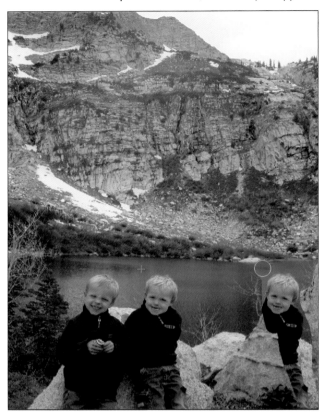

Using alternate clone sources

The Clone Source palette is headed by a lineup of clone stamps. It looks pretty cool, like an army of pawns, but there's a purpose for them. Each one represents a storage unit for a clone source. The best way to understand how it works is to simply try it out.

You can set up to five different clone sources:

1. Click the first Clone Source button on the Clone Source palette.

2. Alt+click (Option+click) an open image. If the Show Overlay option is selected, the ghost of the image you just selected as the clone source follows your cursor.

3. Click the second Clone Source button on the Clone Source palette.

4. Alt+click (Option+click) a different area of the open image. The ghost of the entire image still follows your cursor, but it is offset from the first source.

5. Click the first Clone Source button. The overlay returns to the first clone source.

6. Open a second document.

7. Click the third Clone Source button.

8. Alt+click (Option+click) the newly opened document. The ghost of the new image follows your cursor.

9. Click the first Clone Source button. The first clone source is still the first document.

10. Move your cursor over the second document and click anywhere. You can clone the first document into the second document (see Figure 16.10).

11. Return to the original image.

12. Click the third Clone Source button. The ghost of the second image hovers over the first.

FIGURE 16.10

You can clone just about anything, even a completely different file.

Using alternate clone sources to clone one frame of video into another

This ability to clone other sources is vital to successfully cloning video layers because you can clone one video frame into another. Following is an example of what I mean. Figure 16.11 shows an image of a happy couple on their wedding day. They are preparing for a romantic kiss. The video effect is in slow motion, there's a great love song playing in the background, and love is in the air. Jump ahead several frames, as shown in Figure 16.12. The kiss is still very romantic, the music is still playing, but there is some unromantic company in the shot.

FIGURE 16.11

This shot of the happy couple is unmarred.

FIGURE 16.12

Unexpected company changes the mood of the video.

By using the Clone Source palette, it is easy to rewind to the first frame. Alt+click (Option+click) it to use it as a source, and use the overlay to place it over each of the next few frames to clone out the company with a few quick swipes of the mouse. Although the couple is moving, it's easy to use the architecture of the building as well as the light in the flower bed to line up the overlay exactly (see Figure 16.13). After you line up the overlay, simply click and drag over the areas you want to hide and the illusion is perfect (see Figure 16.14).

FIGURE 16.13

Lining up the clone source is easy using stable objects in the video.

Of course, you can see in Figure 16.15 that only one frame of the video has been changed so far. I'm in for a long frame-by-frame fix. However, using the Clone tool is so much fun that it might even be fun. To really use the five clone source options, you probably want to choose five different frames to clone so that as the camera moves, even a miniscule amount, you have a clone source that easily matches the angle and size.

FIGURE 16.14

By cloning out the extras, romance is restored!

FIGURE 16.15

The Clone tool changes a video layer frame by frame.

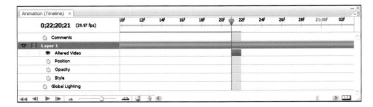

Locking the source frame

As you use the Clone tool to change a video file frame by frame, one option in the Clone Source palette is critical to your success. When you choose a clone source from a video file, you have the option to lock the source to the frame that you originally sampled, or to move the source the same number of frames as you moved from the first target in the Timeline. In other words, after fixing the frame in Figure 16.14, I plan to move onto the next frame of video to fix that frame as well. If the Lock Frame option is selected in the Clone Source palette (see Figure 16.16), the clone source remains the same frame that was used to change the previous frame of video. In this case, frame 40109 continues to be the source. If the Lock Frame option is not selected, the clone source moves ahead one frame in the video. The Clone Source palette in Figure 16.16 shows that the frame offset remains at -77 frames, no matter what frame is targeted.

FIGURE 16.16

Lock the target frame if you want it to be consistent throughout your edits with the Clone tool. Don't lock the target frame if you want it to change each time you move in the Timeline.

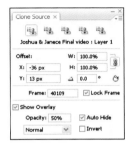 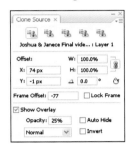

If your video is fairly stable, you'll probably find that it's easier to use a locked source that you know is clear and free of defects. If your video is unsteady, it might be easier to use a frame offset that is only one or two frames away from the frame you are changing. In most cases, this will help to keep the source and sample frames fairly similar.

Changing the size and rotation of the clone sample

To show you how to change the size and rotation of a clone sample, I am going to use a 3D animation that was created several years ago. The software used to create it no longer exists and it never had the capability to export this file in a 3D file format that is universally accepted, such as 3DS. What is left is an AVI file with a very outdated photo sitting on the table. Using the Clone tool is one option for updating this photo.

A new image is selected to replace the image that exists in the 3D animation. The image is sampled using the Clone Stamp tool. With the overlay on, you can see that the image is too large (see Figure 16.17). Rather than going back and forth trying to resize the image to the specifications that will make it perfect for the video file, you can use the Clone Source palette to resize the sample.

In the Clone Source palette, you can change the width, height, or angle of the clone source, an option that should often come in handy. You can leave the clone source floating in the target and make the changes before you lock it into place, or you can place it and then make the changes. The image is still about three times too large for the video file, and so I reduce it to 35 percent of its original size. Now I can place it over the picture frame and paint it in (see Figure 16.18).

NOTE If you place the overlay in the target image before you resize it, center it over the area in which you want to place it. As you resize it, the locked position will be the center of the overlay.

TIP You don't have to type a percentage value to resize or rotate your overlay. Use your cursor to hover over the name of the change; W for the width percentage, for example. Your cursor changes to show a two-directional arrow, which you can click and drag to change the number in the box.

FIGURE 16.17

This overlay is too large for the area in which it needs to be.

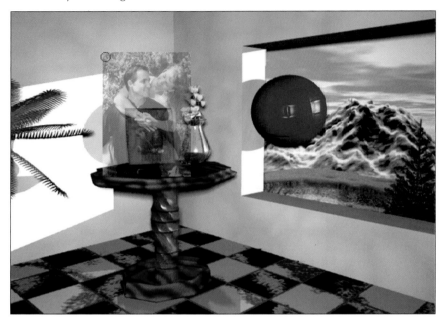

FIGURE 16.18

Change the size of the clone source by reducing the percentage in the Clone Source palette and the image fits easily into the area.

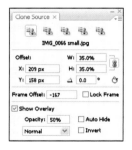

Moving frame by frame, you can paint the image into place to update the AVI file. In this animation, however, the photo is knocked off the table by the ball coming through the window. Figure 16.19 shows that the picture has not only moved, but is falling at an angle. This is where the angle of the image is changed in the clone source. Figure 16.20 shows that by tilting the source -49.4 degrees, it matches the frame once again.

As the picture falls off the table, the clone source needs to be able to rotate.

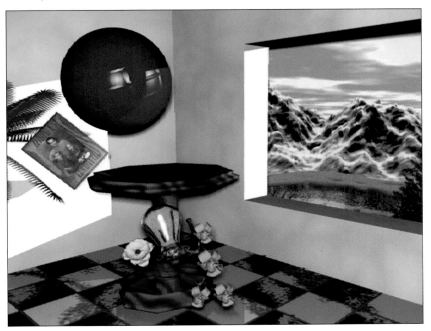

Using the Clone Source options bar

In all the fun of using the Clone Source palette, don't forget to use the options bar. The options bar allows you to change the brush settings, change the Blend mode, choose the layers to sample, and ignore the fill or adjustment layers placed over the source; it also includes a very unassuming Aligned option, which, deselected, can make cloning video layers much easier (see Figure 16.21).

Changing the angle option in the Clone Source palette rotates the image used as the clone source.

The Clone Source options bar.

If you've been following along and practicing your cloning techniques, you've probably been frustrated by the fact that once you lock the overlay, you can't move it without resampling the clone source. The Aligned option in the Clone Source options bar changes all that. The Aligned option is selected by default, locking the clone source once you start painting in the target. If you deselect the Aligned option, the clone source floats perpetually behind your cursor. It stays locked as long as you make your stroke, but when you release the mouse button at the end of your stroke, it floats again (see Figure 16.22). When you move to the next frame of your video, you can reset the source, changing the position, size, and angle as needed. All it takes is a steady hand to clone the needed area with one stroke.

FIGURE 16.22

With the Aligned option deselected, the clone source floats behind the cursor, even after the Clone Stamp tool has been used.

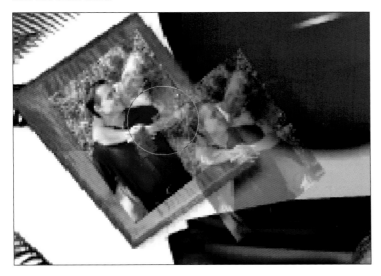

> **TIP** If you are using the entire image as a clone source, as in this example, you can use a huge clone brush to make it fairly easy to clone using one stroke.

Using the Healing Brush Tools to Correct a Video Layer

As you use the Clone Stamp tool, the Healing Brush tools are very useful for touching up areas that cloning leaves smudged or looking unnatural. They are also a useful first step for minor touchups. There are four different tools grouped under the Spot Healing Brush Tool in the Toolbox. In addition to the Spot Healing Brush tool, there are the Red Eye, the Healing Brush, and the Patch tools.

The Red Eye tool

The Red Eye tool is very easy to use. Click the arrow on the Spot Healing Brush button in the Toolbox to open the other choices, and click the Red Eye tool. Your cursor turns into a crosshair. You can adjust the pupil size and darken amounts in the toolbar. Center the cursor on the eye and click. Photoshop takes it from there, darkening the red in the targeted area (see Figure 16.23).

FIGURE 16.23

Using the Red Eye tool can reduce the appearance of red eyes in your image or video.

The Healing Brush tool

The Healing Brush tool is very similar to the Clone Stamp tool, but instead of duplicating the source exactly, the Healing Brush tool blends the pixel information of the sampled area with the lighting, texture, and transparency information of the target area so that the finished product is an area that blends better than a straight clone. This is especially useful for areas that are similar but consist of many different tones, like a face. If you've ever tried to use the Clone Stamp tool to erase blemishes on a face, you'll know what I mean.

The Healing Brush tool is used exactly like the Clone Stamp tool. Click the Healing Brush button in the Toolbox. Alt+click (Option+click) in the area of an image that you want to sample to set the source. Click and drag over the target area, and the source blends with the target. Figure 16.24 demonstrates the usefulness of the Healing Brush tool over the Clone Stamp tool for fixing certain areas. While you use the Healing Brush tool, don't forget to take advantage of the Clone Source palette. Despite the name, it is fully functional with the Healing Brush tool as well, allowing you to create multiple samples, sample from different files, and modify the size and rotation of the source.

The Patch tool

The Patch tool works like the Healing Brush tool to blend the lighting and texture of the source with the color information of the target. It works by using a selected area and is useful for changing larger areas of an image.

FIGURE 16.24

The first image is untouched, the second image removes the scratch using the Clone Stamp tool, and the third image uses the Healing Brush tool, which is a much better option in this case.

To demonstrate the Patch tool, I use an image on which I used the Clone tool earlier. If you refer back to image 16.3, you'll see that the Clone tool was able to remove the vehicle, but something definitely looks wrong with the image.

You can use the Patch tool to remove objects from your image more effectively. Follow these steps:

1. Click the Patch Tool button in the Toolbox.
2. Click and drag to create a selection around the area that you want to change (see Figure 16.25).
3. Click the selection and drag it to the area that you want to mimic. You'll notice in Figure 16.26 that you can preview the changes in real time as you move the selection. In my image, I am careful to keep the sidewalk and the lines in the street aligned.

FIGURE 16.25

The Patch tool works like the Lasso tool to create a selection.

FIGURE 16.26

Click and drag the selection around your image to sample different areas.

4. Release the mouse button to accept the change that you see in the preview. The lighting and texture information blend to create a seamless fix. The preview mimicked the sample area exactly, but the end result is a combination of both sources (see Figure 16.27).

FIGURE 16.27

This image looks more realistic than the image where the vehicle was cloned out, and it took less time.

> **NOTE** The Patch tool uses a selection to replace the targeted area. It doesn't matter if you've used the Patch tool to create the selection. You can make a selection with any selection tool and use the Patch tool to move and replace the selection.

The Spot Healing Brush tool

The Spot Healing Brush tool combines all of the previous tools. I wish I had a Spot Healing Brush tool that worked in real life. From acne to carpet stains, my life would sure be a lot easier. Using the Spot Healing Brush is as simple as using the cursor to paint over the area you want to remove from your image.

The key to using the Spot Healing Brush tool successfully is to use it in an area that is surrounded by consistency. The Spot Healing Brush tool uses the areas around the targeted area to replace the target area; if these areas aren't consistent with what you want your end result to be, you would be better off using one of the other healing tools.

To show you what I mean, look at Figure 16.28. Because the entire background of the image is sand, very similar in color and texture, the Spot Healing Brush works almost flawlessly with just one swipe.

FIGURE 16.28

Using the Spot Healing Brush tool works best with a consistent background.

If I take a very similar image, however, and try to spot heal an area that is bordered by two different areas, the results are not what I intended, as you can see in Figure 16.29. I seem to have cloned a body part into the surrounding sand. This is an image where the Healing Brush tool or the Patch tool would work much better.

FIGURE 16.29

The Spot Healing Brush tool isn't always the best option.

Summary

This chapter showed you how to make improvement to your video files by using the following tools:

- The Clone Stamp tool and the Clone Source palette
- The Healing Brush tools

The next and final chapter shows several different advanced video-editing techniques that can be used to create special effects.

Chapter 17

Applying Advanced Special Effects to a Video

Most video editing applications have canned effects that you can apply to video footage, such as soft edges, lighting, and slow-motion effects. Using the powerful tools of Photoshop, you can create special effects in your videos that are not possible with other video editors. You can use fill and adjustment layers, masks, layer styles, and Blend modes to apply deliberate methods to create much more specific special effects.

It is impossible to cover all of the ways you can create special effects in videos using Photoshop. This chapter focuses on some specific concepts and takes you through some examples of applying special effects to videos. The first concept that is covered is alpha channels. Alpha channels are not unique to video editing; however, they offer some unique applications in creating special effects in video. You need to understand how alpha channels work to be able to apply several of the special effects that are discussed.

The more you understand about masks and their relationship to special effects, the more you will want to use them to fine-tune, manipulate, and enhance other special effects that you add to video footage.

You can use also use layer styles to create effects such as soft edges, lighting effects, and so on. Styles are easily applied to video, and because you can adjust their settings, they can provide infinite possibilities for special effects. And, of course, layer styles can be animated, which increases their usefulness and makes them a lot of fun.

There are several different ways to use multiple video layers to create special effects. You can use duplicate layers of the same video or different video

IN THIS CHAPTER

Using alpha channels to embed transparency in videos

Using layer masks to create video special effects

Adding multiple layers of video, layer styles, and blend modes to create special effects

footage in multiple layers. You can also offset the different video layers. When using multiple layers of video, you will likely be using styles and Blend modes to blend the videos.

You will find that most special effects require the use of more than one of these tools. A good working knowledge of all of them will increase your ability to create incredible special effects and to achieve the specific effects you want. The following sections discuss alpha channels, layer masks, layer styles, and blend modes.

Understanding Alpha Channels

Understanding how to create and use alpha channels can enable you to take your video special effects to the next level. You've already learned how to use various tools to create selections and turn those selections into masks. An alpha channel is basically a permanent mask that is not embedded in a specific layer but can be embedded in a video file. The mask and selection information in an alpha channel can be modified and applied using several different tools.

CROSS-REF If you missed the section on creating selections and masks, you can learn more about them in Chapter 7.

There are several ways that alpha channels can be used in Photoshop. When working with still images, alpha channels are typically used when you are creating a selection or mask that is complex or needs to be duplicated over and over. Because alpha channels are easy to duplicate and then fine-tune, they make it much easier to select around difficult things such as hair.

NOTE One of the best ways to use alpha channels is to store selections that can be combined later. Photoshop's Calculations command is great for blending multiple channels. Choose Image ➪ Calculations to display the Calculations dialog box. Using the Calculations dialog box, you can merge alpha channels using several blending options.

Alpha channels can be applied to video to create special effects in two ways. First, an alpha channel can be used in a rendered video to create a transparent background. Second, alpha channels can be used to implement masks that apply special effects to video layers.

The following sections discuss how to create an alpha channel from a mask and then how to fine-tune it. You also learn how to render a video containing transparency and then how to add video that contains a transparent background to other video projects. Later in this chapter, you learn how to use these techniques to create some cool special effects.

Creating an alpha channel

Alpha channels can easily be created from a current selection. You can use any of the Photoshop selection tools to define a selection and then create an alpha channel. To create an alpha channel from a current selection, follow these steps.

1. Open a video of image file.

2. Select the Ellipse Marquee Tool from the Tools palette.

3. Select an area of the image as shown in Figure 17.1.

4. Choose Select ⇨ Save Selection to display the Save Selection dialog box, as shown in Figure 17.2.

FIGURE 17.1

A simple elliptical selection.

5. Leave the Document setting in the Save Selection dialog box as the current document.

6. Set the Channel setting to New so that a new channel is created.

7. Type the alpha channel name, as shown in Figure 17.2.

8. Click OK, and the alpha channel is created. The Channels palette shows that the newly created alpha channel is now available as a channel in the document (see Figure 17.3).

FIGURE 17.2

The Save Selection dialog box is set to create a new alpha channel from the current selection.

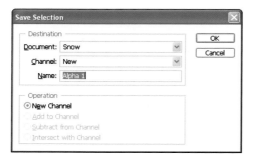

FIGURE 17.3

The Channels palette shows the newly created alpha channel.

Modifying an existing alpha channel

You may find yourself needing to modify an existing alpha channel, especially if you are using the alpha channel to create a complex mask that is to be used later. There are two simple methods to modify an existing alpha channel: First, you can create new selections and apply them to the alpha channel, or second, you can directly edit the alpha channel to make adjustments. The following sections discuss each method.

Saving new selections to an existing alpha channel

New selections can be applied to an existing alpha channel to either modify or replace it. To apply a new selection to an alpha channel, simply create an additional selection and then choose Select ➪ Save Selection to display the Save Selection dialog box, as shown in Figure 17.4. Instead of using the New setting in the Channel drop-down list, select an existing alpha channel; you will be able to select one of the following options to apply the selection to the alpha channel:

■ **Replace Channel:** This operation discards the selected channel and replaces it with the new selection information.

- **Add to Channel:** This operation keeps the selected channel and simply adds the new selection.

- **Subtract from Channel:** This option removes any portion of the selected channel that is located in the current selection from the channel.

- **Intersect with Channel:** This option removes any portion of the selected channel that does not also exist in the current selection, and discards any portion of the current selection that doesn't exist in the selected channel.

FIGURE 17.4

The Save Selection dialog box is configured to replace the selected alpha channel with a new selection.

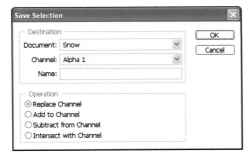

Fine-tuning alpha channels

Just like masks, alpha channels are grayscale images where white represents the selection, black represents the area that isn't selected, and different shades of gray represent a partially opaque selection. After you create an alpha channel, you can fine-tune it by painting white, black, or gray directly in the channel to change the mask. To fine-tune an existing alpha channel you can use the following steps.

1. Select the Channels tab to display the Channels palette as shown earlier in Figure 17.3.

2. Make the alpha channel visible by clicking the Visibility button next to the alpha channel in the Channels palette to display the eye icon.

3. Select the alpha channel.

4. Select a painting tool such as a brush.

5. Set the brush color to black, white, or gray. Black will add to the alpha channel, white will remove from the alpha channel and gray will add opaqueness to the alpha channel depending on the shade of gray.

6. Paint directly to the channel, as shown in Figure 17.5.

TIP When fine-tuning an alpha channel, you may want to hide the other visible channels in the document. This allows you to see the alpha channel selection only, and you will be better able to see flaws in the channel. Figure 17.6 shows the alpha channel with all other channels hidden. You can easily see places where the brush did not fully paint in the channel.

FIGURE 17.5

The alpha channel is displayed as a semitransparent layer in the document, and can be directly painted on using the Photoshop painting tools.

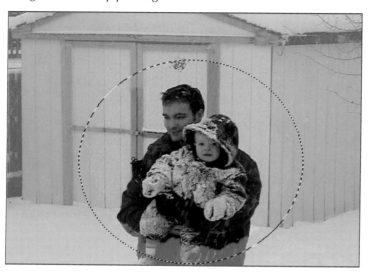

FIGURE 17.6

The alpha channel of a document with all other channels hidden.

Rendering video with an alpha channel

One of the most useful features of alpha channels is that they can be embedded in files as transparent layers that other applications can use. For example, you could create a complex alpha channel using Photoshop's powerful tools and then export the rendered alpha channel as a transparent layer in a video that can be used in video-editing software that supports alpha channels.

After you create an alpha channel in a video project, you can embed it in a video file by choosing File ➪ Export ➪ Render Video to display the Render Video dialog box, as shown in Figure 17.7. The following selections are available in the Alpha Channel drop-down menu in the Render Options section:

- **None:** This option discards the alpha channel data and renders the video using the full footage.

- **Straight-Unmatted:** This option renders the transparent alpha channel using the straight video footage. Typically this is the best option to use for most video.

- **Premultiplied-Matte:** This option premultiplies the alpha channel with the specified color. This option can leave a halo around the video, especially if other applications do not understand premultiplied alpha channels.

FIGURE 17.7

The Render Video dialog box.

Interpreting video with an alpha channel

Photoshop supports adding video files that contain embedded alpha channels to your projects. This is a necessary feature if you are adding video or animation sequences to a video project that requires transparent backgrounds. The alpha channels are automatically applied to the imported video using the straight method of interpreting the alpha channel.

The straight method may not always work well, especially if the alpha channel was originally created using a premultiplied mask. You will see the matte that was used to create the premultiplied alpha channel around the video. You can make the matte transparent by choosing Layer ➪ Video Layers ➪ Interpret Footage to display the Interpret Footage dialog box, as shown in Figure 17.8. Select the Premultiplied-Matte option in the Alpha Channel section and then set the color of the mask to match the color of the matte.

> **TIP** You will get the best results when interpreting footage if you record the RGB color settings that you use when you first create the video with a premultiplied alpha channel and then use the same settings for matte color when interpreting footage.

FIGURE 17.8

The Interpret Footage dialog box.

Implementing Special Effects Using Masks

One of the most common features of Photoshop that you will use to create special effects in videos is masking. A mask defines a specific area of an image or video. Using masks enables you to apply special effects to certain areas of the video footage. When you add a layer mask to a video layer, it

limits what part of the video image is visible. This allows you to apply effects to specific areas of the video, add borders to video, and many other options.

Adding a gradient mask to highlight an area of a video

A great example of using a mask to create a special effect in a video is to highlight a specific area of the video. If you add a layer mask to a video layer, any portion of the layer mask that is filled in with black or gray will be at least semitransparent. To add a highlight effect to a video layer by using a gradient mask, follow these steps:

1. Open a video file to which you want to apply a highlight effect.
2. Add a background layer and fill it with a solid color.
3. Select the video layer and click the Add Layer Mask button in the Layers palette to create a layer mask in the video layer.
4. Click the Channels tab to display the Channels palette.
5. Select the new layer mask in the Channels palette so that you can add a gradient fill to the layer mask to highlight a specific section of the video. You will probably want the RGB channels visible so that you will be able to see the area in the file you want to highlight.
6. Select the Gradient tool from the Toolbox and then select the Foreground to Background gradient from the Gradient drop-down list in the Gradient options bar.

TIP To see the gradient names, hold the mouse over the thumbnails and a screen tip will pop up showing the name of the gradient.

7. Select the Radial Gradient option from the Gradient options bar and make certain that the Reverse, Dither, and Transparency options are selected.
8. Click the center of the area in the video that you want to highlight, and drag the cursor out to the desired radius of the gradient, as shown in Figure 17.9.
9. Release the mouse button. The gradient mask effect is applied to the video, as shown in Figure 17.10.

FIGURE 17.9

Use the Gradient tool to draw a line representing the size of the gradient.

FIGURE 17.10

The gradient highlights an area of the video.

Using a mask to implement a frame around a video

You can apply an image over a video file to create a really cool effect. You can use masks to very quickly create a frame effect using an existing image. All you need to do is select the portion of the image that you want the video to appear in, and use that selection to create a layer mask on the video layer. The following steps take you through an example of using an image and layer mask to create a custom frame around a video:

1. Open the image you want to use as the video frame.

2. Select the area in the image in which you want the video to appear. Figure 17.11 shows an image of a door with the door selected.

3. Click the Channels tab to display the Channels palette.

4. Click the Save Selection as Channel button at the bottom of the Channels palette to create an alpha channel, as shown in Figure 17.12.

5. Click the Visibility button (eye icon) next to the alpha channel to make it visible. You will want to use the visible alpha channel to help you position the video.

FIGURE 17.11

The door in the image is selected to serve as a video frame.

6. Choose Select ➪ Deselect to clear the selection. If you don't remove the selection, it will move as you position the video.

7. Click the Layers tab to display the Layers palette.

8. Choose Layer ➪ Video Layers ➪ New Video Layer from File, and select the video you want to add to the project.

9. Select the Move tool from the Toolbox, and use it to position the video so that it is properly placed in the visible alpha channel, as shown in Figure 17.12. You can also resize the video if you turn the video layer into a Smart Object Layer and use the transformation tools.

10. Click the Channels tab to display the Channels palette.

11. Select the alpha channel. Click the Load Selection button at the bottom of the Channels palette to create a selection from the channel.

12. Click the Visibility button (eye icon) next to the alpha channel to hide it.

13. Click the Layers tab to display the Layers palette.

14. Select the video layer and click the Add Layer Mask button at the bottom of the Layers palette to create a layer mask from the selection, as shown in Figure 17.13.

15. The layer mask is applied to the video layer, creating a frame, as shown in Figure 17.13.

FIGURE 17.12

Use the visible alpha channel to see where the video layer should be placed.

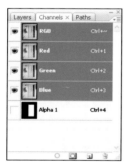

FIGURE 17.13

The layer mask hides video outside the selection, making it appear that the video is inside the door frame.

Using a mask to create a picture-in-picture special effect

Another really cool special effect you can create with masks is a custom picture-in-picture video that displays a second, smaller video on the same screen as the first. That way, you can view footage of two related videos at the same time. The following steps take you through an example of using an image to create a layer mask for a video layer so that it can be applied as a picture in a picture to another video layer:

1. Open the video file that you want to display as the full screen image.

2. Choose Layer ➪ Video Layers ➪ New Video Layer from File, and add the second video layer to the project.

3. In a separate document, open an image that you want to use to build the mask for the picture-in-picture as a separate document. The vehicle shown in Figure 17.14 is an example.

4. Use the Quick Selection tool to create a selection of the outline of the basic shape of the image, as shown in Figure 17.14. In the case of the vehicle image, it was easier to select the white areas and then invert the selection.

FIGURE 17.14

The outline of an image is selected to create an alpha channel.

5. Click the Channels tab to display the Channels palette.

6. Click the Save Selection as Channel button to create an alpha channel for the selection, as shown in Figure 17.15.

7. Click the alpha channel image in the Channels palette so that only the alpha channel is visible (see Figure 17.15).

8. Choose Select ➪ All to select the contents of the alpha channel, as shown in Figure 17.15, and press Ctrl+ C (⌘+C) to copy the selection.

9. Go back to the original video project and select the layer named Video Layer 2.

10. Click the Add Layer Mask button to create a layer mask in the second video layer.

11. Click the Channels tab to display the Channels palette.

12. Hide all but the new layer mask channel.

FIGURE 17.15

The selected alpha channel that was created from the vehicle image.

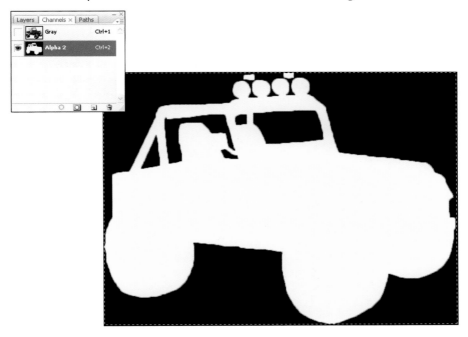

13. Press Ctrl+V (⌘+V) to paste the alpha channel created in Step 6 into the layer mask.

14. Choose Select ➪ Deselect to clear the selection. You can also press Ctrl+D (⌘+D).

15. Make any adjustments to the layer mask that are necessary to fill in the mask properly. For example, you may need to change the size of the image that was pasted in, or you may need to add black or white areas.

16. Click the Layers tab to display the Layers palette.

17. Right-click Layer 2 and choose Convert to Smart Object from the drop-down menu. You will need to change Layer 2 to a Smart Object so that you can change its size.

18. Click the Move tool in the Toolbox.

19. Select the Show Transform Controls option in the Move tool options bar to display the transform tools.

20. Use the transform controls to change the size, angle, and location of Layer 2 so that it completes the picture-in-picture effect, as shown in Figure 17.16.

FIGURE 17.16

The finished video with a picture-in-picture second video layer effect.

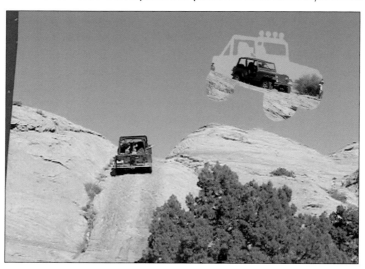

Implementing Special Effects Using Layer Styles, Layers, and Blending

Another method of applying special effects to video is to blend in other layers or layer styles. Styles can be added to layers by clicking the Add a Layer Style button at the bottom of the Layers palette. When you apply a layer style to a video layer, the style is applied throughout the video. Using blend modes with layer styles and multiple layers of video, you can create an infinite number of special effects. The following sections take you through the process of applying a few special effects to a video clip using styles, layers, and blending.

Animating styles to apply a special effect

A great feature of styles is that they can be animated through keyframe animation. Animating the style allows you to apply the effects of the style over time in the video. That way, you can provide a smooth transition to the special effect. The following steps take you through an example of applying a style to a video layer and then animating it so that it is applied over time:

1. Open the video file to which you want to apply the special effect.

2. Select the video layer in the Layers palette.

3. Click the Add a Layer Style button at the bottom of the Layers palette and choose Inner Glow from the drop-down menu to display the Layer Style dialog box (see Figure 17.17).

4. In the Layer Style dialog box, (see Figure 17.17) select settings from the Structure, Elements, and Quality sections for the Inner Glow style. In this example, the color is changed to a pale aqua, the initial size is set to 18 pixels, and the blend mode is set to Vivid Light.

FIGURE 17.17

The Layer Style dialog box displaying the settings for the Inner Glow style.

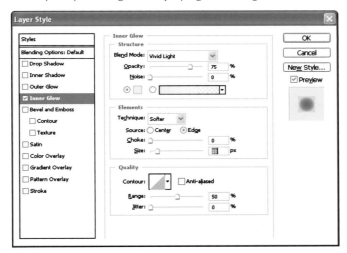

5. Click OK to apply the style to the video layer.

6. Click the triangle next to the name of the video layer in the Timeline to display the layer properties.

7. Position the current-time indicator to the location where you want to begin animating the Inner Glow style.

8. Click the Time-Vary Stop Watch button next to the Style property to activate keyframe animation for the layer style (see Figure 17.18).

The Time-Vary Stop Watch button activates keyframe animation.

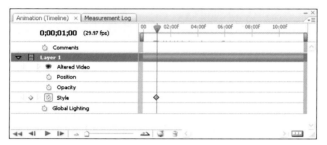

9. Move the current-time indicator to the point in the Timeline where you want the animation of the Inner Glow style to end.

10. Double-click the Inner Glow sublayer in the Layers palette to display the Layer Style dialog box.

11. Click Inner Glow in the Styles list to display the Inner Glow style settings.

12. Set the final Structure, Elements, and Quality settings for the Inner Glow style. In this example, the only change is that the size is set to 200 pixels.

13. Click OK. The new style settings are applied to the video, and a new keyframe is created in the Style property.

14. Preview the video. The Inner Glow style is animated, as shown in Figure 17.19.

FIGURE 17.19

These images illustrate how the Inner Glow style is applied over time through animation.

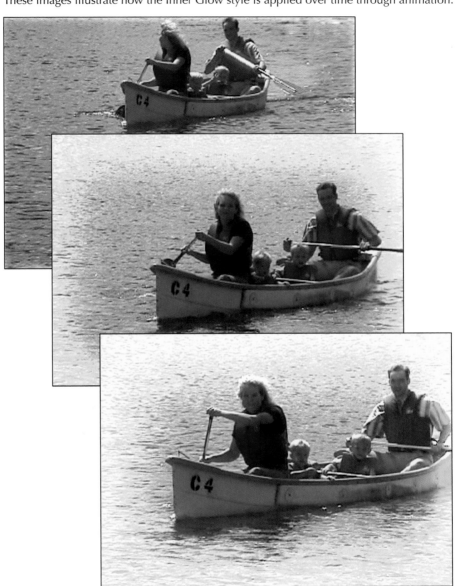

Offsetting video layers to create an echo effect

The Blend Modes options in the Layers palette can be used in several ways to create special effects. A fun special effect that you can create using blend modes is the echo effect. Using a blend mode, you can offset multiple layers of the same video and create an echo. The following steps take you through an example of adding multiple video layers to a file and then using a blend mode to create an echo effect:

1. Open the video file in which you want to apply the special effect.

2. Right-click the video layer in the Layers palette and choose Duplicate Layer from the pop-up menu to create a duplicate layer.

3. Repeat Step 2 to create a second duplicate layer, as shown in Figure 17.20.

4. Select the first copy of the video layer in the Layers palette.

5. Choose the Lighten blend mode from the Blend Modes drop-down menu in the Layers palette.

6. Select the second copy of the video layer in the Layers palette.

7. Repeat Step 5, as shown in Figure 17.20.

FIGURE 17.20

The Layers palette with the Lighten blend mode selected for a duplicate layer.

Blend Mode menu

8. Click and drag the Zoom slider in the Animation (Timeline) palette until the frames are listed in the Time Ruler as every even number, as shown in Figure 17.21.

9. Drag the first copy of the video layer so that it begins at frame 4.

10. Drag the second copy of the video layer so that it begins at frame 8, as shown in Figure 17.21.

11. Preview the video to see a double echo effect, as shown in Figure 17.22.

FIGURE 17.21

The Animation (Timeline) palette with the duplicate layers of the video offset to frames 4 and 8.

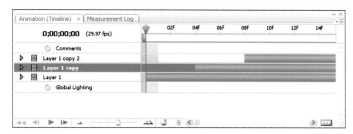

TIP

If you do not want the echoed video layers to be as prominent as the main video layer, you can add a layer mask to them and fill it with gray to make the layers partially transparent. The darker the gray, the more faded the echo will appear.

FIGURE 17.22

This image illustrates the echo effect created by alternating three video layers.

Blending layers of video

One of the most artistic special effects that you can add to video in Photoshop is through blending two or more layers of video. It is not a difficult task, but it requires a lot of creativity to use the video footage and Photoshop blending features properly. There are an infinite number of options that may or may not be successful, depending on the video footage you use. The following steps take you through just one example of blending two video layers to create a special effect:

1. Open the video file that will act as the background for the special effect. This example uses video footage of a sunset horizon.

2. Choose Layer ➪ Video Layers ➪ New Video Layer from File to add a second video layer. This example uses footage of a person rappelling.

3. Select the second video layer in the Layers palette and click the Add Layer Mask button to add a layer mask to the second video file, as shown in Figure 17.23. The layer mask is used to control the transparency of the second layer.

Adding a mask to the second video layer when blending layers allows you to control the transparency of the second layer.

4. Click the Channels tab to display the Channels palette.

5. Select the layer mask. Modify the mask to fit the effect you are trying to create. In this example, I filled the mask with a light gray to make it slightly transparent. You may find yourself creating complex masks here to implement the effect.

6. Click the Layers tab to display the Layers palette.

7. Select the second layer and choose the blend mode that you want to use to blend the layers. This example uses the Lighter Color Blend mode to blend video footage of a person rappelling with video footage panning across a sunset horizon. The Lighter Color blend mode picks up the highlights of the sunset and blends them on top of the person and hillside, as shown in Figure 17.24.

FIGURE 17.24

Using a blend mode and a layer mask to combine two video files makes for very cool video footage.

Summary

This chapter introduced you to powerful Photoshop tools that you can use to create special effects in your videos. As you become more familiar with these tools, you will find yourself using several of the techniques together to apply deliberate methods to create much more specific special effects. You learned how to:

- Create and use alpha channels in your video projects
- Use layer masks to create transparency effects in video projects
- Add multiple video layers, layer styles, and blend modes to implement video special effects

A Final Word

This book has introduced you to the new 3D, animation, and video capabilities in Photoshop CS3 Extended. These capabilities have been added to Photoshop so that the powerful editing tools that are offered by Photoshop can be extended to these file formats. After reading this book, you should have a comprehensive understanding of how these files work in Photoshop and the best way to apply edits to them. You should also have a basic understanding of the most useful editing tools found in Photoshop.

Index

F

M

There's a Visual book for every learning level...

Simplified®

The place to start if you're new to computers. Full color.

- Computers
- Mac OS
- Office
- Windows

Teach Yourself VISUALLY™

Get beginning to intermediate-level training in a variety of topics. Full color.

- Computers
- Crocheting
- Digital Photography
- Dog training
- Dreamweaver
- Excel
- Guitar
- HTML
- Knitting
- Mac OS
- Office
- Photoshop
- Photoshop Elements
- Piano
- Poker
- PowerPoint
- Scrapbooking
- Sewing
- Windows
- Wireless Networking
- Word

Top 100 Simplified® Tips & Tricks

Tips and techniques to take your skills beyond the basics. Full color.

- Digital Photography
- eBay
- Excel
- Google
- Mac OS
- Photoshop
- Photoshop Elements
- PowerPoint
- Windows

Build It Yourself VISUALLY™

Do it yourself the visual way and without breaking the bank. Full color.

- Game PC
- Media Center PC

...all designed for visual learners—just like you!

Master VISUALLY®

Step up to intermediate-to-advanced technical knowledge.
Two-color interior.

- 3ds Max
- Creating Web Pages
- Dreamweaver and Flash
- Excel VBA Programming
- iPod and iTunes
- Mac OS
- Optimizing PC Performance
- Photoshop Elements
- QuickBooks
- Quicken
- Windows
- Windows Mobile
- Windows Server

Visual Blueprint™

Where to go for professional-level programming instruction.
Two-color interior.

- Ajax
- Excel Data Analysis
- Excel Pivot Tables
- Excel Programming
- HTML
- JavaScript
- Mambo
- PHP & MySQL
- Visual Basic

Visual Encyclopedia™

Your A-to-Z reference of tools and techniques. Full color.

- Dreamweaver
- Excel
- Photoshop
- Windows

Visual Quick Tips™

Shortcuts, tricks, and techniques for getting more done in less time.
Full color.

- Digital Photography
- Excel
- MySpace
- Office
- PowerPoint
- Windows
- Wireless Networking

For a complete listing of Visual books,
go to wiley.com/go/visual

Visual®
An Imprint of WILEY
Now you know.